LATIN AMERICAN GRAPHIC DESIGN

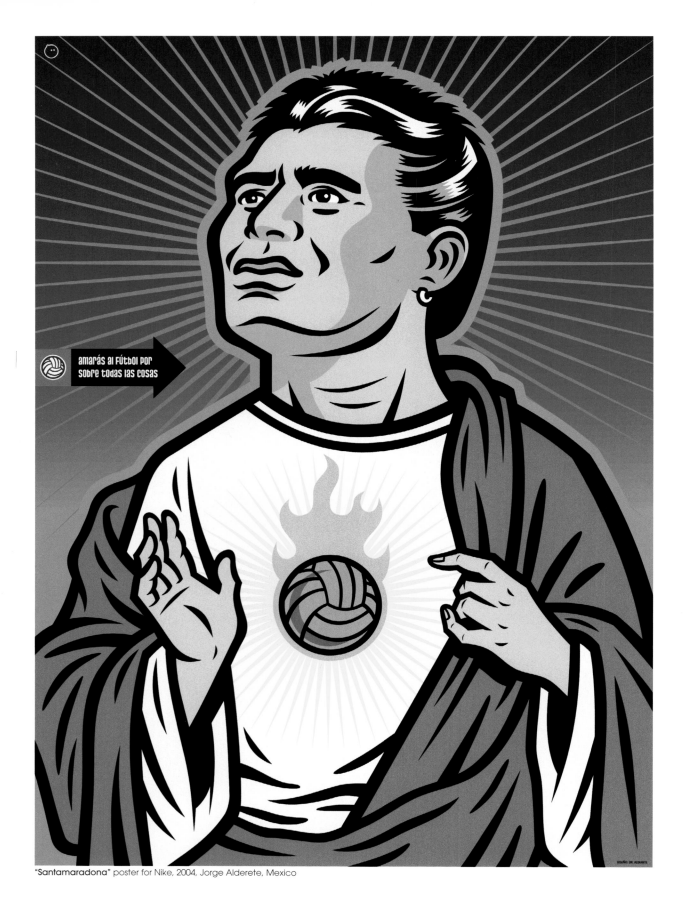

"Santamaradona" poster for Nike, 2004, Jorge Alderete, Mexico

Felipe Taborda
Julius Wiedemann

LATIN AMERICAN GRAPHIC DESIGN

TASCHEN

HONG KONG KÖLN LONDON LOS ANGELES MADRID PARIS TOKYO

CONTENTS

CREATIVIDAD Y COMUNICACIÓN

Foreword by Gonzalo Fargas
Editor, *90+10 Design Magazine*, Argentina

Graphic design in Latin America began to take off as a profession only recently, in the mid-20th century, thanks to the work and talent of different design personalities who helped promote this work in the field of visual communication that is so important and global in contemporary society. It began to acquire more importance over the following decades as big international advertising agencies moved into the region. Many of today's leading graphic designers cut their teeth in an ad agency, and some of their stars continue to form part of the current design panorama.

In its short life in Latin America graphic design has gone through different periods, always in line with the social and economic vicissitudes of the region — a region that has never been quiet, whether socially, politically, or economically speaking, and where different cultures have historically come face to face and combined. It was often left to graphic design to act as a mirror on culture and what was happening in society. And, because of its communicational nature, many times it also suffered poor treatment from forces that considered it a dangerous profession. Today, design has achieved a prominent position in society and is vital to cultural, economic, and social development. Proof of its growth is the large number of universities that include it as a career choice and the thousands of students who study it every year.

Der Beruf des Grafikdesigners entstand in Lateinamerika erst ab der Mitte des 20. Jahrhunderts. Dies ist dem Engagement und Talent verschiedener Designer zu verdanken, die an der Förderung der visuellen Kommunikation beteiligt waren, die für die heutige Gesellschaft so wichtig und allgegenwärtig ist. Nachdem sich große internationale Werbeagenturen in Lateinamerika niedergelassen hatten, gewann das Grafikdesign im Lauf der folgenden Jahrzehnte immer mehr Bedeutung. Viele heute maßgebliche Grafikdesigner begannen ihre berufliche Laufbahn in einer Werbeagentur und manche der Stars aus dieser Zeit sind immer noch Teil der heutigen Designszene.

Das Grafikdesign durchlief in Lateinamerika verschiedene Phasen und spiegelte dabei immer die soziale und wirtschaftliche Unbeständigkeit in diesem Teil der Welt wider – einer Region, in der weder in sozialer, politischer noch wirtschaftlicher Hinsicht je Ruhe herrschte und im Lauf der Geschichte verschiedene Kulturen aufeinandertrafen und sich vermischten. Es war oft die Rolle des Grafikdesigns, Kultur und Gesellschaft den Spiegel vorzuhalten. Und wegen seiner kommunikativen Natur wurde es von den Kräften, die so etwas als gefährlich betrachteten, häufig schlecht behandelt. Heute spielt Design in der Gesellschaft eine bedeutende Rolle und ist für die kulturelle, wirtschaftliche und soziale

En Amérique latine, le graphisme n'a commencé à se développer en tant que profession que vers le milieu du XXe siècle, grâce au travail et au talent de différentes personnalités du design qui ont aidé à forger le métier de la communication visuelle, qui occupe aujourd'hui une place si importante pour la société. Au cours des décennies qui ont suivi, la profession a pris de l'importance à partir de l'installation dans la région de grandes agences de publicité internationales. Beaucoup des grands graphistes contemporains ont fait leurs premiers pas dans la profession au sein d'une agence de publicité, et certains de leurs personnages font toujours partie du paysage actuel du design.

Le graphisme est passé par différentes étapes dans sa courte histoire latino-américaine, toujours en accord avec l'évolution de l'actualité sociale et économique de la région. Une région qui n'a jamais connu de longue période de calme social, politique ou économique, et où différentes cultures se sont confrontées et mélangées au cours de l'histoire. Le graphisme a souvent été chargé d'être le miroir de la culture et des événements sociaux. À cause de cette nature communicante, il a souvent souffert les mauvais traitements de ceux qui considéraient le graphisme comme un métier dangereux. Aujourd'hui, le graphisme a réussi à prendre une place prépondérante dans la société, et s'est rendu indispensable au développement culturel, économique et so-

This book gave me the chance to examine a great many works by local designers in one collection, from which I drew the conclusion that, despite the number of countries we come from and our many and varied customs and folklores, we are not different or distinct. This book demonstrated that, through the creativity and work of different designers (from already-established and well-known artists to the youngest and most energetic) we are all Latin American. Even with their own identities and histories, which shine through in their art and works (such as the Mexicans with their posters and habit of smiling death in the face, the Brazilians with their dance and colors, or the Argentineans with their tango and Maradona), we can see we are all very much alike. In each work it is possible to distinguish a Latin American root and origin, suggesting that we also share the same concerns and problems, the same fears and even the same energy to continue to move forward. All of which is reflected in this book.

Entwicklung unerlässlich. Beleg für diese Entwicklung sind die vielen Universitäten, die Design als Studiengang anbieten, und Tausende von Studenten, die jedes Jahr die Fachrichtung Design wählen.

Dieses Buch gab mir Gelegenheit, zahlreiche Werke einheimischer Designer in einer Sammlung zu untersuchen. Dabei erkannte ich, dass wir ungeachtet unserer unterschiedlichen Herkunftsländer und der vielen Bräuche und Folkloren gar nicht so unterschiedlich sind. Die in diesem Buch gezeigte Kreativität und die Arbeiten verschiedener Designer (von den renommiertesten und bekanntesten Künstlern bis hin zu den jüngsten und dynamischsten) zeigen, dass wir alle Lateinamerikaner sind. Trotz unserer jeweiligen Identitäten und Geschichte, die in der Kunst und den Arbeiten der verschiedenen Designer durchschimmern (z. B. bei den Mexikanern mit ihren Plakaten und ihrer Gewohnheit, dem Tod ins Gesicht zu lachen, den Brasilianern mit ihren Tänzen und Farben oder den Argentiniern mit ihrem Tango und Maradona), sehen wir, dass wir uns sehr ähnlich sind. In jeder Arbeit lassen sich die lateinamerikanischen Wurzeln und die jeweilige Herkunft erkennen, was darauf schließen lässt, dass wir die gleichen Sorgen und Probleme, die gleichen Ängste und sogar die gleiche Energie teilen, die uns weiter voran bringt. All dies findet in diesem Buch seinen Ausdruck!

cial. Le nombre d'universités qui proposent cette discipline et les milliers d'étudiants qui s'y inscrivent chaque année sont la preuve de cette croissance.

Grâce à ce livre, j'ai eu l'occasion de voir en un seul coup d'œil de nombreuses œuvres des graphistes du sous-continent, ce qui m'a permis d'observer et de me rendre compte du fait que, malgré le nombre de pays qui forment la région, et malgré la grande diversité de coutumes et de folklores, nous ne sommes pas différents les uns des autres. Ce livre m'a prouvé qu'à travers la créativité et le travail des graphistes (depuis les professionnels confirmés et reconnus jusqu'aux plus jeunes et dynamiques), nous sommes tous latino-américains. Même si chaque peuple a sa propre identité et sa propre histoire, que les graphistes laissent toujours transparaître dans leur art et dans leurs œuvres (les Mexicains avec leurs affiches et leurs clins d'œil à la mort, les Brésiliens avec la danse et la couleur, ou les Argentins avec le tango et Maradona), on voit bien que nous nous ressemblons beaucoup. On peut retrouver dans chaque œuvre une même racine et une même origine latino-américaine. Nous partageons les mêmes envies, les mêmes problèmes et la même énergie pour avancer. Tout cela se reflète dans ce livre.

REVOLUCIÓN VISUAL

Introduction by Xavier Bermúdez
Director of the International Biennal of the Poster in Mexico

Never before in the history of design has Latin America seen an initiative on the scale of the one presented here, especially in respect of the simple and straightforward reason that inspires it: to provide the world with a window on to the continent of the pampas, plains and reefs, the high mountains and jungles, the whales, condors and jaguars, and an exciting rediscovery of our language after the passage of centuries.

It is clear that purpose, pride, dignity and elegance are the main legacies of the ancient traditions of our people and, I might add, of the men and women from around the world who set up home here, inspired by our open and friendly lands and finding among our landscapes an extraordinary beauty to nourish their souls.

What you have in this beautiful publication on Latin American design is related not just to design understood as a fundamental tool of human co-existence, but also to our feelings, expressed with a vigorous spirit and converted into images, colors and the alphabets we have learned.

Like the fruit of Latin America, it is color that makes our designs stand out. Whether the work of Mexicans or Brazilians, Chileans or Argentineans, who are outside their homelands, or designers who arrived from abroad and became Latin American in Paraguay and Nicaragua, the designs taste of colors, smell of the arts of fertile soil and are observed from the heart. They

Nie zuvor in der Geschichte des Designs hat Lateinamerika ein so umfassendes Engagement gesehen wie dieses, besonders wenn man sich den schlichten und einfachen Grund vor Augen führt, der es inspiriert: der Welt ein Fenster zum Kontinent der Pampas, der Grassteppen und Riffe, der hohen Berge und Dschungel, des Kondors, der Wale und Jaguare zu öffnen. So wird nach Jahrhunderten unsere Sprache auf spannende Weise wiederentdeckt.

Entschlossenheit, Stolz, Würde und Eleganz sind ganz klar das wichtigste Vermächtnis der alten Traditionen unseres Volkes, und ich möchte hinzufügen: der Männer und Frauen aus der ganzen Welt, die sich hier niederlassen, inspiriert von unseren offenen und freundlichen Länder und der außergewöhnlichen Schönheit unserer Landschaften, die ihre Seele berührt.

Diese wunderbare Publikation über lateinamerikanisches Grafikdesign versteht Design nicht nur als ein grundlegendes Werkzeug der menschlichen Koexistenz, sondern auch als Möglichkeit, unsere Gefühle lebhaft und energisch in Form von Bildern, Farben und der Sprache, die wir gelernt haben, zu bschreiben.

Wie bei den Früchten Lateinamerikas sind es die Farben, die unser Design hervorheben. Ob es sich um die Arbeiten von Mexikanern oder Brasilianern, Chilenen oder Argentiniern handelt, die fern der Heimat leben, oder von Designern, die

Jamais auparavant dans l'histoire du design on avait vu une initiative de cette envergure pour nos pays d'Amérique latine inspirée par cette raison toute simple : ouvrir au monde la fenêtre du continent des pampas, des plaines et des récifs, des hautes montagnes et des jungles, des condors, des baleines et des jaguars. Une redécouverte passionnée de notre langage après de nombreux siècles.

L'intention, l'orgueil, la dignité et l'élégance sont les principaux héritages qui nous viennent des traditions les plus anciennes de nos peuples et, pourquoi ne pas le dire, des hommes et des femmes du monde entier qui ont trouvé dans notre espace leur foyer et leur atelier de création de la vie. Sûrement inspirés par notre intérieur ouvert et amical, ils ont trouvé dans nos paysages une beauté extraordinaire qui a nourri leurs cœurs.

Ce que vous trouverez dans ce magnifique ouvrage sur le graphisme latino-américain relève non seulement du design compris comme un outil fondamental de la cohabitation humaine, mais aussi de l'expression de nos sentiments grâce à la transformation de la force mentale en images, en couleurs et en alphabets appris.

Tout comme les fruits d'Amérique latine, nos œuvres se distinguent par leurs couleurs. Réalisées au Mexique ou au Brésil, par des Chiliens ou des Argentins qui ont franchi les frontières, et par des créateurs qui sont arrivés de l'extérieur et sont

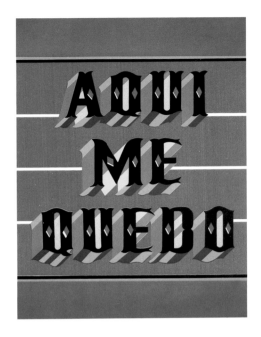

Right "Aqui me quedo" poster, 1985, Propal Productora de Papeles S.A., Dicken Castro, Colombia

Next page "Mex-Mix" illustration, 2006, Eseté magazine, Zoveck Estudio, Mexico

remind us of the sweet treats in our food markets, our liquors and regional dishes. Mestizo and modern, they do not copy but rather propose a new way of visually consuming our realities. White like the blankets of our sierras, their languages are as varied and surprising as our diversity and cultural wealth. On the continent of a thousand masks and rainbow-colored waterfalls, their blurred colors have appeared on streets, in schools and businesses, in mobile printing, off-set printing and through the use of digital media. We know them from almond-shaped eyes, black like Africans with their West Indian afros, like Cubans, white with blue eyes and bronzed skin, smelling of llama wool and wood. A poster of content, with culture: that is Latin American design.

Latin American design has been developed within popular culture: in cultural and social activities, making a mark and providing its visual form of synthesis and modernity. There is no doubt that our ballrooms, our boxing and wrestling, our cinema, music, theatre, danzón[1], Willie Colón[2], our Violeta Parras-style battles[3], aspirations and oppositions, our dictatorships and limitations have resulted in posters in which the author participates not only in the creation of a language but in the discourse itself.

Our designers do not keep quiet — they are restless, they move around, come and go, and produce work for other cultures;

aus dem Ausland kamen und in Paraguay oder Nicaragua zu Lateinamerikanern wurden, diese Designs schmecken nach Farben, riechen nach der Kunst der fruchtbaren Erde und werden mit dem Herzen wahrgenommen. Das Design erinnert uns an die Süßigkeiten auf unseren Märkten, an unsere Getränke und regionalen Gerichte. Sie sind indianisch-europäisch und modern, und sie kopieren nichts, sondern zeigen einen neuen Weg, unsere Realität visuell aufzunehmen. So weiß wie die Ebenen unserer Sierras, so verschiedenartig, wie unser kultureller Reichtum, so vielfältig und überraschend ist auch die Sprache des Designs. Auf diesem Kontinent der 1000 Masken und regenbogenfarbenen Wasserfällen erscheinen die fließenden Farben unseres Designs in den Straßen, Schulen und Geschäften, im mobilen Druck, Offset-Druck und in der Verwendung digitaler Medien. Wir erkennen sie in den mandelförmigen Augen, schwarz wie die Afrikaner und Bewohner der Karibik, wie die Kubaner, weiß mit blauen Augen und sonnengebräunter Haut, duftend nach Lamawolle und Holz. Ein großes Plakat mit Aussage, mit Kultur: So ist lateinamerikanisches Design.

Das lateinamerikanische Design hat sich innerhalb einer populären Kultur entwickelt: in kulturellen und sozialen Aktivitäten. Es hat ein Zeichen gesetzt und eine visuelle Form der Synthese und Moderne geschaffen. Ohne Zweifel

devenus latino-américains au Paraguay ou au Nicaragua. Ce sont des graphismes qui ont un goût coloré, un arôme de lettres et de terre fertile, et qui s'observent avec le cœur. Ils nous rappellent les délices de nos marchés populaires, des liqueurs et des plats régionaux. Métissés et modernes, ils ne copient pas, mais proposent plutôt une nouvelle façon de manger nos réalités avec les yeux. Blancs comme le manteau de nos montagnes, leurs langages sont aussi variés et surprenants que notre diversité et notre richesse culturelles. Sur le continent aux mille visages, en s'évaporant les cascades arc-en-ciel déversent leurs couleurs dans les rues, dans les écoles ou dans les commerces, par le truchement des presses mobiles, offset ou numériques.

Elles ont les yeux bridés, elles sont noires comme les Africains et Afro-Antillais, comme les Cubains, blanches avec des yeux bleus, ou bronzées et embaumant le lama et le bois. C'est cela le graphisme latino-américain, une fédération de contenus, avec de la culture.

Sur notre continent latino-américain, le graphisme a grandi dans la culture populaire, dans les activités culturelles et sociales, par écho, en leur donnant sa forme visuelle de synthèse et de modernité. Il ne fait aucun doute que les salons de danse, la boxe et la lutte libre, notre cinéma, notre musique, notre théâtre, le danzón[1], Willie Colón[2], nos luttes Violetas Parras[3], nos aspirations et nos dissonances,

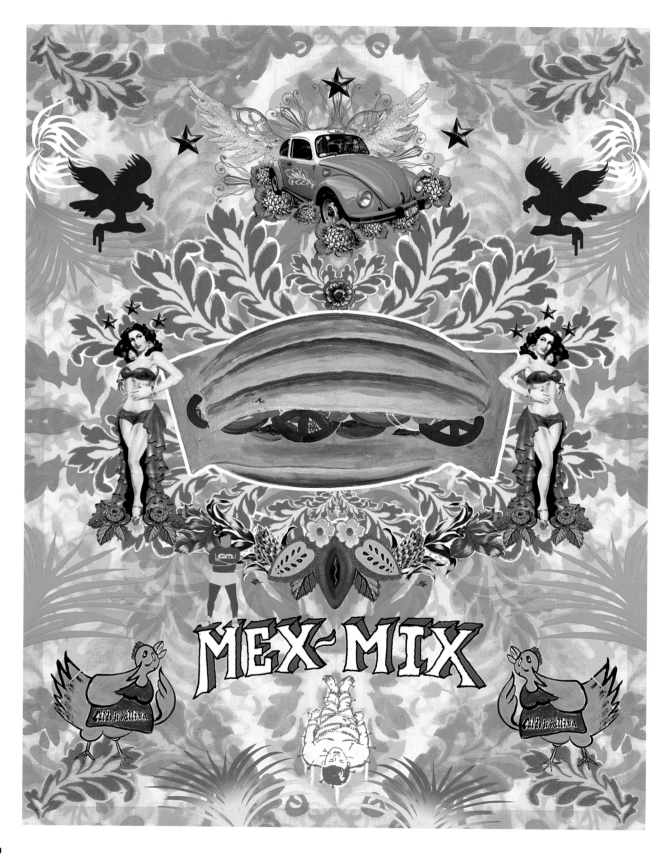

they pursue you and seduce you, and you end up inviting them into your home, office, life and memory. They are like wrapping-paper, with the smell of *pulque* stores[4] and (while I'm at it) books and students, social movements and political problems.

Contemporary Latin American designs from Venezuela, Colombia, Ecuador, and Uruguay, from the Andes regions and from Central America, from our extensive savannas and the art that reaches us by mail from fellow Americans overseas, all feature in this collective exploration of those windows which catch us in memorable snapshots and speak to us of the beauty of mestizos, of the mixing of the blood of lovers, of our feelings, our sorrows and aspirations, and of our respect for life and creation as the maximum expression of the human condition.

Colorín coloreado[5], Latin American design…

führen unsere Tanzlokale, unsere Box- und Ringkämpfe, unser Kino, unsere Musik, unser Theater, *el danzón*,[1] Willie Colón,[2] zu kämpfen wie Violeta Parra,[3] unsere Sehnsüchte und Gegensätze, unsere Diktaturen und Einschränkungen zu Plakaten, bei denen der Urheber nicht nur daran mitwirkt, eine Sprache zu schaffen, sondern am Diskurs selbst beteiligt ist.

Unsere Designer sind nicht still – sie sind ruhelos, wandern umher, kommen und gehen und schaffen Werke für andere Kulturen. Sie sind Ihnen auf der Spur und verführen Sie, und schließlich laden Sie sie in Ihr Haus, Ihr Büro und Ihr Leben und Ihre Erinnerung ein. Unsere Designer sind wie das Einwickelpapier, das nach *Pulque*-Kneipen[4] riecht, und – wo wir gerade davon sprechen – nach Büchern und Studenten, nach sozialer Bewegung und politischen Problemen.

Zeitgenössisches lateinamerikanisches Design aus Venezuela, Kolumbien, Ecuador, Uruguay, aus den Andenregionen und aus Zentralamerika, aus unseren ausgedehnten Grassteppen und die Kunst, die uns per Post von unseren lateinamerikanischen Landsleute aus dem Ausland zugesandt wird – sie alle spielen eine Rolle in dieser gemeinsamen Erkundung jener Fenster, die uns in unvergesslichen Momentaufnahmen einfangen und uns von der Schönheit der Mestizen und den Liebenden, die ihr Blut vermischen, erzählen, von unseren Gefühlen, unserem Leid und unserer Sehnsucht und von unserem Respekt vor dem Leben und der Schöpfung als dem höchsten Ausdruck dessen, was uns menschlich macht.

Colorín coloreado,[5] lateinamerikanisches Design …

nos dictatures et nos liens ont créé un ensemble d'opinions dans lequel l'auteur participe non seulement à la création d'un langage, mais aussi du discours lui-même.

Nos graphistes ne tiennent pas en place, ils vont, ils viennent, ils produisent pour d'autres cultures, ils vous poursuivent, vous séduisent et vous finissez par les inviter chez vous, dans votre foyer, à votre travail, dans votre vie, dans votre mémoire. Ils sont comme le papier d'emballage, comme l'odeur des *pulquerias*[4] et, pourquoi pas, comme les livres et les étudiants, des mouvements qui dénoncent et des problèmes préoccupants.

Le graphisme d'aujourd'hui, le graphisme latino-américain du Venezuela, de Colombie, d'Équateur ou d'Uruguay, des Andes, d'Amérique centrale, de nos vastes savanes, ou le graphisme qui arrive par courrier de nos amis latino-américains de l'étranger, se révèle dans cette aventure collective de fenêtres qui s'ouvrent et nous font plonger dans des moments mémorables. Il nous parle de la beauté du métissage, de la beauté du mélange amoureux des sangs, des sentiments, de nos tristesses et de nos aspirations, du respect de la vie et de la création en tant qu'expression suprême de l'être humain.

Colorín coloreado[5], le graphisme latino-américain…

1. A Cuban dance from the late 19th century.
2. An exponent of salsa music from Puerto Rico.
3. Reference to Violeta Parra, a Chilean singer-songwriter who stood up to the Pinochet dictatorship.
4. An establishment that sells *pulque*, an alcoholic beverage obtained from the fermented juice of the *maguey*, popular in Mexico.
5. A paraphrasing of the Mexican expression used at the end of a story. The original phrase is: "*Colorín colorado, este cuento se ha acabado*" (equivalent to "And they all lived happily ever after").

1. Kubanischer Tanz vom Ende des 19. Jahrhunderts.
2. Vertreter der Salsa-Musik aus Puerto Rico.
3. Violeta Parra war eine chilenische Folksängerin, die gegen die Diktatur von Augusto Pinochet eintrat.
4. *Pulque* ist ein in Mexiko beliebtes alkoholisches Getränk, das aus dem fermentierten Saft der Agavenpflanze hergestellt wird.
5. Colorín coloreado: nach dem mexikanischen Ausdruck am Ende einer Geschichte. Im Original lautet er: „*Colorín colorado, este cuento se ha acabado*" (entspricht dem deutschen Schluss eines Märchens: „ …und wenn sie nicht gestorben sind, dann leben sie noch heute.").

1. Danse cubaine de la fin du XIXe siècle.
2. Personnalité de la salsa à Puerto Rico.
3. Référence à Violeta Parra, chanteuse-compositrice chilienne qui s'était opposée à la dictature d'Augusto Pinochet.
4. Établissement où l'on vend du *pulque*, une boisson alcoolisée mexicaine produite en faisant fermenter l'aguamiel, le jus que l'on extrait de l'agave.
5. D'après l'expression qui conclut les contes pour enfants au Mexique. La phrase originale est : « *Colorín colorado, este cuento se ha acabado* » (un équivalent de « Et ils vécurent heureux et eurent beaucoup d'enfants »).

CULTURA LATINA

Essay by Felipe Taborda

Latin America today perceives a radical change in how the outside world views its culture. However, pride in, and affirmation of its own visual and literary identity has already been expressed many times previously. Perhaps the best examples are the phrase and its illustration by Uruguayan artist Joaquín Torres García (1874–1949), who created the Escuela del Sur in Montevideo in 1935:

"Our north is the south. There shouldn't be a north for us, only the opposite of our south… This rectification was necessary and as a result we now know where we are."

The origins of the words *Latin* and *America*, which together define the region, are very different. The name America first appeared on record in a 1507 world map by German cartographer Martin Waldseemüller, in honor of the Florentine cartographer Amerigo Vespucci. In a book that accompanied the map, Waldseemüller explained that the word came from the Latin form of the name, Americus Vespucius. He then adapted it to the feminine form, "America", to match the gender of the other continents. The name was given a year after the death of the Genoa-born navigator Christopher Columbus (born Cristoforo Colombo), who disembarked in the New World in 1492,

Das heutige Lateinamerika erkennt, dass sich das Ansehen seiner Kultur beim Rest der Welt entscheidend geändert hat. Doch schon viele Male zuvor hat es seinen Stolz auf die eigene visuelle und literarische Identität ausgedrückt und diese Identität bekräftigt. Das vielleicht beste Beispiel dafür ist ein Zitat des uruguayischen Künstlers Joaquín Torres García (1874–1949), der 1935 die Escuela del Sur in Montevideo gründete:

„Unser Norden ist der Süden. Für uns sollte es keinen Norden geben, sondern nur das Gegenteil unseres Südens … Diese Korrektur war nötig, und als Folge davon wissen wir jetzt, wo wir sind."

Der Ursprung der Wörter „Latein" und „Amerika", die zusammen die Region beschreiben, ist sehr unterschiedlich. Der Name Amerika tauchte zum ersten Mal im Jahr 1507 auf einer Weltkarte des deutschen Kartografen Martin Waldseemüller zu Ehren des florentinischen Kartografen Amerigo Vespucci auf. In einem Buch, das die Karte begleitete, erklärte Waldseemüller, dass das Wort ursprünglich von der lateinischen Form des Namens, Americus Vespucius, stammte. Er änderte den Namen zur weiblichen Form „America" ab, damit er grammatisch das gleiche Geschlecht wie die anderen Kontinente hatte. Der Name entstand ein Jahr nach dem Tod

Le monde porte aujourd'hui un nouveau regard sur la culture de l'Amérique latine. La fierté et l'affirmation de l'identité latino-américaine (visuelle et littérale) ont pourtant déjà été exprimées maintes fois. La citation et l'illustration de l'artiste uruguayen Joaquín Torres García (1874-1949), qui a créé en 1935 l'Escuela del Sur à Montevideo, en sont peut-être le meilleur exemple :

« Notre nord est le Sud. Pour nous, il ne doit pas y avoir de nord si ce n'est par opposition à notre sud… Cette rectification était nécessaire, car maintenant nous savons où nous sommes. »

Les mots « Amérique » et « latine » ont des origines très différentes. Le nom Amérique apparaît pour la première fois sur une carte du monde du cartographe allemand Martin Waldseemüller datant de 1507, en l'honneur du cartographe florentin Amerigo Vespucci. Dans le livre qui accompagnait la carte, Martin Waldseemüller expliquait que le mot était dérivé de la forme latinisée du nom propre, *Americus Vespucius*. Il est du genre féminin, comme les noms des autres continents. Le baptême eut lieu l'année suivante, à l'occasion du décès du navigateur genevois Christophe Colomb (né Cristoforo Colombo), qui avait débarqué au Nouveau Monde en 1492, plus exac-

1. "América Invertida"
1943, Museo Torres García,
Joaquín Torres García, Uruguay

1

more specifically in today's El Salvador. Both Columbus and Vespucci worked for the King of Spain. This trip is commonly considered the official discovery voyage of the Americas, although various theories suggest previous expeditions by groups such as the Vikings and other sailing nations. The word *Latin* originates from the ancient language of the same name, which is the root of the two dominant languages in the region, Portuguese and Spanish.

Latin America is not a geopolitical but rather a cultural definition. The concept was first suggested either by Chile's Francisco Bilbao at a conference in Paris in 1856, or proposed in 1861 by the French academic L. M. Tisserand in an article for the magazine *La Revue des Races Latines*. There are also other hypotheses, however, these appear to be less valid. Although French is also a language derived from Latin, the French-speaking countries of the Americas do not form part of the group. Latin America is consequently formed of 20 countries: Argentina, Bolivia, Brazil, Chile, Colombia, Costa Rica, Cuba, the Dominican Republic, El Salvador, Ecuador, Guatemala, Honduras, Mexico, Nicaragua, Panama, Paraguay, Peru, Puerto Rico, Uruguay and Venezuela, which have a combined total of more than 550 million inhabitants.

One of Latin America's great challenges has always been to identify itself. Following centuries of exploitative colonialism, the region is ethnically composed

des aus Genua stammenden Seefahrers Christoph Kolumbus (geboren als Cristoforo Colombo), der 1492 mit seinem Schiff die Neue Welt erreichte, genauer gesagt das heutige El Salvador. Sowohl Kolumbus als auch Vespucci standen im Dienst des spanischen Königs. Diese Reise wird gemeinhin als offizielle Entdeckung des amerikanischen Kontinents betrachtet, obwohl andere Theorien besagen, dass bereits Wikinger und andere Seevölker Expeditionen dorthin unternommen hatten. Das Wort „Latein" bezieht sich auf die alte lateinische Sprache, die Basis der beiden vorherrschenden Sprachen der Region: Portugiesisch und Spanisch.

Lateinamerika ist keine geopolitische, sondern eher eine kulturelle Definition. Der Begriff wurde erstmals entweder 1856 von dem aus Chile stammenden Francisco Bilbao auf einer Konferenz in Paris vorgeschlagen oder 1861 von dem französischen Gelehrten L. M. Tisserand in einem Artikel für die Zeitschrift *La Revue des Races Latines*. Darüber hinaus gibt es noch weitere, doch weniger stichhaltige Hypothesen. Obwohl auch Französisch vom Lateinischen abstammt, gehören die französischsprachigen Länder des amerikanischen Kontinents nicht zu dieser Gruppe. Lateinamerika besteht somit aus 20 Staaten: Argentinien, Bolivien, Brasilien, Chile, Kolumbien, Costa Rica, Kuba, El Salvador, Ecuador, Guatemala, Honduras, Mexiko, Nicaragua, Panama, Paraguay, Peru, Puerto Rico, die

tement là où se trouve actuellement le Salvador. Colomb et Vespucci étaient au service du roi d'Espagne. Ce voyage est communément considéré comme la découverte officielle du continent américain, bien que plusieurs théories suggèrent des expéditions antérieures menées par les Vikings et d'autres peuples de navigateurs. Le mot « latine » tire son origine du latin, la base des deux langues dominantes de la région : le portugais et l'espagnol.

L'Amérique latine n'est pas une définition géopolitique, mais culturelle. Ce concept a été suggéré pour la première fois par le Chilien Francisco Bilbao, lors d'une conférence à Paris en 1856, ou proposé en 1861 par l'universitaire français L. M. Tisserand dans un article pour le magazine *La Revue des Races latines*. Bien que le français soit également une langue latine, les pays francophones du continent américain ne font pas partie du groupe « latin ». L'Amérique latine se compose de 20 pays : l'Argentine, la Bolivie, le Brésil, le Chili, la Colombie, le Costa Rica, Cuba, le Salvador, l'Équateur, le Guatemala, le Honduras, le Mexique, le Nicaragua, le Panama, le Paraguay, le Pérou, Puerto Rico, la République dominicaine, l'Uruguay et le Venezuela. Au total, plus de 550 millions d'habitants.

L'identité de l'Amérique latine a toujours été l'un de ses grands défis. Après des siècles de colonisation, elle est composée d'un mélange de plusieurs peuples

of a mix of various peoples (indigenous, Africans, Europeans, Arabs, and Asians). However, one apparent difficulty in accepting itself as Latin American has dragged on for hundreds of years and penetrated deeply into the soul. In the formation of its identity, the region always appeared to be divided between Europe and the US: from the first it inherited its cultural base and from the second a model of independence and economic success.

With the acceleration of globalization, many of the regional traditions and cultures were transformed over the years into attractions for the world at large, such as Mexican tequila, Brazilian *bossa nova*, Argentinean tango, Chilean wine and Peru's Inca culture.

When analyzing Latin America's cultural production, we can see that what it did (and continues to do) in the course of the 20th century was always in tune with the West: there was a synchronism of events but an absence of communication between the countries in the region. There is an almost insurmountable barrier between the nations of Latin America, whether because of political disputes or prejudice, infrastructure or physical distance. Mutual ignorance is detrimental to individual growth and very little is done to change

Dominikanische Republik, Uruguay und Venezuela. Es hat insgesamt mehr als 550 Millionen Einwohner.

Eine der großen Herausforderungen Lateinamerikas bestand immer darin, die eigene Identität zu finden. Nach jahrhundertelanger Ausbeutung durch den Kolonialismus besteht diese Region aus einer Mischung verschiedener Völker (indigene Völker, Afrikaner, Europäer, Araber und Asiaten). Doch ebenso lange kämpfen diese Völker damit, sich selbst als Lateinamerikaner zu akzeptieren. In der Entwicklung ihrer Identität scheint die Region immer zwischen Europa und USA hin und her gerissen zu sein. Ersteres wird als kulturelle Basis angesehen, während Letzteres als Vorbild für Unabhängigkeit und wirtschaftlichen Erfolg dient.

Im Zuge der schnell voranschreitenden Globalisierung wurden allmählich viele regionale Traditionen und Kulturen zu Attraktionen für die ganze Welt, z.B. mexikanischer Tequila, brasilianischer Bossa Nova, argentinischer Tango, chilenischer Wein und die peruanische Inka-Kultur.

Bei einer Analyse der kulturellen Produktion Lateinamerikas erkennt man, dass alles, was zu Beginn des 20. Jahrhunderts (und seither) passierte, stets mit den Entwicklungen der westlichen

(indigènes, africains, européens, arabes et asiatiques). Mais il semble que pendant plusieurs siècles les Latino-Américains aient eu du mal à s'identifier en tant que tels, et que cela ait pénétré l'âme de la région. L'Amérique latine a toujours été divisée entre l'Europe et les États-Unis d'Amérique. L'Europe est sa base culturelle, et les États-Unis sont son modèle d'indépendance et de succès économique.

Avec le rythme effréné de la mondialisation, beaucoup des traditions et cultures régionales se sont transformées en attractions pour les touristes du monde entier, comme la tequila mexicaine, la bossa-nova brésilienne, le tango argentin, le vin chilien et les Incas du Pérou.

Lorsque l'on analyse la production culturelle de l'Amérique latine, on voit que ce qui s'est fait à partir du XXᵉ siècle a toujours été en synchronisation avec le monde occidental. Mais les différents pays du sous-continent ne communiquent pas entre eux. Il semble qu'une sorte de barrière pratiquement infranchissable se soit érigée entre les nations latino-américaines, fondée sur des disputes politiques, des préjugés, des infrastructures inadéquates ou la distance physique. Le manque de connaissance mutuelle porte préjudice à la croissance individuelle, et

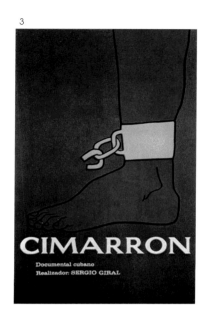

2. "Melissa #4 (Tropical)"
illustration, 2007, Melissa Gallery
(Grendene), Muti Randolph, Brazil

3. "Cimarron" film poster,
1967, Instituto Cubano de Arte de la
Industria Cinematográfica (ICAIC),
Alfredo Rostgaard, Cuba

the *status quo*. One example is that nearly all the Latin American countries depend on international news agencies to find out what is happening in neighboring nations, and as a result the stories do not arrive with a local vision but are colored by the external viewpoint.

There is also the problem of the continued existence of Latin American stereotypes. Although there is undoubtedly a measure of truth in most stereotypes, they certainly cannot be taken as read. The region wants to be known as more than the home of the banana, the samba, the tango, salsa, drugs, dictators, mariachis and other such colorful images. One example is the conference held in 2007 by the Argentineans Victor Boldrini and Gato Ficcardi (graphic designers who specialize in wine posters and labels), right when the exportation problems facing the Argentinean drinks industry was making news. The pair had spent years working with leading vineyards in the city of Mendoza, known for the quality of its wine products, and were well aware of the difficulties involved with positioning Argentina's best-known goods on the world's markets. "Consumers in the region are reluctant to buy a more expensive, Argentinean wine, even if it is better. Whether because of inertia, tradition or ignorance, they prefer to buy French or Italian wine, even if they are worse quality and more expensive than Argentinean wine."

Nationen übereinstimmte: Viele Dinge ereigneten sich synchron, doch gab es unter den lateinamerikanischen Ländern selbst keinen Austausch. Zwischen den Völkern Lateinamerikas scheint es eine unüberwindbare Barriere zu geben, sei es aufgrund politischer Streitigkeiten oder Vorurteile, Infrastruktur oder räumlicher Distanz. Die gegenseitige Unkenntnis behindert das Wachstum der einzelnen Länder, und es wird nur wenig getan, um diese Situation zu ändern. Beispielhaft sei genannt, dass sich fast alle Länder Lateinamerikas an internationale Nachrichtenagenturen wenden, um etwas über ihre Nachbarn zu erfahren.

Zudem werden die Länder immer noch mit gängigen lateinamerikanischen Klischees konfrontiert. Die Region will nicht nur als Heimat von Bananen, Samba, Tango, Salsa, Drogen, Diktatoren, mexikanischer Musik und ähnlich exotischen Vorstellungen gelten. Ein gutes Beispiel ist die Konferenz, an der die beiden Argentinier Victor Boldrini und Gato Ficcardi (Grafikdesigner, die sich auf Logos und Etiketten für Wein spezialisiert haben), 2007 teilnahmen, gerade als die Exportprobleme der argentinischen Getränkeindustrie bekannt wurden. Seit Jahren hatten Boldrini und Ficcardi für Weinproduzenten aus Mendoza, das für die Qualität seiner Weine bekannt ist, gearbeitet und wussten sehr wohl, wie schwer es war, die bekanntesten argentinischen Produkte auf dem Weltmarkt zu positionieren. „Die Verbraucher in dieser

l'on ne fait pas grand-chose pour changer le *statu quo*. Par exemple, presque tous les pays d'Amérique latine ont recours aux agences de presse internationales pour s'informer sur ce qui se passe chez leurs voisins. Ces nouvelles n'ont donc aucune dimension locale, et parviennent avec le biais d'un regard externe.

Il y a aussi le problème des éternels stéréotypes latino-américains. Tout stéréotype comporte sans aucun doute une part de vérité, mais aucun ne représente les faits dans leur totalité. L'Amérique latine essaie de s'éloigner de cette image des pays de la banane, de la samba, du tango, de la salsa, des drogues, des dictateurs et des mariachis. La conférence que les Argentins Victor Boldrini et Gato Ficcardi (graphistes spécialisés dans les étiquettes de vin) ont donnée en 2007 en est un bon exemple. Ils y abordaient les problèmes que le vin argentin rencontre à l'exportation. Ils travaillent depuis des années pour les principaux vignobles de la ville de Mendoza, connue pour la qualité de sa production, et ils connaissent bien les difficultés de positionnement des produits argentins sur le marché mondial. « Le consommateur de ces régions ne veut pas acheter un vin plus cher, argentin, bien qu'il soit meilleur. Il préfère, par inertie, tradition ou ignorance, acheter un vin français ou italien, bien qu'il soit de qualité inférieure et à un prix plus élevé que le vin argentin. »

4

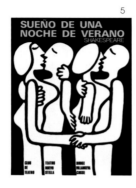

5

6

tacuabé

The tradition of defining limitations has existed since the time of the colonies. The countries of Latin America were discovered and colonized by the Portuguese and Spanish from 1492, with the odd French and Dutch incursion over time. Initially, industrial development in the region was precarious because the existence of commercial firms and projects that might compete with products manufactured in Europe ran counter to the Empires' interests. The same thing happened in the graphic-arts industry, which was the monopoly of the Crown. One of the most efficient ways to maintain a *status quo* has always been to ban free thought. From the moment the printed book appeared, the Church and the monarchy went to great lengths to oversee this medium for the dissemination of ideas.

Portugal and Spain determined what should be read and consumed in their New World colonies.

The few books and newspapers that were read came from Europe, and even then they had to pass a rigid selection and censorship process. With the exception of Mexico, Peru and Bolivia, which had already had their own print industries since 1535, 1577 and 1612, respectively, printing was practically banned in all the various countries for more than two centuries.

Region zögern, einen teureren, argentinischen Wein zu kaufen, auch wenn er besser ist. Ob aus Trägheit, Tradition oder Ignoranz – sie kaufen lieber einen französischen oder italienischen Wein, obwohl er vielleicht eine minderwertige Qualität hat oder teurer ist als argentinischer Wein."

Die Tradition der Abgrenzung voneinander existiert bereits seit den Kolonialzeiten. Die lateinamerikanischen Länder wurden ab 1492 von Portugiesen und Spaniern entdeckt und kolonisiert. Anfangs war die industrielle Entwicklung der Region prekär, da die Mutterländer kein Interesse an Konkurrenzfirmen und -produkten aus den Kolonien hatte. Das Gleiche traf auf die Druckindustrie zu, denn eines der wirksamsten Werkzeuge zur Erhaltung einer Machtposition bestand immer darin, das freie Denken zu verbieten.

Portugal und Spanien legten fest, was in ihren Kolonien in der Neuen Welt gelesen und konsumiert werden sollte.

Die wenigen Bücher und Zeitungen, die gelesen wurden, kamen aus Europa, und selbst die wurden streng ausgewählt und zensiert. Mit Ausnahme von Mexiko, Peru und Bolivien, die bereits ab 1535, 1577 bzw. 1612 eigene Druckindustrien hatten, wurde den lateinamerikanischen Ländern mehr als zwei Jahrhunderte lang praktisch verboten, etwas zu drucken.

La définition de limites est une tradition qui existe depuis l'époque des colonies. Les pays d'Amérique latine ont été découverts et colonisés par les Portugais et les Espagnols à partir de 1492, avec quelques incursions des Français et des Hollandais. À l'origine, le développement industriel était précaire dans la région, car l'empire ne voyait pas d'un bon œil les entreprises ou les produits commerciaux qui pouvaient concurrencer les produits fabriqués en Europe. Il en allait de même pour l'industrie graphique, monopole des couronnes. L'une des forces les plus efficaces dans le maintien du pouvoir a toujours été l'interdiction de la liberté de pensée. Depuis l'apparition du livre imprimé, l'Église, les rois et les reines ont exercé une grande vigilance sur ce moyen de diffusion des idées.

Le Portugal et l'Espagne décidaient de ce qui devait être lu et consommé dans leurs colonies du Nouveau Monde.

Les quelques livres et journaux qui étaient lus venaient d'Europe, et étaient soumis à une sélection et à une censure très strictes. À l'exception du Mexique, du Pérou et de la Bolivie, qui possédaient déjà leurs propres imprimeries depuis 1535, 1577 et 1612 respectivement, pendant plus de deux siècles il a été pratiquement interdit d'imprimer quoi que ce soit dans tous les pays d'Amérique latine.

4. "La Recuperación de la Memoria (100 Años de Fotografía)" exhibition poster, 2003, Museo de Arte de Lima, Studio A, Peru

5. "Sueño de una noche de verano" poster, 1974, Club de Teatro de Montevideo, Carlos Palleiro, Uruguay

6. "Ediciones Tacuabé" logo, 1971, Tacuabé Records, Ayax Barnes, Uruguay

7. "Romeo y Julieta" cigars box, Habanos S.A., Cuba

Printing presses did not really become widely used until the late 17th and early 18th centuries. The first printed works were mostly books by Jesuit priests or accounts of scientific expeditions which described local characteristics through reports nearly always filled with exotic and generalized connotations, in keeping with what Europeans imagined the New World was like. The immediate presence of talented artists such as Albert Eckhout, William Hodges, Charles Landseer, Johann Moritz Rugendas, Franz Post and Jean-Baptiste Debret, on all the European scientific missions, made a decisive contribution to the evolution of graphic arts. These artists-cum-scientists were responsible for providing pictorial evidence of the places they visited in their capacity as visual chroniclers. Their mission was to deliver their original drawings to engravers and lithographers in London or Paris, who would reproduce them on printing plates which were then generally filled in by hand with water-colors.

In the New World there was a string of agricultural products unknown on the Old Continent at the time. Today it would be impossible to imagine Europe without potatoes, tomatoes, peppers, chocolate, tobacco, corn, peanuts or vanilla, all of which hail from Latin America.

Druckerpressen waren vor dem Ende des 17. und Anfang des 18. Jahrhunderts kaum verbreitet. Die ersten gedruckten Werke waren hauptsächlich Bücher von jesuitischen Priestern oder Chroniken wissenschaftlicher Expeditionen im Land. Diese Berichte enthielten fast immer viel Exotik und viele Verallgemeinerungen, die sich den europäischen Vorstellungen von der Neuen Welt anpassten. Die Anwesenheit begabter Künstler auf allen europäischen wissenschaftlichen Expeditionen (z. B. Albert Eckhout, William Hodges, Charles Landseer, Johann Moritz Rugendas, Franz Post und Jean-Baptiste Debret) trug maßgeblich zur Weiterentwicklung der Grafik bei. Diese Wissenschaftler, die zugleich Künstler waren, hatten als visuelle Chronisten die Aufgabe, grafische Nachweise der besuchten Orte anzufertigen. Ihr Auftrag war es, ihre Originalzeichnungen an Stecher und Lithografen in London oder Paris zu liefern, die diese auf Druckplatten reproduzierten und von Hand mit Wasserfarben kolorierten.

In der Neuen Welt gab es eine Reihe landwirtschaftlicher Erzeugnisse, die in der Alten Welt damals unbekannt waren. Heute kann man sich Europa ohne Kartoffeln, Tomaten, Paprika, Schokolade, Tabak, Mais, Erdnüsse und Vanille gar nicht vorstellen.

C'est seulement à partir de la fin du XVIIe siècle et du début du XVIIIe siècle que les imprimeries ont commencé à apparaître. Les premiers produits imprimés furent essentiellement des livres de pères jésuites ou des chroniques d'expéditions scientifiques qui décrivaient les particularités locales avec des récits remplis d'anecdotes exotiques et de généralisations reflétant l'image que les Européens se faisaient du Nouveau Monde. Toutes les missions scientifiques européennes comprenaient des artistes talentueux, comme Albert Eckhout, William Hodges, Charles Landseer, Rugendas, Franz Post et Debret, ce qui a notablement contribué à l'évolution des arts graphiques. Ces « artistes-scientifiques » étaient chargés de rapporter des chroniques visuelles des lieux visités. Ils donnaient leurs dessins à des graveurs ou à des lithographes parisiens ou londoniens, qui les reproduisaient sur des planches imprimées, généralement aquarellées à la main par la suite.

Le Nouveau Monde possédait alors de nombreux produits agricoles que le Vieux Continent ne connaissait pas encore. Il serait aujourd'hui impossible d'imaginer l'Europe sans pomme de terre, tomate, piment, chocolat, tabac, maïs, cacahouète et vanille, tous originaires d'Amérique.

8

The region's leading economic forces have always been agriculture and stock-breeding. The production and marketing of these products decided European investments and the development of the colonies. In the countries with the most natural resources and therefore the strongest economies, such as Mexico, Argentina, Venezuela, Colombia, and Brazil, the graphic-arts industry developed faster, at the exact time when commerce demanded services of this nature. The international renown of some local products also aided in the development of several countries, e.g. Cuba, where Havana cigars, with their characteristic boxes and the graphic quality of their labels, no doubt contributed to the product's strong presence around the world.

Following the gradual independence of the different countries, their political, economic, social and cultural rates of change determined the trajectories of local life and industry. However, nearly all the countries went down similar routes, with decades of political dictatorship, frequent currency devaluations and social chaos, together with a constant rise in the misery of the people. Slowly but surely, the graphic-arts industry began to take hold in Latin America, firstly with the printing of newspapers and labels in general, and then the gradual appearance of their respective national mints, responsible for printing money, title deeds and other

Die führenden Wirtschaftszweige der Region waren immer Landwirtschaft und Viehzucht. Produktion und Vermarktung dieser Produkte bestimmten die europäischen Investitionen und die Entwicklung der Kolonien. In den Ländern mit den größten natürlichen Ressourcen und somit den stärksten Ökonomien, darunter Mexiko, Argentinien, Venezuela, Kolumbien und Brasilien, entwickelte sich die Grafikindustrie schneller, weil ihre Dienstleistungen benötigt wurden. Gleichzeitig half auch die internationale Bekanntheit einiger regionaler Produkte: In Kuba trugen z. B. die Havanna-Zigarren in ihren typischen Kisten und mit der grafischen Qualität ihrer Etiketten zweifellos zu der starken weltweiten Präsenz des Produktes bei.

Als die Länder nach und nach unabhängig wurden, bestimmten die politischen, wirtschaftlichen, sozialen und kulturellen Veränderungen das Leben und die Industrie in den unterschiedlichen Gegenden. Jedoch nahmen fast alle Länder einen ähnlichen Weg, zu dem neben jahrzehntelangen Diktaturen, häufigen Geldentwertungen und sozialem Chaos auch das ständig wachsende Elend der Bevölkerung gehörte. Langsam aber sicher setzte sich die grafische Industrie in den lateinamerikanischen Ländern durch, zunächst mit dem Druck von Zeitungen und Logos und dann durch die Eröffnung der nationalen Prägeanstalten, die Geld,

L'agriculture et l'élevage ont toujours été les principales forces économiques de la région. La production et la commercialisation de ces produits ont conditionné les investissements européens et le développement des colonies. Dans les pays qui disposent des ressources naturelles les plus riches et donc de la plus grande puissance économique, comme le Mexique, l'Argentine, le Venezuela, la Colombie et le Brésil, le développement de l'industrie graphique a été plus rapide car le commerce a généré une demande de ce type de services. D'un autre côté, la notoriété internationale de certains produits locaux a également contribué au développement de certaines nations. C'est le cas de Cuba et de ses cigares, les havanes. La forme singulière des boîtes de cigares et la qualité des étiquettes ont certainement contribué au succès mondial de ce produit.

Graduellement, chaque pays a acquis son indépendance, et les différents rythmes politiques, économiques, sociaux et culturels ont déterminé les trajectoires de la vie et de l'industrie locales. Mais presque tous ont cependant connu des histoires semblables, des décennies de dictature politique, de fréquentes dévaluations de la monnaie et un chaos social lié à la misère croissante de la population. Peu à peu, l'industrie graphique des pays d'Amérique latine a commencé à prendre de l'importance. Tout d'abord avec l'impression des journaux, des étiquettes

items of value. The first newspaper in Latin America, the *Diário de Pernambuco*, which circulated in northwest Brazil, was founded in 1825. The first illustrated weekly magazine was *O Cruzeiro*, in the same country in 1928. In 1950, and again in Brazil, the impresario Assis Chateaubriand created the region's first television station, TV Tupi, named after an indigenous tribe from the southeast Brazilian coast.

With the growth of the graphic-arts industry, a number of artists emerged who contributed to its evolution, including engravers, woodcut artists and lithographers, all precursors to graphic designers.

Of note in Mexico was the work of José Guadalupe Posada, in the late 19th century, and, slightly more recently, Francisco 'Chicho' Mata, in Venezuela, among many other examples with a more- or less-extensive local influence. Also, in the mid-19th century, it was common to find a number of satirical publications, either newspapers or magazines, in various countries, such as Brazil's *Revista Ilustrada*, the *Papel Periódico Ilustrado*, sold in various countries, and Paraguay's *Cabuchui*, which was strident in its criticism of the government and institutions. The industry's evolution tried to take the best of international technical progress; however,

Eigentumsurkunden und andere wichtige Dokumente druckten. 1825 wurde im Nordwesten von Brasilien die erste Zeitung in Lateinamerika herausgegeben, die *Diário de Pernambuco*. Die erste illustrierte Wochenzeitschrift war *O Cruzeiro*, die 1928 ebenfalls in Brasilien erschien, und 1950 gründete der Geschäftsmann Assis Chateaubriand den ersten Fernsehkanal des Landes, TV Tupi, benannt nach einem indigenen Volk von der Südostküste Brasiliens.

Das Wachstum der Grafik-industrie brachte eine Reihe von Fachleuten wie Drucker, Holzschneider und Lithografen hervor, allesamt Vorläufer der heutigen Grafikdesigner.

Bemerkenswert waren u. a. die Arbeiten von José Guadalupe Posada in Mexiko gegen Ende des 19. Jahrhunderts und in jüngerer Zeit die Werke von Francisco ‚Chicho' Mata in Venezuela. Zudem verbreiteten sich Mitte des 19. Jahrhunderts verschiedene satirische Publikationen – Zeitungen oder Zeitschriften, die in mehreren Ländern veröffentlicht wurden und die Regierungen und Institutionen scharf kritisierten. Dazu zählten *Revista Ilustrada* in Brasilien, *Papel Periódico Ilustrado*, die in verschiedenen Ländern erschien, und *Cabuchui* in Paraguay. Die Grafikindustrie versuchte, mit der internationalen tech-

et des visuels en général, jusqu'à l'apparition progressive des différents hôtels de la Monnaie, responsables de l'impression des billets, titres bancaires et autres effets de valeur. Le premier journal latino-américain, le *Diario de Pernambuco*, a été créé en 1825. Il circulait dans le nord-ouest du Brésil. Le premier magazine hebdomadaire illustré a été *O Cruzeiro*, en 1928, dans le même pays. En 1950, l'entrepreneur Assis Chateaubriand a créé, également au Brésil, la première chaîne de télévision d'Amérique latine : TV Tupi, qui porte le nom d'une tribu indigène du littoral sud-est du Brésil.

Avec la croissance de l'industrie graphique sont également apparus les métiers de graveur, de xylographe et de lithographe, ancêtres du métier de graphiste.

Entre autres exemples aux dimensions locales variables, on peut remarquer l'œuvre graphique de José Guadalupe Posada au Mexique à la fin du XIXᵉ siècle et, plus récemment, l'œuvre de Francisco « Chicho » Mata au Venezuela. Au milieu du XIXᵉ siècle, on trouvait couramment différentes publications satiriques (journaux ou magazines) dans plusieurs pays, comme la *Revista Ilustrada* au Brésil, *Papel Periódico Ilustrado* en Colombie, et *Cabichui* au Paraguay, qui critiquaient sévèrement le gouvernement et les institutions. L'évolution

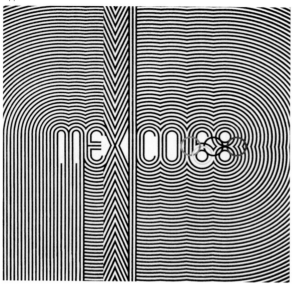

11. "Mexico Olympic Games"
poster, 1968, Lance Wyman (design),
Eduardo Terrazas, Pedro Ramírez
Vázquez (art direction), Mexico

12. "Carteles Mexicanos" poster, 1990,
International Biennal of the Poster,
Rafael López Castro, Mexico

13. "La canción del pulque"
film poster, 2003, Centro de
Capacitación Cinematográfica,
Alejandro Magallanes, Mexico

14. "México un libro abierto"
logo, 1992, Frankfurt Book Fair,
Vicente Rojo, Mexico

financial constraints very often slowed this process down.

In the 20th century, the graphic-design profession began to find itself better defined with the arrival of designers from Europe, who helped establish new concepts and guidelines in countries such as Mexico, Venezuela, Colombia, Argentina, Chile and Brazil. The appearance of specialized schools and departments at universities, the creation of professional associations and the staging of international events and exhibitions, such as the poster biennials, also contributed over time to the consolidation of professional activity in the region. Since then, Latin American graphic design has created its own school and languages of expression. It has been shaping its identity for more than half a century and is today trying to position itself as something different from the rest of the world. It is no longer seen just as a consumer market or sub-product and has become a source of inspiration and creativity.

In Mexico, possibly the Latin American country with the sharpest awareness of its own identity, the celebration of nationality has always been considered something natural.

The strong presence of pre-Hispanic culture has been a determining factor in the products made there to date. The

nologischen Entwicklung Schritt zu halten, wurde aber oft durch fehlende finanzielle Mittel ausgebremst.

Im 20. Jahrhundert kamen Designer aus Europa, die halfen, das Berufsbild des Grafikdesigners klarer zu definieren und in Ländern wie Mexiko, Venezuela, Kolumbien, Argentinien, Chile und Brasilien neue Konzepte und Richtlinien zu etablieren. Die Entstehung von Fachschulen und Designfachbereichen an den Universitäten, die Gründung von Berufsverbänden sowie internationale Veranstaltungen und Ausstellungen wie die Plakatbiennalen festigten ebenfalls das berufliche Wirken der Designer in der Region. Seither hat sich eine eigene Schule lateinamerikanischen Designs mit einer eigenen Sprache entwickelt. Ein gutes halbes Jahrhundert lang hat sie ihre Identität geformt und möchte sich heute vom Rest der Welt abheben. Grafikdesign wird nicht mehr als Verbrauchermarkt oder Nebenprodukt betrachtet, sondern als Quelle der Inspiration und Kreativität.

Für Mexiko, das lateinamerikanische Land, das sich seiner Identität am stärksten bewusst ist, war es schon immer ganz natürlich, seine Nationalität zu feiern.

Die starke Präsenz der präkolumbianischen Kultur hat großen Einfluss genommen auf die mexikanischen

de l'industrie tentait d'accompagner au mieux le développement technologique mondial. Les difficultés économiques ont souvent retardé ce processus.

Au XXᵉ siècle, avec l'arrivée de graphistes européens, le métier a commencé à mieux se définir. Ils ont aidé à établir de nouveaux concepts et lignes directrices au Mexique, au Venezuela, en Colombie, en Argentine, au Chili et au Brésil. L'apparition d'écoles spécialisées et de départements de design dans les universités, la création d'associations professionnelles et la réalisation d'expositions et d'événements internationaux, comme les biennales d'affiches, ont au fil du temps consolidé l'activité professionnelle. Pendant plus de cinquante ans, le graphisme a créé son identité et aujourd'hui, il cherche sa position par rapport au reste du monde. Il n'est plus considéré seulement comme un marché consommateur, ou sous-produit, et est devenu une source d'inspiration et de créativité.

Au Mexique, la célébration du sentiment national a toujours été naturelle chez les habitants. Jusqu'à aujourd'hui, la forte présence de la culture préhispanique a été un facteur déterminant pour la production.

La vitalité et la variété de l'offre culinaire, les artistes de renommée internationale,

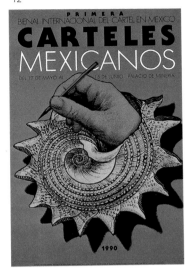

12

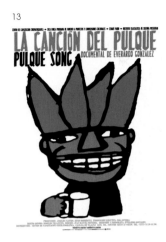

13

14

vitality and variety of Mexican cuisine (which has won admirers from every corner of the earth), its gallery of internationally renowned artists, and drinks like tequila and Corona beer (an example of international marketing) contribute to the expansion of a strong local market in graphic-design production. The event where Mexican graphic design first came to international attention was undoubtedly the 1968 Olympic Games. At the time, Pedro Ramírez Vásquez, the general coordinator of the Games, invited Mexican architect Eduardo Terrazas and American designer Lance Wyman to design the visual identity of the Olympics. The result of that creative process is still considered one of the most surprising, contemporary and timeless graphic-design projects in the world. The freshness and innovation of the graphic applications, combined with the impressive schedule of cultural events that took place during the Games, make them an international masterwork.

Later on, in the early 1970s, the Iberoamericana University and the National Autonomous University of Mexico, two of the leading educational institutions in Mexico City, began to offer courses in design studies, which led to the first generation of designers in the country. At the same time, experimental studios such as Imprenta Madero, run by Vicente Rojo, one of the precursors of graphic design in Mexico, formed groups of professionals

Produkte. Vitalität und Vielfalt der mexikanischen Küche (die überall auf der Welt Bewunderer gefunden hat), international berühmte Künstler oder Getränke wie Tequila und Corona-Bier (ein Beispiel für internationales Marketing) haben alle zur Entwicklung eines starken regionalen Marktes für Grafikdesign beigetragen. Zweifellos wurde man anlässlich der Olympischen Spielen 1968 erstmals international auf mexikanisches Grafikdesign aufmerksam. Zu jener Zeit lud Pedro Ramírez Vásquez als Hauptkoordinator der Spiele den mexikanischen Architekten Eduardo Terrazas und den amerikanischen Designer Lance Wyman ein, die visuelle Identität der Olympischen Spiele zu entwerfen. Das Ergebnis dieses kreativen Prozesses zählt nach wie vor zu den erstaunlichsten zeitgenössischen und zeitlosen Grafikdesignprojekten der Welt. Die Frische und Innovation der grafischen Anwendungen, kombiniert mit dem beeindruckenden Programm der kulturellen Veranstaltungen während der Spiele, machten sie zu einem Meisterwerk, das international Anerkennung fand.

Etwas später, Anfang der 70er Jahre, richteten zwei der bedeutendsten Bildungseinrichtungen in Mexico City, die Universidad Iberoamericana und Universidad Nacional Autónoma de México, Studiengänge in Design ein, in denen die erste Designergeneration des Landes ausgebildet wurden. Gleichzeitig

les boissons comme la tequila et la bière Corona (un cas d'école de marketing) ont favorisé le développement d'un marché graphique local solide. L'événement qui a marqué le changement dans la perception du graphisme mexicain fut, sans aucun doute, les Jeux olympiques de 1968. C'est à cette occasion que le coordinateur général de la compétition, Pedro Ramírez Vásquez, a demandé à l'architecte mexicain Eduardo Terrazas et au graphiste américain Lance Wyman de créer l'identité visuelle des Jeux. Le résultat est encore aujourd'hui l'un des projets de graphisme les plus surprenants et intemporels du monde. La fraîcheur et l'innovation de tous les éléments, combinées à un programme impressionnant d'événements culturels lors des Jeux, ont hissé ce travail au rang des meilleures œuvres internationales.

Peu après, au début des années 1970, l'Université ibéroaméricaine et l'Université nationale autonome de Mexico, deux des principales institutions d'enseignement de la ville de Mexico, ouvrirent des programmes de design industriel. Au même moment, des studios expérimentaux comme Imprenta Madero, dirigé par Vicente Rojo — l'un des précurseurs du graphisme au Mexique —, formaient des groupes de professionnels qui ont marqué leur époque, comme Rafael López Castro, Germán Montalvo, Bernardo Recamier, Peggy Espinoza, Azul Morris et Luis Almeida.

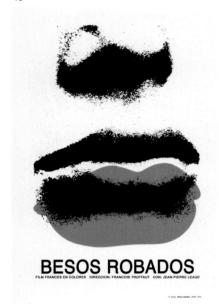

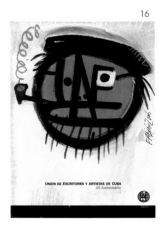

15. "Besos robados" film poster, 1970, Instituto Cubano de Arte de la Industria Cinematográfica (ICAIC), René Azcuy, Cuba/Mexico

16. "45th anniversary Unión de Escritores y Artistas de Cuba (UNEAC)" poster, 2006, Fabián Muñoz, Cuba

that marked an age and included Rafael López Castro, Germán Montalvo, Bernardo Recamier, Peggy Espinoza, Azul Morris and Luis Almeida. In the same period, the celebration of the poster as a major part of the design world also took off: Mexico and Cuba are the main exponents of this advertising vehicle in Latin America. Proof of this is the International Biennial of the Poster in Mexico, which has been held since 1990 and is one of the biggest events on the design calendar in the whole of Latin America. The current liveliness of the Mexican arts scene is very surprising: the country produces international-level cinema, music which combines global influences and local culture in an unusual fashion, and architecture that crosses borders, as well as plastic arts of global quality and top-rate contemporary graphic design.

In Cuba, the tradition of poster production gained strength in the 1960s following the triumph of the revolution led by Fidel Castro.

One of the main people behind the new creative force of Cuban posters was Eladio Rivadulla, whose extensive work in the field had already begun prior to the revolution. His poster celebrating Castro's victory, conceived and produced the night before Castro took power and disseminated right across the island the following morning, is a classic in

schlossen sich experimentelle Studios wie Imprenta Madero unter der Leitung von Vicente Rojo, einem Vorkämpfer des Grafikdesigns in Mexiko, mit Designern wie Rafael López Castro, Germán Montalvo, Bernardo Recamier, Peggy Espinoza, Azul Morris und Luis Almeida zusammen, die der Ära ihren Stempel aufdrückten. Zur gleichen Zeit begann man, das Plakat als wichtigen Teil des Grafikdesigns zu feiern. In Lateinamerika sind Mexiko und Kuba die Hauptvertreter dieses Werbeträgers. Das zeigt sich auch in der Internationalen Plakatbiennale in Mexiko, die bereits seit 1990 stattfindet und eine der wichtigsten Veranstaltungen des Grafikdesigns in ganz Lateinamerika ist. Die Vitalität der heutigen mexikanischen Kunst- und Kulturszene ist erstaunlich: Das Land produziert Kinofilme von internationalem Niveau, die Musik kombiniert globale Einflüsse mit einheimischer Kultur, die Architektur durchbricht Schranken, plastische Kunstwerke von Weltklasse und hervorragendes zeitgenössisches Grafikdesign entstehen.

In Kuba gewann in den 60er Jahren die Plakatproduktion an Einfluss, nachdem die Revolution unter Fidel Castro gesiegt hatte.

Eine der Hauptpersonen dieser neuen kreativen Bewegung war Eladio Rivadulla, dessen umfangreiche Arbeiten in diesem Bereich schon vor der Revolution eine be-

Toujours à la même période, les affiches sont devenues un support majeur dans l'univers du graphisme. En Amérique latine, le Mexique et Cuba en sont les principaux représentants. La Biennale internationale de l'affiche de Mexico, créée en 1990, est l'un des plus grands événements de toute l'Amérique latine dans le secteur du graphisme. Actuellement, le Mexique fait preuve d'une effervescence culturelle surprenante. Ce pays produit l'un des meilleurs cinémas du monde, une musique qui mélange les influences mondiales à la culture locale avec originalité, une architecture qui dépasse les frontières, des arts plastiques de niveau international et un graphisme contemporain de premier choix.

À Cuba, la tradition de la production d'affiches a pris de l'ampleur à partir des années 1960, après le triomphe de la révolution menée par Fidel Castro.

L'un des principaux responsables de la nouvelle créativité dans les affiches cubaines est Eladio Rivadulla, un artiste déjà prolifique dans ce domaine avant la révolution. Son affiche célébrant la victoire de Castro, conçue et produite dans la nuit précédant la prise de pouvoir et diffusée dans toute l'île dès le matin suivant, est l'un des grands classiques du graphisme latino-américain. Avec le nouveau gouvernement, il a fallu produire des affiches

17. "Leyendo en Casa" logo,
2005, Casa de las Américas,
Nelson Ponce, Cuba

18. "Fidel Castro" poster of the
Cuban Revolution, 1959,
Eladio Rivadulla, Cuba

17

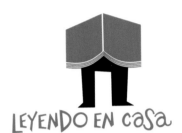

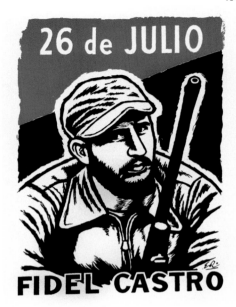

Latin American graphic design. The new government required the production of posters to convey political information to the population as well as information on the new health programs. Of particular importance in this activity were Alfredo Rostgaard, Félix Beltrán, Faustino Pérez, Olivio Martínez, José Papiol, Lázaro Abreu, Ernesto Padrón, Rafael Enríquez, Rafael Morante, Emilio Gómez and Frémez. Furthermore, the Cuban Institute of Films and the Film Industry always supported the production of posters with a more artistic concept than the commercial style of the American posters which had predominated until then. Silk-screen works, sometimes printed on poor-quality paper (as it was hard to find good paper in Cuba) and a new style of posters based on simple ideas and a more creative use of striking colors, created a generation of designers including Rafael Morante, Eduardo Muñoz Bachs and Antonio Fernández Reboiro, in addition to Antonio Pérez 'Ñiko', René Azcuy and Félix Beltrán, who later emigrated to Mexico.

The process of teaching Cubans to read and write, and the cultural development which followed, led to a huge growth in Cuban posters and their immediate worldwide recognition, especially in the 1960s and 1970s. Editorial design also benefited from the demand for mass copies of books for the education system. The creation of a national publishing house,

deutende Rolle gespielt hatten. Sein Plakat, das den Sieg Castros feierte und das er in der Nacht vor Castros Machtergreifung entwarf, produzierte und am nächsten Morgen über die gesamte Insel verteilte, zählt zu den lateinamerikanischen Klassikern. Die neue Regierung benötigte Plakate, um die Bevölkerung über Politik und neue Gesundheitsprogramme zu informieren. Dabei waren Alfredo Rostgaard, Félix Beltrán, Faustino Pérez, Olivio Martínez, José Papiol, Lázaro Abreu, Ernesto Padrón, Rafael Enríquez, Rafael Morante, Emilio Gómez und Frémez besonders wichtig. Zudem unterstützte das Kubanische Institut für Film und die Filmindustrie stets die Produktion von Plakaten mit einem künstlerischeren Konzept als es die kommerzielleren amerikanischen Plakate aufwiesen, die bis dato überwogen. Siebdrucke auf manchmal minderwertigem Papier und ein neuer Plakatstil, der auf einfachen Ideen und dem kreativeren Einsatz kraftvoller Farben beruhte, schuf eine neue Generation von Designern. Dazu zählten Rafael Morante, Eduardo Muñoz Bachs und Antonio Fernández Reboiro sowie Antonio Pérez ‚Ñiko`, René Azcuy und Félix Beltrán, die später nach Mexiko emigrierten.

Die Alphabetisierung und die folgende kulturelle Entwicklung in Kuba führten zu einem enormen Wachstum im kubanischen Plakatdesign und zu seiner weltweiten Anerkennung, besonders während der 60er und 70er Jahre. Auch das Editorial

pour communiquer avec la population. Alfredo Rostgaard, Félix Beltrán, Faustino Pérez, Olivio Martínez, José Papiol, Lázaro Abreu, Ernesto Padrón, Rafael Enríquez, Rafael Morante et Emilio Gómez e Frémez se sont particulièrement illustrés dans cette activité. De plus, l'Institut cubain d'art et d'industrie cinématographique a toujours soutenu la production d'affiches de films artistiques, en contraste avec le style commercial des affiches américaines qui prédominait alors. Imprimées en sérigraphie, parfois sur du papier de mauvaise qualité, ces affiches d'un nouveau genre basées sur des idées simples alliées à une utilisation créative des couleurs ont donné naissance à une nouvelle génération de graphistes, notamment Rafael Morante, Eduardo Muñoz Bachs et Antonio Fernández Reboiro, ainsi qu'Antonio Pérez « Ñiko », René Azcuy et Félix Beltrán, qui émigrèrent au Mexique plus tard.

L'alphabétisation de toute la population cubaine et le développement culturel qui s'ensuivit ont stimulé le développement des affiches cubaines, essentiellement dans les années 1960 et 1970. Le design éditorial a également bénéficié de la demande massive de livres pour le système scolaire. L'Editora Nacional, devenue plus tard l'Instituto Cubano del Libro, a embauché de nombreux graphistes des années 1970 jusqu'au début des années 1990. Avec la création de l'Institut supérieur de design

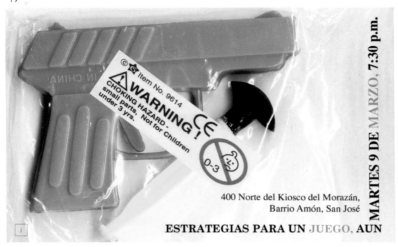

Editora Nacional (later the Cuban Book Institute), employed a great many designers between the 1970s and the early 1990s. With the opening of the Higher Institute of Design in 1984, Cuba could boast free tertiary courses in product design and graphic design. This was the period when the first Cubans with a tertiary education in design emerged. Despite major social and economic difficulties, Cuban graphic designers currently enjoy greater artistic and cultural freedom than before. Many work for publishing companies or advertising agencies as well as for the Government, which is no longer one of the island's main customers. The Cuban design community is represented by the organization Comité Prográfica Cubana, created by Héctor Villaverde in 1994. The island's economic growth, based on a rise in tourism and oil company wealth, has increased the amount of work available for local professionals. One reason for Cuba's leadership in this field has always been the encouragement of cultural expression, despite strong censorship in some areas. This has seen the blossoming of a national identity in the arts and the creation of a strong sense of unity over the decades, something dictators in other countries in the region were unable to achieve.

In a situation without equal among the countries selected for this book, Puerto Rico is at once a completely Latin country and a territory of the US. The cultural

Design profitierte von der Nachfrage nach Büchern in hohen Auflagen für das Bildungssystem. Das neu gegründete nationale Verlagshaus Editora Nacional (später Kubanisches Institut des Buches) stellte von den 70er bis zu den frühen 90er Jahren viele Designer ein. Mit der Eröffnung des Instituto Superior de Diseño 1984 konnte Kuba kostenlose universitäre Ausbildungen in Produkt- und Grafikdesign anbieten. Zu jener Zeit tauchten die ersten Kubaner mit einem Abschluss in Design auf. Trotz großer sozialer und wirtschaftlicher Schwierigkeiten genießen die kubanischen Grafikdesigner heute mehr künstlerische und kulturelle Freiheit als zuvor. Viele arbeiten bei Verlagen oder Werbeagenturen sowie für die Regierung, die nicht mehr zu den Hauptkunden auf der Insel zählt. Die kubanischen Designer werden von der Organisation Comité Prográfica Cubana vertreten, die 1994 von Hector Villaverde gegründet wurde. Das wirtschaftliche Wachstum auf der Insel durch zunehmenden Tourismus und Ölförderung brachte den einheimischen Designern mehr Aufträge. Kuba ist führend in diesem Bereich, weil der kulturelle Ausdruck sehr gefördert wurde, trotz strenger Zensur in einigen Bereichen. Dadurch wuchs im Lauf der Jahrzehnte eine nationale Identität in der Kunst und führte zu einem starken Zusammengehörigkeitsgefühl – etwas, was die Diktaturen in anderen Ländern des Kontinents nie erreicht haben.

industriel, en 1984, Cuba a commencé à proposer une formation gratuite de design industriel et de graphisme. C'est alors qu'apparurent les premiers Cubains diplômés en design et en graphisme. Malgré de grandes difficultés sociales et économiques, les graphistes cubains jouissent actuellement d'une plus grande liberté culturelle et artistique. La plupart d'entre eux travaillent pour des maisons d'édition ou pour des agences de publicité, ou pour le gouvernement, aujourd'hui encore l'un des principaux clients de l'île. Cette communauté est représentée par le Comité Prográfica Cubana, créé en 1994 par Héctor Villaverde. La croissance économique de l'île, générée par l'augmentation du tourisme et par les entreprises pétrolières, a stimulé l'offre de travail. L'encouragement de l'expression culturelle, bien qu'assortie d'une censure sévère dans certains domaines, a toujours fait partie de la politique cubaine. C'est grâce à cela que l'identité nationale s'est épanouie dans les arts et que Cuba a été très unie au cours des décennies. Les dictatures d'autres pays de la région n'ont jamais réussi sur ce point.

La situation de Porto Rico est différente de celle de tous les autres pays de ce livre, car c'est un pays totalement latin, mais aussi un territoire des États-Unis. La dualité culturelle est omniprésente dans la vie portoricaine. La monnaie locale est le dollar américain, et la langue officielle est

RODOLFO ABULARACH EN MACONDO

duality is ever-present in Puerto Rican life. The local currency is the US dollar and the official language is Spanish. However, speaking English is relatively common and there is a strong presence of the American way of life at every turn, with enormous shopping malls and fast-food chains. The impact this has on local culture can be seen in the possibilities generated by economic strength. One good example is technology, which is just as accessible and affordable as in any American city. There is no doubt that the strength of the US lifestyle has also penetrated other countries, but the case of Puerto Rico is truly unique.

Puerto Ricans are part of America's economic empire and can act and move as its citizens. Even so, when they talk about cultural identity, they always emphasize the fact they are Latin.

Local tradition in the field of Puerto Rican graphic art began in the 1950s with the creation of a number of government offices and university departments, such as the Division of Community Education, the Institute of Puerto Rican Culture and the University of Puerto Rico. These organizations, generally run by artists who had trained in Europe or Mexico, expressed a national affirmation via esthetic and conceptual ideas that were always aimed at the majority of

Puerto Rico nimmt unter allen Ländern in diesem Buch eine Sonderstellung ein. Es handelt sich um ein durch und durch lateinamerikanisches Land, das aber gleichzeitig mit den USA assoziiert ist. Diese kulturelle Dualität gehört in Puerto Rico zum Alltag. Die einheimische Währung ist der amerikanische Dollar, während Spanisch die Amtssprache ist. Doch es wird recht häufig Englisch gesprochen, und die amerikanische Lebensart ist überall präsent, z. B. in den riesigen Einkaufzentren und Fast-Food-Ketten. Der Einfluss auf die einheimische Kultur manifestiert sich in den Möglichkeiten, die eine starke Wirtschaft bietet. Ein gutes Beispiel dafür sind Technologien, die hier genauso leicht verfügbar und erschwinglich sind wie in jeder nordamerikanischer Stadt.

Die Puertoricaner gehören zum amerikanischen Wirtschafts-imperium und können sich wie nordamerikanische Bürger bewegen und verhalten.

Doch wenn sie über ihre kulturelle Identität sprechen, betonen sie immer, dass sie Lateinamerikaner sind. Die puer-to-ricanische, grafische Tradition nahm ihren Anfang in den 50er Jahren mit der Gründung verschiedener staatlicher Institutionen und Universitäten wie z. B. der División de Educación de la Comunidad, dem Instituto de Cultura Puertoriqueña

l'espagnol. Il y est pourtant assez courant de parler anglais, et l'on rencontre l'*American way of life* à tous les coins de rue, avec d'immenses *shopping centers* et des chaînes de *fast-food*. L'influence de ce contexte sur la culture locale se perçoit dans les possibilités générées par la puissance économique. Par exemple, les produits technologiques sont aussi faciles d'accès et bon marché que dans n'importe quelle ville nord-américaine. Il ne fait aucun doute que la force et la pénétration du style nord-américain existent aussi dans d'autres pays, mais le cas de Porto Rico est vraiment particulier.

Les Portoricains font partie de l'empire économique et peuvent agir et se déplacer en tant que citoyens nord-américains. Pourtant, leur identité culturelle est avant tout latine.

La tradition portoricaine des arts graphiques naît dans les années 1950, avec la création de bureaux gouvernementaux et universitaires, comme le Département d'Éducation de la Communauté, ou l'Institut de la Culture portoricaine et l'Université de Porto Rico. Ces bureaux, généralement dirigés par des artistes formés en Europe ou au Mexique, exprimaient une affirmation nationale au travers d'idées esthétiques et conceptuelles qui s'adressaient toujours à une grande partie de la popu-

the population. The strong presence of silk-screen printing, woodcut printing and the use of typographies with expressive characteristics was hugely successful in promoting cultural and political activities in the management of the country. In 1970, the Biennial of Latin American and Caribbean Engraving was created in the city of San Juan. It was later renamed the San Juan Polygraphic Triennial and is today considered one of the most important events dedicated to graphic art in the region.

Graphic design developed in a more irregular fashion in certain countries of Central America, South America and the Caribbean, mainly because of changes in their economies and the constant political upheavals that made systematic industrialization and subsequent progress more difficult.

However, in the specific case of the Dominican Republic, its geographic proximity to the United States has always aided the importation and employment of technological resources, as well as exchange. Graphic design is taught in line with the international curriculum, where the Diseño Altos de Chavón school, affiliated with the Parsons New School for Design of New York, is one example. At the same time,

und der Universidad de Puerto Rico. Diese Institutionen wurden gewöhnlich von in Europa oder Mexiko ausgebildeten Künstlern geleitet, die durch ästhetische und konzeptionelle Ideen eine nationale Bestätigung ausdrückten, die sich an die Mehrheit der Bevölkerung richtete. Der Einsatz von Siebdruck, Holzschnitt und ausdrucksstarken Typografien bei der Förderung kultureller und politischer Aktivitäten erwies sich für die Führung des Landes als ausgesprochen erfolgreich. 1970 wurde in San Juan die Biennale der lateinamerikanischen und karibischen Druckgrafik ins Leben gerufen. Später wurde sie in San Juan Triennale der Polygrafie umbenannt und ist heute eine der wichtigsten Veranstaltungen für grafische Kunst in Lateinamerika.

In einigen zentral- und südamerikanischen Ländern und der Karibik entwickelte sich das Grafikdesign ungleichmäßiger, vor allem wegen der wirtschaftlichen Veränderungen und der ständigen politischen Umbrüche, die eine systematische Industrialisierung und den daraus folgenden Fortschritt erschwerten.

Im besonderen Fall der Dominikanischen Republik hat jedoch die geografische Nähe zu den USA Import und Anwendung neuer Technologien und den Austausch

lation. La forte présence de la sérigraphie et de la xylographie et l'utilisation d'une typographie expressive ont beaucoup contribué à la diffusion des activités culturelles et politiques dans la gestion du pays. La Biennale de la Gravure latino-américaine et des Caraïbes, qui est plus tard devenue la Triennale polygraphique de San Juan, a été créée en 1970 dans la ville de San Juan. Elle est aujourd'hui considérée comme l'un des événements les plus importants de la région dans le domaine des arts graphiques.

Dans certains pays d'Amérique centrale, du Sud et des Caraïbes, le développement du graphisme a été plus irrégulier, à cause des fluctuations de l'économie et des constants changements politiques qui ont systématiquement freiné l'industrialisation et le progrès.

Dans le cas de la République dominicaine, la proximité géographique avec les États-Unis a cependant favorisé les échanges, et l'importation et l'utilisation de ressources technologiques. Ainsi, l'enseignement du graphisme suit les normes internationales, par exemple l'école Diseño Altos de Chavón, affiliée à la Parsons New School for Design, de New York. Quant au reste, les cultures fortes se distinguent par la grande influence indigène, présente aujourd'hui encore

22. "Aurora Book" book
illustration, 2003, Aurora,
Esteban Salgado, Ecuador

23. "Pajaros Ancestrales"
t-shirt illustration, Peter Mussfeldt,
Ecuador

24. "Rosa a $1 Dola" exhibition
poster, 2006, Personal work,
Mairena Briones, Panama

strong cultures are distinguished by their great indigenous influence, present even today in various layers of society. Uruguay experienced a high level of design production from the 1960s, principally when the publishing market included major groups like Arca, Alfa, and Banda Oriental, which contributed to the steady growth of the industry. After the army took over in 1973, the clampdown on freedom of expression directly impacted on creative production and it would not take off again until the return of democracy in 1985.

Some of the Latin American countries have experienced constant difficulties and continue to do so today, as for example, suffering from restricted access to new technologies and a shortage of materials. However, this has not stopped newspapers, magazines and publishing companies from emerging. Publications have always offered precious space for the work of local artists, who could use them to showcase their graphic-art creations, illustrations and cartoons. The display of talent in turn contributed to the development of the profession. With regard to teaching, many of the courses were run by immigrants or local professionals who had studied abroad and brought home new methods which influenced culture and teaching. The first regular graphic-design courses began to be taught in the 1970s. Examples include Costa Rica's National School of Fine Art, founded in

begünstigt. Die Grafikdesignausbildung ist am internationalen Lehrplan orientiert, so z. B. an der Schule Diseño Altos de Chavón, die der Parsons New School for Design in New York angeschlossen ist. Gleichzeitig sind starke Kulturen sehr vom Einfluss ihrer einheimischen Kultur gekennzeichnet, der auch heute noch in verschiedenen Schichten der Gesellschaft gegenwärtig ist. In Uruguay hatte sich die Designproduktion Ende der 60er Jahre sehr stark entwickelt, hauptsächlich durch wichtige Verlagsgruppen wie Arca, Alfa und Banda Oriental, die der Branche zu einem stetigen Wachstum verhalfen. 1973 übernahm das Militär die Macht, dessen hartes Vorgehen gegen die freie Meinungsäußerung nicht ohne Wirkung auf die kreative Produktion blieb, bis das Land 1985 zur Demokratie zurückkehrte.

Einige lateinamerikanische Länder kämpfen weiter mit Schwierigkeiten, z. B. wegen des beschränkten Zugangs zu neuen Technologien und Materialengpässen. Das hat jedoch nicht verhindert, dass Verlage, Zeitungen und Magazine gegründet werden. Diese Publikationen waren schon immer für die Arbeiten einheimischer Künstler wertvoll, weil sie darin ihre Grafiken, Illustrationen und Cartoons präsentieren konnten. Die Veröffentlichung dieser Arbeiten fördert ihrerseits das Berufsbild des Grafikdesigners. Häufig wurden diese von Immigranten oder einheimischen Designern unterrich-

dans plusieurs couches de la société. Le graphisme uruguayen a connu un niveau élevé de production à partir de la fin des années 1960, surtout lorsque le marché éditorial comprenait de grandes maisons d'édition, comme Arca, Alfa et Banda Oriental, qui ont favorisé la croissance constante de ce secteur. À partir de 1973, avec la prise de pouvoir des militaires, le manque de liberté d'expression a eu des effets directs sur la production créative. Jusqu'à 1985, l'année du retour de la démocratie en Uruguay.

Certains de ces pays souffrent encore d'un accès restreint aux nouvelles technologies et d'une pénurie de matériaux. Cela n'a cependant pas empêché la création de journaux, de magazines et de maisons d'édition. Ces publications ont toujours offert de magnifiques espaces pour le travail des artistes locaux. L'exposition de leurs talents a contribué au développement de la profession. En ce qui concerne l'enseignement, une grande partie des cours a été orientée par des immigrés ou des professionnels locaux qui, après avoir étudié à l'étranger, ont rapporté de nouvelles méthodes et ont influencé la culture et l'enseignement. Les premiers cours de graphisme sont apparus autour des années 1970. Il en fut ainsi, par exemple, pour l'École nationale des Beaux-Arts du Costa Rica, créée en 1897 (qui fut ensuite intégrée à l'Université du Costa Rica et commença

25. "Petroleos de Venezuela"
logo, 1975, PDVSA,
Jesús Emilio Franco, Venezuela

26. "Venezuelan Pavillion"
poster, 2005, The Venice Biennale,
Ibrahin Nebreda, Venezuela

1897 and which later became part of the University of Costa Rica. It first offered design and advertising courses in the late 1970s. Other examples were the Carlos Alberto Imery School of Applied Arts in El Salvador, the National School of Fine Art in Honduras, and the Vocational Technical School of Graphic Arts in Paraguay. After the Sandinista People's Revolution in Nicaragua in 1961, graphic art began to be taught at the National School of Fine Art under the artist Oscar Rodríguez. In 1989, the Casa de los Tres Mundos Foundation was created in Granada to promote the teaching of graphic art. It was established with financial support from Germany and went on to become a reference point in the country. Since the late 1980s, these nations have seen the number of private schools and the general level of activity really take off. The natural path was for professional associations, design museums and galleries, and specialized magazines to come into being. Publications have included Costa Rica's *Colectiva* and *Difusión* (the latter published by the Veritas University's School of Advertising Design), Ecuador's *Markka Registrada* and Paraguay's *Wild*. Regular design exhibitions have been organized, such as the biennial shows of the graphic designers' associations of Ecuador, Bolivia, and Honduras, as well as the Panamá Gráfico event, all of which speak for the maturity of activity in these countries.

tet, die im Ausland studiert und neue Methoden mit nach Hause gebracht hatten, die nun Kultur und Lehrinhalte beeinflussten. Die ersten regelmäßigen Grafikdesignstudiengänge gab es in den 70er Jahren z. B. an der Nationalen Schule für bildende Kunst in Costa Rica, die 1897 gegründet worden war und später Teil der Universität von Costa Rica wurde. Dort wurden Ende der 70er Jahre erstmalig Studiengänge für Design und Werbung angeboten. Weitere Beispiele waren die Carlos Alberto Imery Schule für angewandte Kunst in El Salvador, die Nationale Schule für bildende Kunst in Honduras und die Berufsfachschule für Grafik in Paraguay. Nach der sandinistischen Volksrevolution in Nicaragua 1961 begann die Grafikausbildung an der Nationalen Schule für bildende Kunst unter der Leitung des Künstlers Oscar Rodríguez. 1989 wurde in Granada die Stiftung Casa de los Tres Mundos eröffnet, um die Lehre der Grafik zu fördern. Die Stiftung wurde mit finanzieller Unterstützung aus Deutschland gegründet und im ganzen Land zu einer Empfehlung. Gegen Ende der 80er Jahre nahm die Anzahl der privaten Schulen und der Aktivitäten im Grafikbereich in diesen Ländern stark zu. Das zog natürlich die Gründung von Berufsverbänden nach sich, die Eröffnung von Museen oder Galerien, die sich auf Design spezialisierten, und die Veröffentlichung von Fachzeitschriften, darunter *Colectiva* und *Difusión* in Costa

à proposer des cours de graphisme et de publicité à la fin des années 1970) ; l'École d'Arts appliqués « Carlos Alberto Imery » du Salvador ; l'École nationale des Beaux-Arts du Honduras et l'Escuela Técnica Vocacional de Artes Gráficas au Paraguay. Au Nicaragua, à partir de la Révolution populaire sandiniste de 1961, l'enseignement des arts graphiques a commencé à se développer à l'École nationale des Beaux-Arts sous la direction de l'artiste Oscar Rodríguez. En 1989, la fondation Casa de los Tres Mundos fut créée dans la ville de Granada pour promouvoir l'enseignement des arts graphiques, avec le soutien financier de l'Allemagne, et est depuis devenue une référence dans le pays. À partir de la fin des années 1980, ces pays ont connu une forte croissance de leur activité et des écoles privées. Naturellement, plusieurs associations professionnelles, musées et galeries consacrés au graphisme apparurent, ainsi que des magazines spécialisés comme *Colectiva* et *Difusión* au Costa Rica (ce dernier édité par l'École de graphisme publicitaire de l'Universidade Veritas), *Markka Registrada* en Équateur et *Wild* au Paraguay. La réalisation périodique d'expositions collectives de graphisme, comme les biennales des associations de graphistes d'Équateur, de Bolivie et du Honduras, ou comme Panama Gráfico, montre que cette activité a atteint une certaine maturité dans ces pays.

27. "El Farol # 240 magazine" cover,
1972, Creole Petroleum Corporation,
Nedo M.F., Venezuela

28. "Skull" t-shirt illustration,
2006, Summer-Fall t-shirt design,
MASA, Venezuela

27

In Venezuela, money from the oil industry facilitated significant investment in other areas, including culture. In the 1950s, '60s and '70s, Venezuela was the world's third-biggest oil exporter.

The arts benefited from this situation and flourished with the establishment of numerous museums and institutions and the immigration of European artists. The scene ended up generating a great deal of international recognition for the talent and creativity of local designers, such as Jesús Soto and Gego. The American typographer Larry June, Italy's Nedo M.F. and the German Gerd Leufert formed the basis of the professionalization of graphic design in Venezuela, together with local artists Carlos Cruz-Diez, Mateo Manaure, Alirio Palacios, John Lange and Jesús Emilio Franco. Publications such as *Nosotros* and *El Farol*, both sponsored by the Creole Petroleum Corporation, started up during these three decades and quickly became continental references of good design.

The Venezuelan phenomenon is only comparable with the events that unfolded in Mexico, Argentina and Brazil. Graphic design benefited profoundly from the creativity and emergence of possibilities the country afforded. The Neumann Design Institute was founded in Caracas in 1964, one of the first formal teaching institutions of design in South America. There

Rica (Letztere herausgegeben von der Veritas Hochschule für Werbedesign), *Markka Registrada* in Ecuador und *Wild* in Paraguay. Regelmäßig finden Ausstellungen wie die Biennale der Grafikdesignverbände in Ecuador, Bolivien und Honduras sowie die Veranstaltung Panamá Gráfico statt, die alle von dem hohen Entwicklungstand in diesen Ländern zeugen.

In Venezuela erlaubte das von der Ölindustrie erwirtschaftete Geld umfangreiche Investitionen auch im Kulturbereich. In den 50er, 60er und 70er Jahren war Venezuela der drittgrößte Ölexporteur der Welt.

Wissenschaft und Kunst profitierten davon und blühten dank der Gründung zahlreicher Museen und Institutionen sowie der Zuwanderung europäischer Künstler auf. In der Kunstszene gab es für das Talent und die Kreativität einheimischer Künstler wie Jesús Soto und Gego viel internationale Anerkennung. Der amerikanische Typograf Larry June, der Italiener Nedo M.F. und der Deutsche Gerd Leufert bildeten gemeinsam mit den einheimischen Künstlern Carlos Cruz-Diez, Mateo Manaure, Alirio Palacios, John Lange und Jesús Emilio Franco die Basis, die das Grafikdesign in Venezuela professionalisierte. Während dieser drei Jahrzehnte wurden Publikationen

Dans les années 1950, 1960 et 1970, le Venezuela était le troisième exportateur de pétrole du monde, et les revenus générés ont été réinvestis dans de nombreux domaines.

Les arts en ont également bénéficié et se sont beaucoup développés grâce à la création de plusieurs musées et institutions, et à la venue d'artistes européens. Ces conditions ont fini par favoriser une reconnaissance internationale du talent et de la créativité des artistes locaux, comme Jesús Soto et Gego. Le typographe américain Larry June, l'Italien Nedo M.F. et l'Allemand Gerd Leufert ont été à la base de la professionnalisation du graphisme au Venezuela, aux côtés des Vénézuéliens Carlos Cruz-Diez, Mateo Manaure, Alirio Palacios, John Lange et Jesús Emilio Franco. Ces trois décennies ont vu naître des publications comme *Nosotros* et *El Farol*, toutes deux sponsorisées par la Creole Petroleum Corporation, et qui sont rapidement devenues des références du graphisme à l'échelle du continent.

Ce qui s'est produit au Venezuela ne peut se comparer qu'à ce qui s'est fait au Mexique, en Argentine et au Brésil. Le graphisme a énormément bénéficié de la créativité et des nouvelles possibilités que le pays proposait. L'Instituto de Diseño Neumann a été créé en 1964 à Caracas. Ce fut l'une des premières institutions

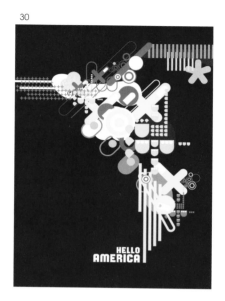

is no doubt that the economic stability of the time, together with cultural incentives, cemented the development of new and excellent artists, such as the generation headed by Álvaro Sotillo, Ibrahin Nebreda and Santiago Pol, through to contemporary designers like Miguel Vásquez "Masa". However, the country entered a period of political and social instability in the late 1990s, with constant setbacks for freedom of expression and culture, which was reflected in the development of art and design.

In Colombia, the big boost came in the first half of the 20th century, when nationwide magazines like *El Gráfico*, *Pan* and *Estampa* set a new stage by taking a different view of typography, the use of colors and photography.

The appearance of advertising agencies also contributed to the development of the profession, which slowly found its path in local culture. By the late 1960s, the National University of Colombia and the Jorge Tadeu Lozano University, both in Bogota, and the Pontificia Bolivariana University in Medellin, began to offer courses in graphic design. This was when the first generation of local designers emerged, led by Dicken Castro (one of the most important designers in the country and one of the great names

wie *Nosotros* und *El Farol*, beide gefördert von der Creole Petroleum Corporation, schon bald auf dem gesamten Kontinent zum Synonym für gutes Design.

Das venezolanische Phänomen ist nur vergleichbar mit den Ereignissen in Mexiko, Argentinien und Brasilien. Das Grafikdesign profitierte enorm von der Kreativität und den neu entstehenden Möglichkeiten, die das Land bot. 1964 wurde das Instituto de Diseño Neumann in Caracas gegründet, eines der ersten offiziellen Lehrinstitute für Design in Südamerika. Ohne Zweifel bot die damalige wirtschaftliche Stabilität zusammen mit kulturellen Anreizen die Basis für hervorragende neue Designer wie der Generation von Álvaro Sotillo, Ibrahin Nebreda und Santiago Pol bis hin zu zeitgenössischen Designern wie Miguel Vásquez „Masa". Ab Ende der 90er Jahre erlebte das Land jedoch eine Phase politischer und sozialer Instabilität, die Einschränkungen für die freie Meinungsäußerung und die Kultur mit sich brachte und sich auch in der Entwicklung von Kunst und Design widerspiegelte.

In Kolumbien kam der große Anstoß in der ersten Hälfte des 20. Jahrhunderts, als überregionale Magazine wie *El Gráfico*, *Pan* und *Estampa* neue Wege in der Typografie und der Verwendung von Farben und Fotografie einschlugen.

d´enseignement formel du graphisme en Amérique du Sud. La stabilité économique qui régnait alors, alliée à des mesures incitatives dans le domaine de la culture, a sans aucun doute servi de fondation pour le développement de nouveaux graphistes de grande qualité, comme ceux de la génération d´Álvaro Sotillo, Ibrahin Nebreda et Santiago Pol, jusqu´aux artistes contemporains comme Miguel Vásquez « Masa ». À partir de la fin des années 1990, le pays a plongé dans l´instabilité politique et sociale, avec de constants revers pour la liberté d´expression et culturelle, et des conséquences sur le développement de l´art et du design.

En Colombie, le graphisme a connu son grand essor dans la première moitié du XX^e siècle, lorsque les magazines nationaux comme *Gráfico*, *Pan* et *Estampa* définirent un nouveau paradigme en innovant dans leur traitement de la typographie, des couleurs et de la photographie.

L´apparition d´agences de publicité a également contribué au développement du métier, qui s´est peu à peu fait une place dans la culture locale. À la fin des années 1960, l´Université nationale de Colombie et l´Université Jorge Tadeu Lozano, toutes deux situées à Bogota, ainsi que l´Universidad Pontifica Bolivariana, à

29. "Concierto de Jazz"
concert poster, 1964,
Centro Colombo Americano,
David Consuegra, Colombia

30. "Hello America" magazine
illustration, 2006, Zupi Magazine,
Wonksite (Jorge Restrepo), Colombia

31. "Proyecto Demo Australis" book
design, 2005, Cristián Gonzáles Sáiz
and Daniel Berczeller, Chile

31

of Latin America), David Consuegra, Antonio Grass and, later, Marta Granados, whose work focused on poster design. A group of Bogota-based artists established the Colombian Graphic Designers' Association in April 2006, which aims to forge greater interaction among Colombian designers. The country is also home to another case of Latin American marketing that has scored worldwide fame: the creation and international promotion of the character Juan Valdez, used in the advertisements of the National Federation of Coffee Growers of Colombia since 1959. Thought up specially by the American agency DDB (Doyle Dane Benbark) to promote pure Colombian coffee and distinguish it from other brands, it has helped forge the product's reputation as one of the best coffees in the world.

Chile, colonized by the Spanish and later the recipient of various waves of European immigrants, is today one of the countries with the fewest indigenous characteristics in Latin America. Boosted by decisive economic growth, due mainly to the exportation of Chilean nitrate and copper, since the 1970s it has worked to diversify the economy, emphasizing agriculture and the production of fruit, wine and fish (in recent years, Chile has equalled Norway as the world's biggest exporter of salmon). Today it is experiencing a degree of economic and social

Auch die Gründung von Werbeagenturen trug zur Entwicklung des Designerberufs bei. Ende der 60er Jahre boten die Nationale Universität von Kolumbien und die Jorge Tadeu Lozano Universität (beide Bogotá) sowie die Universidad Pontificia Bolivariana in Medellín erstmals entsprechende Studiengänge an. Dies brachte die erste Generation der kolumbianischen Grafikdesigner hervor, zuallererst Dicken Castro (einen der wichtigsten Designer des Landes und einen der bekanntesten in Lateinamerika), David Consuegra, Antonio Grass und später Marta Granados, deren Arbeit sich auf Plakatdesign konzentrierte. Im April 2006 gründete eine Gruppe von Designern in Bogotá die Gesellschaft der kolumbianischen Grafikdesigner, um die Interaktion unter den kolumbianischen Designern zu verbessern. Von dort stammt ein weiteres Beispiel für weltweit erfolgreiches lateinamerikanisches Marketing: die Schöpfung und internationale Vermarktung der Figur „Juan Valdez", die seit 1959 in der Werbung für den Nationalen Verband der kolumbianischen Kaffeeproduzenten verwendet wird. Erfunden von der amerikanischen Agentur DDB (Doyle Dane Benbark), um den reinen kolumbianischen Kaffee zu fördern und ihn von anderen Kaffeemarken zu unterscheiden, verhalf diese Figur dem Produkt zu seinem Ansehen als eine der besten Kaffeesorten der Welt.

Medellín, ont commencé à proposer des cours de graphisme. C'est alors qu'apparut la première génération de graphistes boliviens, menée par Dicken Castro (l'un des graphistes les plus importants de ce pays, et l'un des plus grands noms en Amérique latine), David Consuegra, Antonio Grass et, plus tard, Marta Granados, avec un travail orienté vers la création d'affiches. En avril 2006, des graphistes de Bogota ont créé l'ADG locale, l'Association de graphistes de Colombie. Son rôle sera de favoriser l'interaction entre les graphistes colombiens. C'est aussi de Colombie que nous vient un autre cas d'école du marketing latino-américain : la création et la diffusion internationale du personnage Juan Valdez, utilisé par la Fédération nationale des producteurs de café de Colombie depuis 1959. Il a été conçu tout spécialement par l'agence de publicité américaine DDB (Doyle Dane Benbark) pour promouvoir le café 100 % colombien et le démarquer des mélanges communément utilisés. C'est grâce à lui que le café colombien est considéré comme l'un des meilleurs au monde.

Après avoir été colonisé par les Espagnols, le Chili a reçu de nombreux immigrants européens, et est aujourd'hui l'un des pays d'Amérique latine où la culture indigène est la plus diluée. Le pays, porté par une croissance économique principalement due à l'exportation de nitrate (salpêtre) et de cuivre, a connu

32. "Como nace una idea" calendar illustration, 2003, Larrea Impresores, Luis Flaco Albornoz, Chile

33. "Editorial Andina" logo, 1974, Editorial Andina SA, Mario Fonseca, Chile

33

development that puts it among the most stable economies in the world. With its unique geography, nestled between the Pacific Ocean to the west and the Andes mountain range to the east, Chile also has its history in the field of graphic arts, with the printing press arriving after the country attained independence from Spain in the early 19th century. It went on to receive waves of French and English immigrants, attracted by the favorable political situation. The forerunner to the Chilean graphic-arts industry started to emerge within this framework, with the appearance of various newspapers and magazines.

The University of Chile was founded in 1843, and afterwards there sprang up a number of institutions focused on the promotion of artistic careers.

By the end of the 19th century, the country had around 200 typographic establishments and in the first half of the 20th century there was an explosion of monthly magazines, including the prestigious *Zig-Zag*. Because there was also a need to promote Chilean products among the local population (nitrate, for example), government policies, exhibitions and spring festivals required many posters and sign-work during this period, which culminated in competitions that attracted a great many artists.

Chile, das von Spaniern kolonisiert wurde und später verschiedene Wellen europäischer Emigranten aufnahm, gehört heute zu den Ländern mit den wenigsten indigen Merkmalen in Lateinamerika. Durch das Wirtschaftswachstum, das sich den Salpeter- und Kupferexporten verdankt, bemüht sich Chile seit den 70er Jahren, seine Wirtschaft zu diversifizieren. Heute zählt es dank seiner wirtschaftlichen und sozialen Entwicklung zu den stabilsten Volkswirtschaften der Welt. Neben seiner außergewöhnlichen Geografie, eingebettet zwischen dem Pazifischen Ozean im Westen und den Anden im Osten, hat Chile auch im Bereich der Grafikkunst Einzigartiges zu bieten. Die Druckerpresse erreichte Chile erst nach dessen Unabhängigkeit von Spanien Anfang des 19. Jahrhunderts, zeitgleich mit dem Zustrom französischer und englischer Einwanderer.

1843 wurde die Universität von Chile gegründet, gefolgt von verschiedenen Institutionen für die künstlerische Ausbildung.

Ende des 19. Jahrhunderts gab es ungefähr 200 Setzereien im Land. In der ersten Hälfte des 20. Jahrhunderts verbreiteten sich die monatlich erscheinenden Zeitschriften explosionsartig, darunter das prestigeträchtige Magazin *Zig-Zag*. Dass die Bevölkerung auch über chilenische

à partir des années 1970 un effort de diversification économique, surtout dans l'agriculture, la production de fruits, de vins et de poissons (dans les dernières années, le Chili a rattrapé la Norvège, le plus grand exportateur mondial de saumon). Aujourd'hui, le développement économique et social du Chili le place au rang des pays les plus stables du monde. Ce pays à la géographie unique en son genre, situé entre l'océan Pacifique à l'ouest et la Cordillère des Andes à l'est, possède aussi son histoire des arts graphiques. Le développement de l'imprimerie n'a commencé qu'après l'indépendance, au début du XIXᵉ siècle. Le pays a alors commencé à recevoir des immigrants français et anglais, attirés par la situation politique favorable. C'est dans ces circonstances qu'est né ce qui allait devenir l'industrie graphique chilienne, avec l'apparition de plusieurs journaux et magazines.

L'Université du Chili a été créée en 1843, puis différentes institutions proposant des formations artistiques ont ouvert leurs portes.

À la fin du XIXᵉ siècle, le Chili comptait environ 200 établissements typographiques, et dans la première moitié du XXᵉ siècle, il y eut une explosion de magazines mensuels. *Zig-Zag* était le plus important à l'époque. Comme il fallait communi-

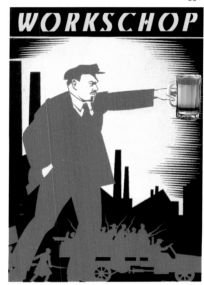

34. "Unifrutti" logo, 1982,
Alex Gonzales, Chile

35. "Workschop" intervention
on a poster by Adolf Strakhov
from 1924, 2007, personal work,
Leonardo Ahumada, Chile

Two giants of the American advertising industry, J. Walter Thompson and McCann Erickson, set up shop in Chile at the end of World War II, marking the start of a new period in the development of advertising in the country. Another milestone in the history of graphic design in Chile was Josef Albers' 1953 visit to the Faculty of Architecture, Design and Urban Studies at the Pontificia Catholic University. The former Bauhaus professor and then head of design at Black Mountain College in North Carolina (US) taught a series of courses in Basic Design and took part in a study program for the Catholic University art school, which eventually began in 1959. Shortly afterwards, the arrival of television in Chile, which coincided with the 1962 Football World Cup, was an important factor in the professionalization of local design; this was the period when the first famous professionals emerged, including Vicente Larrea, José Messina, Alex Gonzales and Mario Fonseca. Following a long period of political turbulence, with a military dictatorship between 1973 and 1990, Chile is today enjoying strong growth and the professionalization of graphic design: from courses at universities and institutions around the country through to associations that put on regular shows of domestic production and the annual publication of catalogs with leading works from around the country.

Produkte (z. B. Nitrat), Regierungserlasse, Ausstellungen und Frühlingsfeste informiert werden musste, kurbelte die Produktion von Plakaten und Schildern stark an.

Am Ende des Zweiten Weltkriegs ließen sich die beiden Giganten der amerikanischen Werbeindustrie, J. Walter Thompson und McCann Erickson, in Chile nieder und begründeten damit eine neue Ära in der Entwicklung der Werbung. Ein weiterer Meilenstein war 1953 die Gastprofessur von Josef Albers an der Fakultät für Architektur, Design und Stadtplanung der Päpstlichen Universität von Chile. Der ehemalige Bauhaus-Professor hatte damals den Lehrstuhl für Design am Black Mountain College in North Carolina (USA) inne, gab in Chile einen Grundkurs in Design und beteiligte sich an der Planung eines Studiengangs an der Kunsthochschule der Katholischen Universität, der schließlich 1959 startete. Etwas später verschaffte die Einführung des Fernsehens, die mit der Fußball-WM 1962 zusammenfiel, dem chilenischen Design einen enormen Aufschwung. Die ersten prominenten Designer waren Vicente Larrea, José Messina, Alex Gonzales und Mario Fonseca. Nach einer langen Periode politischer Turbulenzen und der Militärdiktatur von 1973 bis 1990 erfreut sich Chile heute eines starken Wachstums und zunehmender Professionalisierung des Grafikdesigns: von Studiengängen an Universitäten und Instituten im ganzen

quer sur les produits chiliens (notamment la promotion du salpêtre), les politiques gouvernementales, les expositions et la célébration des fêtes du printemps auprès de la population, la production d'affiches a également été intense durant cette période, ce qui a mené à la réalisation de concours qui attiraient de nombreux artistes.

Après la Deuxième Guerre mondiale, deux grandes agences de publicité américaines se sont installées au Chili. La présence de J. Walter Thompson et de McCann Erickson a constitué une nouvelle étape dans le développement de la publicité chilienne. La visite de Josef Albers à la Faculté d'architecture, de design et d'études d'urbanisme de la Pontificia Universidad Católica de Chile en 1953 a été un événement majeur dans l'histoire du graphisme chilien. Ancien professeur du Bauhaus et, à l'époque, titulaire d'une chaire de design au Black Mountain College de Caroline du Nord, aux États-Unis, Josef Albers a créé une série de cours de Design basique, et a participé à un programme d'études pour l'école d'art de l'Universidad Católica, qui a commencé à fonctionner en 1959. Peu après, la naissance de la télévision chilienne, au moment du mondial de football de 1962, fut un facteur important pour la professionnalisation du graphisme dans le pays. C'est alors qu'apparurent les premiers professionnels d'envergure,

36

summma

Estudio STAFF

Bielus, Goldemberg,
Wainstein - Krasuk, arqs.
Segundo período: 1974-1981

37

36. "Summa" magazine
cover #169, 1981, Argentina

37. "Nueva Visión" magazine
cover #1, 1951, Argentina

In Argentina, one of Latin America's most developed nations both culturally and economically, the tradition of good design started up in the 1940s.

An economic power due mainly to the fact that it produced wheat and meat which it supplied to the world's markets throughout both World Wars, Argentina underwent a surprising development and retained its prosperity through to the mid-1980s. Buenos Aires, the capital and one of the most cosmopolitan cities in the whole of Latin America, is popularly known as the 'Latin Paris'. The city's lively cultural scene, together with a profound political tradition among the Argentinean people, has made the country a reference point in the region.

In the design field, until the mid-1940s products were called advertising art or illustrations and were usually commissioned for the magazines and publications of the day, especially *Arturo*. For many local historians, 1948 marked the start of professional graphic design in Argentina as it is understood today. As well as being the year the Faculty of Architecture and Urban Studies at the University of Buenos Aires began, it was also the year the art magazine *Ciclo*, with one of Argentina's design pioneers, Tomás Maldonado, as its art director, first hit the streets. The graphic

In Argentinien, einem der kulturell und wirtschaftlich am weitesten entwickelten Länder der Region, geht die Tradition des professionellen Designs auf die 1940er-Jahre zurück.

Seine wirtschaftliche Stärke beruht überwiegend auf der Produktion und dem weltweiten Export von Weizen und Fleisch während der beiden Weltkriege, und das Land erfreute sich bis Mitte der 80er Jahre eines überraschenden Aufschwungs und Wohlstands. Die Hauptstadt Buenos Aires ist eine der kosmopolitischsten Städte des Kontinents und wird allgemein als „lateinamerikanisches Paris" betrachtet. Die lebhafte Kulturszene der Stadt in Verbindung mit der tief verwurzelten politischen Tradition der Argentinier hat das Land zu einem Bezugspunkt in der Region werden lassen.

Im Bereich des Designs wurde bis Mitte der 40er Jahre von Werbekunst oder Illustrationen gesprochen, die von den zeitgenössischen Magazinen und Publikationen, hauptsächlich *Arturo*, in Auftrag gegeben wurden. Viele einheimische Historiker betrachten das Jahr 1948 als Beginn des professionellen

Land bis zu Designerverbänden, die regelmäßig Ausstellungen der heimischen Produktion veranstalten und jährlich Kataloge mit den wichtigsten Arbeiten des Landes veröffentlichen.

comme Vicente Larrea, José Messina, Alex Gonzales et Mario Fonseca. Après une longue période de turbulences politiques, avec une dictature militaire de 1973 à 1990, le Chili vit aujourd'hui une grande époque de développement. Le graphisme se professionalise grâce à l'enseignement dispensé dans les universités et institutions de tout le pays et aux associations de graphistes qui organisent régulièrement des expositions de la production nationale, en plus de la publication annuelle de catalogues présentant les meilleurs travaux réalisés dans le pays.

En Argentine, l'un des pays les plus développés d'Amérique latine, aussi bien culturellement qu'économiquement, la tradition de qualité dans le graphisme remonte aux années 1940.

L'Argentine est devenue une puissance économique principalement parce qu'elle a fourni le monde en viande et en blé pendant les deux guerres mondiales. Elle a connu une croissance surprenante et une prospérité qui a duré jusqu'à la moitié des années 1980. Buenos Aires, la capitale, est l'une des villes les plus cosmopolites de toute l'Amérique latine, et a reçu le surnom de « Paris latin ». L'effervescence culturelle de la ville, alliée à une tradition politique profondément enracinée chez

38. "Centro de Esquí Los Penitentes"
logo, 1980, Provincia de Mendoza,
Guillermo González Ruiz, Argentina

39. "Taxis" sign, 1971,
Buenos Aires Visual Plan sign system,
Diseño Shakespear, Argentina

38

art experimentations it proposed, with
the use of new typographies by László
Moholy-Nagy and Herbert Bayer, both
from Bauhaus, marked the new edito-
rial path. This was also the year of the
Nuevas Realidades exhibition, which
featured product design works from
Spanish designers and Italian studios. In
1950, Maldonado, along with Alfredo
Hlito and Enio Iomi, further early designers,
held a group exhibition at the Institute of
Modern Art which was cutting-edge both
in terms of its concept and the creation
of the catalog. And, together with other
colleagues, they founded the magazine
Nueva Visión, dedicated to the visual arts:
between 1951 and 1957, the magazine
was the mouthpiece for the dissemination
of concrete art, new architecture and
design, and featured regular contributions
from Max Bill and other European artists
who shared its revolutionary ideas. In 1954,
Maldonado, Hlito and Carlos Méndez
Mosquera founded Axis, Argentina's pre-
mier advertising agency.

The early 1960s saw a sea change
in the perception of graphic design in
Argentina, not just from a formal viewpoint
but conceptually as well. The worldwide
influence of pop culture caused the
abandonment of an esthetic based on
visual simplicity in lieu of a new form of
expression. Another major publishing event
occurred in 1963: the launch of the art
magazine *Summa*, founded by Mosquera.

Grafikdesigns in Argentinien. In jenem Jahr
wurde auch die Fakultät für Architektur
und Stadtplanung an der Universität
von Buenos Aires gegründet, und das
Kunstmagazin *Ciclo* erschien, geleitet
von Artdirector Tomás Maldonado,
einem der Designpioniere Argentiniens.
Die grafischen Experimente mit neuen
Typografien von László Moholy-Nagy
und Herbert Bayer (beide vom Bauhaus)
bestimmten den neuen redaktionellen
Weg. Es war auch das Jahr der Ausstellung
Nuevas Realidades, die Produktdesign
von spanischen Designern und italie-
nischen Studios zeigte. 1950 veranstalteten
Maldonado, Alfred Hlito und Enio Iomi,
ebenfalls frühe Vertreter des Designs, eine
gemeinsame Ausstellung im Institut für mo-
derne Kunst, die sowohl im Hinblick auf das
Konzept der Ausstellung als auch für die
Gestaltung des Katalogs wegweisend war.
In Zusammenarbeit mit weiteren Kollegen
gründeten sie das Magazin *Nueva Visión*.
Von 1951 bis 1957 war diese Zeitschrift das
Sprachrohr der Vertreter von konkreter
Kunst, neuer Architektur und zeitgenös-
sischem Design und enthielt regelmä-
ßige Beiträge von Max Bill und anderen
europäischen Künstlern, die die gleichen
revolutionären Ideen vertraten. 1954
gründeten Maldonado, Hlito und Carlos
Méndez Mosquera die erste Werbeagentur
Argentiniens, Axis.

Zu Beginn der 60er Jahre änderte
sich die Sichtweise des Grafikdesigns in

le peuple argentin, a fait de ce pays une
référence pour le sous-continent.

Dans le domaine du design, il y a eu
jusqu'à la moitié des années 1940 ce
que l'on appelait l'art publicitaire, ou
les illustrations, souvent réalisées pour les
magazines et les publications de l'époque,
principalement *Arturo*. De nombreux histo-
riens considèrent 1948 comme l'année de
naissance de la pratique professionnelle
du graphisme en Argentine, tel que nous
le connaissons aujourd'hui. C'est l'année
de création de la Faculté d'architecture
et d'urbanisme de l'Université de Buenos
Aires, mais aussi du magazine d'art *Ciclo*,
piloté par le directeur artistique Tomás
Maldonado, l'un des pionniers du gra-
phisme dans le pays. Les expériences gra-
phiques qu'il a proposées, avec l'utilisation
de nouvelles typographies dessinées par
László Moholy-Nagy et Herbert Bayer, tous
deux du Bauhaus, ont défini une nouvelle
tendance éditoriale. C'est également en
1948 que s'est tenue l'exposition *Nuevas
Realidades*, avec des concepts de pro-
duits de quelques créateurs espagnols et
de studios italiens. En 1950, Maldonado,
Alfredo Hlito et Enio Iomi, autres précur-
seurs du graphisme, organisèrent une
exposition collective à l'Institut d'art
moderne et y présentèrent une vision très
moderne pour l'époque. Avec d'autres
collègues, ils fondèrent de plus le maga-
zine *Nueva Visión*, consacré à la culture
visuelle. De 1951 à 1957, ce magazine a

40. "Burgues Script" typographic work, 2007, Sudtipos/Veer, Alejandro Paul, Argentina

41. "Mujeres de dictadores" cover for Página/12 newspaper supplement, 2002, Alejandro Ros, Argentina

42. "Zoo" poster, 2004, Centro Cultural de España (CCEC), Octavio Martino, Argentina

The profusion of ad agencies that sprang up in Buenos Aires created a new generation of designers, including Juan Carlos Distéfano, Guillermo González Ruiz, Rubén Fontana, Ronald Shakespear and Eduardo Canovas.

The strength of business ventures like Di Tella also impacted on the profession in Argentina. One of the companies in the Di Tella stable was the advertising agency Agens, responsible for contracting diverse designers of the day, and the Di Tella Institute, with a graphic arts department run by Juan Carlos Distéfano. The end of the decade saw many Argentinean designers migrate to Barcelona, including Carlos Rolando, América Sánchez and Mario Eskenazi, all of whom had a major influence on Catalan design in the 1970s and '80s. The 1971 hiring of Ronald Shakespear and Guillermo González Ruiz to head up the City of Buenos Aires Visual Plan, which included the whole of the urban signaling system, proved to be an experiment of great social importance. Creative excellence, united with simple industrial execution, saw the project expand through every city in the country and is still in use today. One of the most emblematic pieces is the sign with a hand which identifies taxi ranks. Another important event was the organization of the Football World Cup in 1978. Under the

Argentinien grundlegend, nicht nur vom formalen, sondern auch vom konzeptionellen Standpunkt her. Der weltweite Einfluss der Popkultur bestimmte den Wandel von einer Ästhetik, die auf visueller Einfachheit beruhte, hin zu einer neuen Ausdrucksform. 1963 markierte das Erscheinen des von Mosquera gegründeten Kunstmagazins *Summa* einen Meilenstein im Verlagsgeschäft.

Die vielen neuen Werbeagenturen in Buenos Aires brachten eine neue Generation von Designern hervor, darunter Juan Carlos Distéfano, Guillermo González Ruiz, Rubén Fontana, Ronald Shakespear und Eduardo Canovas.

Auch leistungsstarke Unternehmen wie Di Tella prägten den Beruf des Designers in Argentinien. Zu dieser Gruppe gehörte u. a. die Werbeagentur Agens, die verschiedene junge Designer unter Vertrag nahm, sowie das Instituto Di Tella mit seiner von Juan Carlos Distéfano geleiteten Grafikabteilung. Ende der 60er Jahre emigrierten viele argentinische Designer nach Barcelona, darunter auch Carlos Rolando, América Sanchez und Mario Eskenazi, die alle großen Einfluss auf das katalanische Design in den 70er und 80er Jahren nahmen. 1971 wurden Ronald Shakespear und Guillermo González

été le principal organe de diffusion de l'art concret, de la nouvelle architecture et du design, et il a bénéficié de nombreuses collaborations européens avec Max Bill et d'autres artistes européens qui partageaient les mêmes idées révolutionnaires. En 1954, Tomás Maldonado, Alfredo Hlito et Carlos Méndez Mosquera fondèrent Axis, la première agence de design argentine.

Le début des années 1960 fut le théâtre d'un changement général dans la perception formelle et conceptuelle du graphisme dans le pays. L'influence mondiale de la culture pop causa une transition d'une esthétique caractérisée par la simplicité visuelle vers un nouveau genre d'expression. En 1963, changement de cadre éditorial : Mosquera crée le magazine d'art *Summa*.

La profusion d'agences de publicité apparues à Buenos Aires a créé une nouvelle génération de graphistes, comme Juan Carlos Distéfano, Guillermo González Ruiz, Rubén Fontana, Ronald Shakespear et Eduardo Canovas.

La force de groupes d'entreprises comme Di Tella marque le graphisme argentin. Ce groupe possédait entre autres l'agence de publicité Agens, ainsi que l'Instituto Di Tella, avec un service graphique dirigé par Juan Carlos Distéfano. À la fin

MUJERES DE DICTADORES

direction of Gui Bonsiepe, the graphic applications designed for the event have gone down in history.

During the 1960s, '70s and '80s, political events in Argentina, as in the other countries of Latin America, were determining factors in the social changes that took place. The populist policies of President Juan Carlos Perón and his successors, as well as the following years of military repression, undermined the creative vigor that characterized the country. Argentina would have to wait until the late 1980s, with the return of democracy and the resurgence of the industry, to get back on track. The magazine *TipoGráfica*, launched in 1987 and edited by Rubén Fontana, was one of the principal vehicles for ideas, debates and trends in the design and creativity field through to 2007. Another project with a major social impact was the signaling of the Subte (the abbreviation by which the Buenos Aires underground is known) between 1995 and 2007, led by Lorenzo and Juan Shakespear (Diseño Shakespear). In recent years, with Argentina enjoying economic growth, it has been possible to find excellent designers and studios, as well as a large number of design schools right across the country. This helped lead UNESCO to select Buenos Aires as the 2006 City of Design.

Brazil is the biggest country in Latin America, covering more than eight

Ruiz angeheuert, um das Team für den „visuellen Plan" der Stadt Buenos Aires zu leiten. Dieser Auftrag schloss das gesamte städtische Beschilderungssystem mit ein und stellte sich als Experiment von großer sozialer Bedeutung heraus. Dieses Projekt verband kreative Exzellenz mit einfacher industrieller Ausführung und griff auf alle Städte des Landes über; es ist noch heute in Gebrauch. Eines der markantesten Stücke ist das Schild mit einer Hand, das einen Taxistand anzeigt. Ein weiteres wichtiges Ereignis war 1978 die Organisation der Fußball-WM. Unter der Leitung von Gui Bonsiepe wurden für dieses Ereignis Grafikanwendungen geschaffen, die Geschichte geschrieben haben.

Die politischen Ereignisse der 60er, 70er und 80er Jahre in Argentinien sowie in anderen lateinamerikanischen Ländern bestimmten den sozialen Wandel jener Zeit. Der Populismus des Präsidenten Juan Carlos Perón und seiner Nachfolger sowie die folgenden Jahre der Militärdiktatur trugen zum Verlust der kreativen Energie bei, die das Land auszeichnete. Argentinien musste das Ende der 80er Jahre abwarten, bis es mit der Rückkehr von Demokratie und Wirtschaftskraft zur Normalität zurückfand. Das 1987 von Rubén Fontana gegründete und herausgegebene Magazin *TipoGráfica* war bis 2007 eine der wichtigsten Plattformen für Ideen, Debatten und Tendenzen im Bereich Design und Kreativität. Ein weiteres

de la décennie, il y eut une grande vague d'émigration de graphistes argentins vers Barcelone. Ce fut le cas de Carlos Rolando, América Sanchez et Mario Eskenazi, qui ont sûrement eu une grande influence sur le graphisme catalan des années 1970 et 1980. Le recrutement de Ronald Shakespear et Guillermo González Ruiz pour diriger l'équipe qui a réalisé le Plan visuel de la Ville de Buenos Aires, qui comprenait tout le système de signalisation urbaine, s'est révélé être une expérience sociale de grande importance. Grâce à son excellence créative et à sa simplicité d'exécution industrielle, le projet a été appliqué à toutes les villes du pays, et est toujours utilisé aujourd'hui. L'un de ses éléments les plus emblématiques est la plaque qui identifie les stations de taxis. Le mondial de football de 1978 a également été un événement majeur. Sous la direction de Gui Bonsiepe, les éléments graphiques réalisés pour l'événement ont marqué leur époque.

Pendant les années 1960, 1970 et 1980, les événements politiques ont été, en Argentine comme dans d'autres pays d'Amérique latine, déterminants pour les changements sociaux qui ont suivi. Le populisme du président Juan Carlos Péron et de ses successeurs et les années de dictature militaire ont contribué au déclin de la vigueur créative qui caractérisait le pays. Ce n'est qu'à la fin des années 1980, avec le retour de la démocratie et de l'industrie, que l'évolution de l'Argentine a repris son

million square kilometers. The presence of Africans (brought over as slaves following colonization), native indigenous people and Portuguese, played a fundamental role in contributing to the development of Brazilian culture. As well as inheriting the language (Brazil is the only non Spanish-speaking country in the region) Brazil also inherited inter-breeding from the Portuguese, a defining characteristic of the colonizers. The Portuguese were different from the Spaniards in that they interacted a lot more with the Africans and indigenous people and their cultures. Over time, thousands and thousands of Europeans settled in the country, adding new contributions, whether genetic, cultural or linguistic. Another noteworthy fact is that the world's first major Japanese emigration was to Brazil, in 1908.

The Brazilian graphic-arts industry began around 1808, with the arrival of the Portuguese royal family. Portugal was one of the few European countries not to succumb to Napoleon. The Portuguese crown made the clever strategic decision to move to Brazil, taking all of the kingdom's wealth with it, which meant the French found nothing to rob when they entered the country. A new period of prosperity began in Brazil with the arrival of financial institutions, the Treasury, libraries, fine-art schools and the press. Brazil declared its independence from Portugal in 1822 and became an empire through

Projekt mit großen sozialen Auswirkungen war die Beschilderung für die Subte (die U-Bahn von Buenos Aires) von 1995 bis 2007 unter der Leitung von Lorenzo und Juan Shakespear (Diseño Shakespear). Durch das wirtschaftliche Wachstum der letzten Jahre finden sich heute im ganzen Land hervorragende Designer und Ateliers sowie viele verschiedene Designschulen. 2006 wurde Buenos Aires von der UNESCO zur „Stadt des Designs" gewählt.

Brasilien ist mit einer Fläche von mehr als 8 Millionen Quadratkilometern das größte Land der Region. Afrikaner, die während der Kolonialisierung als Sklaven ins Land gebrachten wurden, die indigene Bevölkerung und Portugiesen prägten im Wesentlichen die Entwicklung der brasilianischen Kultur. Brasilien erbte nicht nur die Sprache von den Portugiesen (es ist das einzige nicht spanischsprachige Land der Region), sondern auch die für die portugiesischen Siedler typische Rassenvermischung. Im Gegensatz zu den Spaniern vermischten sich die Portugiesen stark mit der afrikanischen und einheimischen Bevölkerung und deren Kulturen. Mit der Zeit siedelten sich Abertausende weitere Europäer im Land an und trugen genetisch, kulturell oder sprachlich zur Entwicklung des Landes bei. Zudem hatte 1908 die erste große Auswanderungswelle aus Japan Brasilien zum Ziel.

Brasilianisches Design trat erstmals um 1808 in Erscheinung, als die portu-

cours. Le magazine *TipoGráfica*, lancé en 1987 et dirigé par Rubén Fontana, fut l'un des principaux véhicules d'idées, de débats et de tendances dans le domaine du graphisme et de la créativité jusqu'en 2007. La signalisation du Subte (abréviation de « subterráneo »), le réseau de métro de Buenos Aires, est également un projet qui a eu un grand impact social. Il a été mené de 1995 à 2007 sous la direction de Lorenzo et Juan Shakespear (Diseño Shakespear). Aujourd'hui, l'Argentine est en phase de croissance économique et l'on peut y trouver d'excellents graphistes et studios. C'est cela, avec le nombre d'écoles de graphisme que compte le pays, qui a mené l'UNESCO à déclarer Buenos Aires Ville du Design en 2006.

Le Brésil est le plus grand pays d'Amérique latine, avec une superficie de plus de 8 millions de kilomètres carrés. La présence d'Africains, emmenés comme esclaves après la colonisation, d'indigènes et de Portugais a été un facteur fondamental dans le développement de la culture brésilienne. Outre la langue (c'est le seul pays non hispanophone de la région), le Brésil a également hérité des Portugais le métissage. Les Portugais ont beaucoup plus interagi avec les Africains et les indigènes que les Espagnols. C'est l'une des raisons du grand brassage que forment le peuple brésilien et sa culture. Avec le temps, des milliers d'autres Européens se sont établis dans le pays et y ont apporté de nouvelles

43. **"1000 Cruzeiros"** banknote design concept (developed by João de Souza Leite, Washington Dias Lessa), 1977, Casa da Moeda do Brasil, Aloisio Magalhães, Brazil

44. **"Banespa"** (Banco do Estado de São Paulo) logo, 1969, Aloisio Magalhães, Brazil

45. **"Prima Eletrodomésticos"** logo, 1964, Ruben Martins, Brazil

46. **"Ultragaz"** logo for distributor of home-use compressed gas, 1977, Alexandre Wollner, Brazil

44

46

to 1899, when it was declared a republic. An eminently agricultural country, the first big industries appeared at the start of the 1950s, with the arrival of car manufacturers. However, Brazilians had been publishing a wide range of newspapers and magazines, both political and satirical, since independence.

With the implementation of industry in the 1950s, cultural life in Brazil became more cosmopolitan.

Boosted by the spirit of renewal born from the construction and inauguration of the new capital city, Brasilia, in 1960 — an international architectural milestone and the fruit of a project by Lucio Costa and Oscar Niemeyer — Brazil began a period in which it was bursting with creativity. As well as the architecture of the time, in the field of music came the groundbreaking *bossa nova* movement, led by João Gilberto, Antonio Carlos Jobim, Carlos Lyra and Roberto Menescal, the film industry produced Cinema Novo, whose main exponent was Glauber Rocha, the director of such classics as *Black God, White Devil*, and the plastic arts also found expression, with the São Paulo Biennial being another testament to Brazil's cultural fertility.

It was a unique period for the graphic arts, too: a design course was

giesische Königsfamilie in der Kolonie eintraf. Portugal war eines der wenigen Länder Europas, die sich Napoleon nicht unterwarfen. Die portugiesische Krone unternahm den strategisch geschickten Schachzug, nach Brasilien zu gehen und alle Reichtümer des Königreichs mitzunehmen. Die Franzosen fanden daher bei ihrer Ankunft in Portugal nichts vor, was sie hätten stehlen können. Mit der Ankunft von Banken, der Staatskasse, Bibliotheken, Kunsthochschulen und der Presse begann in Brasilien eine neue Blütezeit. Im Jahr 1822 erklärte Brasilien seine Unabhängigkeit von Portugal und wurde zum Kaiserreich, bis schließlich 1899 die Republik ausgerufen wurde. In den 50er Jahren entstanden mit der Autoproduktion die ersten großen Industrien in dem landwirtschaftlich geprägten Land. Doch schon seit seiner Unabhängigkeit erschienen in Brasilien verschiedene politische und satirische Magazine und Zeitungen.

Mit dem Beginn der Industrialisierung in den 50er Jahren wurde das kulturelle Leben in Brasilien kosmopolitischer.

Die neue Hauptstadt Brasília wurde erbaut und 1960 eingeweiht – ein weltweiter architektonischer Meilenstein und die Krönung des Projekts von Lucio Costa und Oscar Niemeyer. Von diesem Geist der Erneuerung beflügelt begann für Brasilien

contributions, génétiques, culturelles ou linguistiques. De plus, la première grande vague d'émigration japonaise s'est réalisée vers le Brésil, en 1908.

L'industrie graphique brésilienne n'est apparue qu'en 1808, avec l'arrivée de la famille royale portugaise. Le Portugal fut l'un des rares pays européens qui ne succombèrent pas à la domination de Napoléon. Pour la couronne portugaise, la décision d'aller au Brésil (et d'y emporter toute la richesse du royaume) se révéla une stratégie efficace. Les Français ne trouvèrent rien à voler lorsqu'ils entrèrent au Portugal. Ce fut le début d'une nouvelle période de prospérité au Brésil, avec l'arrivée d'institutions financières, du Trésor national, de bibliothèques, d'écoles des beaux-arts et de la presse. En 1822, le Brésil déclara son indépendance et devint un empire jusqu'à 1899, année de proclamation de la république. Pays éminemment agricole, les premières grandes industries y apparurent à partir des années 1950, avec l'arrivée des usines automobiles. Mais depuis leur indépendance, les Brésiliens produisaient déjà une grande variété de magazines et de journaux, politiques ou satiriques.

Avec l'implantation de l'industrie dans les années 1950, la vie culturelle brésilienne commença également à devenir de plus en plus cosmopolitaine.

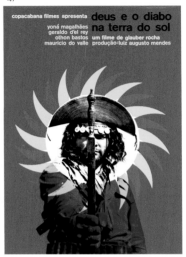

47. "Deus e o Diabo na Terra do Sol"
(Black God, White Devil) film poster,
1964, film by Glauber Rocha,
Rogério Duarte, Brazil

48. "Globo TV network" logo,
1975–2008, Hans Donner, Brazil

49. "Harper's Bazaar" magazine cover,
May 1967, USA
Art direction Bea Feitler, Ruth Ansel,
Photo Frank Horvat

50. "The Beatles" book, 1980, Rolling
Stone Press (published by Times Books,
The New York Times Book Co., Inc.)
Art direction Bea Feitler
Artwork Andy Warhol

added to the academic subjects on offer at the Faculty of Architecture and Urban Studies at the University of São Paulo, and the ESDI (Escola Superior de Desenho Industrial) opened in Rio de Janeiro in 1963, the oldest design school in the country. Big national companies employed the professional services of designers such as Aloisio Magalhães, Alexandre Wollner and Ruben Martins, among other pioneers in the country. Brazil's ad industry began to make waves around the world, take home the main prizes at the most important international festivals, and shore up its position as one of the most expressive industries on the planet. Historians tend to refer to this period as 'the Brazilian miracle'. The 1964 military coup plunged the country into a long period of repression and dictatorship; even so, it was a special time for the arts, in contrast to the gloomy political situation the country was experiencing.

It was also during the 1960s that Brazil saw the birth of Rede Globo de Televisão, still the most popular television network today and an unprecedented event at the international level. With varied programming and extreme technical precision, it not only emphasized graphic design and animation (mainly by the Austrian designer Hans Donner) but quickly made a name for itself as one of the strongest and most influential broadcasters in the world.

eine Zeit überbordender Kreativität. So wie sich die Architektur der Ära wandelte, entstand auch in der Musik eine neue Stilrichtung: Die Bossa-Nova-Bewegung mit ihrem neuartigen Rhythmus kam auf, die von João Gilberto, Antônio Carlos Jobim, Carlos Lyra und Roberto Menescal angeführt wurde, ebenso das Cinema Novo, dessen Hauptvertreter Glauber Rocha war, Regisseur von Klassikern wie *Gott und der Teufel im Lande der Sonne*, die Bildhauerei gewann an Bedeutung, und die Biennale in São Paulo ist ebenfalls ein Beleg für die kulturelle Fruchtbarkeit Brasiliens.

Auch für das Design war dies eine wichtige Zeit: Der Studiengang Design wurde von der Fakultät für Architektur und Stadtplanung an der Universität von São Paulo eingeführt, und die ESDI (Escola Superior de Desenho Industrial), die älteste Designschule in Brasilien, öffnete 1963 in Rio de Janeiro ihre Pforten. Große brasilianische Unternehmen beauftragten Designer wie Aloisio Magalhães, Alexandre Wollner und Ruben Martins, um nur einige der Designpioniere des Landes zu nennen. Die brasilianische Werbeindustrie begann, weltweit von sich reden zu machen, wichtige Preise bei internationalen Festivals zu gewinnen und sich als eine der ausdrucksstärksten Branchen der Welt zu etablieren. Diese Periode wird von Historikern häufig als „das brasilianische Wunder" bezeichnet. Der Putsch im Jahr 1964 stürzte das Land

Stimulé par l'esprit de renouvellement amené par la construction et l'inauguration (en 1960) de la nouvelle capitale, Brasília, chef-d'œuvre architectural de Lucio Costa et d'Oscar Niemeyer, le Brésil vécut un moment d'effervescence créative très intense. Parallèlement aux événements architecturaux de l'époque, la bossa-nova fit son apparition dans le paysage musical. Ce sont les talentueux João Gilberto, Antonio Carlos Jobim, Carlos Lyra et Roberto Menescal qui menaient le mouvement. Le *cinema novo*, dont le plus grand représentant était Glauber Rocha, réalisateur de classiques comme *Le Dieu noir et le diable blond*, et les arts plastiques, avec la Biennale de São Paulo, sont d'autres preuves de la fertilité culturelle du Brésil.

Ce fut aussi une période très particulière pour le design : la Faculté d'architecture et d'urbanisme de l'Université de São Paulo ouvrit un cours de design industriel, et l'ESDI (École supérieure de design industriel), l'école de design la plus ancienne du Brésil, fut inaugurée à Rio de Janeiro en 1963. De grandes entreprises brésiliennes décidèrent de s'attacher les services professionnels de designers comme Aloisio Magalhães, Alexandre Wollner et Ruben Martins, entre autres pionniers brésiliens dans ce domaine. La publicité brésilienne commença à gagner en notoriété à travers le monde et à remporter les principales récompenses des plus grands festivals

Another important name from this period was the Brazilian art director Bea Feitler. After training at the Parsons School of Design in New York, she returned to Brazil for a short period before basing herself in America, where she went on to become one of the most influential designers of the time.

She was responsible for publishing projects for the magazines *Harper's Bazaar*, *Vanity Fair*, *Ms*, *Self* and *Rolling Stone*, as well as books and record covers, including the Rolling Stone's *Black and Blue* album, and *Bush Doctor*, by Peter Tosh. Born in Rio de Janeiro in 1938, Feitler died young from cancer, in New York in 1982. After her death, New York's Art Directors Club began an annual award in her name.

In the 1980s, with the gradual weakening and disappearance of the military regime, the country underwent a new period of optimism and democracy. Music returned to the fore with a new generation of rock composers and groups, definitively impacting on the course of graphic and visual arts in the country. The magazine *Gráfica*, a national reference point edited and published by the designer Oswaldo Miranda, has been on the market since 1983. The first professional associations also started up, along

in eine lange Zeit der Unterdrückung und Diktatur, für die Kunst jedoch war dies auch eine besondere Zeit, die im Gegensatz zu der düsteren politischen Situation des Landes stand.

In den 60er Jahren erlebte Brasilien zudem die Geburt von Rede Globo de Televisão, bis heute der beliebteste Fernsehsender, der auf internationaler Ebene ohne Beispiel bleibt. Mit abwechslungsreichen Programmen, äußerst präziser Technologie und den Schwerpunkten Grafikdesign und Animation (hauptsächlich unter der Leitung des österreichischen Designers Hans Donner) etablierte sich Rede Globo schnell als eines der stärksten und einflussreichsten Medienunternehmen der Welt.

Eine weitere bedeutender Persönlichkeit zu jener Zeit war die brasilianische künstlerische Leiterin Bea Feitler. Nach ihrer Ausbildung an der Parsons School of Design in New York kehrte sie zunächst für kurze Zeit in ihr Heimatland zurück, bevor sie sich in den USA niederließ, wo sie zu einer der einflussreichsten Designerinnen wurde.

Sie war für Projekte in den Magazinen *Harper's Bazaar*, *Vanity Fair*, *Ms*, *Self* und *Rolling Stone* verantwortlich sowie für Bücher und Plattencover, darunter *Black*

internationaux. Les historiens appellent cette période le « miracle brésilien ». Le coup militaire de 1964 a plongé le pays dans une longue période de répression et de dictature. Ce fut pourtant un moment très particulier pour les arts, en contrepoint de la noirceur de la situation politique.

Toujours dans les années 1960, la chaîne de télévision Rede Globo de Televisão vit le jour. Elle est encore aujourd'hui numéro un de l'audience, ce qui est un fait sans précédent dans le monde. Avec une programmation variée et une grande rigueur technique, ainsi qu'un graphisme et des animations de grande qualité (principalement sous la direction de l'Autrichien Hans Donner), la Rede Globo s'est rapidement imposée comme l'une des chaînes de télévision les plus puissantes et les plus influentes du monde.

La directrice artistique Bea Feitler a également été un grand nom de l'époque. Elle avait étudié à la Parsons School of Design de New York avant de revenir brièvement au Brésil, puis s'installa aux États-Unis où elle devint l'un des designers les plus influents du moment.

Elle s'est chargée de projets éditoriaux pour les magazines *Harper's Bazaar*, *Vanity Fair*, *Ms*, *Self*, *Rolling Stone*, ainsi que de projets de livres et de pochettes de

with various regular design exhibitions and competitions.

The arrival of the computer brought about a new professional model in the late 1980s. Today the whole of Latin America is witnessing a proliferation of design studios and artists that incorporate other areas, such as the Internet, video, illustration and fashion into their activities. The digital media have expanded the borders of what was known as graphic design. The 21st-century designer is connected to various forms of communication and has permanently crossed the lines that used to define the profession. The constant growth in access to information has forged much more versatile and multimedia professionals whose main characteristic is the diversity that surrounds them. Although it is made up of different countries with strong and distinct characteristics, Latin America today presents a cultural identity unique to humankind. The dynamic of its creativity and culture speaks for the vivacity of the region, while its products, languages, music and people make up one of the principal and richest centers of cultural identity in the modern world.

and Blue von den Rolling Stones und *Bush Doctor* von Peter Tosh. Feitler wurde 1938 in Rio de Janeiro geboren und starb 1982 in New York jung an Krebs. Seit ihrem Tod verleiht der Art Directors Club in New York jährlich einen Preis in ihrem Namen.

Mit der allmählichen Schwächung und Auflösung der Diktatur in den 80ern begann für Brasilien eine neue Phase des Optimismus und der Demokratie. Die Musik trat mit einer neuen Generation von Komponisten und Rockgruppen wieder in den Vordergrund, die auch Grafik und bildende Kunst des Landes beeinflussten. Das Magazin *Gráfica* erscheint seit 1983 unter Leitung des Designers Oswaldo Miranda und setzt national Maßstäbe. Man gründete die ersten Berufsverbände und führte regelmäßige Ausstellungen und Wettbewerbe für Design durch.

Der Computer ermöglichte Ende der 80er Jahre ganz neue Formen des professionellen Designs. Dies hat heute in ganz Lateinamerika eine starke Zunahme von Designstudios und Designern zur Folge, die sich auch weitere Bereiche wie das Internet, Video, Illustration und Mode erschließen. Die digitalen Medien haben die Grenzen des herkömmlichen Grafikdesigns erweitert. Der Designer des 21. Jahrhunderts kann auf viele Kommunikationswege zugreifen und überschreitet ständig die Grenzen dessen, was bisher diesen Beruf definierte. Der Zugang zu stetig wachsenden Informationen

disques. *Black and Blue*, des Rolling Stones, et *Bush Doctor*, de Peter Tosh, en sont de bons exemples. Née en 1938 à Rio de Janeiro, Bea Feitler est décédée prématurément des suites d'un cancer en 1982, à New York. Après sa mort, l'Art Directors Club de New York a créé un prix annuel portant son nom.

Dans les années 1980, avec l'affaiblissement graduel puis la disparition de la dictature militaire, le pays vécut une nouvelle période d'optimisme et de démocratie. Une fois de plus, la musique ressurgit avec une nouvelle génération de compositeurs et de groupes de rock, ce qui influença définitivement le cours des arts graphiques et visuels dans le pays. De nouvelles publications apparurent, et le graphisme gagna en force et en présence, avec des cours dans les universités de la plupart des grandes villes brésiliennes. Le magazine *Gráfica*, référence nationale dirigée et éditée par le graphiste Oswaldo Miranda, est publié depuis 1983. Les premières associations professionnelles se sont créées à cette époque, ainsi que les salons et les concours de graphisme.

L'arrivée de l'ordinateur a défini un nouveau paradigme professionnel à partir de la fin des années 1980. Une multitude de studios et de graphistes de toute l'Amérique latine ont étendu leurs activités à d'autres domaines, comme Internet, la vidéo, l'illustration et la mode. Les médias numériques ont repoussé les

51. "Almanaque anos 80" book,
2004, Ediouro, Marcelo Martinez, Brazil

52. "Gráfica Magazine" cover,
1991, Oswaldo Miranda, Brazil
Photo Klaus Mitteldorf

53. "Grafica para arquitectura
futurista" illustration, 2006,
Antonio Sánchez, Mexico

53

produziert vielseitigere und mulitmediale Designer, deren Hauptmerkmal die Vielfalt ist, die sie umgibt. Heute präsentiert Lateinamerika der Welt seine einzigartige kulturelle Identität, obwohl es aus verschiedenen Ländern besteht, die starke individuelle Merkmale aufweisen. Die Dynamik der hiesigen Kreativität und Kultur steht für das Temperament des Kontinents. Lateinamerikas Produkte, Sprachen, Musik und Menschen lassen eine der bedeutendsten und reichhaltigsten kulturellen Identitäten der modernen Welt entstehen.

limites du graphisme. Le graphiste du XXIe siècle est connecté à différents moyens de communication et franchit constamment les frontières qui définissaient la profession autrefois. L'accès à l'information a généré des professionnels toujours plus polyvalents, multimédias, caractérisés par la diversité. Aujourd'hui, l'identité de l'Amérique latine est unique au monde, bien qu'elle soit formée de plusieurs pays aux caractéristiques individuelles fortes et bien distinctes. Le dynamisme de sa créativité et de sa culture témoigne de la vivacité de la région. Ses produits, ses langues, sa musique et son peuple forment l'un des pôles d'identité culturelle les plus importants et les plus riches de notre époque.

"Why do trees conceal the splendor of their roots?"
— Pablo Neruda, 1974
The Book of Questions

„Warum verbergen die Bäume die Pracht ihrer Wurzeln?"
— Pablo Neruda, 1974
Buch der Fragen

«Pourquoi les arbres cachent-ils l'éclat somptueux de leurs racines ?»
— Pablo Neruda, 1974
Le livre des questions

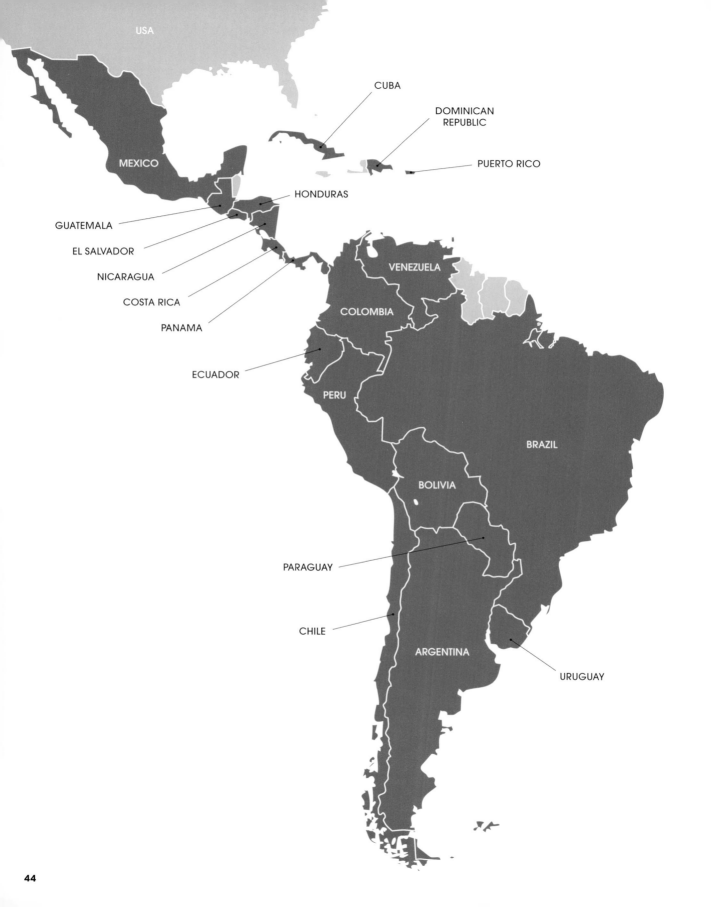

USA

CUBA

DOMINICAN
REPUBLIC

PUERTO RICO

MEXICO

HONDURAS

GUATEMALA

EL SALVADOR

NICARAGUA

COSTA RICA

PANAMA

VENEZUELA

COLOMBIA

ECUADOR

PERU

BRAZIL

BOLIVIA

PARAGUAY

CHILE

ARGENTINA

URUGUAY

44

ARGENTINA
Population: 40.3 million
Capital: Buenos Aires

COSTA RICA
Population: 4.1 million
Capital: San José

HONDURAS
Population: 7.4 million
Capital: Tegucigalpa

PERU
Population: 28.6 million
Capital: Lima

BOLIVIA
Population: 9.1 million
Capital: La Paz

CUBA
Population: 11.3 million
Capital: Havana

MEXICO
Population: 108.7 million
Capital: Mexico City

PUERTO RICO
Population: 3.9 million
Capital: San Juan

BRAZIL
Population: 183.8 million
Capital: Brasilia

EL SALVADOR
Population: 5.8 million
Capital: San Salvador

NICARAGUA
Population: 5.6 million
Capital: Managua

DOMINICAN REPUBLIC
Population: 9.7 million
Capital: Santo Domingo

CHILE
Population: 16.5 million
Capital: Santiago

ECUADOR
Population: 13.8 million
Capital: Quito

PANAMA
Population: 3.3 million
Capital: Panama City

URUGUAY
Population: 3.4 million
Capital: Montevideo

COLOMBIA
Population: 44 million
Capital: Bogota

GUATEMALA
Population: 12.7 million
Capital: Guatemala City

PARAGUAY
Population: 6.1 million
Capital: Assuncion

VENEZUELA
Population: 27.7 million
Capital: Caracas

6D ESTÚDIO

1

6D Estúdio is a young and vibrant design collective founded in 2004 by no less than seven professionals with a wide background of expertise including architecture, marketing, graphic design and motion graphics. In these few years of existence, they have taken a very dynamic approach to design, incorporating a strong and modern visual language to their works that include music clips, CD packaging, TV spots and visual identity for a number of concerts. They have also brought in a new breed of web design in Rio de Janeiro, where the studio is based. The group has worked on clients such as the band Monobloco, fashion designer Maria Bonita and photographer Emmanuelle Bernard. Their video clip for Jota Quest was awarded with an MTV Video Music Brasil Award.

6D Estúdio ist ein junges, lebhaftes Gemeinschaftsstudio, das 2004 von 7 Profi-Designern gegründet wurde, die in Architektur, Marketing, Grafikdesign und Motions-Design sehr erfahren sind und über umfangreiches Fachwissen verfügen. In den wenigen Jahren seines Bestehens arbeitet 6D Estúdio sehr dynamisch, und die Arbeiten zeigen eine starke, moderne, visuelle Sprache. Neben Musik-Clips, CD-Verpackungen, TV-Spots und Visual Identity für eine Reihe von Konzerten hat 6D Estúdio in Rio de Janeiro, wo das Studio seinen Sitz hat, auch eine neue Art des Webdesigns entwickelt. Zu den Kunden zählen u.a. die Band Monobloco, die Modedesignerin Maria Bonita und die Fotografin Emmanuelle Bernard. Der Videoclip für Jota Quest wurde mit dem MTV Video Music Brasil Award ausgezeichnet.

6D Estúdio est un collectif jeune et plein de vitalité fondé en 2004 par sept professionnels venant d'horizons variés : architecture, marketing, graphisme et animation. Au cours de ces quelques années d'existence, ils ont adopté une approche très dynamique du design. Ils utilisent un langage visuel fort et moderne pour créer des vidéos musicales, des pochettes de CD, des spots télévisés et l'identité visuelle de nombreux concerts. Ils ont également apporté du sang neuf dans la conception de sites web à Rio de Janeiro, où se trouve le studio. Le groupe a travaillé pour des clients tels que le groupe de samba funk Monobloco, la créatrice de mode Maria Bonita et la photographe Emmanuelle Bernard. Leur vidéo-clip pour Jota Quest a reçu un prix MTV Video Music Brasil.

1. "Revisitados" CD packaging
(various artists) 2005, Dubas Música
Art direction/design Beto Martins,
Emilio Rangel
Illustration Emilio Rangel

BANCO DO BRASIL apresenta

ISMAEL SILVA DEIXA FALAR

DE 1º DE FEV A 1º DE MAR DE 2005. TERÇAS - 12h30 E 18h30

1/02: PEÇAM BIS - ELTON MEDEIROS E CLÁUDIO NUCCI • 15/02: AMOR DE MALANDRO - FÁTIMA GUEDES E FLÁVIO BAURAQUI
22/02: OS BAMBAS DO ESTÁCIO - MONARCO, TERESA CRISTINA E PEDRO MIRANDA • 1/03: SE VOCÊ JURAR - MÔNICA SALMASO E CLÁUDIO JORGE
DIREÇÃO GERAL: LUÍS FILIPE DE LIMA

Rua Primeiro de Março, 66
Centro Rio de Janeiro RJ 20010-000
Informações: (21) 3808-2020
cultura-e.com.br

LEI DE
INCENTIVO
À CULTURA
MINISTÉRIO
DA CULTURA

BRASIL
UM PAÍS DE TODOS
GOVERNO FEDERAL

Patrocínio e Realização

CENTRO CULTURAL
BANCO DO BRASIL

2. **"Ismael Silva, Deixa Falar"** concert poster, 2005, CCBB (Centro Cultural Banco do Brasil)/Tema Eventos
Art direction/design Beto Martins
Illustration Emilio Rangel

3. **"021"** logo and brand identity system, 2007, 021 Restaurant
Art direction Beto Martins
Design Joana Plautz

4. **"O Sol"** music video, 2006, Jota Quest, Sony BMG Brazil
Art direction Mateus Araújo
Design Mateus Araújo, Bernardo Vieira, Kai Hattermann, Gabriel "Cabral"

5. **"Floribella"** motion graphics for TV series opening, 2005, TV Band
Art direction Mateus Araújo
Design Mateus Araújo, Bernardo Vieira

3

4

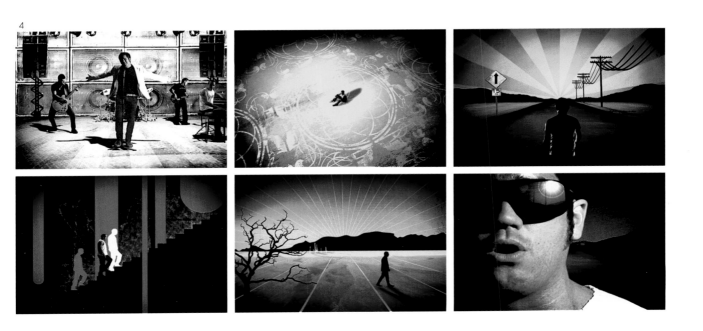

5

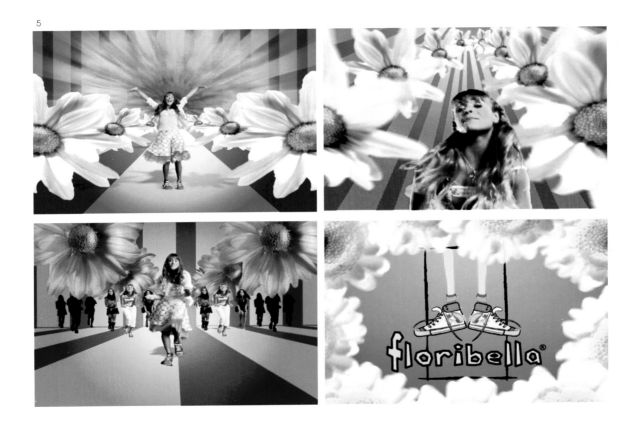

*1991, Bolivia

A&J ASOCIADOS

1. "Calles Muertas" poster, 2006

2. "La Picota del Gallo" poster, 2006

Aldo Mercado began his career in advertising, before shifting his attention to concentrate on graphic design in 1991. He is now director of the Estudio de Diseño Gráfico A&J Asociados, which has, over the last 10 years, served a number of commercial enterprises throughout the country. The studio has notably been involved in projects with the central government and various public institutions that have helped to raise the profile of businesses in some of the less developed regions in the north of the country, supporting them to improve the communication of their products and services through the design of corporate identity. These days, Mercado's personal work and interests have converged to research and develop projects with socio-political ambition, using design as a tool to create awareness of and help improve Bolivia's social conditions.

Aldo Mercado begann seine Laufbahn in der Werbung, bevor er sich 1991 dem Grafikdesign zuwandte. Er ist Geschäftsführer des Estudio de Diseño Gráfico A&J Asociados, das in den letzten 10 Jahren für verschiedene Wirtschaftsunternehmen des Landes tätig war. Das Studio beteiligte sich vor allem an Projekten der Zentralregierung und verschiedenen öffentlichen Institutionen, die die Profile von Unternehmen in einigen weniger entwickelten Regionen im Norden des Landes verbessern sollten. Durch Entwicklung der Corporate Identity unterstützte das Studio die Unternehmen darin, den Bekanntheitsgrad ihrer Produkte und Dienstleistungen zu erhöhen. Heute konzentriert sich Mercado in seiner persönlichen Arbeit auf Recherche und Entwicklung von Projekten mit sozialpolitischen Ambitionen. Hier arbeitet er mit Design als Werkzeug, um die sozialen Bedingungen Boliviens bewusster zu machen und zu verbessern.

Aldo Mercado a commencé sa carrière dans la publicité, avant de se consacrer au graphisme en 1991. Il est aujourd'hui directeur de l'agence Estudio de Diseño Gráfico A&J Asociados, qui a travaillé ces dix dernières années pour de nombreuses entreprises commerciales dans tout le pays. L'agence a notamment participé à des projets du gouvernement central et de plusieurs organismes publics, qui ont permis de relever l'image d'entreprises de certaines des régions les plus défavorisées du nord du pays en les aidant à améliorer la communication sur leurs produits et services à travers la conception d'une identité d'entreprise. Dernièrement, le travail personnel et les centres d'intérêt de Mercado ont convergé dans la recherche et le développement de projets ayant un fond socio-politique, en utilisant le design pour sensibiliser le public aux conditions sociales en Bolivie et pour contribuer à leur amélioration.

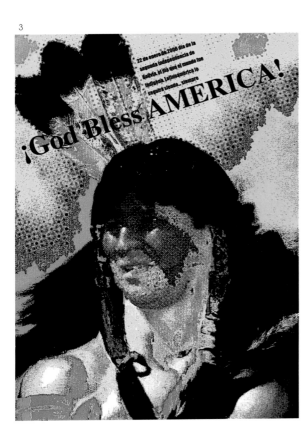

5

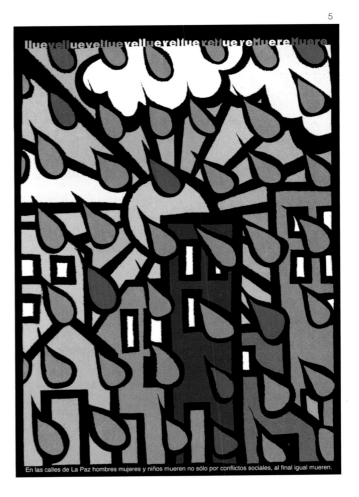

4

*1989, Venezuela, www.abvtaller.com

ABV TALLER DE DISEÑO

Founded in 1989 by three of the most remarkable design professionals in Venezuela (Oscar Vásquez, Waleska Belisario and Carolina Arnal), ABV Taller de Diseño is one of the most respected studios in the country. Vásquez, who died in 2002, was one of the greatest names in contemporary poster design; his work remains in the permanent collections of the Wilanow Poster Museum in Warsaw, the Museo de Bellas Artes in Caracas and MoMA in New York. The group has received numerous national and international awards, especially for their work on editorial design for books and countless posters, which have been exhibited in Leipzig, Germany, and Lathi in Finland. The studio has also featured in publications such as *Graphis* in the United States, and the Swiss publication *Who's Who in Graphic Art*.

ABV Taller de Diseño wurde 1989 von drei der bemerkenswertesten professionellen Designern in Venezuela gegründet (Oscar Vásquez, Waleska Belisario und Carolina Arnal) und ist eines der angesehensten Studios des Landes. Vásquez, der 2002 starb, war einer der größten Namen des zeitgenössischen Plakatdesigns; seine Arbeit bleibt in den ständigen Sammlungen des Wilanow Plakatmuseums in Warschau, des Museums der schönen Künste in Caracas und des MoMA in New York erhalten. Die Gruppe wurde mit zahlreichen nationalen und internationalen Preisen ausgezeichnet, besonders für ihre Arbeit im Bereich Editorial Design für Bücher und unzählige Plakate, die in Leipzig sowie Lathi (Finnland), ausgestellt wurden. Das Studio wurde zudem in Publikationen wie *Graphis* in den USA und der Schweizer Publikation *Who's Who in Graphic Art* veröffentlicht.

Créé en 1989 par trois des plus brillants graphistes du Venezuela (Oscar Vásquez, Waleska Belisario et Carolina Arnal), ABV Taller de Diseño est l'un des studios les plus respectés du pays. Oscar Vásquez, décédé en 2002, était l'un des plus grands noms contemporains dans la création d'affiches. Son œuvre nous reste dans les collections permanentes du Musée Wilanow de l'affiche de Varsovie, du Museo de Bellas Artes de Caracas et du MoMA de New York. Le groupe a reçu de nombreuses récompenses nationales et internationales, en particulier pour leurs conceptions de livres et leur multitude d'affiches, qui ont été exposées à Leipzig en Allemagne et à Lathi en Finlande. Le studio a également fait l'objet d'articles dans des publications telles que *Graphis* aux États-Unis, et *Who's Who in Graphic Art* en Suisse.

3

1. **"50ᵗʰ Anniversary Tópicos Magazine"** poster, 1989

2. **"50ᵗʰ Anniversary Tópicos Magazine"** magazine cover, 1989

3. **"Tópicos Magazine #535"** magazine cover, 1984

4. **"Centro para la paz y los Derechos Humanos"** logo, 2004, Universidad Central de Venezuela

5. **"Sonarte"** logo, 1998, Sonarte audio engineering

6. **"Digimagen"** logo, 2003, Digimagen audiovisual company

4

5

6

7. **"XX Aniversario de la Galería de Arte Nacional"** poster, 1996, Galería de Arte Nacional, Caracas, Venezuela

8. **"Energía Solar"** poster, 1983, Universidad Simón Bolívar, IV Congreso Latinoamericano de Energía Solar, Caracas, Venezuela

9. **"Asovac"** poster, 1982, Asociación Venezolana para el Avance de la Ciencia

8

9

7

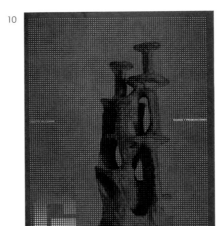

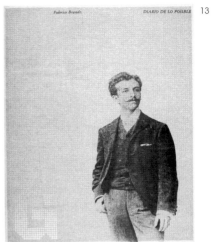

10. "Colette Delozanne" catalogue cover, 1980, Galería de Arte Nacional, Caracas, Venezuela

11. "Gradaciones del Agua, Gladys Meneses" catalogue cover, 1979, Galería de Arte Nacional, Caracas, Venezuela

12. "Juan Pedro López" catalogue cover, 1982, Galería de Arte Nacional, Caracas, Venezuela

13. "Federico Brandt" catalogue cover, 1982, Galería de Arte Nacional, Caracas, Venezuela

14. "Segunda Exposición Anual del Libro y la fotografía Documental" catalogue cover, 1980, Galería de Arte Nacional, Caracas, Venezuela

15. "Los Signos Habitables" catalogue cover, 1985, Galería de Arte Nacional, Caracas, Venezuela

ADÉ DESIGN

1

Adé Design, formed in 1995, is the creative studio of brothers Fabián and Daniel Alvarez Delgado, born in 1973 and 1979 respectively, and trained as designers at the Universidad del Azuay in Cuenca, south of Quito. Since becoming professionals they have worked together on a number of projects in corporate identity, editorial, web and motion, trying to apply design to all communication channels available. They are also the founders of Morena Brothers, an institution that promotes cultural events, including the Festival Internacional de Música y Diseño *Infusion* in Cuenca, where they have been invited to represent their country at the VIII Bienal Internacional de Arte.

Das 1995 gegründete Adé Design ist das kreative Studio der Brüder Fabián und Daniel Alvarez Delgado, die 1973 bzw. 1979 geboren und an der Universidad del Azuay in Cuenca südlich von Quito, Ecuador, zu Designern ausgebildet wurden. Seitdem sie als professionelle Designer arbeiten, haben sie gemeinsam etliche Projekte im Bereich Corporate Identity, Editorial Design, Web- und Motions-Design durchgeführt und versuchen, das Design auf alle verfügbaren Kommunikationskanäle anzuwenden. Sie sind zudem Begründer der Morena Brothers, eine Institution, die kulturelle Veranstaltungen fördert, zum Beispiel das internationale Design- und Musikfestival *Infusion* in Cuenca, wo sie eingeladen wurden, ihr Land bei der VIII. internationale Kunst-Biennale zu repräsentieren.

Adé Design, créé en 1995, est le studio de création des frères Fabián et Daniel Alvarez Delgado, nés respectivement en 1973 et en 1979. Ils ont étudié le graphisme à l'Universidad del Azuay de Cuenca, au sud de Quito. Au cours de leur vie professionnelle, ils ont travaillé ensemble sur de nombreux projets d'identité visuelle d'entreprise, dans l'édition, pour le web et dans l'animation, et ont cherché à appliquer le graphisme à tous les modes de communication disponibles. Ils sont également les fondateurs de Morena Brothers, une institution qui fait la promotion d'événements culturels, notamment le festival international *Infusion* de musique et de graphisme de Cuenca, où ils ont été invités pour représenter leur pays à la VIIIe Biennale internationale d'art.

1. **"Alianza Francesa"** calendar,
2004, Alianza Francesa de
Quito/Cuenca/Guayaquil

2. **"Eurocine"** poster, 2004,
Alianza Francesa

3. **"Migrazion"** poster, 2002
Awards 3rd Prize, IV National Biennial
of Graphic Design, Ecuador 2002;
1st Prize, category original poster,
IV National Biennial of Graphic
Design, Ecuador 2002

LEONARDO AHUMADA

1

A design graduate from the Pontificia Universidad Católica de Santiago de Chile, Leonardo Ahumada launched his own practice, Bloc-Diseño, in 1987, focusing mainly on editorial, cultural and political briefs. Specialising in poster design and illustration, he combines a diverse set of graphic languages in his design mix. As well as creating posters for films and environmental projects, his most popular pieces to date have been for the theatre company La Troppa. Since 2002 Ahumada has been a frequent lecturer at both the Universidad Mayor and the Universidad del Mar, where he has taught the history, theory and culture of design. His work has been published in *La Historia del Diseño Gráfico en Chile* (published by the Catholic University in Chile) and in the magazine *Diseño*.

Als graduierter Designer von der Pontificia Universidad Católica de Santiago de Chile gründete Leonardo Ahumada im Jahr 1987 sein eigenes Studio Bloc-Diseño und konzentrierte sich hauptsächlich auf redaktionelle, kulturelle und politische Themen. Spezialisiert auf Plakatdesign und Grafik, kombiniert er unterschiedlichste grafische Elemente in seinem Designmix. Neben Plakaten für Filme und Umweltprojekte hat er seine bis heute populärsten Arbeiten für das Theaterensemble La Troppa geschaffen. Seit 2002 hält Ahumada regelmäßig Vorlesungen an der Universidad Mayor sowie an der Universidad del Mar, wo er Geschichte, Theorie und Kultur des Designs lehrt. Seine Arbeiten wurden in *La Historia del Diseño Gráfico en Chile* (erschienen bei der Pontificia Universidad Católica de Santiago de Chile) und in dem Magazin *Diseño* veröffentlicht.

Diplômé en graphisme de la Pontifica Universidad Católica de Santiago du Chili, Leonardo Ahumada a créé sa propre agence, Bloc-Diseño, en 1987. Il travaille principalement dans l'édition et les projets culturels et politiques. Il est spécialisé dans les affiches et l'illustration, et ses œuvres sont le résultat d'un mélange de différents langages graphiques. Outre ses affiches de films ou pour des projets environnementaux, ses œuvres les plus populaires sont les affiches qu'il a réalisées pour la compagnie de théâtre La Troppa. Depuis 2002, Leonardo Ahumada a donné de nombreux cours magistraux à l'Universidad Mayor et à l'Universidad del Mar, où il a enseigné l'histoire, la théorie et la culture du graphisme. Son travail a été publié dans *L'Histoire du graphisme au Chili*, publié par l'Université catholique du Chili, et dans le magazine *Diseño*.

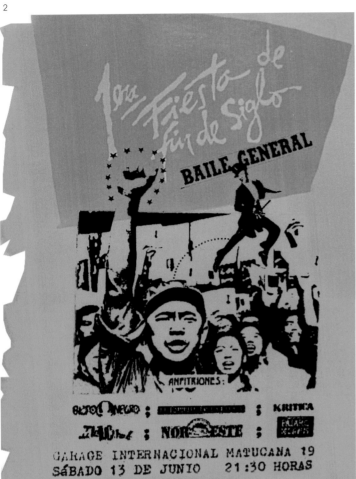

1. "Poema" personal work, 2007

2. "Primera fiesta de Fin de Siglo" poster for a cultural event, 1987, El Espíritu de la Época magazine

3. "Té" personal work, 2006

4. "Lobo" promotional poster for theater play, 1994, Grupo de Teatro La Troppa

4

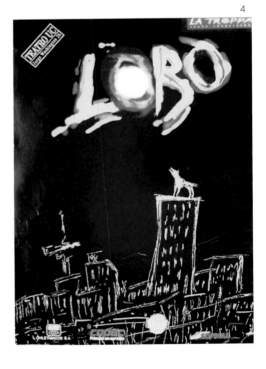

3

AJÍ PINTAO

1

1-3. "Ají Pintao catalogue"
Art direction Mariana Núñez,
Sebastián Chávez, Sally Angel
Design Sally Angel, Carlo Leone
Photo iStockphoto, Gustavo Araujo

Founded in 1996 by Mariana Núñez, Priscilla Conte and Sebastián Chávez, Ají Pintao is the major creative force in Panama, housing a multidisciplinary team of over 15 creative talents, including designers Sally Angel, Clinio García, Carlo Leone, Lorena Carrasco, Laura Arias, Adolfo Alabarca and Justher Rovi. Under the leadership of Mariana Núñez, a graduate in graphic design and also in communication from the Boston University in Massachusetts, the design team service many of the international companies in the country, developing corporate identity, providing collateral material and working as strategic partners on communication projects. Their clients include Museo de la Biodiversidad, Naciones Unidas, Canal de Panamá and BMW Latinoamérica.

Das 1996 von Mariana Núñez, Priscilla Conte und Sebastián Chávez gegründete Studio Ají Pintao steht für bedeutende schöpferische Kraft in Panama und besteht aus einem Team von über 15 kreativen Talenten. Dazu gehören Designer wie Sally Angel, Clinio García, Carlo Leone, Lorena Carrasco, Laura Arias, Adolfo Alabarca und Justher Rovi. Unter der Leitung von Mariana Núñez, Absolventin in Grafikdesign und Kommunikation an der Boston University in Massachusetts, entwickelt das Designteam mit vielen internationalen Unternehmen des Landes deren Corporate Identity, erarbeitet Begleitmaterialien und unterstützt Kommunikationsprojekte als strategischer Partner. Zu ihren Kunden zählen das Museo de la Biodiversidad, Naciones Unidas, Canal de Panamá und BMW Lateinamerika.

En 1996, Mariana Núñez, Priscilla Conte et Sebastián Chávez ont fondé Ají Pintao, la plus grande force de création au Panama. L'agence abrite une équipe pluridisciplinaire de plus de 15 talents créatifs, dont des graphistes comme Sally Angel, Clinio García, Carlo Leone, Lorena Carrasco, Laura Arias, Adolfo Alabarca et Justher Rovi. Sous la direction de Mariana Núñez, diplômée en graphisme et en communication de l'Université de Boston, dans le Massachusetts, l'équipe de graphisme travaille pour de nombreuses multinationales panaméennes, sur leur identité visuelle, les documents annexes et en tant que partenaires stratégiques sur leurs projets de communication. On trouve parmi leurs clients le Museo de la Biodiversidad, les Nations Unies, le Canal de Panamá et BMW Amérique latine.

2

Darle la vuelta al mundo.

trabajo internacional Seguir... cruzando fronteras, llegando a más destinos, comunicando
en otros idiomas y mirando hacia nuevos horizontes.

3

Que la marca deje su huella.

identidad Todos buscamos una identidad propia, que nos satisfaga, que nos distinga
y que se transmita desde el momento en que causamos la primera impresión.

La vida es un elevador

4. "Pa'na'má Quererte"
editorial design, short stories
by Consuelo Tomás
Art direction Mariana Núñez
Production Assistant Adolfo
Alabarca, Justher Rovi
Photo/illustration Mariana Núñez

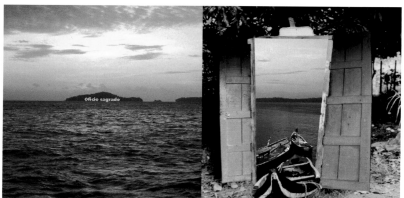

Oficio sagrado

4

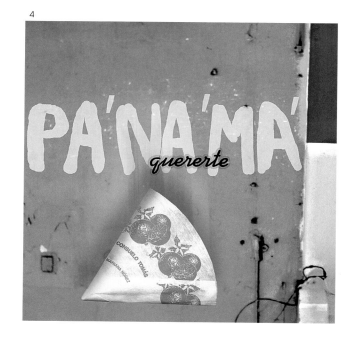

PA'NA'MA'
quererte

CONSUELO TOMÁS
MARIANA NÚÑEZ

5

5. "Panama Art Biennial"
visual identity and applications
Art direction Mariana Núñez
Design Mariana Núñez, Sally Angel
Illustration Mariana Núñez

VI Bienal de Arte de Panamá **2002**

Cervecería Nacional

ENTREGA DE CARPETAS
de artistas para Pre-Selección
septiembre y octubre 2001

BASES DISPONIBLES EN
Museo de Arte Contemporáneo,
Galerías de Arte y agencias de
la Cervecería Nacional, S.A.
en el interior.

PARA MAYOR INFORMACION
teléfonos 262-8012 ó 262-3380

MUSEO DE ARTE CONTEMPORANEO

*1977, Panama, http://shk-studio.blogspot.com

JANET ALBORNOZ

Janet Albornoz is a designer and illustrator whose expertise lies in her ability to combine a wide range of experimental techniques and mediums in her creative projects. Working under her artistic name, Shik.Studio, she has become one of the most prominent young graphic artists in the country. Defining her own work as "tropical classic with flavour", Albornoz's inspiration comes from a variety of sources, such as old streets with antique shops and hotels. Her work often uses elements from Panama's rich heritage of arts and crafts, whilst highlighting the prevailing culture of counterfeit products that are so popular in the country's markets. Albornoz recently launched *Salsipuedes Tropical Stereo*, a project aimed at creating a number of screen-printed products inspired by the popular culture in Panama, especially the famous Salsipuedes market in the capital, which is characterised by its narrow and colourful streets.

Janet Albornoz ist eine Designerin und Grafikerin mit der Fähigkeit, eine große Auswahl von experimentalen Techniken und Medien in kreativen Projekten zu kombinieren. Unter ihrem Namen Shik.Studio wurde sie zu einer der prominentesten jungen Grafikkünstlerinnen des Landes. Sie definiert ihre Arbeiten als „tropische Klassiker mit Geschmack" und lässt sich von den unterschiedlichsten Quellen inspirieren, wie zum Beispiel alten Straßen mit antiken Geschäften und Hotels. Sie arbeitet oft Elemente aus Panamas reichhaltigem Kunsthandwerk mit ein, während sie die vorherrschende Kultur der gefälschten Produkte hervorhebt, die auf den Märkten des Landes so weit verbreitet ist. Albornoz rief vor kurzem *Salsipuedes Tropical Stereo* ins Leben, ein Projekt zur Gestaltung von Serigrafie-Produkten, die durch die volkstümliche Kultur in Panama inspiriert wurden, besonders durch den berühmten Markt Salsipuedes in der Hauptstadt mit seinen engen und bunten Straßen.

Janet Albornoz est une graphiste et illustratrice capable de combiner un vaste éventail de techniques et de supports expérimentaux dans ses projets créatifs. Sous son nom d'artiste, Shik.Studio, elle est devenue l'une des jeunes graphistes les plus en vue dans son pays. Elle définit son travail comme « très tropical, avec un goût relevé ». Son inspiration provient de sources variées, notamment les vieilles rues bordées de magasins d'antiquités et d'hôtels. Elle reprend souvent des éléments du riche héritage des arts et métiers panaméens, tout en soulignant la culture prédominante des produits contrefaits, si populaires sur les marchés de tout le pays. Janet Albornoz a récemment lancé *Salsipuedes Tropical Stereo*, un projet qui vise à créer des objets sérigraphiés inspirés de la culture populaire panaméenne, particulièrement du célèbre marché Salsipuedes de la capitale, caractérisé par ses rues étroites et pleines de couleurs.

2

1. **"Montañas Moviles"** artwork,
BLANK magazine #11

2. **"Stereogum"** artwork and illustration,
ZUPI magazine #1, Brazil

3. **"Navidisco"** artwork and illustration,
Revolver Industries Design Studio

4. **"Rótulos"** artwork and lettering,
collection Aguacero/Solazo,
Salsipuedes Tropical

4

3

*1971, Mexico, www.jorgealderete.com

JORGE ALDERETE

1

Jorge Alderete is one of Latin America's most iconic graphic artists working today, uniting in his visual language both the characteristic symbols of the region and a very modern vectorial approach. Born in Argentina, Alderete studied visual communication at the Universidad Nacional de La Plata, before commencing his career as an animator, producing breathtaking works for MTV in Japan and Latin America. He has already served as a juror at the One Show awards in New York, and his work has featured in such major publications as *Rolling Stone, El País* and *Clarín.* After a long period in Mexico City Alderete now lives and works in Spain. As a side project, Alderete runs Isotonic Records together with partner Juan Moragues, a music label specialized in instrumental rock.

Jorge Alderete ist einer der größten Kultfiguren unter den heute tätigen Grafikern Lateinamerikas. Er verbindet in seiner visuellen Sprache die charakteristischen Symbole der Region mit sehr moderner Vektorgrafik. Geboren in Argentinien studierte Alderete Visuelle Kommunikation an der Universidad Nacional de La Plata, bevor er seine berufliche Laufbahn als Trickzeichner begann und atemberaubende Arbeiten für MTV in Japan und Lateinamerika produzierte. Er war bereits als Juror bei den One Show Awards in New York tätig, und seine Arbeiten wurden in solch bedeutenden Publikationen wie *Rolling Stone, El País* und *Clarín* veröffentlicht. Nachdem Alderete lange Zeit in Mexico City verbracht hatte, lebt und arbeitet er nun in Spanien. Als Nebenprojekt betreibt Alderete zusammen mit seinem Partner Juan Moragues das Musiklabel Isotonic Records, das sich auf instrumentalen Rock spezialisiert.

Jorge Alderete est l'un des graphistes en activité les plus emblématiques d'Amérique latine. Son langage visuel allie les symboles caractéristiques de la région et une approche vectorielle très moderne. Né en Argentine, Jorge Alderete a étudié la communication visuelle à l'Universidad Nacional de la Plata, avant de commencer sa carrière d'animateur. Il a produit des œuvres magnifiques pour MTV au Japon et en Amérique latine. Il a déjà été juré pour les récompenses One Show de New York, et son travail a figuré dans des publications prestigieuses comme *Rolling Stone, El País* et *Clarín.* Après une longue période passée à Mexico, il vit et travaille à présent en Espagne. Avec son partenaire Juan Moragues, Jorge Alderet dirige en outre Isotonic Records, une maison de disques spécialisée dans le rock instrumental.

66

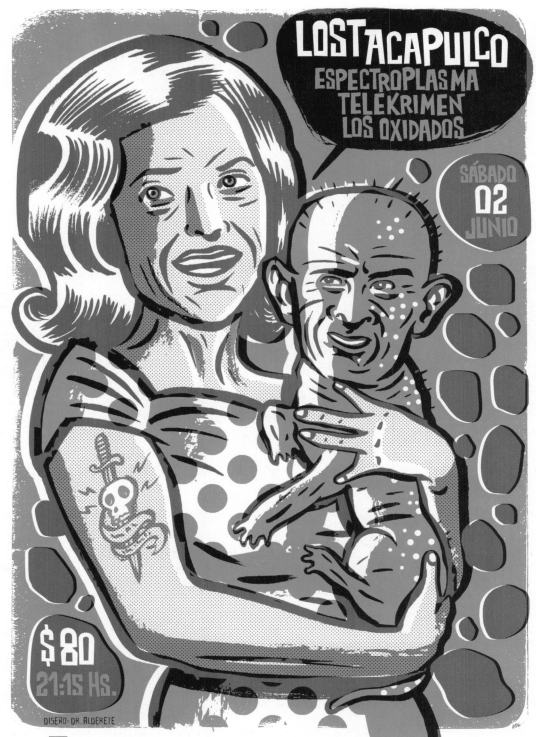

1.
"Sueño Americano"
"Naranja Mecanica"
"Alegria Carioca"
"Monstruo Verde"
posters, 2006, Nike

2. "Woman's pet" poster,
2007, Multiforo Cultural Alicia,
Lost Acapulco

3. "Latino Surf Explosion" poster,
2006, Multiforo Cultural Alicia,
Lost Acapulco

4. "Represion S.A." poster,
2004, Hematoma Collective

5. "DJ revolution" poster, 2003,
Hematoma Collective, Mutek

6. "Wrestlers" poster, 2003,
Multiforo Cultural Alicia,
Lost Acapulco

7. "Day of Dead" poster,
2003, Multiforo Cultural Alicia,
Lost Acapulco

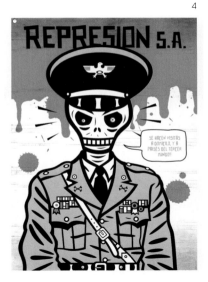

*1945, Uruguay, www.estudioalies.com

HUGO ALÍES

1

centro municipal de exposiciones **tercera bienal del objeto artesanal**

1. **"Objeto"** poster, 2002,
III Bienal del Objeto Artesanal

2. **"Árbol"** poster,
Feria de Libros y Artesanías

Hugo Alíes graduated in visual arts from the school of architecture at the Universidad de la República in the capital Montevideo, later studying fine arts at the Estudio Camnitzer in Italy. Since 1985, Alíes led his own educational programme at the Museo de Artes Plásticas y Visuales, having previously worked as a professor of design at the Universidad de la Empresa, His commercial career path started in 1975, when he served at various design studios, working both on graphic and product design briefs, including La Línea, Signo, and Moebius. His creative work on cultural events for institutions such as the Ministry of Culture and the Museo Torres García brought visibility to Alíes' works over the last two decades. He was also responsible for creating the visual identity for the Feria de Libros y Grabados, a national book fair supported by the European Community.

Hugo Alíes machte seinen Abschluss in Bildender Kunst an der Fakultät für Architektur der Universidad de la República in Montevideo, der Hauptstadt von Uruguay, und studierte später Bildende Kunst am Estudio Camnitzer in Italien. Seit 1985 leitet Alíes sein eigenes Ausbildungsprogramm im Staatlichen Museum der Bildenden Künste, Uruguay, nachdem er zuvor als Professor für Design an der Universidad de la Empresa arbeitete. Seine berufliche Laufbahn begann 1975, als er bei verschiedenen Designstudios beschäftigt war und an Aufträgen sowohl für Grafik- als auch Produktdesign arbeitete, darunter für La Línea, Signo und Moebius. Seine kreativen Werke zu kulturellen Veranstaltungen für Institutionen wie z.B. das Kultusministerium und das Museum Torres García stellten seine Arbeit der letzten beiden Jahrzehnte öffentlich vor. Zudem war er verantwortlich für die Visual Identity der Feria de Libros y Grabados, eine nationale Buchmesse, die von der EU unterstützt wird.

Hugo Alíes est diplômé en arts visuels de l'école d'architecture de l'Universidad de la República de Montevideo. Il a ensuite étudié les beaux-arts à l'Estudio Camnitzer en Italie. Depuis 1985, Alíes a dirigé son propre programme d'enseignement au Museo de Artes Plásticas y Visuales, après avoir enseigné le graphisme à l'Universidad de la Empresa. Sa carrière commerciale a commencé en 1975. Il a travaillé dans plusieurs agences, sur des projets de graphisme et de conception de produit, notamment La Línea, Signo et Moebius. Au cours des deux dernières décennies, le travail de création qu'il a réalisé sur des événements culturels pour des institutions telles que le ministère de la Culture et le Museo Torres García a donné plus de visibilité à son œuvre. Il a également créé l'identité visuelle de la Feria de Libros y Grabados, un salon du livre uruguayen soutenu par la Communauté européenne.

2

3. "Cultura en Obra" poster,
Ministerio de Educación y Cultura

4. "Trote" poster,
Zona Escuela de Arte y Diseño

3

4

*1946, Mexico

LUIS ALMEIDA

1

NOMÁS

1. "No más" poster, Universidad Nacional Autónoma de México

2. "Mariana Pineda" poster, Universidad Nacional Autónoma de México
Awards VII Internacional Poster Biennial in Mexico (Shortlist)

Luis Almeida is a true veteran, and one of the most important figures in the development of modern graphic design in Mexico. Having graduated in architecture from the Universidad Nacional Autónoma de México, Almeida went on to study in Florence, Italy and later on at the Sorbonne in Paris, before returning to his country to work for Imprenta Madero, where he collaborated with Vicente Rojo. Since 1985 he has concentrated primarily on corporate identity and editorial at Redacta, where he would later produce a defining series of posters that illustrate the hallmark of his bold design style. Notable projects have included designing for newspapers *El Nacional*, *Gaceta de la UNAM*, and *La Crónica*. In addition, Almeida is a founding member of Quórum, the mexican designers' council, and his works have been published in Japan, United States, Italy, and in the United Kingdom.

Luis Almeida ist ein wahrer Veteran und eine der wichtigsten Figuren in der Entwicklung des modernen Grafikdesigns in Mexiko. Nachdem er sein Studium der Architektur an der Universidad Nacional Autónoma de México abgeschlossen hatte, führte Almeida seine Studien zunächst in Florenz und später an der Sorbonne in Paris fort. Schließlich kehrte er nach Mexiko zurück, wo er für Imprenta Madero tätig wurde und mit Vicente Rojo zusammenarbeitete. Seit 1985 hat er sich hauptsächlich auf Corporate Identity und Editorial Design bei Redacta konzentriert und eine Reihe von bedeutenden Plakaten produziert, die als Markenzeichen seines kühnen Designstils angesehen werden können. Beachtenswerte Projekte sind zum Beispiel seine Arbeiten für Zeitungen wie *El Nacional*, *Gaceta de la UNAM* und *La Crónica*. Zudem ist Almeida Gründungsmitglied von Quórum, dem mexikanischen Designrat. Seine Arbeiten sind in Japan, USA, Italien und in Großbritannien veröffentlicht worden.

Luis Almeida est un vrai vétéran, et l'une des figures les plus importantes dans le développement du graphisme moderne au Mexique. Après avoir reçu son diplôme en architecture de l'Universidad Nacional Autónoma de Mexico, il a continué ses études à Florence, en Italie, puis à la Sorbonne à Paris, avant de retourner dans son pays pour travailler chez Imprenta Madero, où il a collaboré avec Vicente Rojo. Depuis 1985, il s'est principalement concentré sur des projets éditoriaux et d'identité d'entreprise chez Redacta, où il a ensuite produit une série d'affiches qui illustre son style audacieux caractéristique. Parmi ses projets les plus notables, on peut citer ses concepts graphiques pour les journaux *El Nacional*, *Gaceta de la UNAM*, et *La Crónica*. Luis Almeida est en outre un membre fondateur de Quórum, le Conseil des graphistes mexicains, et ses œuvres ont été publiées au Japon, aux États-Unis, en Italie et au Royaume-Uni.

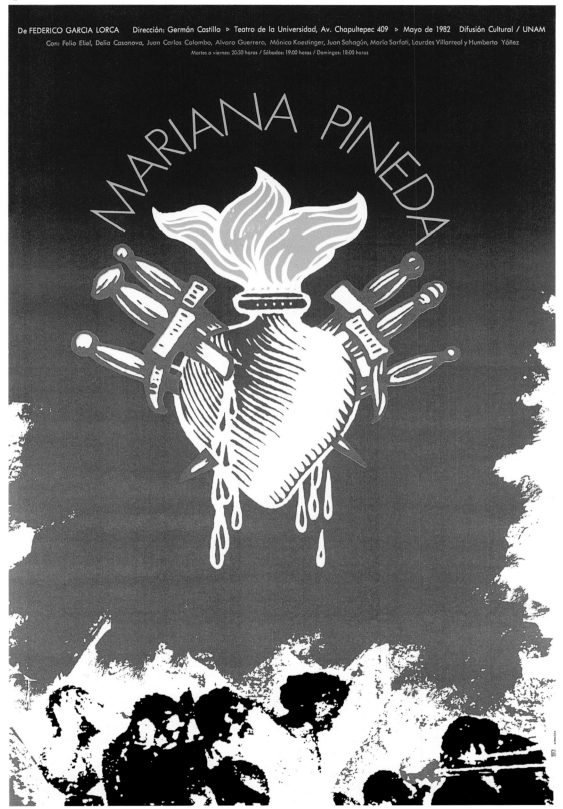

*1972, Mexico, www.alexdinamo.com

ROGELIO LÓPEZ ALVAREZ

1. "I Love" poster, 2004
Awards Computerlove.net
competition (Shorlist)

2. "Me late leer" poster, 2006,
Periódico El Informador, Guadalajara
International Book Fair, Mexico

3. "Summer Exhibitions"
invitation, 2007, Museo de Arte
Moderno de Zapopan, Mexico
Photo Rafael del Río

Rogelio López Alvarez has been successful in harnessing the visual language of a new generation of designers in Mexico with the traditional forms of graphic media, such as posters and print design. A graduate from the Universidad Autónoma de Guadalajara, López Alvarez has run his own creative studio since 1999, producing cutting edge animation, web and multimedia projects for many prestigious clients in the country. He is one of the founders of Colectivo Hematoma, whose aims are to revive the traditional poster medium in Mexico. López Alvarez's designs have been shown at exhibitions in the United States, Europe and Latin America. His work has also featured in books such as *Web Design Index* and *Websites 100% Loaded*.

Rogelio López Alvarez hat die visuelle Sprache einer neuen Generation von Designern in Mexiko erfolgreich mit den traditionellen Formen der Grafikmedien, wie z.B. Plakat und Printdesign, verbunden. Nach Abschluss seines Studiums an der Universidad Autónoma de Guadalajara, leitet López Alvarez seit 1999 sein eigenes Kreativstudio und produziert innovative Animationen sowie Web- und Multimedia-Projekte für viele repräsentative Kunden des Landes. Er ist Mitbegründer von Colectivo Hematoma, die sich zum Ziel nehmen, das traditionelle Medium Plakat in Mexiko zu neuem Leben zu erwecken. López Alvarez Arbeiten wurde in Ausstellungen in den USA, Europa und Lateinamerika gezeigt. Seine Werke wurde zudem in Büchern wie *Web Design Index* und *Websites 100% Loaded* veröffentlicht.

Rogelio López Alvarez a réussi à exploiter le langage visuel d'une nouvelle génération de graphistes mexicains sur des supports traditionnels, comme les affiches et les supports imprimés. Diplômé de l'Universidad Autónoma de Guadalajara, il dirige sa propre agence de création depuis 1999. Cette agence produit des projets d'animation, Internet et multimédia d'avant-garde pour de nombreux clients mexicains de premier rang. Il est l'un des fondateurs du Colectivo Hematoma, un groupe qui souhaite donner une nouvelle vie au support traditionnel de l'affiche au Mexique. Les œuvres de Rogelio López Alvarez ont été exposées aux États-Unis, en Europe et en Amérique latine, et ont figuré dans des livres comme *Web Design Index* et *Websites 100% Loaded*.

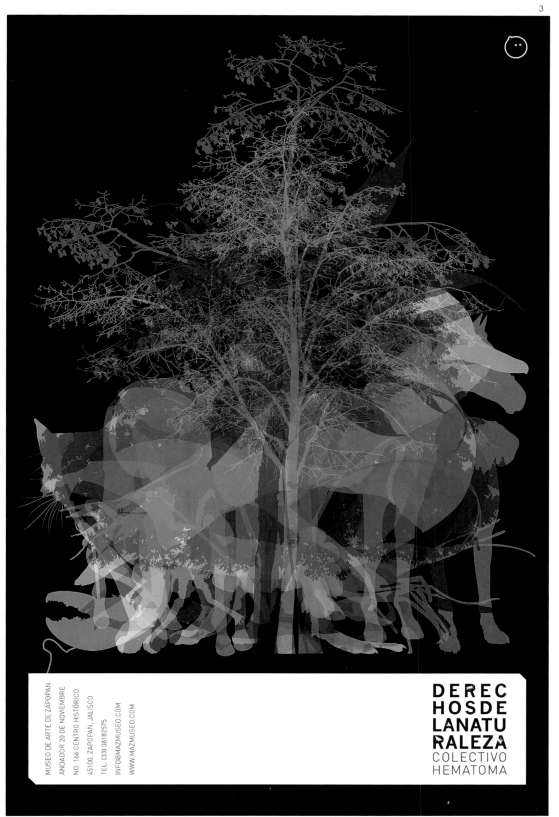

MUSEO DE ARTE DE ZAPOPAN

ANDADOR 20 DE NOVIEMBRE

NO. 166 CENTRO HISTÓRICO

45100. ZAPOPAN, JALISCO

TEL. (33) 38182575

INFO@MAZMUSEO.COM

WWW.MAZMUSEO.COM

DEREC
HOSDE
LANATU
RALEZA
COLECTIVO
HEMATOMA

4

4. "Teatro Diana"
promotional poster, 2007,
Guadalajara, Mexico

5. "El Arte" illustration, 2007
Replicante magazine #5

6. "El Informador" poster, 2005,
Periódico El Informador, Guadalajara
International Book Fair, Mexico
Typography Büro Destruct

5

el informador

*1996, Ecuador, http://web.mac.com/pabloiturralde

ÁNIMA

1. "Enchanted Roses" logo, 1997
Design Alberto Montt

2. "Imprenta Segura" logo, 2006
Design Pablo Iturralde

3. "Casa Nieves Hostal Hacienda"
logo, 1998
Design Alberto Montt

1 2 3

In 1996 a group of students at the *Instituto Latinoamericano* in the capital city of Quito founded a new design group called Ánima. Over a decade later, the studio has gathered a handful of awards and received international recognition at events, such as the *International Biennial of the Poster in Mexico* and the *Festival del Nuevo Cine Latinoamericano de La Habana*, in Cuba. Their work has also appeared in *Graphis* magazine. Ánima's collective ambition has been to use design as a tool to empower social change and to apply design in areas of social need in the country, as well to raise the profile of the local culture. In association with a host of other Ecuadorian professionals, Pablo Iturralde, one of the founders of Ánima, is currently redesigning the capitals visual identity, including its international airport.

Im Jahr 1996 gründete eine Gruppe von Studenten des Instituto Latinoamericano in der ecuadorianischen Hauptstadt Quito ein neues Designstudio namens Ánima. Mehr als ein Jahrzehnt später hat das Studio eine Reihe von Auszeichnungen erhalten und bekam auf Veranstaltungen wie der International Biennial of the Poster in Mexiko und dem kubanischen Festival del Nuevo Cine Latinoamericano de La Habana internationale Anerkennung. Die Arbeiten der Gruppe sind zudem im Magazin *Graphis* erschienen. Ánima gemeinschaftliches Ziel besteht darin, Design als Werkzeug für den sozialen Wandel einzusetzen und im Land auf Gebiete mit sozialen Problemen anzuwenden sowie die Selbstdarstellung der regionalen Kultur zu verbessern. Gemeinsam mit einigen weiteren professionellen ecuadorianischen Designern arbeitet Pablo Iturralde, einer der Gründer von Ánima, zurzeit an der Neugestaltung der Visual Identity der Hauptstadt sowie des dortigen internationalen Flughafens.

En 1996, un groupe d'étudiants de l'Instituto Latinoamericano de Quito fonde un nouveau groupe de design, qu'ils appellent Ánima. Plus de dix ans après, le studio a remporté une poignée de récompenses et a gagné une reconnaissance internationale lors d'événements tels que la Biennale internationale de l'affiche de Mexico et le Festival du nouveau cinéma latino-américain de La Havane, à Cuba. On a également pu voir les œuvres du groupe dans le magazine *Graphis*. L'ambition collective d'Ánima est d'utiliser le graphisme comme un outil de changement social et de l'appliquer aux domaines sociaux qui en ont besoin dans le pays, ainsi que de contribuer à la culture locale. En association avec de nombreux autres professionnels équatoriens, Pablo Iturralde, l'un des fondateurs d'Ánima, travaille actuellement sur la nouvelle identité de la capitale et de son aéroport international.

4. "Ratas ratones rateros" film poster
for USA, Mexico, and Japan, 1999
Design Pablo Iturralde

5. "Ratas ratones rateros"
film poster, 1999
Design Alberto Montt, Ana Galarza,
Jorge Luis Moscoso, Pablo Iturralde
Photo Lorena Cordero
Awards Biennial of Graphic Design in
Ecuador 2002 (best poster);
XXI Festival Internacional del Nuevo
Cine (nomination), La Habana, Cuba

5

4

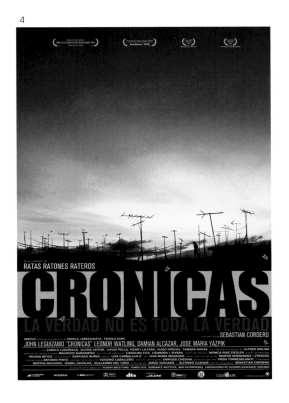

*1940, Uruguay

HORACIO AÑÓN

1. "La rebelión de la flor"
book cover, 1988, Linardi y Risso

2. "CINVE" poster, 1987,
Centro de Investigaciones
Económicas

3. "Diocesis de Montevideo"
poster, 1978

Graphic designer and photographer Horacio Añón studied drawing and sculpture at the studio of Fernández Tudurí, and is one of the most respected names in design in Uruguay. Through his renowned portfolio of posters and cover designs for magazines and books, Añón has helped to raise the profile of the profession across the whole subcontinent. Among the many publications he has contributed to are *Nuestra Tierra, Los Departamentos, Montevideo, Despegue, Víspera, Nexo, Sport Ilustrado* and *CINVE*. He also curated *Andares del Humor*, an exhibition celebrating 40 years of graphical humour in Uruguay and featuring over 800 artworks from 60 artists in the country. Añón's work has been exhibited at the 1974 Biennial of Graphic Design in Brno, Czechoslovakia, and at the national Museo de Arte Contemporáneo.

Der Grafikdesigner und Fotograf Horacio Añón lernte Zeichnen und Bildhauerei im Studio von Fernández Tudurí und gehört heute zu den angesehensten Designern Uruguays. Mit seinem berühmten Portfolio, bestehend aus Plakaten und Umschlaggestaltungen für Magazine und Bücher, hat Añón dazu beigetragen, die Bedeutung seines Berufes auf dem gesamten Subkontinent zu steigern. Zu den vielen Veröffentlichungen, an denen er mitgewirkt hat, zählen *Nuestra Tierra, Los Departamentos, Montevideo, Despegue, Víspera, Nexo, Sport Ilustrado* und *CINVE*. Añón kuratierte außerdem *Andares del Humor*, eine Ausstellung, die 40 Jahre Grafik und Humor in Uruguay feiert und über 800 Kunstwerke von 60 Künstlern aus dem ganzen Land zeigt. Añón Arbeiten wurden 1974 auf der Grafikdesign-Biennale in Brno, Tschechoslowakei, ausgestellt und sind im Museo de Arte Contemporáneo in Uruguay zu sehen.

Graphiste et photographe, Horacio Añón a étudié le dessin et la sculpture au studio de Fernández Tudurí, et est l'un des noms les plus respectés dans le domaine du graphisme en Uruguay. Grâce à ses célèbres affiches et couvertures de magazines et de livres, il a beaucoup contribué à l'image de sa profession dans toute l'Amérique latine. Il a contribué à de nombreuses publications, dont *Nuestra Tierra, Los Departamentos, Montevideo, Despegue, Víspera, Nexo, Sport Ilustrado* et *CINVE*. Il a également été le commissaire d'*Andares del Humor*, une exposition qui célébrait 40 ans d'humour graphique en Uruguay et qui présentait plus de 800 œuvres de 60 artistes du pays. Ses œuvres ont été exposées à la Biennale du graphisme de Brno, en Tchécoslovaquie, et au Museo nacional de Arte Contemporáneo de l'Uruguay.

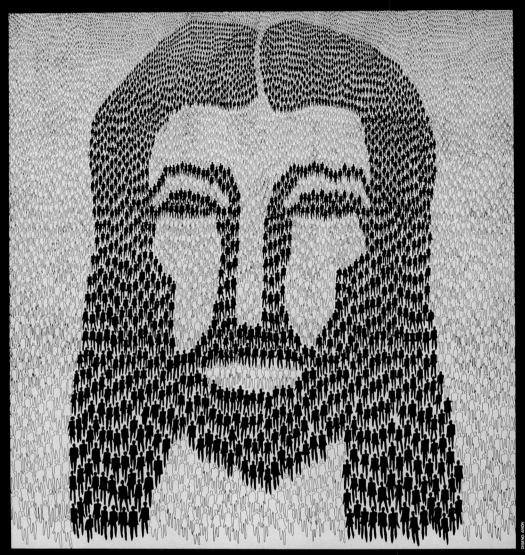

1878 · 1978 : CENTENARIO DE LA DIOCESIS DE MONTEVIDEO

CAMINANDO CON CRISTO EN LA HISTORIA DE UN PUEBLO

*1974, Mexico, www.neurografismos.com

EDUARDO BARRERA ARAMBARRI

1 2 3

Much of Eduardo Barrera Arambarri's work can be defined through the poster designs he has been producing in recent years. After completing his fine art studies at the Universidad Nacional Autónoma de México, he attended a series of courses led by prominent designers like Jukka Veistola, Takashi Akiyama, Peter Pocs and Uwe Loesch, which inspired him to develop his personal approach to design. His professional career began at Trama Visual, where he worked with Xavier Bermúdez. He then went on to build a career in advertising, working in Mexico and Austria and winning a handful of awards along the way. Soon after his return to Mexico in 2001, he set up his own design practice, focusing on corporate identity, editorial, and multimedia. He currently produces a series of posters for cultural spectacles in collaboration with artist Erick Beltrán.

Eduardo Barrera Arambarri Arbeit ist größtenteils durch sein Plakatdesign bestimmt, das er in den letzten Jahren geschaffen hat. Nachdem er sein Kunststudium an der Universidad Nacional Autónoma de México abgeschlossen hatte, besuchte er eine Reihe von Lehrgängen, die von prominenten Designern wie Jukka Veistola, Takashi Akiyama, Peter Pocs und Uwe Loesch geleitet wurden und die ihn inspirierten, seinen eigenen Designstil zu entwickeln. Seine berufliche Laufbahn begann bei Trama Visual, wo er mit Xavier Bermúdez zusammenarbeitete. Danach wandte er sich dem Werbebereich zu, arbeitete in Mexiko und Österreich und gewann nebenbei verschiedene Preise. 2001 kehrte er nach Mexiko zurück und gründete sein eigenes Designstudio, dessen Schwerpunkt auf Corporate Identity, Editorial- und Multimedia-Design liegt. Zurzeit produziert Arambarri in Zusammenarbeit mit dem Künstler Erick Beltrán eine Serie von Plakaten für kulturelle Veranstaltungen.

Les affiches qu'Eduardo Barrera Arambarri a créées ces dernières années sont le meilleur aperçu que l'on puisse avoir de son travail. Après avoir terminé ses études de beaux-arts à l'Universidad Nacional Autónoma de Mexico, il a assisté à une série de cours dirigés par des graphistes renommés tels que Jukka Veistola, Takashi Akiyama, Peter Pocs et Uwe Loesch, qui lui ont donné l'inspiration nécessaire pour développer son approche personnelle du graphisme. Sa carrière professionnelle a commencé chez Trama Visual, où il a travaillé avec Xavier Bermúdez. Il s'est ensuite forgé une carrière dans la publicité, a travaillé au Mexique et en Australie et a remporté une poignée de récompenses en chemin. Peu après son retour au Mexique en 2001, il a créé sa propre agence de design et s'est concentré sur les domaines de l'identité d'entreprise, de l'édition et du multimédia. Il travaille actuellement sur une série d'affiches pour des spectacles culturels en collaboration avec l'artiste Erick Beltrán.

1. "El cuervo roba la luz"
exhibition poster: "Rabe stiehlt
das Licht – Tradition und Moderne
in indianischen Siebdrucken", 2001,
Museum of Ethnology, Vienna, Austria

2. "Del principio, el Final"
exhibition poster, 2005, Escena 40°
theatre company, Mérida, Mexico

3. "De la Edad de la Prunus
domestica" theatre play poster,
2005, Escena 40° theatre company,
Mérida, Mexico

4. "Chernobyl" exhibition poster, 2006
Awards Eco-Poster Triennale, Kharkov,
Ukraine (3rd Place at 4th Block)

5. "El Ahumado Pulmón de Jesús"
awareness campaign poster
for lung-related diseases, 2003

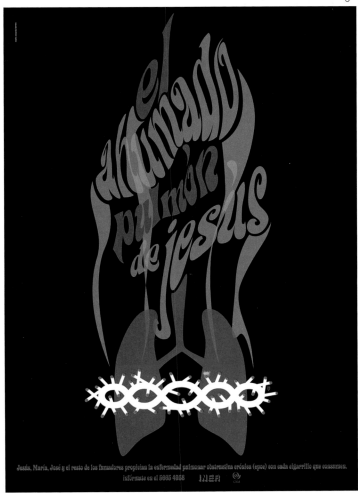

4

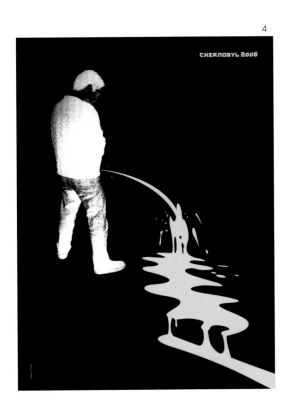

*1970, Mexico, http://arandagrafica.blogspot.com

RENATO ARANDA

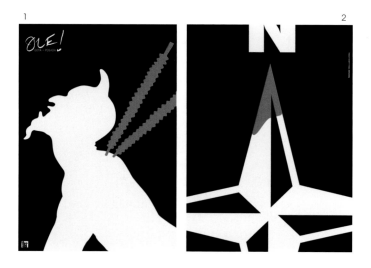

1

2

1. "Goya-Posada" exhibition poster, 2002, Instituto de México en España
Awards The Colorado XXIII International Invitational Poster Exhibition (winner); VIII International Biennial of Poster in Mexico (Bronze)

2. "Frontera Norte" exhibition poster, 2003, Goethe Institut, Mexico

3. "Lolita" cinema and literature event poster, 2006

Renato Aranda is most known for his striking work on modern posters, a design medium that Mexico has been a leading force in throughout Latin America. Having exhibited across the region and overseas in France, United States, Japan, Bulgaria, Spain, Italy, his work is characteristic for its eye-catching visuals and often provocative approach. Educated in graphic design at the Universidad Autónoma Metropolitana, Aranda has also taught at the Benemérita Universidad Autónoma in Puebla, north of the capital Mexico City. He has also been an international spokesman on Mexican design, taking part in regular conferences around the world, and has received numerous accolades including awards at the Ibero-American Poster Biennial in Bolivia and Internacional Biennial of the Poster in Mexico. He is currently art director at Random House Mondadori in Mexico.

Renato Aranda ist bekannt für seine eindrucksvollen modernen Plakatarbeiten. Bei diesem Designmedium hat Mexiko in ganz Lateinamerika eine führende Rolle inne. Seine Werke, die regional sowie in Frankreich, USA, Japan, Bulgarien, Spanien und Italien ausgestellt wurden, sind charakteristisch für ihre auffälligen Grafiken und oft provokativen Ansätze. Aranda schloss sein Studium in Grafikdesign an der Universidad Autónoma Metropolitana ab und lehrte an der Benemérita Universidad Autónoma in Puebla, nördlich der Hauptstadt Mexico City. Er war zudem als internationaler Sprecher für das mexikanische Design tätig und nahm regelmäßig an Konferenzen auf der ganzen Welt Teil. Aranda hat zahlreiche Auszeichnungen erhalten sowie Preise bei der iberoamerikanischen Plakatbiennale in Bolivien und der internationalen Plakatbiennale in Mexiko. Er ist zurzeit als Art Director bei Random House Mondadori in Mexiko tätig.

Renato Aranda est surtout connu pour le travail saisissant qu'il a réalisé sur ses affiches modernes, un support pour lequel le Mexique s'est révélé être une force majeure en Amérique latine. Son travail, caractérisé par des visuels accrocheurs et une approche souvent provocante, a été exposé dans toute l'Amérique latine, ainsi qu'en France, aux États-Unis, au Japon, en Bulgarie, en Espagne et en Italie. Renato Aranda a étudié le graphisme à l'Universidad Autónoma Metropolitana, et a enseigné à la Benemérita Universidad Autónoma de Puebla, au nord de Mexico. Il a également été un porte-parole international du graphisme mexicain, et a participé à de nombreuses conférences aux quatre coins du globe. Il a reçu de nombreuses récompenses, par exemple à la Biennale ibéro-américaine de l'affiche en Bolivie et à la Biennale internationale de l'affiche de Mexico. Il est actuellement directeur artistique chez Random House Mondadori à Mexico.

lolita

Stanley Kubrick
Film basado en la obra de
Vladimir Nabokob

4

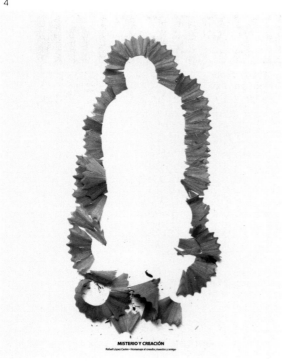

MISTERIO Y CREACIÓN
Rafael López Castro • Homenaje al creador, maestro y amigo

4. "Homenaje a Rafael López Castro"
exhibition poster, 2005, Encuadre
(Asociación Mexicana de Escuelas
de Diseño Gráfico)

5. "El Regreso del idiota"
book cover, 2006, Editorial Debate,
Random House Mondadori

6. "El tercer chimpancé"
book cover, 2007, Editorial Debate,
Random House Mondadori
Design/photo Mélanie Wintersdorff

7. "Don Quijote" film poster, 2006

8 "Represión-Expresión" awareness
poster, 2006, Comisión de Derechos
Humanos del Distrito Federal, Mexico

9. "Homenaje a José Martí"
celebration poster, 2003,
Proyecto Poesía y Diseño

10. "USA en Irak" poster,
2003, personal work

5

6

Manuel Gutiérrez Aragón
El Caballero Don
QUIJOTE

Film basado en la obra
El Ingenioso Hidalgo Don Quijote de la Mancha
de Miguel de Cervantes Saavedra

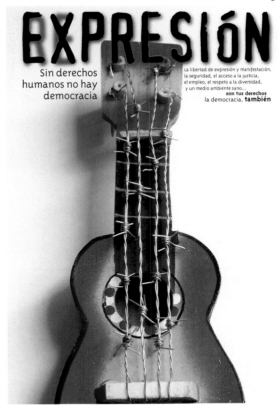

EXPRESIÓN

Sin derechos
humanos no hay
democracia

La libertad de expresión y manifestación,
la seguridad, el acceso a la justicia,
el empleo, el respeto a la diversidad,
y un medio ambiente sano...
son tus derechos
la democracia, **también**

José Martí
1853-2003

USA contra IRAK
¡No a la guerra!

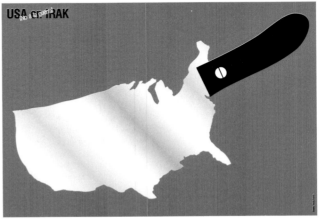

*1965, Bolivia

FRANK ARBELO

1. "Parque Nacional Madidi 10 Años"
anniversary poster series, 2005,
The Madidi National Park, Bolivia

2. "American Visa" film poster,
2005, Bola Ocho Producciones

Frank Arbelo left his native Cuba in 1997, when he set up his own graphic design and illustration studio in Bolivia's capital, La Paz. He graduated from the Instituto Politécnico de Diseño Industrial de La Habana (Polytechnic Institute of Industrial Design in Havana) and started his career there, designing mainly for magazines and books in the music and cultural field. Since moving to Bolivia, he has been associated with a number of agencies and studios as an art director, and has worked for major national clients such as Bodegas y Viñedos de La Concepción, Banco Sol, Conservación Internacional, Naciones Unidas (PNUD) and Editorial Santillana. Arbelo has received awards at the International Biennial of the Poster in Mexico, and at the Ibero-American Poster Biennial in Bolivia, where he won First Prize.

Frank Arbelo verließ 1997 seine Heimat Kuba, um sein eigenes Studio für Grafikdesign und Illustration in La Paz, der Hauptstadt von Bolivien, zu gründen. Nach Abschluss seines Studiums am Instituto Politécnico de Diseño Industrial de La Habana begann er seine berufliche Laufbahn in Havanna und entwarf hauptsächlich für Zeitschriften und Bücher in den Bereichen Musik und Kultur. Seitdem Arbelo in Bolivien lebt, ist er für verschiedene Agenturen und Studios als Art Director tätig gewesen und hat für bedeutende nationale Kunden wie Bodegas y Viñedos de La Concepción, Banco Sol, Conservación Internacional, Naciones Unidas (PNUD) und Editorial Santillana gearbeitet. Arbelo ist auf der internationalen Plakatbiennale in Mexiko ausgezeichnet worden sowie auf der ibero-amerikanischen Plakatbiennale in Bolivien, wo er den ersten Preis gewann.

En 1997, Frank Arbelo a quitté son pays, Cuba, pour créer sa propre agence de graphisme et d'illustration à La Paz, la capitale de la Bolivie. Il est diplômé de l'Institut polytechnique de design industriel de La Havane, et c'est à La Havane qu'il a commencé sa carrière en travaillant principalement sur des magazines et des livres dans les domaines de la musique et de la culture. Depuis son arrivée en Bolivie, il a été associé à plusieurs agences et studios en tant que directeur artistique, et il a travaillé pour des clients prestigieux, notamment Bodegas y Viñedos de La Concepción, Banco Sol, Conservación Internacional, les Nations Unies (PNUD) et Editorial Santillana. Frank Arbelo a reçu des récompenses à la Biennale internationale de l'affiche de Mexico et à la Biennale ibéro-américaine de l'affiche en Bolivie, où il a remporté le premier prix.

5

3. "La Calle, Peléala con dignidad"
poster, 2005, II Ibero-American Poster
Biennial in Bolivia

4. "Alcaldesas y Concejalas"
poster, 2005, ACOBOL

5. "Luis Rico" concert poster, 2006

6. "Historieta Española
Contemporánea" poster,
2006, Embassy of Spain, Bolivia

6

*1962, Venezuela

ANNELLA ARMAS

1

Born in Venezuela, Annela Armas graduated in 1986 with a fine arts degree from the Instituto de Diseño Neumann in fine arts. Two years later she set up her own design practice to work on a vast number of projects in visual identity and exhibitions. With a focus on editorial, she redesigned a large number of nationally distributed magazines and catalogues. In 1988 she founded Tierra Chigüire, an enterprise to create didactic materials to educate children on environmental and conservation issues. Armas has been published both regionally and in Europe, and among her accolades to date, she received an award at the International Print Exhibition at The Silvermine Guild Arts Center in the United States and at the Japanese Post Office's International Stamp Design Competition.

Geboren in Venezuela, absolvierte Annela Armas ihr Studium der Bildenden Kunst am Instituto de Diseño Neumann, das sie 1986 abschloss. Zwei Jahre später eröffnete sie ihr eigenes Designstudio und arbeitete an sehr vielen Projekten im Bereich Visual Identity und für Ausstellungen. Sie gestaltete eine große Anzahl von nationalen Zeitschriften und Katalogen neu. 1988 gründete sie Tierra Chigüire, ein Unternehmen für den Entwurf von didaktischem Material, mit dem Kinder Umwelt- und Naturschutzthemen nahe gebracht werden. Die Arbeiten von Armas sind in Venezuela und in Europa veröffentlicht worden. Sie erhielt mehrere Auszeichnungen, darunter eine von der International Print Exhibition im Silvermine Guild Arts Center in den USA und eine bei der International Stamp Design Competition der japanischen Post.

Née au Venezuela, Annela Armas a obtenu son diplôme des beaux-arts à l'Instituto de Diseño Neumann en 1986. Deux ans plus tard, elle a créé sa propre agence pour travailler sur de nombreux projets dans les domaines de l'identité visuelle et des expositions. Travaillant plus particulièrement pour l'édition, elle a revu la maquette d'un grand nombre de magazines et catalogues distribués dans tout le pays. En 1988, elle a fondé Tierra Chigüire, une entreprise qui crée des supports pédagogiques pour sensibiliser les enfants aux questions environnementales et de conservation. Annela Armas a été publiée en Amérique latine et en Europe, et parmi les récompenses qu'elle a reçues jusqu'à aujourd'hui, on peut citer un prix à l'International Print Exhibition du Silvermine Guild Arts Center aux États-Unis, et au Concours international de création de timbre de la poste japonaise.

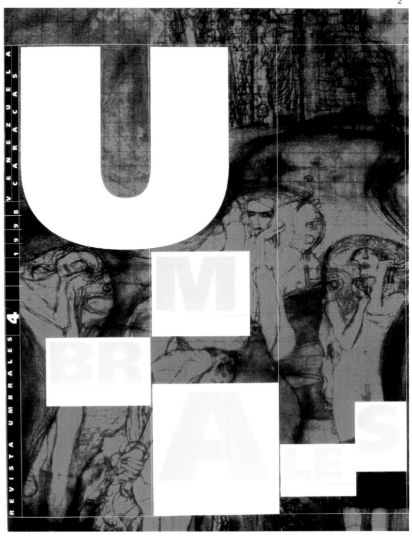

1. "Perro", "Rana", "Fin de la Pluralidad" exhibition poster, 2006, graphic design exhibition Hora "0", FAU UCV

2. "Umbrales" magazine cover and magazine design, 1998, Fundación Metropolis Caracas, Venezuela

*1977, Brazil, www.yomaraugusto.com

YOMAR AUGUSTO

1

1. **"Flower girls"** illustration, 2006, S/N Magazine
Art direction Eliane Stephan
Embroidment Maristella Padão

2. **"MTV names"** typography Illustration, 2005, MTV magazine
Art direction Beto Shibata

Yomar Augusto is one of the strongest voices to emerge from the new generation of designers and graphic artists in Brazil. Born in Brasilia, and having initially trained as a graphic designer, Augusto went on to study photography at the School of Visual Arts in New York, before completing an MA in Type Design from The Royal Academy of Art in The Hague, the Netherlands. Augusto has presented both commercial and conceptual pieces in solo exhibitions in Japan, Europe and Brazil. His highly typographic and illustrated work has captivated clients in both his native country and abroad, where he designed for a host of brands such as EMI, Warner Music, Sony BMG, Adidas, Graniph Japan, Random House, and others. Augusto currently divides his time between the Netherlands and Brazil.

Yomar Augusto ist einer der stärksten Vertreter der neuen Generation von Designern und Grafikkünstlern in Brasilien. Geboren in Brasilien und zunächst als Grafikdesigner ausgebildet, studierte Augusto später Fotografie an der School of Visual Arts in New York und absolvierte schließlich an der Royal Academy of Art in Den Haag in den Niederlanden einen MA-Studiengang in Type Design. Augusto hat sowohl kommerzielle als auch konzeptionelle Stücke in Einzelausstellungen in Japan, Europa und Brasilien gezeigt. Kunden aus dem In- und Ausland sind fasziniert von seinen hoch-typografischen Arbeiten und Illustrationen. Augusto entwarf für eine Reihe von Marken wie EMI, Warner Music, Sony BMG, Adidas, Graniph Japan, Random House und andere. Zurzeit arbeitet er in den Niederlanden und in Brasilien.

Yomar Augusto est l'une des voix les plus fortes de la nouvelle génération d'artistes graphiques brésiliens. Né à Brasília, et graphiste de formation, Augusto a ensuite étudié la photographie à la School of Visual Arts de New York avant d'obtenir une maîtrise en conception de police de caractères de l'Académie royale des Beaux-Arts de La Haye, aux Pays-Bas. Augusto a présenté des expositions en solo d'œuvres commerciales et conceptuelles au Japon, en Europe et au Brésil. Ses travaux très illustrés et au caractère typographique très prononcé lui ont attiré des clients dans son pays natal et à l'étranger, et il a créé pour de nombreuses marques, notamment EMI, Warner Music, Sony BMG, Adidas, Graniph Japan et Random House, entre autres. Augusto partage actuellement son temps entre les Pays-Bas et le Brésil.

3

4

3. **"Calligraphy Rio"** sketch book
page/calligraphy illustration,
2005, Oi Magazine
Art direction Eduardo Varela

4. **"Lungs"** fashion illustration,
2006, Redley
Art direction Eduardo Campos

5. **"ROJO Air/Nike"**
photography illustration,
2005, ROJO magazine/Nike

6. **"ROJO Adidas"**
photography illustration,
2005, ROJO magazine/Adidas

6

5

*1957, Bolivia

ERNESTO AZCUY

1

1. "Retablo/ensamblaje"
calendar, 1999, Bodegas y Viñedos
de La Concepción
Photo Alejandro Azcuy

2. "Primer Plano" poster,
2001, Centro Cultural Kyros

A self taught painter, illustrator, graphic artist, and designer, Ernesto Azcuy was originally born in Havana, Cuba before moving to the Bolivian capital, La Paz. In a career spanning more than 30 years, he has received numerous awards in Bolivia, Cuba and other countries, notably for his poster designs. Azcuy's works have also been shown widely in various galleries and museums, both in collective and solo exhibitions. In addition to his professional work, he is also director of the Grupo Promotor Catalográfica and president of the Ibero-American Poster Biennial in Bolivia. Azcuy has also served as a jury member for a number of awards in the region, including the IX International Biennial of the Poster in Mexico.

Der autodidaktische Zeichner, Grafiker und Designer Ernesto Azcuy stammt ursprünglich aus Havanna, Kuba, bevor er nach La Paz, die Hauptstadt Boliviens, umsiedelte. In den mehr als 30 Jahren seiner beruflichen Laufbahn hat er zahlreiche Auszeichnungen in Bolivien, Kuba und weiteren Ländern erhalten, vor allem für seine Arbeit im Plakatdesign. Azcuys Werke wurden zudem in den verschiedensten Galerien und Museen gezeigt – sowohl in Gemeinschafts- als auch Einzelausstellungen. Neben seiner beruflichen Arbeit ist Azcuy Direktor der Grupo Promotor Catalográfica und Präsident der Iberoamerikanischen Plakatbiennale in Bolivien. Azcuy fungierte außerdem als Jurymitglied bei einigen Wettbewerben der Region, darunter für die IX. Internationale Plakatbiennale in Mexiko.

Peintre, illustrateur, graphiste et designer autodidacte, Ernesto Azcuy est né à La Havane, à Cuba. Il vit à La Paz, la capitale de la Bolivie. Au cours d'une carrière de plus de 30 ans, il a reçu de nombreuses récompenses en Bolivie, à Cuba et dans d'autres pays, notamment pour ses affiches. Ses œuvres ont également été présentées dans des expositions collectives ou en solo dans différents musées et galeries. Outre son travail professionnel, il est aussi le directeur du Grupo Promotor Catalográfica et le président de la Biennale ibéro-américaine de l'affiche en Bolivie. Il a également été membre du jury pour plusieurs récompenses décernées en Amérique latine, dont la IXe Biennale internationale de l'affiche de Mexico.

PRIMER PLANO
Semana del video boliviano

junio 18 al 23 del 2001
estreno de videos

Movimiento del nuevo cine y video boliviano
Retrospectiva del cineasta **Jorge Ruiz**

lunes: Charlas sobre Formación Audiovisual
martes: Mesa redonda
Producción Nacional de Publicidad
miércoles: Producción Nacional para Televisión
jueves: Mesa redonda: una nueva mirada-video indígena

Centro Cultural
KYROS Casa del Arquitecto calle Jaen #765
tel. 280772

viernes: Cine y Video posibilidades y perspectivas
Gran maratón: 24 horas de Video

BACHS

1. "Mariposas" film poster
(screen-printing), 1974

2. "Los impostores" poster, 1970

3. "La dama del Alba"
film poster, 1966

Eduardo Muñoz Bachs is a design legend in Cuba, having played a pivotal role in the field in the 60s and 70s, and having produced over 1000 posters. Born in Valencia, Spain, Bachs immigrated to the island when he was four years old. Together with René Azcúy, Antonio Pérez 'Ñiko' and Héctor Villaverde, among others, Bachs helped to establish what is widely recognised as the Cuban school of poster design. Entirely self taught, he designed his first poster in 1961 for the film *Historias de la Revolución*, which heralded the start of a prolific career spanning 40 years, during which time he produced illustrations for countless children's books. Bachs received over 30 international awards before his death in 2001, just one week after the Design Week in Havana, for which he befittingly designed the poster.

Eduardo Muñoz Bachs ist in Kuba zu einer Design-Legende geworden, da er in den 60er und 70er Jahren eine Schlüsselrolle im Design spielte und während seiner Laufbahn mehr als 1.000 Plakate produzierte. Bachs wurde im spanischen Valencia geboren und emigrierte im Alter von 4 Jahren nach Kuba. Zusammen mit René Azcúy, Antonio Pérez „Ñiko", Héctor Villaverde und weiteren Designern half Bachs bei der Gründung dessen, was weithin als die Kubanische Schule für Plakatdesign anerkannt ist. Der rein autodidaktische Künstler entwarf sein erstes Plakat im Jahr 1961 für den Film *Historias de la Revolución*, was den Beginn einer produktiven beruflichen Laufbahn über eine Zeitspanne von 40 Jahren einleitete. In dieser Zeit schuf er Illustrationen für zahllose Kinderbücher. Bachs erhielt bis zu seinem Tod über 30 internationale Auszeichnungen. Er starb 2001, nur eine Woche nach der Design Week in Havanna, für die er das Plakat entworfen hatte.

Eduardo Muñoz Bachs est une légende du graphisme à Cuba. Il a joué un rôle central dans le secteur dans les années 1960 et 1970, et a créé plus de 1 000 affiches. Né à Valence, en Espagne, il a immigré vers l'île de Cuba lorsqu'il avait quatre ans. Avec René Azcúy, Antonio Pérez « Ñiko » et Héctor Villaverde, entre autres, Bachs a contribué à la naissance de ce qui est maintenant largement reconnu comme l'école de l'affiche cubaine. Totalement autodidacte, il a créé sa première affiche en 1961 pour le film *Historias de la Revolución*, qui a marqué le début d'une carrière prolifique de 40 ans, pendant laquelle il a créé des illustrations pour une multitude de livres pour enfants. Bachs a reçu plus de 30 récompenses internationales avant son décès en 2001, quelques jours après la Semaine du graphisme à La Havane, événement pour lequel il avait justement créé l'affiche.

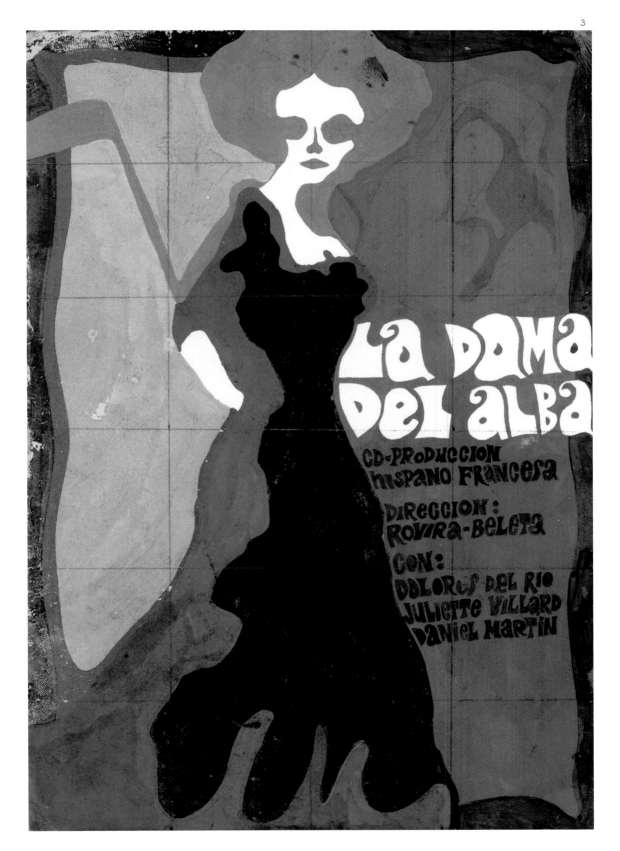

4. "Quinzaine des Realisateurs"
film festival poster, 1981,
Cannes International Film Festival

5. "Cine Móvil" initiative poster
(screen-printing), 1969, Instituto
Cubano de Arte de la Industria
Cinematográfica (ICAIC)

5

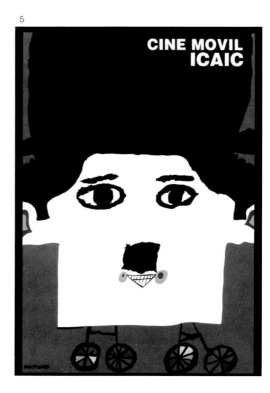

4

6. "Desierto Rojo" film poster
(screen-printing), 1966

7. "Semana de Diseño Gráfico"
conference poster, 2001

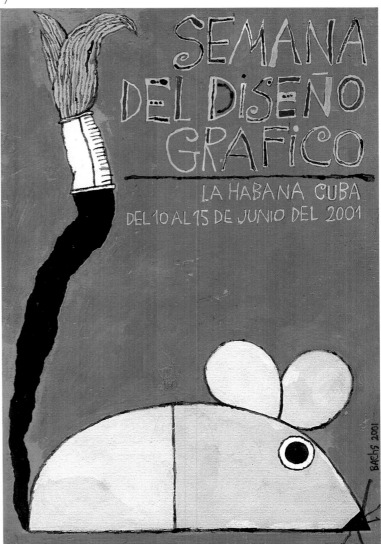

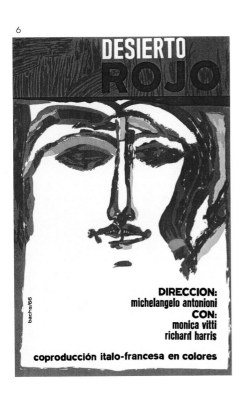

*1938, Mexico

FÉLIX BELTRÁN

1
2
3
4

Born in Havana, Cuba and later natural-ised as a Mexican citizen, Félix Beltrán is most famous for his strong conceptual approach to poster and logo design, an art form that he has been mastering in a career that has spanned over five decades. He studied graphic design at the School of Visual Arts and Graphic Art Center-Pratt Institute, in New York. Beltrán has shown his posters at more than 500 exhibitions around the world, and his highly acclaimed works are housed in 60 museum collections. Beltrán has written four books, and his work has been listed in all the major graphic surveys around the world. He received a *Doctorate Honoris Causa* in Arts from the International University Foundation in Delaware, for his immense contribution to graphic design. His legacy is a style of design that is thought pro-voking and radical in its simplicity.

Félix Beltrán, geboren in Havanna, Kuba, und später in Mexiko eingebürgert, ist berühmt für seine starke konzeptionelle Betrachtungsweise beim Plakat- und Logodesign, eine Kunstform, die er in seiner nun mehr als fünf Jahrzehnte dauernden Karriere meistert. Er studierte Grafikdesign an der School of Visual Arts und am Graphic Art Center-Pratt Institute in New York. Beltráns Plakate wurden in über 500 Ausstellungen auf der ganzen Welt gezeigt und seine gefeierten Werke sind in den Sammlungen von 60 Museen enthalten. Beltrán hat vier Bücher verfasst und seine Arbeiten wurden in allen wichtigen Grafik-Sammlungen der Welt aufgelistet. Er erhielt von der International University Foundation in Delaware den Grad eines Ehrendoktors für seine außerordentlichen Beiträge im Bereich Grafikdesign. Sein Vermächtnis ist ein Designstil, der in seiner Simplizität als provokant und drastisch angesehen wird.

Né à La Havane, à Cuba, puis natura-lisé Mexicain, Félix Beltrán est surtout connu pour son approche très conceptuelle des affiches et des logos, une forme artistique qu'il a appris à maîtriser tout au long d'une carrière de plus de cinquante ans. Il a étudié le graphisme à l'École des Arts visuels et au Graphic Art Center-Pratt Institute, à New York. Ses affiches ont été présentées dans plus de 500 expositions aux quatre coins du globe, et 60 collections de musées abritent ses œuvres plébiscitées. Félix Beltrán a écrit quatre livres, et son travail figure dans toutes les grandes études réalisées dans le monde sur les arts graphiques. L'International University Foundation du Delaware lui a décerné un *doctorat honoris causa* pour son immense contribution au graphisme. Il a laissé en héri-tage un style qui pousse à la réflexion, et qui est radical dans sa simplicité.

1. "Hotel Habana" logo, 1956, Hotel Habana

2. "Xpos" logo, 1975, Xpos Co., modular exhibition panels

3. "Cruz Roja Cubana" logo, 1968, Cuban Red Cross, films to help social causes

4. "Hábitat" illustration for invitation, 2003, Hábitat Conference

5

5. "Construcción" illustration for invitation front cover, 1963, Ministry of Construction, Mexico

6. "Contra la Contaminación del Aire" awareness campaign poster, 1997, Gobierno del Distrito Federal (Mexico City local government)

*1973, Chile, www.bercz.net

DANY
BERCZELLER

Dany Berczeller was born in the Chilean capital of Santiago and trained as a designer from the Catholic University, where he also studied cultural enterprise management. He subsequently travelled to Spain, where he completed an MA in editorial design. Berczeller has widely collaborated with numerous magazines in the region, including *Diseño, Diseñoetc!, Nuevo Diseño, 180,* and *ARQ* from Chile and *TipoGráfica* from Argentina. He has also organised a number of exhibitions, among them *El Afiche Chileno: Expresión Gráfica de un País* (Chilean Posters: A Graphic Expression of a Nation), and has edited the book *Proyecto Demo: Australis,* together with Cristián Gonzalez Saiz. Berczeller teaches at the Catholic University in Santiago, where he has been a member of the typographic studies faculty since 2002.

Dany Berczeller stammt aus der chilenischen Hauptstadt Santiago und erhielt seine Ausbildung zum Designer an der Katholischen Universität, wo er außerdem noch kulturelle Unternehmensführung studierte. Dann reiste er nach Spanien und schloss dort ein Magisterstudium in Editorial Design ab. Berczeller arbeitete mit vielen verschiedenen regionalen Magazinen und Zeitschriften zusammen, z.B. *Diseño, Diseñoetc!, Nuevo Diseño, 180* und *ARQ* in Chile sowie *TipoGráfica* in Argentinien. Zudem organisierte er mehrere Ausstellungen, u.a. *Chilenische Plakate: Der grafische Ausdruck einer Nation,* und gab zusammen mit Cristián Gonzalez Saiz das Buch *Proyecto Demo: Australis* heraus. Berczeller lehrt an der Katholischen Universität in Santiago, wo er seit 2002 Mitglied der Fakultät für Typografie ist.

Dany Berczeller est né à Santiago du Chili et y a étudié le graphisme et la gestion culturelle d'entreprise à l'Université catholique. Il a ensuite obtenu une maîtrise en graphisme éditorial en Espagne. Il a beaucoup travaillé avec de nombreux magazines sud-américains, notamment *Diseño, Diseñoetc!, Nuevo Diseño, 180,* et *ARQ* pour le Chili et *TipoGráfica* pour l'Argentine. Il a également organisé de nombreuses expositions, dont *El Afiche Chileno: Expresión Gráfica de un País* (Affiches chiliennes : l'expression graphique d'une nation), et a publié le livre *Proyecto Demo: Australis,* avec Cristián Gonzalez Saiz. Dany Berczeller enseigne à l'Université catholique de Santiago, où il est membre de la faculté d'études typographiques depuis 2002.

1. "Arte+Técnica" poster, 2003,
Universidad Diego Portales
Fotografía Fotodigital Chile
Model Kahy Berczeller

2. "Roman Kalarus: Maestro
del Afiche Polaco" poster, 2005,
FAAD/Universidad Diego Portales

3. "Faad & Rock (Hudson*)"
poster, 2005, FAAD/Universidad
Diego Portales

4. "Wladyslaw Pluta" poster, 2002,
FAAD/Universidad Diego Portales
Photo Dany Berczeller

3

*1974, Colombia

DIEGO GIOVANNI BERMÚDEZ AGUIRRE

Diego Giovanni Bermúdez Aguirre has many years of experience as a professional designer and teacher at the Pontificia Universidad Javeriana and the Fundación Universitaria del Área Andina, both in the Colombian capital of Bogotá. He has coordinated the design and production of the university's journal, a long term editorial project that culminated in the creation of a new corporate identity for the entire institution. Bermúdez has been associated with a number of international design organisations, including the Icograda, Society for News Design, The Design History Society and The Open Design Alliance, and has also chaired events on editorial design. Many of his posters have been widely exhibited in conferences and design biennials in Argentina, Colombia, Cuba, Spain, Italy, Mexico, Ukraine and Venezuela.

Diego Giovanni Bermúdez Aguirre verfügt über langjährige Erfahrung als Designprofi und lehrt an den Universitäten Pontificia Universidad Javeriana und Fundación Universitaria del Área Andina, die beide in der kolumbianischen Hauptstadt Bogotá ansässig sind. Er koordinierte Design und Produktion der Universitätszeitung. Mit diesem langfristigen redaktionellen Projekt wurde die Corporate Identity der gesamten Institution neu geschaffen. Bermúdez ist Mitglied bei einer Reihe von internationalen Organisationen für Design, dazu gehören Icograda, Society for News Design, The Design History Society und The Open Design Alliance. Zudem war er Vorsitzender bei verschiedenen Veranstaltungen im Bereich Editorial Design. Viele seiner Plakate wurden in Konferenzen und Design-Biennalen in Argentinien, Kolumbien, Kuba, Spanien, Italien, Mexiko, der Ukraine und Venezuela ausgestellt.

Diego Giovanni Bermúdez Aguirre a de nombreuses années d'expérience en tant que graphiste professionnel et professeur à la Pontificia Universidad Javeriana et à la Fundación Universitaria del Área Andina de Bogota, la capitale de la Colombie. Il s'est chargé du graphisme et de la production du journal de l'université, un projet éditorial à long terme qui a été couronné par la création d'une nouvelle identité d'entreprise pour toute l'institution. Il a été associé a plusieurs organisations internationales de graphisme, notamment l'icograda, Society for News Design, The Design History Society et The Open Design Alliance, et a également présidé des événements sur le graphisme éditorial. Beaucoup de ses affiches ont été exposées lors de congrès et de biennales de graphisme en Argentine, en Colombie, à Cuba, en Espagne, en Italie, au Mexique, en Ukraine et au Venezuela.

diversidad cultural

3

1. **"XX Aniversario Instituto de Diseño Darias"** 10th anniversary poster, 2006, Instituto de Diseño Darias

2. **"La Mirada de Nosotros"** poster, 2006, Encuentro Latinoamericano de Diseño, Argentina

3. **"Diversidad Cultural"** (Cultural Diversity) exhibition poster, 2007, UNESCO (Regional Bureau for Latin America and the Caribbean), Cuban Prografica Committee

4. **"Quixote"** poster for exhibition, 4th centennial of Don Quijote (Miguel de Cervantes), El Quijote Gráfico, 400 años del viaje de aquella triste figura, 2005, Venezuela

5. **"San Fermín de Pamplona"** promotional poster, 2005, Spain

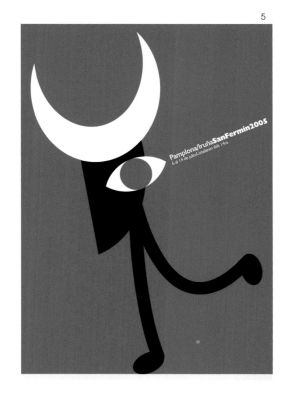

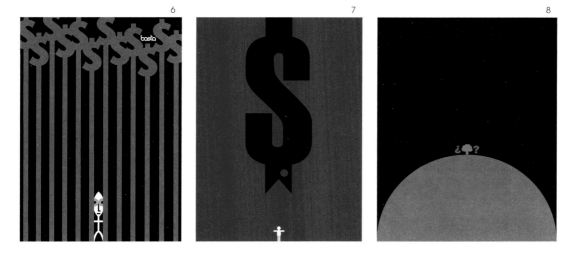

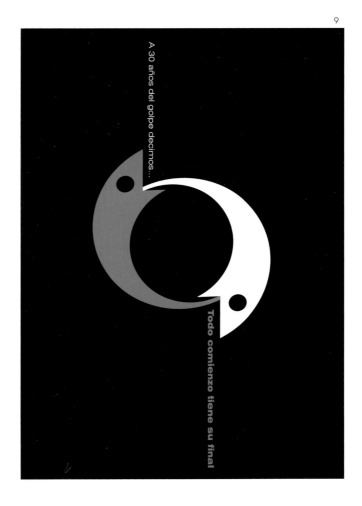

6. "Basta" poster for competition, 2005, Centro de Diseño de Rosario

7. "Das Gelt" poster for competition, 2006, EuroTypo, Italy

8. Poster selected for exhibition, 2006, XX International Biennial of the Poster in Mexico

9. "Todo comienzo tiene su final" poster for competition, 2006, Argentina

*1953, Mexico

XAVIER BERMÚDEZ

Xavier Bermúdez is a designer, musician, activist and founder of the International Biennial of the Poster in Mexico. He is also editor of *Lúdica*, a magazine dedicated to art, design and culture. Trained at the Universidad Autónoma Metropolitana in Mexico and at the Scuola Politécnica di Design in Milan (Italy), Bermúdez's work has been published worldwide, including in *Print, Idea* and *Línea Gráfica*. He is a professor at the Universidad Autónoma Metropolitana and at the Universidad Veracruzana, where he heads the design department. In 1992 he was selected for the UN exhibition *30 Posters on the Environment & Development*, and has served as a juror at design biennials in Lathi (Finland) and Fort Collins, Colorado (USA).

Xavier Bermúdez ist Designer, Musiker, Aktivist und Gründer der Internationalen Plakatbiennale in Mexiko. Er ist außerdem Herausgeber von *Lúdica*, einem Magazin, das Kunst, Design und Kultur zum Thema hat. Bermúdez erhielt seine Ausbildung an der Universidad Autónoma Metropolitana in Mexiko und der Scuola Politécnica di Design in Mailand, Italien. Seine Arbeiten wurden weltweit veröffentlicht, darunter auch in *Print, Idea* und *Línea Gráfica*. Er ist als Professor an der Universidad Autónoma Metropolitana tätig sowie an der Universidad Veracruzana, wo er den Fachbereich Design leitet. 1992 wurde er für die UN-Ausstellung *30 Posters on the Environment & Development* ausgewählt. Zudem fungierte er als Jurymitglied bei den Designbiennalen in Lathi (Finnland) und Fort Collins, Colorado (USA).

Xavier Bermúdez est graphiste, musicien, activiste et fondateur de la Biennale internationale de l'affiche de Mexico. Il est également le rédacteur en chef de *Lúdica*, un magazine consacré à l'art, au graphisme et à la culture. Il a étudié à l'Universidad Autónoma Metropolitana de Mexico et à la Scuola Politécnica di Design de Milan, en Italie. Son travail a été publié dans le monde entier, notamment dans *Print, Idea* et *Línea Gráfica*. Il est professeur à l'Universidad Autónoma Metropolitana et à l'Universidad Veracruzana, où il dirige le département de graphisme. En 1992, il a été sélectionné pour l'exposition de l'ONU *30 Posters on the Environment & Development*, et il a été juré pour des biennales de graphisme à Lathi (Finlande) et à Fort Collins, Colorado (États-Unis).

1. "Finn Nygaard"
50ᵗʰ anniversary poster, 2006

2. "Toulouse Lautrec"
exhibition poster, 2001, Ediciones
Escorbiac-Toulouse, France

3. "XII International Biennial
of the Poster in Mexico"
promotional poster, 2004

4. "IX International Biennial
of the Poster in Mexico"
promotional poster, 2005

Novena Bienal Internacional del Cartel en México
Ninth International Biennial of the Poster in Mexico
Kansainvälinen julistebiennaali Meksikossa

PAÍS INVITADO FINLANDIA / KUSTUVIERASMAANA SUOMI

INSTITUCIONES CONVOCANTES:

SECRETARÍA DE RELACIONES EXTERIORES / PROGRAMA DE NACIONES UNIDAS PARA EL MEDIO AMBIENTE,
OFICINA REGIONAL PARA AMÉRICA LATINA Y EL CARIBE / CONSEJO NACIONAL PARA LA CULTURA Y LAS ARTES
INSTITUTO NACIONAL DE BELLAS ARTES / SECRETARÍA DE EDUCACIÓN Y CULTURA DEL ESTADO DE VERACRUZ DE IGNACIO DE LA LLAVE
INSTITUTO VERACRUZANO DE LA CULTURA / MUNICIPIO DE XALAPA, VERACRUZ / SECRETARÍA DE CULTURA DEL GOBIERNO DEL DISTRITO FEDERAL
UNIVERSIDAD NACIONAL AUTÓNOMA DE MÉXICO / UNIVERSIDAD AUTÓNOMA METROPOLITANA / UNIVERSIDAD VERACRUZANA / ESCUELA GESTALT DE DISEÑO
EVENTO AVALADO / ENDORSED BY ICOGRADA • ORGANIZADORES / ORGANIZERS: TRAMA VISUAL, A. C. / MATATENA VISUAL

Informes / information: www.bienalcartel.org.mx / Tels: 01 (55) 55 25 92 73 • 01 (55) 55 25 94 11 / correos: tramavis@prodigy.net.mx / relpublicas@prodigy.net.mx

3

BERNARDO + CELIS

1

Javier Bernardo and Jimena Celis, born in 1974 and 1975 respectively, both studied at the Universidad de Palermo. They joined forces in 1996 to form Bernardo + Celis, specialising in the development of both product and graphic design. They were responsible for redesigning the visual identity of the well-known British Arts Centre and the CCEBA (Spanish Cultural Centre), both in Buenos Aires. The pair have exhibited internationally, and in the last decade have won a handful of important national awards for their product and identity design projects, including the first prize at the National Urban Furniture Awards of Buenos Aires in 2005.

Javier Bernardo und Jimena Celis, geboren 1974 bzw. 1975, studierten beide an der Universidad de Palermo, Argentinien. Sie gründeten 1996 zusammen das Studio Bernardo + Celis, das sich auf die Entwicklung von Produkt- und Grafikdesign spezialisierte. Sie waren für die Neugestaltung der visuellen Identität des namhaften British Arts Centre sowie des CCEBA (Centro Cultural de Espana en Buenos Aires) verantwortlich, die sich beide in Buenos Aires befinden. Beide nahmen an internationalen Ausstellungen teil und erhielten in den letzten zehn Jahren einige wichtige nationale Auszeichnungen für ihre Projekte im Bereich Produkt- und Identity-Design, darunter 2005 den ersten Preis des National Urban Furniture Awards of Buenos Aires.

Javier Bernardo et Jimena Celis, nés respectivement en 1974 et 1975, ont tous les deux étudié à l'Universidad de Palermo. En 1996, ils ont formé ensemble Bernardo + Celis, et se sont spécialisés dans la conception de produits et le graphisme. Ils ont créé la nouvelle identité visuelle du célèbre British Arts Center et du CCEBA (centre culturel espagnol), tous deux situés à Buenos Aires. Ils ont exposé à l'étranger, et ont remporté ces dix dernières années une poignée de grandes récompenses nationales pour leurs projets de conception de produit et d'identité visuelle, notamment le premier prix au Concurso Nacional de Mobiliario Urbano de Buenos Aires en 2005.

1. "BAC" visual identity, 2006,
British Arts Centre, Argentina
Art direction Javier Bernardo,
Jimena Celis

2–3. "CCEBA" visual identity,
2004, Centro Cultural de España
en Buenos Aires
Art direction Javier Bernardo,
Jimena Celis, Eugenia Lardiés.

2

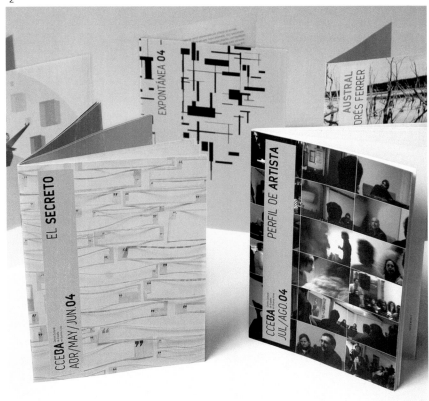

3

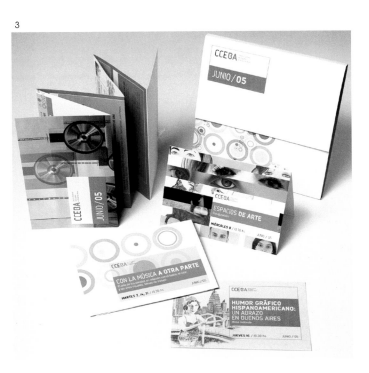

*1965, Brazil, www.giovannibianco.com

GIOVANNI BIANCO

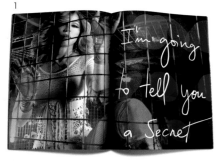

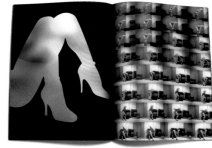

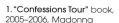

1. "Confessions Tour" book, 2005–2006, Madonna

Creative director Giovanni Bianco has worked both in Brazil and abroad. His studio, GB65, based in New York City, has developed iconic marketing concepts for a number international clients including Dsquared2, D&G, 'S MaxMara, Pepe Jeans, Missoni and Alessandro Dell'Acqua. In recent years, his identity and graphic creations for Madonna (*The Reinvention Tour, The Confessions Tour* and *Confessions on a Dance Floor*) have emphasized the recognition and respect he has gained in the industry. Giovanni Bianco has already published three solo books, and has collaborated with photographer Steven Klein to create the acclaimed limited edition publications, *X-STaTIC PRO=CeSS* for Madonna and *Speed 2004* for Nike. Moreover he has contributed to magazines such as W, Vogue Italia and L'Uomo Vogue.

Die Arbeit des Kreativdirektors Giovanni Bianco hat sowohl in Brasilien als auch international Kultstatus erreicht. Sein Studio GB65 mit Sitz in New York City entwickelte ikonenhafte Marketingkonzepte für eine Reihe internationaler Kunden wie zum Beispiel für Dsquared2, D&G, 'S MaxMara, Pepe Jeans, Missoni und Alessandro Dell'Acqua. In den letzten Jahren haben seine Identity- und Grafikkreationen für Madonna (*The Reinvention Tour, The Confessions Tour* und *Confessions on a Dance Floor*) die Anerkennung und Hochachtung deutlich werden lassen, die er in der Branche erworben hat. Giovanni Bianco hat bereits drei Bücher veröffentlicht und in Zusammenarbeit mit dem Fotografen Steven Klein die gefeierten limitierten Auflagen der Publikationen *X-STaTIC PRO=CeSS* für Madonna und *Speed 2004* für Nike geschaffen. Zudem wirkte er an Magazinen wie W, Vogue Italia und L'Uomo Vogue mit.

Giovanni Bianco a travaillé en tant que directeur de la création au Brésil et à l'étranger. Son studio, GB65, situé à New York, a élaboré des concepts marketing emblématiques pour plusieurs clients internationaux, notamment Dsquared2, D&G, 'S MaxMara, Pepe Jeans, Missoni et Alessandro Dell'Acqua. Ces dernières années, ses créations graphiques et d'identité visuelle pour Madonna (*The Reinvention Tour, The Confessions Tour* et *Confessions on a Dance Floor*) ont accru la reconnaissance et le respect dont il bénéficiait déjà dans le secteur. Il a déjà publié trois livres en solo, et a travaillé avec le photographe Steven Klein pour créer *X-STaTIC PRO=CeSS* pour Madonna et *Speed 2004* pour Nike, des éditions limitées qui ont rencontré un grand succès. Il a en outre collaboré avec des magazines tels que W, *Vogue Italia* et *L'Uomo Vogue*.

2. **"Confessions"** CD Album,
2005–2006, Madonna

3. **"Hung Up"** CD Single,
2005–2006, Madonna

4. **"Get Together"** CD Single,
2005–2006, Madonna

5. **"Sorry"** CD Single,
2005–2006, Madonna

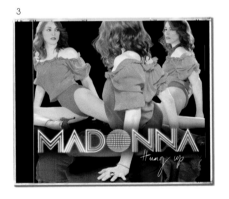

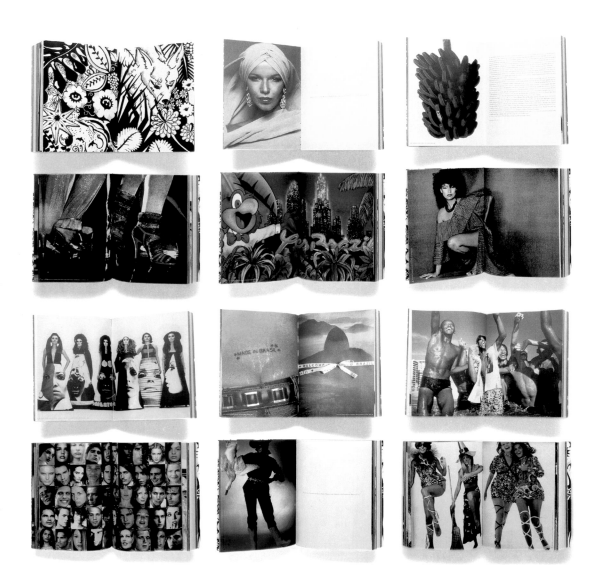

6

6. "O Brasil na Moda" book,
2006, Caras Publishing

7. "Nike Speed" book
(limited edition), Nike
Photo Steven Klein

*1940, Argentina, www.ricardoblanco.netfirms.com

RICARDO BLANCO

1. "Ente Binacional Yaciretá"
logo submission for competition
(2nd Prize), 1975

2. "Universidad de Mar del Plata"
logo competition (winner), 1969

3. "Universidad Tecnológica"
logo competition (winner), 1968

1

2

3

Originally qualified as an architect, Ricardo Blanco has built a career as both graphic and product designer. As professor with over 20 years experience at the Universidad de Buenos Aires, Blanco is one of the most respected figures in the professional study of design in Argentina, currently teaching at half a dozen universities in the country. He has introduced a number of undergraduate and postgraduate courses, including furniture design and product design. Aside from his prolific academic agenda, he has created countless iconic logos for national enterprises with his striking simplicity, along with a number of typographic families that have become recognised as an integral aspect of the Argentinean school of design. Blanco has published five books on product design and has served on jury panels for numerous awards in Latin America.

Ricardo Blanco schloss zunächst eine Ausbildung zum Architekten ab, doch er machte schließlich Karriere als Grafik- und Produktdesigner. Als Professor mit mehr als 20 Jahren Lehrerfahrung an der Universidad de Buenos Aires ist Blanco einer der angesehensten Persönlichkeiten der professionellen Designerausbildung in Argentinien. Er unterrichtet an einem halben Dutzend Universitäten des Landes und hat eine Reihe von Grund- und Aufbaustudiengängen eingeführt, darunter Möbeldesign und Produktdesign. Neben seinem produktiven akademischen Programm hat Blanco zahllose Logos für nationale Unternehmen kreiert. Seine eindrucksvolle Simplizität in Verbindung mit einigen typografischen Gruppen sind zu einem anerkannten Aspekt der argentinischen Schule des Designs geworden. Blanco hat fünf Bücher zum Thema Produktdesign veröffentlicht und diente als Jurymitglied bei zahlreichen Preisverleihungen in Lateinamerika.

Architecte de formation, Ricardo Blanco s´est forgé une carrière de graphiste et de concepteur de produit. Il a plus de 20 ans d´expérience en tant que professeur à l´Universidad de Buenos Aires, et est l´une des figures les plus respectées dans l´étude professionnelle du graphisme en Argentine. Il enseigne actuellement dans une demi-douzaine d´universités argentines. Il a créé plusieurs programmes de deuxième et de troisième cycle, dont la conception de meubles et la conception de produits. En-dehors de son emploi du temps universitaire chargé, il a créé une multitude de logos emblématiques à la simplicité saisissante pour des entreprises argentines, ainsi que plusieurs familles de polices de caractères qui sont devenues partie intégrante de l´école de graphisme argentine. Il a publié cinq livres sur la conception de produit et a été membre du jury pour de nombreuses récompenses décernées en Amérique latine.

4. "Truco y Sapo" exhibition
poster (Baraja Española),
1981, Espacio Giesso

*1991, Argentina, www.boldrini-ficcardi.com.ar

BOLDRINI
& FICCARDI

1

If the Argentinean vineyards had to select a mark of their quality through the graphic design aesthetic of their wine bottle labels, then the studio of Boldrini & Ficcardi would probably be the obvious choice. In 1991 designers Víctor Boldrini and Leonardo Ficcardi set up their studio in the heart of the acclaimed wine region of Mendoza. They were quick to realise that better packaging could definitely improve market awareness of the high quality wines produced in their homeland; the pair set out with the aim of creating elegant and sophisticated designs for most of the best wine makers, having since incorporated clients in Chile, the United States and Europe. They also work on corporate identity and editorial projects and their packaging designs have received numerous international awards.

Falls die argentinischen Weinberge ihre Qualitätsmarke durch die grafische Ästhetik der Labels ihrer Weinflaschen aussuchen müssten, würde ihre Wahl wahrscheinlich auf das Studio Boldrini & Ficcardi fallen. Die Designer Víctor Boldrini und Leonardo Ficcardi richteten 1991 ihr Studio im Herzen der berühmten Weinregion Mendoza ein. Sie erkannten schnell, dass eine besse-re Verpackung das Marktbewusstsein für hochwertige Weine sicherlich verbessert, die in ihrem Heimatland produziert werden. Die beiden Designer setzten sich das Ziel, elegante und anspruchsvolle Designs für viele der besten Winzer zu kreieren, und konnten auch Kunden in Chile, in den USA und in Europa gewinnen. Sie arbeiten außerdem an Projekten zu Corporate Identity und Editorial Design. Ihr Verpackungsdesign hat zahlreiche internationale Auszeichnungen erhalten.

Si les vignobles argentins devaient sélectionner une façon d'exprimer leur qualité à travers le graphisme des étiquettes de leurs bouteilles de vin, le studio Blodrini & Ficcardi serait probablement un choix évident. En 1991, les graphistes Victor Boldrini et Leonardo Ficcardi ont créé leur studio au cœur de la célèbre région viticole de Mendoza. Ils ont vite réalisé qu'une meilleure présentation du produit pourrait vraiment aider à augmenter la notoriété des grands vins produits à côté de chez eux. Ils ont donc décidé de créer des graphismes élégants et sophistiqués pour la plupart des meilleurs viticulteurs, et ont depuis gagné des clients au Chili, aux États-Unis et en Europe. Ils ont également travaillé sur des projets éditoriaux et d'identité d'entreprise, et leurs concepts d'emballage ont reçu de nombreux prix internationaux.

EL VINO

Guía breve para el paladar exigente

Adriana Ruth de la Mota

ROBELLO EDICIONES

1. "Boldrini & Ficardi" logo

2. "El vino" book,
2004, Robello Ediciones
Design Victor Boldrini,
Laura Fresneda
Art direction Victor Boldrini,
Leonardo Ficcardi
Illustration Victor Boldrini
Photo Victoria Milán

3. "Punto Final Varietal y Reserva"
wine label, 2003, Bodega Renacer
Design Victor Boldrini,
Leonardo Ficcardi

4. "Otello varietales" wine label,
2004, Bodega Sottano
Design Victor Boldrini,
Leonardo Ficcardi
Illustration Victor Boldrini

3

4

*2003, Argentina, www.brainpatch.com

BRAINPATCH!

1

Brainpatch! is a young and dynamic design studio based in the city of Cordoba, northwest of the capital Buenos Aires. Directed by Nicolas Contreras, Laureano Solis and Gastón Traverssa, Brainpatch! has been operating as a full-service design consultancy since 2003, developing websites and designing for print and corporate identity. In the few years they have been together, the group has collected a number of prestigious clients, including the Centro Cultural España Córdoba and Natura. Their style, offers a characteristic dynamism and freshness to graphics, with meticulous use of vectors and illustration. Vibrant colour schemes also feature prominently in their visual language, often combined with an urban aesthetic; an approach that has been applauded in both the music and cultural sectors.

Brainpatch! ist ein junges und dynamisches Designstudio mit Sitz in Cordoba, nordwestlich der argentinischen Hauptstadt Buenos Aires. Geleitet von Nicolas Contreras, Laureano Solis und Gastón Traverssa bietet Brainpatch! seit 2003 umfassende Designberatung an, entwickelt Websites und entwirft Druckprojekte und Corporate Identity. In den wenigen Jahren der gemeinschaftlichen Arbeit hat die Gruppe schon viele angesehene Kunden gewinnen können, darunter das Centro Cultural España Córdoba und Natura. In ihrem Designstil bekommen die Grafiken durch sorgfältigen Einsatz von Vektorgrafiken und Illustrationen eine charakteristische dynamische Kraft und Frische. Lebhafte Farbzusammenstellungen häufig kombiniert mit einer urbanen Ästhetik, zeichnen ihre markante visuelle Designsprache aus. Dieser Ansatz hat im Musik- und Kulturbereich einen großen Anklang gefunden.

Brainpatch! est un studio de graphisme jeune et dynamique, situé à Córdoba, au nord-ouest de la capitale de l'Argentine, Buenos Aires. Dirigé par Nicolas Contreras, Laureano Solis et Gastón Traverssa, depuis 2003 Brainpatch est un cabinet de conseil en graphisme qui propose une gamme complète de services dans les domaines du développement de sites Internet, de la presse et de l'identité d'entreprise. Dans les quelques années qui ont suivi sa formation, le groupe a convaincu un certain nombre de clients prestigieux, notamment le Centro Cultural España Córdoba et Natura. Leur style apporte au graphisme un dynamisme et une fraîcheur caractéristiques, et se distingue également par une utilisation méticuleuse des vecteurs et de l'illustration. Les palettes de couleurs vives jouent aussi un grand rôle dans leur langage visuel, et sont souvent combinées à une esthétique urbaine. C'est une approche qui a été applaudie dans les secteurs de la musique et de la culture.

1. **"Fuencarral's Shop"** billboard
and facade design, 2006, Fuencarral

2. **"Fuencarral's Opening"**
promotional flyer, 2006, Fuencarral

3. **"Fuencarral's Flyer"** design applied
to flyer and notepad institutional
inspired in Adidas, 2006, Fuencarral

4. **"Fuencarral's Wallpaper"**
inspired in the Nike Air Force One,
2006, Fuencarral

3

brainpatch! | *www.brainpatch.com*

tienda *fuencarral*®

BSAS.956.NVA.CBA
0351 4333390
WWW.TIENDAFUENCARRAL.COM
WWW.FLICKR.COM/TIENDAFUENCARRAL
TIENDA@TIENDAFUENCARRAL.COM

2

4

*1979, Panama

MAIRENA BRIONES

Born in Panama, Mairena Briones studied advertising at the Universidad Veritas in San José, Costa Rica. She gained her early professional experience at the Ají Pintao design studio, and currently leads the creative team at GrupoBlank, where she manages a large number of projects in corporate identity, print and web design. Throughout her career, Briones has managed accounts for large corporations, including Sony, Red Bull, BellSouth and UNICEF. In 2006 her graphic work was selected for the exhibition, *Coca-Cola 100 años en Panamá* to celebrate the company's 100th year in the country. She has also collaborated with studios abroad, including Blur Ediciones in Madrid.

Mairena Briones wurde in Panama geboren und studierte Werbung an der Universidad Veritas in San José, Costa Rica. Sie sammelte ihre ersten Berufserfahrungen im Designstudio Ají Pintao und leitet zurzeit das Kreativteam bei GrupoBlank, wo sie eine große Anzahl an Projekten zu Corporate Identity, Druck- und Webdesign betreut. Während ihrer beruflichen Laufbahn hat Briones Werbeaufträge von großen Unternehmen wie Sony, Red Bull, BellSouth und UNICEF durchgeführt. 2006 wurde ihre grafische Arbeit für die Ausstellung *Coca-Cola 100 años en Panamá* ausgewählt, eine Ausstellung zur 100-Jahr-Feier des Unternehmens im Land. Briones arbeitete zudem mit ausländischen Studios zusammen, darunter Blur Ediciones in Madrid.

Née au Panama, Mairena Briones a étudié la publicité à l'Universidad Veritas de San José, au Costa Rica. Elle a fait ses premières armes au studio de graphisme Ají Pintao, et dirige actuellement l'équipe créative de GrupoBlank, où elle s'occupe de nombreux projets dans les domaines de l'identité d'entreprise, de la presse et de la conception de sites web. Au cours de sa carrière, elle a été responsable de projets pour de grandes entreprises, notamment Sony, Red Bull, BellSouth et UNICEF. En 2006, ses graphismes ont été sélectionnés pour l'exposition *Coca-Cola 100 años en Panamá*, qui célébrait le centenaire de la présence de Coca-Cola dans le pays. Elle a également travaillé avec des studios étrangers, dont Blur Ediciones à Madrid.

1. "Random Vol. 1 (color me)"
graphic-expo illustration, 2006

2. "vOrtice parties" promotional
t-shirt logo, 2005

3. "Coca Cola is natura" illustration,
2005, Coca-Cola Panama

2

3

VICTOR BURTON

1

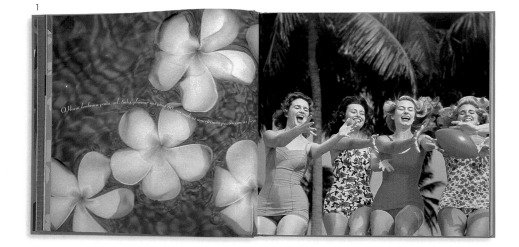

1. **"Havaianas"** promotional book, 2000, Editora DBA

Victor Burton was born in Rio de Janeiro, and trained to become a professional designer at the Franco Maria Ricci publishing house in Milan, Italy, where he lived from 1963 to 1979. There he created his first book cover for the title *Il Formichiere*. Back in Brazil he has mainly designed for the publishing and cultural industry, producing covers and content design for the most prestigious authors and publishers. Over the last 25 years Victor Burton has designed more than 2500 book covers including over 100 limited editions. He has been one of the highlights of the Graphic Design Biennial and has won the Gold Medal at the ADG, among many other awards in the country. Burton currently runs his own design practice in his hometown.

Victor Burton wurde in Rio de Janeiro geboren und erhielt seine Ausbildung zum professionellen Designer beim Verlagshaus Franco Maria Ricci in Mailand, Italien, wo er von 1963 bis 1979 lebte. In Mailand entwarf er seinen ersten Bucheinband für den Titel *Il Formichiere*. Seit seiner Rückkehr nach Brasilien arbeitet er hauptsächlich für die Verlags- und Kulturbranche und entwirft Bucheinbände und Content-Design für die angesehensten Autoren und Verleger. Während der letzten 25 Jahre hat Victor Burton mehr als 2500 Bucheinbände entworfen, darunter über 100 limitierte Auflagen. Er stellte einen der Höhepunkte bei der Grafikdesign-Biennale dar und gewann, neben vielen anderen Auszeichnungen des Landes, die Goldmedaille der ADG. Burton leitet zurzeit ein eigenes Designstudio in seiner Heimatstadt.

Victor Burton est né à Rio de Janeiro, et s'est formé en tant que graphiste professionnel à la maison d'édition Franco Maria Ricci de Milan, en Italie, où il a vécu de 1963 à 1979. C'est là qu'il a créé sa première couverture de livre, pour *Il Formichiere*. De retour au Brésil, il a principalement travaillé pour les secteurs de l'édition et de l'industrie culturelle, et a créé des couvertures et des illustrations pour les auteurs et les maisons d'édition les plus prestigieux. Au cours des 25 dernières années, Victor Burton a créé plus de 25 000 couvertures de livres, dont plus de 100 éditions limitées. Il a été l'un des invités d'honneur de la Biennale du graphisme, et a remporté la médaille d'or de l'ADG, entre autres nombreuses récompenses reçues dans le pays. Il dirige actuellement son propre cabinet de graphisme dans sa ville natale.

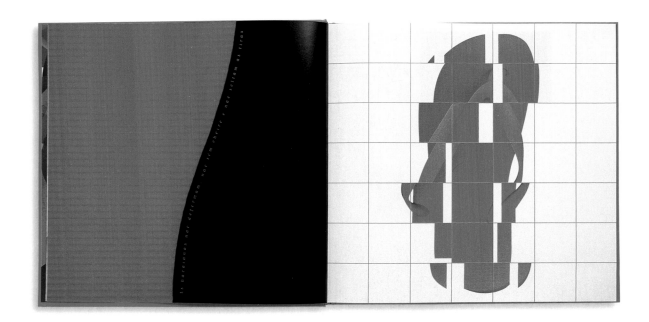

2

3

2. "100 Brasileiros" limited edition
book, 2004, Secretaria de
Comunicação da Presidência
da República/Biblioteca Nacional

3. "Grandes traduções"
book series, 2006, Editora Record

4. "Retratos da Bahia" book,
2002, Editora Corrupio
Photo Pierre Verger
Design assistant Ana Paula Daudt
Brandão

*1974, Mexico, www.abracadabra.com.mx

BENITO CABAÑAS

1

2

1. "Juntos contra el SIDA" awareness campaign poster against AIDS, 2004, France

2. "World Environment Day" poster, 2006, Mexico

3. "Carteles de México" exhibition poster, 2000, France

Benito Cabañas began his design career in France, working for the Anatome agency in Marseille and Paris, before going on to become a graphic consultant to UNESCO in Paris. Educated in graphic design at the Universidad de las Américas, in Puebla (Mexico), Cabañas is one of the most internationally recognised poster artists in the country, having exhibited in Russia, France, Belgium, Ukraine, Czech Republic and Mexico. His work was selected for the 60th anniversary of UNESCO, and he is also a close collaborator of the Asociación de las Culturas Franco-Mexicanas in Marseille. His posters on socio-political subjects, including AIDS awareness, have been critically acclaimed in Europe and in Latin America. Cabañas runs his design studio in Puebla, north of the capital, Mexico City.

Benito Cabañas begann seine Karriere als Designer in Frankreich, wo er zunächst für die Agentur Anatome in Marseille und Paris arbeitete, bevor er Grafikberater für die UNESCO in Paris wurde. Cabañas studierte Grafikdesign an der Universidad de las Américas in Puebla (Mexiko). Er ist einer der international anerkanntesten Plakatkünstler des Landes und stellte in Russland, Frankreich, Belgien, der Ukraine, der Tschechischen Republik und Mexiko aus. Seine Arbeit wurde für das 60-jährige Jubiläum der UNESCO ausgewählt und er ist zudem ein enger Mitarbeiter der Asociación de las Culturas Franco-Mexicanas in Marseille. Seine Plakate zu sozialpolitischen Themen, unter anderem zum Thema AIDS, wurden in Europa und in Lateinamerika von der Kritik gefeiert. Cabañas leitet sein Designstudio in Puebla, nördlich der Hauptstadt Mexico City.

Benito Cabañas a commencé sa carrière en France, où il a travaillé pour l'agence Anatome à Marseille et à Paris, avant de devenir consultant graphique pour l'UNESCO à Paris. Il a étudié le graphisme à l'Univesidad de las Américas de Puebla (Mexique), et est dans son pays l'un des créateurs d'affiches les plus renommés au niveau international. Il a exposé en Russie, en France, en Belgique, en Ukraine, en République tchèque et au Mexique. Son œuvre a été sélectionnée pour le 60e anniversaire de l'UNESCO, et il est un proche collaborateur de l'Association des cultures franco-mexicaines de Marseille. Les affiches qu'il a réalisées sur des sujets sociaux et politiques, et notamment sur la sensibilisation au SIDA, ont été plébiscitées par la critique en Europe et en Amérique latine. Benito Cabañas dirige son propre studio de graphisme à Puebla, au nord de Mexique.

3

CARTELES
MEXICO
DE

▶ LES MEXICAINS À PARIS DU 22 SEPTEMBRE AU 2 DÉCEMBRE 2000

◆ GALERIE ANATOME ◆
38 RUE SEDAINE, PARIS 75011
MÉTRO : BASTILLE, VOLTAIRE, BRÉGUET-SABIN

4

WELCOME TO Canada

5

kosovo 1999

7

6

CABINA

1

1. "Ciudad Cultural Konex"
visual identity, 2006

2. "Juana de Arco"
corporate identity, 2004

3. "Terminal A" airport magazine,
logo and visual identity, 2004–2006

Coni Luna and Caro Mikalef, both born in 1972, joined forces in 2004 to start what they primarily acknowledge as a studio for visual experience, Espacio Cabina. For these two talents, design acts as a mediator through which a new level of visual communication can emerge. With an extensive portfolio that encompasses corporate identity, editorial, branding, fashion, graphics, illustration, packaging, corporate design and promotional material, Luna and Mikalef have always set out with the directive to generate a dynamic and colourful visual language. Their inspiration has come from their experiences of travelling around the world, combined with a passion for literature, architecture and installation art.

Coni Luna und Caro Mikalef, beide 1972 geboren, schlossen sich 2004 zusammen und gründeten das Studio Espacio Cabina, das sie in erster Linie als Studio für visuelles Experiment ansehen. Diesen beiden Talenten dient Design als Vermittler, durch den eine neue Ebene der visuellen Kommunikation entstehen kann. Bei ihrem umfangreichen Angebot über Corporate Identity, Editorial Design, Corporate Branding, Modedesign, Grafikdesign, Illustration, Verpackungsdesign, Corporate Design und Werbematerial halten sich Luna und Mikalef immer an den Leitsatz, eine dynamische und anschauliche visuelle Sprache zu schaffen. Sie lassen sich durch weltweite Reisen und ihre Leidenschaft für Literatur, Architektur und Installationskunst inspirieren.

Coni Luna et Caro Mikalef, tous deux nés en 1972, ont uni leurs forces en 2004 pour créer Espacio Cabina, qu'ils considèrent comme un studio essentiellement consacré à l'expérience visuelle. Pour ces deux professionnels talentueux, le graphisme est le moyen de faire émerger un nouveau niveau de communication visuelle. Leur portfolio englobe les domaines de l'identité d'entreprise, l'édition, la stratégie de marque, la mode, le graphisme, l'illustration, les emballages, le stylisme d'entreprise et les articles promotionnels. Ils ont toujours cherché à créer un langage visuel dynamique et coloré. Leur inspiration leur vient de leurs voyages autour du monde, et de leur passion pour la littérature, l'architecture et les installations d'art.

A terminal [A]
airport
magazine

*1973, Paraguay, www.victorcandia.com

VÍCTOR CANDIA

1. "WILD Magazine" covers
(Frutas de la Pasión/Radiowild), 2004,
EMG* Entertaintment & Media Group
Photo Martín Crespo

Designer, art director and illustrator, Paraguayan Víctor Candia is considered one of the most talented young creatives in the country. Trained in design at the Universidad Católica de Asunción, Candia has been a close collaborator of the *Taller Línea y Color* from the Centro de Estudios Brasileños in the capital Asuncion. He worked as creative director for advertising agencies DDB and McCann Eriksson, and provided art direction for magazines *Wild* (Paraguay) and *Las Rosas* (Argentina). His illustration work has received first prize at Chake, a national comic competition, and has since been published frequently in national magazines and newspapers. Candia currently divides his time between Asunción and Buenos Aires and Cordoba in Argentina.

Der paraguayische Designer, Art Director und Illustrator Víctor Candia wird als einer der talentiertesten jungen Künstler des Landes angesehen. Er schloss sein Designstudium an der Universidad Católica de Asunción, Paraguay, ab und wurde enger Mitarbeiter der *Taller Línea y Color* des Centro de Estudios Brasileños in der Hauptstadt Asunción. Er arbeitete als Kreativchef für die Werbeagenturen DDB und McCann Eriksson und übernahm die Art Direction für die Magazine *Wild* (Paraguay) und *Las Rosas* (Argentinien). Seine Illustrationen haben den ersten Preis bei Chake erhalten, einem nationaler Comic-Wettbewerb, und werden seitdem häufig in nationalen Zeitschriften und Zeitungen veröffentlicht. Candia pendelt gegenwärtig zwischen Asunción in Paraguay und Buenos Aires und Cordoba in Argentinien.

Graphiste, directeur artistique et illustrateur paraguayen, Víctor Candia est considéré comme l'un des jeunes créatifs les plus talentueux de son pays. Il a étudié à l'Universidad Católica de Asunción, et a été un proche collaborateur de *Taller Línea y Color*, du Centre d'études brésiliennes de la capitale, Asunción. Il a travaillé comme directeur de la création pour les agences de publicité DDB et McCann Eriksson, et comme directeur artistique pour les magazines *Wild* (Paraguay) et *Las Rosas* (Argentine). Ses illustrations ont reçu le premier prix de Chake, un concours national de bande dessinée, et il a depuis été fréquemment publié dans des magazines et journaux nationaux. Il partage actuellement son emploi du temps entre Asunción, Buenos Aires et Córdoba en Argentine.

2. "Más es más" poster,
2005, self promotion

avecanibal

cuentos de **marta cortés monroy**

3. "**Avecanibal**" book cover,
Marta Cortés Monroy

4. **"Líbido green torso"** t-shirt,
2003, Líbido t-shirts

5. **"BBB 2"** t-shirt, 2003,
BurnBabylonBurn colectivo de diseño

6. **"BBB colectivo"** logo, 2005,
BurnBabylonBurn colectivo de diseño

7. **"Ozono lounge"** logo, 2003,
EMG* Entertaintment & Media Group

6

4

5

7

*1957, Brazil, www.gringocardia.com.br

GRINGO CARDIA

1. "Riocena Contemporânea",
theater festival poster, 2002–2004,
Prefeitura do Rio
Assistant Bruno Warchavsky,
Diogo Magalhães
Photo Flavio Colker

Based in Rio de Janeiro, Gringo Cardia is a multi talented graphic designer, director, architect and stage designer, working widely on music clips, graphics, theatre and fashion. He has been deeply involved in both the performing arts and music scene from his early career, and has created for the top artists and groups in the country. Among his other works, he has produced stage designs for the Deborah Colker Dance Company, which received a Laurence Olivier Award in the United Kingdom. His music clients include Carlinhos Brown, Marisa Monte and Maria Bethânia. As a parallel activity, Cardia also runs *Spectaculu*, a charity project that teaches poor children creative skills, seeking to give them new opportunities in a world that has applauded his work for a long time.

Mit Sitz in Rio de Janeiro ist Gringo Cardia ein vielseitig talentierter Grafikdesigner, Kreativchef, Architekt und Bühnenbildner, der überwiegend im Bereich Musikvideo, Grafik, Theater und Mode arbeitet. Durch seine frühe Karriere ist er stark mit den darstellenden Künsten und der Musikszene verbunden und hat für die größten Künstler und Musikgruppen des Landes gearbeitet. Neben anderen Werken hat Cardia Bühnenbilder für die Deborah Colker Dance Company entworfen, die in Großbritannien den Laurence Olivier Award erhielten. Zu seinen Auftraggebern gehören die Musiker Carlinhos Brown, Marisa Monte und Maria Bethânia. Zusätzlich leitet Cardia das karitative Projekt *Spectaculu*, das die kreativen Fähigkeiten bedürftiger Kinder fördert und ihnen neue Möglichkeiten in einer Welt eröffnet, in der die Arbeiten von Cardia schon seit langer Zeit großen Beifall finden.

Basé à Rio de Janeiro, Gringo Cardia a de multiples talents : il est graphiste, metteur en scène, architecte et décorateur, et a beaucoup travaillé sur des clips vidéo, dans le graphisme, dans le théâtre et dans la mode. Au début de sa carrière, il était très impliqué dans le monde des arts de performance et de la musique, et il a créé pour les meilleurs artistes et groupes du pays. Il a entre autres créé les décors de scène de la compagnie de danse Deborah Colker, qui a reçu un prix Laurence Olivier au Royaume-Uni. Dans le domaine de la musique, il a compté parmi ses clients Carlinhos Brown, Marisa Monte et Maria Bethânia. Parallèment à ses activités principales, il dirige également *Spectaculu*, un projet philanthropique qui enseigne la création aux enfants défavorisés, et cherche à leur donner de nouvelles opportunités dans un monde qui acclame son travail depuis longtemps.

2. "Brasileirinho" CD cover,
2004, Maria Bethânia,
Biscoito Fino Records
Design Bruno Warchavsky
Assistant Fabio Arruda
Illustration Mendes

3. "Para Todos" CD cover,
1993, Chico Buarque,
BMG Brazil

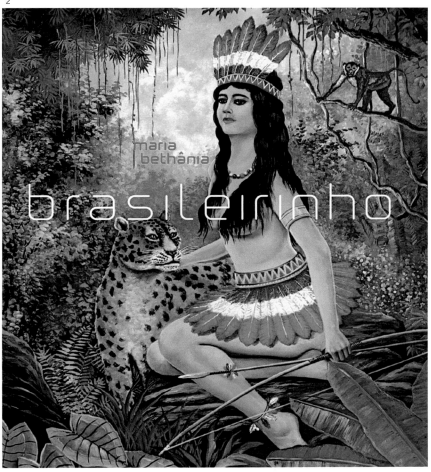

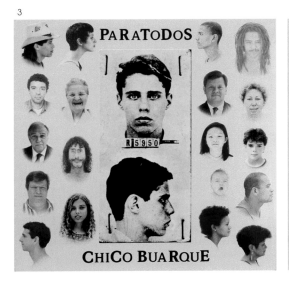

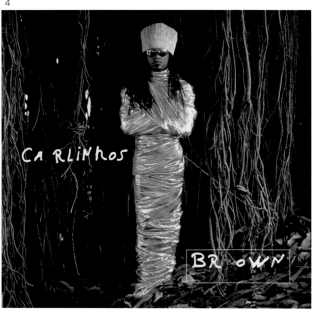

4. "Alfagamabetizado" CD cover,
1996, Carlinhos Brown, EMI Brazil
Foto Mário Cravo Neto
Design assistant Leonardo Eyer
Art assistant Cláudia Stancioli

5. "Severino" CD cover, 1994,
Os Paralamas do Sucesso, EMI Brazil
Design assistant Wesley Cardia
Artwork Arthur Bispo do Rosário

5

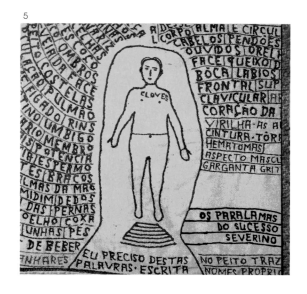

6. "Nó" ballet play poster, 2005,
Cia de Dança Deborah Colker
Assistant Leonardo Eyer
Photos Flavio Colker

7. "Barulhinho Bom" VHS packaging,
1996, Marisa Monte, EMI Brazil
Artwork Carlos Zéfiro
Design assistant Leonardo Eyer
Art assistant Bruno Porto

JULIÁN CARDOZO

1

Manifiesto 79 is the independent platform of graphic artist and designer Julián Cardozo, born in Cali, Colombia second largest city. Working in a variety of areas from illustration and experimental graphics, to corporate identity and art direction for advertising, Julián Cardozo gained public attention with his series called *Conspiración Visualgore* (www.visualgore.tv), a project that began as a colourful urban intervention, with paintings on walls and fences, and manifesting into a range of T-shirts and posters. He has also worked closely with a number of local and national bands, producing logos to complete CD packages. His work has also been shown at *Desfase Primer Asalto*, an international street art expo in Bogotá.

Manifiesto 79 ist die eigenständige Plattform des Grafikdesigners und Designers Julián Cardozo, der gebürtig aus Cali, der zweitgrößten Stadt Kolumbiens stammt. Er arbeitet in vielfältigen Bereichen: von Illustration und experimenteller Grafik bis hin zur Corporate Identity und Werbedesign. Julián Cardozo erhielt mit seinen sogenannten *Conspiración Visualgore*-Serien (www.visualgore.tv) öffentliche Aufmerksamkeit, ein Projekt, das als farbenfrohe städtische Intervention mit Malereien auf Wänden und Zäunen begann, die mittlerweile auf T-Shirts und Plakate gedruckt werden. Er arbeitete außerdem eng mit einigen lokalen und nationalen Musikbands zusammen und entwarf Logos für CD-Verpackungen. Seine Werke wurden auf der *Desfase Primer Asalto*, ausgestellt, einer internationale Street-Art-Ausstellung in Bogotá.

Manifiesto 79 est la plateforme indépendante de l'artiste et graphiste Julián Cardozo, né à Cali, la deuxième ville de Colombie. Il a travaillé dans des domaines variés, de l'illustration au graphisme expérimental, de l'identité d'entreprise à la direction artistique dans la publicité, et il a attiré l'attention du public avec sa série intitulée *Conspiración Visualgore* (www.visualgore.tv), un projet qui a commencé sous la forme d'une intervention urbaine colorée, avec peintures sur des murs et des barrières, et qui s'est transformé en une gamme de t-shirts et d'affiches. Il a aussi travaillé en étroite collaboration avec plusieurs groupes musicaux locaux et nationaux, et leur a créé des logos et des livrets CD complets. Son travail a également été présenté à *Desfase Primer Asalto*, une exposition internationale d'art de la rue à Bogota.

1. "El Soye" CD cover
and booklet, 2005, Discosoye

2. "El monstruo de los mangones"
artwork, 2007, www.fuzil.ws

3. "Brinca Brinca" poster,
personal work

3

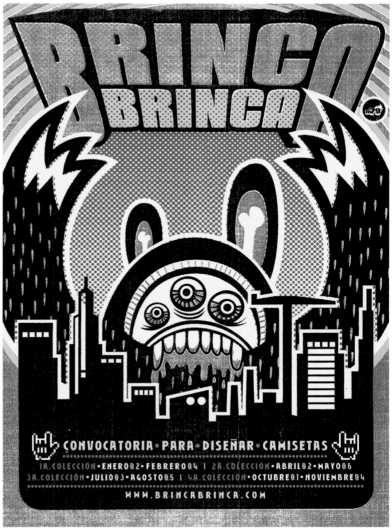

2

JORGE CARROZZINO

Jorge Carrozino is one of the most important personalities in the history of Uruguayan graphic design, having also worked intensively in textile, stage and product design. His career started in 1950, when he integrated a team of artists to create *El Grillo*, a magazine commissioned by the Ministry of Education. In 1967 he met the group of pioneers that would change the face of the graphic design in the country, including Ayax Barnes, José Campaña, Manuel Epínola Gómez and Carlos Palleiro. Working together at the advertising agency Fidel, the team collaborated on a groundbreaking series of political posters. Together with Nicolás Loureiro, Carrozino collaborated on the design of the *Enciclopedia Uruguaya*, before being exiled to Paris in 1973 where he died in 1986.

Jorge Carrozino ist eine der wichtigsten Persönlichkeiten in der Geschichte des Grafikdesigns in Uruguay. Darüber hinaus arbeitete er intensiv in den Bereichen Textildesign, Bühnenbildgestaltung und Produktdesign. Seine Karriere begann 1950, als er ein Künstlerteam zur Herausgabe von *El Grillo* zusammenstellte, eine Zeitschrift, die vom Bildungsministerium in Auftrag gegeben wurde.1967 traf er die Pioniere, die das Bild des Grafikdesigns im Land veränderten, zu denen Ayax Barnes, José Campaña, Manuel Epínola Gómez und Carlos Palleiro gehörten. Das Team arbeitete zusammen bei der Werbeagentur Fidel und entwarf eine bahnbrechende Serie von politischen Plakaten. Gemeinsam mit Nicolás Loureiro entwickelte Carrozino das Design der *Enciclopedia Uruguaya*, bevor er 1973 nach Paris ins Exil ging, wo er 1986 starb.

Jorge Carrozino est l'une des personnalités les plus importantes dans l'histoire du graphisme uruguayen. Il a également beaucoup travaillé dans la conception textile, théâtrale et de produits. Sa carrière a commencé en 1950, lorsqu'il a rejoint une équipe d'artistes pour créer *El Grillo*, un magazine commissionné par le ministère de l'Éducation. En 1967, il a rencontré un groupe de pionniers qui allait transformer le visage du graphisme dans le pays et qui comprenait Ayax Barnes, José Campaña, Manuel Epínola Gómez et Carlos Palleiro. L'équipe travaillait au sein de l'agence de publicité Fidel, et a créé une série d'affiches politiques extrêmement novatrices. Avec Nicolás Loureiro, Jorge Carrozino a travaillé à la conception de l'*Enciclopedia Uruguaya*, avant d'être exilé à Paris en 1973, où il est décédé en 1986.

1. "La expresión americana y otros ensayos de José Lezama Lima"
book cover, 1969, Editorial Arca

2. "Sobre García Márquez"
book cover, 1971,
Editorial Biblioteca de Marcha

3. "Ursula y otros cuentos"
book cover

4. "El hombre que se comió un autobus" book cover, Editorial Arca

3

4

*1922, Colombia

DICKEN CASTRO

1

1. **"Pre-Colombian"** postage stamps, 1973, National Post of Colombia

Dicken Castro belongs to the select and highly important group of professionals that established the foundation for graphic design in the region. In 1962 he set up the first ever design practice in Colombia, in Bogotá, and was a prominent figure in the educational development of graphic arts, having lectured at the Universidad Nacional de Colombia for over 25 years. The characteristic visual style of his generation has always filtered through his own peculiar interpretation, creating fascinating logos and posters that have stood the test of time. Originally trained as an architect, Castro soon realised the necessity for a dedicated graphic design studio, and exercised his professionalism with natural impulse. He has accumulated countless awards and exhibited his works throughout the world.

Dicken Castro gehört zu der ausgewählten und wichtigen Gruppe professioneller Designer, die das Fundament für Grafikdesign im Land legte. 1962 gründete er in Bogotá das erste Designstudio in Kolumbien. Er lehrte mehr als 25 Jahre an der Universidad Nacional de Colombia und stellt damit eine der bedeutendsten Figuren in der Entwicklung der Grafikerausbildung dar. Der charakteristische visuelle Stil seiner Generation unterlag immer seiner eigenen besonderen Interpretation, und er kreierte dabei faszinierende Logos und Plakate, die sich bis heute bewährt haben. Ursprünglich zum Architekten ausgebildet, erkannte Castro bald die Notwendigkeit für ein engagiertes Designstudio und nutzt seine Professionalität mit natürlichem Antrieb. Er hat für seine Arbeit zahllose Preise erhalten und seine Werke auf der ganzen Welt ausgestellt.

Dicken Castro appartient au petit groupe prestigieux de ceux qui ont posé les fondations du graphisme en Amérique latine. En 1962, il a créé le tout premier cabinet de graphisme en Colombie, à Bogota, et a tenu un grand rôle dans le développement de l'enseignement des arts graphiques. Il a donné des cours magistraux à l'Universidad Nacional de Colombie pendant plus de 25 ans. Le style visuel caractéristique de sa génération a toujours transparu dans sa propre interprétation, et a donné des logos et des affiches fascinants qui ont résisté à l'épreuve du temps. Architecte de formation, Dicken Castro a vite compris qu'il existait une demande pour un studio consacré au graphisme, et a exercé sa profession avec un instinct tout naturel. Il a remporté une multitude de récompenses, et a exposé ses œuvres dans le monde entier.

*1983, El Salvador, www.eduardochang.sv.tc

EDUARDO CHANG

1. "Pesía y Presente – Luis Muñoz" conference invitation, Centro Cultural de España en El Salvador

2. "Hechos de Ben Ciudano" exhibition teaser, Centro Cultural de España en El Salvador
Photo Eduardo Chang

3. "Medioteca" visual identity and opening invitation, Centro Cultural de España, Centro Cultural de España en El Salvador

The work created by Eduardo Chang for the Centro Cultural de España in El Salvador has brought a new dynamic to the status quo of the institution's visual communication. Educated in fine arts at the Universidad de El Salvador, specialising in photography, Chang was already an emerging new talent in graphic design before he even completed his degree. His projects with digital imagery, such as the series of posters entitled *Salvadoreño Calidad de Exportación*, are a definite representation of his style: a mix of street art, typography, illustration and photography. Chang currently resides and works in Costa Rica. He has been a lecturer at the Museo de Arte y Diseño Contemporáneo de Costa Rica and at the Museo de Arte de El Salvador.

Die Arbeiten von Eduardo Chang für das Centro Cultural de España in El Salvador haben eine neue Dynamik in die gegenwärtige visuelle Kommunikation der Institution gebracht. Ausgebildet in Bildender Kunst an der Universidad de El Salvador und spezialisiert auf Fotografie, war Chang bereits vor Abschluss seines Studiums ein aufstrebendes junges Talent des Grafikdesigns. Seine Projekte mit digitaler Symbolik, wie zum Beispiel die Plakatserie mit dem Titel *Salvadoreño Calidad de Exportación*, verkörpern genau seinen Stil: eine Mischung aus Street-Art, Typografie, Illustration und Fotografie. Chang wohnt und arbeitet gegenwärtig in Costa Rica. Er ist Dozent am Museo de Arte y Diseño Contemporáneo de Costa Rica und am Museo de Arte de El Salvador.

Les créations d'Eduardo Chang pour le Centro Cultural de España du Salvador a injecté une nouvelle dynamique dans la communication visuelle trop routinière des institutions. Eduardo Chang a étudié les beaux-arts à l'Universidad de El Salvador, s'est spécialisé dans la photographie, et était déjà un nouveau talent remarqué dans le graphisme avant de décrocher son diplôme. Ses projets dans l'imagerie numérique, comme la série d'affiches intitulée *Salvadoreño Calidad de Exportación*, sont une représentation magistrale de son style : un mélange d'art urbain, de typographie, d'illustration et de photographie. Il travaille et réside actuellement au Costa Rica. Il a été conférencier au Museo de Arte y Diseño Contemporaneo de Costa Rica et au Museo de Arte de El Salvador.

[*] clásicos [*] narrativa

[*] revistas [*] diccionarios

DAVID CONSUEGRA

1

3

2

David Consuegra was one of the most prestigious designers in Colombia, having studied at both Boston and Yale University, under tutors such as Arthur Hoener, Karl Fortess, Paul Rand, and Norman Ives, amongst many other design gurus of his time. With a strong passion for typography, Consuegra authored several books on the subject, and served as professor emeritus of graphic design, layout, and typography at the Universidad Nacional de Colombia. His acclaimed work has been widely exhibited around the world, and his design consultancy has worked for companies such as IBM, Uniroyal, and the Museo de Arte Moderno de Bogota. He received numerous awards and was a member of the International Trademark Center in Belgium.

David Consuegra war einer der angesehensten Designer in Kolumbien. Er studierte an den Universitäten von Boston und Yale unter Tutoren wie Arthur Hoener, Karl Fortess, Paul Rand und Norman Ives, um nur einige Design-Gurus seiner Zeit zu nennen. Mit einer großen Leidenschaft für Typografie verfasste Consuegra mehrere Bücher zu diesem Thema und lehrte als emeritierter Professor für Grafikdesign, Layout und Typografie an der Universidad Nacional de Colombia. Seine Werke haben große Anerkennung gefunden und wurden auf der ganzen Welt ausgestellt, während sein Designstudio für Unternehmen wie IBM, Uniroyal und das Museo de Arte Moderno de Bogota tätig war. Er erhielt zahlreiche Auszeichnungen und war Mitglied des International Trademark Centers in Belgien.

David Consuegra a été l'un des graphistes les plus prestigieux de Colombie. Il a étudié à Boston et à Yale, et a reçu les enseignements d'Arthur Hoener, Karl Fortess, Paul Rand et Norman Ives, et de bien d'autres gourous du graphisme de l'époque. Passionné de typographie, il a écrit plusieurs livres sur le sujet, et a été professeur émérite de graphisme, mise en page et typographie à l'Universidad Nacional de Colombie. Son travail est très apprécié et a été exposé aux quatre coins du globe. Parmi les clients de son cabinet de conseil en graphisme, on peut citer IBM, Uniroyal, et le Museo de Arte Moderno de Bogota. Il a reçu de nombreuses récompenses, et il était membre de l'International Trademark Center en Belgique.

1. "National Board for Tourism"
logo, 1991

2. "Artesanías de Colombia"
logo, 1968, Bureau for Colombian
handcrafts

3. "ENA" logo, 1963,
School of Architecture,
National University of Mexico

4. "Boston Symphony Orchestra"
promotional poster, 1960
Photo David Consuegra

5. "Artes" conference poster

6. "Museo de Arte Moderno
de Bogotá" logo, 1964,

ARTE Y UNIVERSIDAD

SEMINARIO SOBRE LA CONCEPTUALIZACIÓN
Y LA ENSEÑANZA DE LAS ARTES PLÁSTICAS Y LA MÚSICA

4

6

MUSEO DE ARTE MODERNO BOGOTÁ 1964

*1968, Ecuador

DIEGO CORRALES

1

1. "Blak Mama" poster and event program, 2004, Cine Ocho y Medio
Photo Miguel Alvear

2. "Festival de cine hecho en casa" film festival poster, 2005, Cine Ocho y Medio
Photo Diego Corrales, Miguel Alvear

Educated at the Instituto Metropolitano de Diseño de Quito as a designer, Diego Corrales moved to Stuttgart in Germany and worked as art director on a number of campaigns for the advertising agency Dema. After gaining a wealth of industry experience, he returned to set up his own studio in the capital city of Quito, where he divides his time between graphic design and art directing educational books. With a deep passion for illustration, Corrales' design focus has been on the cultural sector in the country, including national cinema, dance shows, theater, and visual arts, which have undergone a strong revival in recent years. He also continues to develop corporate identity projects and editorial design for commercial clients in the country.

Nach seiner Designausbildung am Instituto Metropolitano de Diseño de Quito, Ecuador, zog Diego Corrales nach Stuttgart, wo er für einige Kampagnen der Werbeagentur Dema als Art Director tätig war. Nachdem er umfangreiche Erfahrungen in der Branche gesammelt hatte, kehrte er nach Ecuador zurück und gründete sein eigenes Designstudio in der Hauptstadt Quito. Neben dem Grafikdesign entwirft und illustriert er Lehrbücher. Mit einer tiefen Leidenschaft für Illustration konzentriert sich Corrales in seiner Arbeit auf den kulturellen Bereich des Landes. Dazu gehören Kino, Tanzshows, Theater und Visual Arts, die in den letzten Jahren einen starken Aufschwung erfahren haben. Er entwickelt zudem weiterhin Corporate Identity-Projekte und Editorial Design für Geschäftskunden im ganzen Land.

Diego Corrales a étudié le graphisme à l'Instituto Metropolitano de Diseño de Quito, puis est parti à Stuttgart, en Allemagne, où il a été directeur artistique pour de nombreuses campagnes de l'agence de publicité Dema. Après avoir accumulé des trésors d'expérience dans le secteur, il est retourné à Quito pour y créer son propre studio, où il partage son temps entre le graphisme et la direction artistique de livres pédagogiques. Passionné d'illustration, il a surtout travaillé dans le secteur culturel péruvien, notamment le cinéma, les spectacles de danse, le théâtre et les arts visuels, qui ont connu un grand renouveau ces dernières années. Il continue également de développer des projets d'identité d'entreprise et de design éditorial pour des clients commerciaux péruviens.

OCHOYMEDIO

qué alhaja!

Muestra de películas
hechas en casa y
exposición de fotografías
y álbumes familiares

16-17 de abril, 17h00

**Con la actuación
estelar de**

los Crespo
los Peñafiel
los Reyes
los Hidalgo
los Moncayo
los Vargas
los Alvear
los Merino
los Montero
los Cuvi
los Falconí
los Darquea
los Luzuriaga
los Ortiz
los Simpson
y muchos más

Lecciones de cine

18 de abril, 15h00
Acercamiento a los lenguajes
del Cine Amateur

19 de abril, 15h00
Historias de la vida cotidiana:
dimensión cultural de
la fotografía familiar

OCHOYMEDIO
Valladolid N24 353
y Vizcaya

una producción propia
de OCHOYMEDIO
y WILMAN CHICHA

3

2007 *eurocine*

3. "Eurocine 2007" film festival poster and program, 2007, Cine Ocho y Medio

4. "INCINE" logo, 2004, Insitituto Superior Tecnológico de Cine y Actuación (INCINE)

5. "Ochoporojo" logo, 2004, Cine Ocho y Medio

6. "La cenicienta, ballet filmado" (Cinderella, filmed ballet play) poster, 2004, Cine Ocho y Medio

Royal Ballet
en una histórica presentación de 1969
con coreografía del guayaquileño
Sir Frederick Ashton

17 de septiembre a las 18h00
MAAC CINE

La
Cenicienta
ballet filmado

En homenaje al centenario del nacimiento de Sir Frederick Ashton. Entrada gratuita

*1980, Panama

RAUL CORREA DE BOUTAUD

1

1. **"Woman"** personal work, 2007

2. **"Love"** personal work, 2007

3. **"Broken"** personal work, 2007

4. **"Desahogo"** personal work, 2007

5. **"Tuto"** logo, 2007

Raul Correa de Boutaud belongs to the new breed of professional designers in Panama, An experienced art director, Correa de Boutaud has worked for advertising powerhouses such as JWT, McCann Eriksson and Ogilvy, handling regional accounts for Nestle and Samsung among many others. His work has received a number of national and international awards, including at the Caribe International Advertising Festival and at the national festival Lo Mejor del Patio. His works have been published in a variety of magazines, including *Made in Turbo* and *Blank*. Correa de Boutaud originally studied at the Ganexa School of Visual Arts and at the American University of Science and Technology, later teaching design and advertising in both Panama and Argentina.

Raul Correa de Boutaud gehört zu der neuen Generation professioneller Designer in Panama. Als erfahrener Art Director hat Correa de Boutaud für Werbegrößen wie JWT, McCann Eriksson und Ogilvy gearbeitet und regionale Kundenverträge mit Nestle und Samsung betreut. Seine Werke sind mit einer Reihe von nationalen und internationalen Preisen ausgezeichnet worden, unter vielen anderen auch beim Caribe International Advertising Festival und dem Festival Nacional Lo Mejor del Patio. Seine Arbeiten wurden in zahlreichen Magazinen veröffentlicht, darunter *Made in Turbo* und *Blank*. Correa de Boutaud studierte ursprünglich an der Ganexa American University of Science and Technology (ULACIT) und lehrte später Design und Reklamewesen in Panama und Argentinien.

Raul Correa de Boutaud appartient à la nouvelle génération de graphistes professionnels du Panama. Directeur artistique chevronné, il a travaillé pour de grandes agences de publicité telles que JWT, McCann Eriksson et Ogilvy, et s'est chargé entre autres des comptes Nestlé et Samsung pour l'Amérique latine. Son travail a reçu plusieurs récompenses nationales et internationales, notamment au festival international de la publicité Caribe et au festival national Lo Mejor del Patio. Ses créations ont été publiées dans de nombreux magazines, notamment *Made in Turbo* et *Blank*. Il a d'abord étudié à l'École des Beaux-Arts Ganexa et à l'Université des sciences et technologies (ULACIT), et a par la suite enseigné le graphisme et la publicité au Panama et en Argentine.

2

3

BR KEN

4

5

*1948, Brazil, www.joaobaptista.art.br

JOÃO BAPTISTA DA COSTA AGUIAR

COMPANHIA DAS LETRAS

COMPANHIA DAS LETRAS

COMPANHIA DAS LETRAS

Companhia das Letrinhas

Companhia das Letrinhas

Companhia das Letrinhas

CIA. DAS LETRAS

CIA. DAS LETRAS

CIA. DAS LETRAS

1

A graduate of FAAP in São Paulo, João Baptista started his career at Abril Publishing in the 70s, serving as the art director for *Vogue Brazil* from 1976 to 1979, before moving on to work exclusively on cultural projects. After a period of study at the Campinas State University, where he helped to establish the Creative Development Centre, he moved back to graphic design in 1986 to create the much acclaimed identity for the publishing house Editora Companhia das Letras. Soon after, da Costa Aguiar accepted an appointment as visual communications adviser for São Paulo City Hall, where he directed a number of projects in a bid to raise the city's profile by improving and standardising the visual identity of its many areas. He currently runs his design studio in São Paulo.

João Baptista da Costa Aguiar schloss in den siebziger Jahren sein Studium an der FAAP in São Paulo ab und begann seine berufliche Laufbahn bei Abril Publishing. Von 1976 bis 1979 war er als Art Director für *Vogue Brazil* tätig, bevor er sich ausschließlich kulturellen Projekten zuwandte. Nach einer Studienzeit an der Landesuniversität von Campinas, wo er beim Aufbau des kreativen Entwicklungscenters half, beschäftigte er sich ab 1986 wieder mit Grafikdesign und kreierte die viel gelobte Corporate Identity für das Verlagshaus Editora Companhia das Letras. Kurz danach nahm da Costa Aguiar eine Stellung als Berater für Visuelle Kommunikation im Rathaus von São Paulo an. Dort leitete er einige Projekte, die zum Ziel hatten, das Profil der Stadt durch die Verbesserung und Vereinheitlichung der Visual Identity ihrer vielen Stadtteile besser darzustellen. Er leitet zurzeit sein eigenes Designstudio in São Paulo.

Diplômé de la FAAP de São Paulo, João Baptista a commencé sa carrière chez Abril Publishing dans les années 1970, a été directeur artistique pour *Vogue Brésil* de 1976 à 1979, puis s'est consacré exclusivement aux projets culturels. Après une période d'études à l'Université d'état de Campinas, où il a contribué à la création du Centre de développement créatif, il est retourné au graphisme en 1986 pour créer l'identité de la maison d'édition Editora Companhia das Letras, un projet qui a rencontré un franc succès. Peu après, il a accepté un poste de conseiller en communication visuelle pour l'Hôtel de Ville de São Paulo, où il a dirigé plusieurs projets pour améliorer l'image de la ville et harmoniser l'identité visuelle de ses multiples branches. Il dirige actuellement son studio de graphisme à São Paulo.

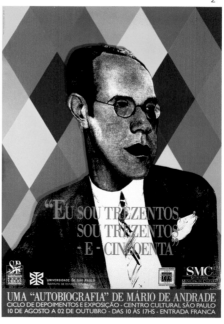

1. "Companhia das Letras"
visual identity system,1986,
Companhia das Letras
Publishing House

2. "São Paulo dos Mil Povos"
anniversary poster, 1992,
Secretaria Municipal de Cultura
Awards II National Design Biennial

3. "Eu sou Trezentos,
sou Trezentos-e-cincoenta"
book launch event poster, 1990,
Secretaria Municipal de Cultura
da cidade de São Paulo.
Awards II National Design Biennial

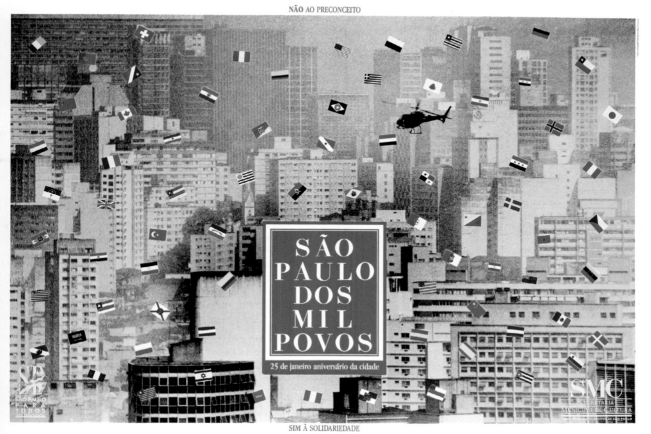

*1964, Brazil, www.anacouto.com.br

ANA COUTO

1

Ana Couto was born in Rio de Janeiro. Her studio, Ana Couto Branding & Design, is a specialised design and branding consultancy that has rapidly gained a reputation over the last decade, having developed a wide range of projects for national and international clients such as Procter & Gamble, WWF, L'Oréal, Ernst&Young, Coca-Cola, Petrobras and Embraer. With a strong emphasis on brand strategy, the company employs over 50 people in São Paulo and Rio de Janeiro, from designers to trend researchers, marketing professionals to account managers. Their activities range from identity to packaging, annual report design to complete brand positioning. The consultancy has received a number of awards, including the Design Office of the Year and their works have been widely published in Brazil and abroad.

Ana Couto wurde in Rio de Janeiro geboren. Ihr Studio Ana Couto Branding & Design hat sich auf Beratungen im Bereich Design und Corporate Branding spezialisiert und innerhalb von zehn Jahren sehr gut etabliert. Das Beratungsunternehmen hat zahlreiche Projekte für nationale und internationale Kunden entwickelt, zu denen Procter & Gamble, WWF, L'Oréal, Ernst&Young, Coca-Cola, Petrobras und Embraer zählen. Mit ihrem Schwerpunkt auf Strategien zum Corporate Branding beschäftigt das Unternehmen über 50 Mitarbeiter in São Paulo und Rio de Janeiro. Dazu gehören Designer, Trendforscher, Marketingexperten und Kundenbetreuer. Ihre Aktivitäten reichen von Corporate Identity und Verpackungsdesign über Design von Geschäftsberichten bis hin zur vollständigen Positionierung von Warenzeichen. Die Gruppe hat eine Reihe von Preisen erhalten, darunter die Auszeichnung Designstudio des Jahres, und ihre Arbeiten wurden in großem Umfang in Brasilien und im Ausland ausgestellt.

Ana Couto est née à Rio de Janeiro. Son studio, Ana Couto Branding & Design, est un cabinet de conseil spécialisé dans le graphisme et la stratégie de marque. Sa réputation a rapidement grandi au cours des dix dernières années, car le cabinet s'est occupé de nombreux projets pour de grands clients nationaux et internationaux, notamment Procter & Gamble, WWF, L'Oréal, Ernst&Young, Coca-Cola, Petrobras et Embraer. Le cabinet travaille surtout sur la stratégie de marque, et emploie plus de 50 personnes à São Paulo et à Rio de Janeiro, graphistes, experts en tendances, professionnels du marketing et responsables de comptes. Leurs activités vont de l'identité d'entreprise à la conception d'emballage, et de la conception des rapports annuels au positionnement complet d'une marque. Le cabinet a reçu de nombreuses récompenses, dont le prix Design Office of the Year, et leurs créations ont beaucoup été publiées au Brésil et à l'étranger.

1. "Blah!" brand identity and brand manual, 2002, Blah!

2. "House of Erika Palomino" logo and applications, 2006, Erika Palomino

3–4. "Klabin" sustainability and annual report (Raízes do Crescimento), 2006–2007, Klabin

3

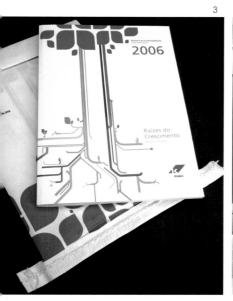

4

*1945, Mexico

FELIPE COVARRUBIAS

1. "XI Congreso ENEDI Servicio"
poster, 1993, ENEDI

2. "Diseño – Designio"
poster, 1998, Escuela de Diseño
ITESO Design School

Felipe Covarrubias studied architecture at the Universidad Jesuita de Guadalajara, before specialising in typography at Croydon College of Design and Technology in the United Kingdom. Upon his return to Mexico, his first appointment as a designer was at the regional government of Jalisco province, northwest of Mexico City. He currently serves as director of the design department of the university he graduated from, and is a frequent lecturer in the region, having taught in Argentina, Colombia, Cuba, Guatemala, El Salvador, Nicaragua and Canada. Since 1980 Covarrubias has also managed his own design consultancy, focusing mainly on corporate identity and editorial design. His works have been published in *Novum* magazine, and in the book *World Graphic Design*.

Felipe Covarrubias studierte am Universidad Jesuita de Guadalajara in Mexiko Architektur, bevor er sich an der Croydon College of Design and Technology in Großbritannien auf Typografie spezialisierte. Nach seiner Rückkehr in sein Heimatland erhielt er seine erste Anstellung als Designer bei der Regierung des Bundesstaates Jalisco, nordwestlich von Mexico City. Covarrubias ist derzeit als Leiter des Fachbereichs Design an der Universität tätig, an der er sein Studium abgeschlossen hatte, und ist zudem ein gefragter Dozent im In- und Ausland. Er lehrte bereits in Argentinien, Kolumbien, Kuba, Guatemala, El Salvador, Nicaragua und Kanada. Seit 1980 leitet Covarrubias sein eigenes Beratungsunternehmen für Design, das sich hauptsächlich auf Corporate Identity und Editorial Design spezialisiert hat. Seine Arbeiten wurden im Magazin *Novum* und in dem Werk *World Graphic Design* veröffentlicht.

Felipe Covarrubias a étudié l'architecture à l'Universidad Jesuita de Guadalajara, avant de se spécialiser en typographie au Croydon College of Design and Technology, au Royaume-Uni. À son retour au Mexique, il a occupé son premier poste de graphiste pour le gouvernement régional de la province de Jalisco, au nord-ouest de Mexico. Il est actuellement directeur du département de graphisme de l'université où il a reçu son diplôme, et donne souvent des cours magistraux dans la région. Il a enseigné en Argentine, en Colombie, à Cuba, au Guatemala, au Salvador, au Nicaragua et au Canada. Depuis 1980, Felipe Covarrubias dirige également son propre cabinet de conseil en graphisme, spécialisé dans l'identité d'entreprise et le design éditorial. Ses travaux ont été publiés dans le magazine *Novum* et dans le livre *World Graphic Design*.

3. **"Martirio Gráfico"** artwork,
1994, personal work

4. **"Las contadoras"** artwork,
2005, personal work

*1977, Mexico, www.coyotelabofdesign.com

JOSÉ LUIS COYOTL MIXCOATL

1

José Luis Coyotl Mixcoatl graduated from the Benemérita Universidad Autónoma in Puebla. He is a multitalented designer, typographer, and illustrator, whose work mixes a lot of the three disciplines that he dominates, approaching each piece with a very contemporary language. His work has been featured in *TipoGráfica* in Argentina, *Step* in the United States, *New Typographics with Font Samples* in Japan, and *NEO2* in Spain, among many other design publications. His engagement in social causes has led him to create fonts, from which all proceeds are donated to the project *Font Aid III*; a fund that helps people affected by the Asian tsunami in 2004. Coyotl Mixcoatl's work on snowboards has also been nominated at the Salomon Snowboards Artwork Contest in 2005.

José Luis Coyotl Mixcoatl absolvierte sein Studium an der Benemérita Universidad Autónoma in Puebla, Mexiko. Er ist ein multitalentierter Designer, Typograf und Illustrator, in dessen Arbeiten sich diese drei Disziplinen stark vermischen. Dadurch erhält jedes Werk eine sehr moderne und zeitgenössische Sprache. Neben anderen Design-Publikationen wurden seine Arbeiten in *TipoGráfica* in Argentinien vorgestellt, sowie in *Step* (USA), in *New Typographics with Font Samples* (Japan) und in *NEO2* (Spanien). Sein Engagement im Sozialbereich hat ihn dazu geführt, Schriftarten zu schaffen, deren sämtliche Erlöse dem Projekt *Font Aid III* zugute kommen. Dieser Fond hilft Menschen, die von dem Asiatischen Tsunami 2004 betroffen waren. Coyotl Mixcoatls Arbeiten auf Snowboards wurden 2005 auf dem Salomon Snowboards Artwork Contest ausgezeichnet.

José Luis Coyotl Mixcoatl est diplômé de la Benemérita Universidad Autónoma de Puebla. C'est un graphiste, typographe et illustrateur aux talents multiples. Son travail est un mélange des trois disciplines qu'il maîtrise, et il approche chaque projet avec un langage très contemporain. Son travail a été publié dans *TipoGráfica* en Argentine, *Step* aux États-Unis, *New Typographics with Font Samples* au Japon, et *NEO2* en Espagne, entre autres nombreuses apparitions dans d'autres publications. Son engagement dans les causes sociales l'a mené à créer des polices de caractères dont tous les bénéfices sont reversés au projet *Font Aid III*. C'est un fonds qui aide les victimes du tsunami qui a eu lieu en Asie en 2004. Le travail qu'il a réalisé sur des planches de snowboard a également été nominé au concours Salomon Snowboards Artwork en 2005.

1. **"Almas y Flores"** snowboard
artwork, 2005

2. **"Hoy viviré"** CD artwork, 2002, BMG

3. **"IES 10th anniversary"** poster, 2005,
Instituto de Estudios Superiores en
Arquitectura y Diseño de Puebla

3

2

*1923, Venezuela

CARLOS CRUZ-DIEZ

1. "Contemporary Venezuelan Artists"
exhibition poster, 1978,
Artists Market Gallery, London

2. "Reflexion sobre el color"
book cover, 1989, Fabriart

3. "La calidad de la vida"
magazine cover, 1974,
El Farol Magazine

Carlos Cruz-Diez is an internationally renowned artist, known for his kinetic and op art pieces, and one of the pioneers of modern design in Venezuela. He studied fine art at the Escuela de Artes Plásticas y Aplicadas de Caracas between 1940-45, during which time he started working as a cartoonist and illustrator for magazines *La Esfera* and *Tricolor*. Cruz-Diez went on to meet American typographer Larry June at the Creole Petroleum Corp. where he worked as art director, collaborating on numerous projects, including the remarkable *El Farol* magazine. Later, his ideas on colour, typography and editorial design would have a major impact on the direction of graphic design in the country, a practise that he would never abandon throughout his predominantly fine arts career. In 1997, the Carlos Cruz-Diez Print and Design Museum officially opened in Caracas. He currently lives in Paris.

Carlos Cruz-Diez ist ein international renommierter Künstler, der für seine kinetischen und Op-Art-Werke berühmt ist, und zudem einer der Pioniere des modernen Design in Venezuela. Während seines Studiums der bildenden Künste an der Escuela de Artes Plásticas y Aplicadas de Caracas von 1940-1945 begann er seine Arbeit als Karikaturist und Illustrator für die Zeitschriften *La Esfera* und *Tricolor*. Später traf Cruz-Diez den amerikanischen Typografen Larry June bei der Creole Petroleum Corp., wo er als Art Director tätig war, und arbeitete mit ihm zusammen an zahlreichen Projekten, darunter das bemerkenswerte Magazin *El Farol*. Mit seinen Ideen und Vorstellungen über das Zusammenwirken von Farbe, Typografie und Editorial Design hatte er größten Einfluss auf die Richtung des Grafikdesigns im Land und wurde mit seinem der konkreten Kunst zuzurechnenden Werk mehrfach mit Preisen ausgezeichnet. Im Jahr 1997 wurde das Carlos Cruz-Diez Druck- und Designmuseum offiziell in Caracas eröffnet. Er lebt zurzeit in Paris.

Carlos Cruz-Diez est un artiste à la renommée internationale, connu pour ses œuvres d'art cinétique et optique. C'est l'un des pionniers du graphisme moderne au Venezuela. Il a étudié les beaux-arts à l'École d'art plastique et appliqué de Caracas entre 1940 et 1945, et a en même temps commencé à travailler comme auteur de bande dessinée et illustrateur pour les magazines *La Esfera* et *Tricolor*. Il a ensuite rencontré le typographe américain Larry June à la Creole Petroleum Corp., où il a été directeur artistique et a contribué à de nombreux projets, dont le remarquable magazine *El Farol*. Plus tard, ses idées sur la couleur, la typographie et le design éditorial allaient avoir un impact énorme sur le graphisme dans son pays, discipline qu'il n'a jamais abandonnée tout au long de sa carrière plutôt axée sur les beaux-arts. Le musée Carlos Cruz-Diez de la presse et du graphisme a été inauguré en 1997 à Caracas. Il vit actuellement à Paris.

EL FAROL 1974 · LA CALIDAD DE LA VIDA 1

*2001, Colombia, www.cuartopiso.com

CUARTOPISO

1

1. "¿Qué dia es hoy?"
calendar in collaboration
with Arutza Onzaga
Concept Carlos J. Roldán
Illustration Alejandro Posada,
Carlos J. Roldán

2. "Apartment" website,
www.apartment.com.co

Cuartopiso is the creative studio of Alejandro Posada (b.1972), a graduate in fine arts from the Universidad Nacional de Colombia, and graphic designer Carlos J. Roldán (b.1973), a graduate of the Universidad Pontificia Bolivariana de Medellín (UPB). United by their passion for visual arts, the pair founded Cuartopiso in 2001, where they divide their time among collaborative and independent projects. Their focus has been the Internet, animation, multimedia projects and the development of DVD design and interface, mostly for the fashion, art and architecture sectors. They have received several awards, including the most important design prize in the country, Lápiz de Acero. Their works have been published both in Colombia and abroad.

Bei Cuartopiso handelt es sich um das Kreativstudio von Alejandro Posada (geb. 1972, Abschluss an der Universidad Nacional de Colombia in Bildender Kunst) und dem Grafikdesigner Carlos J. Roldán (geb. 1973, Absolvent der Universidad Pontificia Bolivariana de Medellín, UPB). Verbunden durch ihre Leidenschaft für Visual Art gründeten die beiden 2001 das Studio Cuartopiso, in dem sie gemeinschaftliche und eigenständige Projekte durchführen. Ihr Schwerpunkt liegt in den Bereichen Internet und Animation sowie in Multimedia-Projekten und der Entwicklung von DVD-Design, überwiegend für die Sparten Mode, Kunst und Architektur. Sie haben mehrere Preise erhalten, darunter den wichtigsten Designerpreis des Landes: Lápiz de Acero. Ihre Arbeiten wurden in Kolumbien und im Ausland veröffentlicht.

Cuartopiso est le studio de création d'Alejandro Posada (né en 1972), diplômé des beaux-arts de l'Universidad Nacional de Colombia, et du graphiste Carlos J. Roldán (né en 1973), diplômé de l'Universidad Pontificia Bolivariana de Medellín (UPB). Unis par leur passion pour les arts visuels, ils ont fondé Cuartopiso en 2001. Ils partagent leur emploi du temps entre projets collaboratifs et indépendants. Ils se sont spécialisés dans les domaines de l'Internet, de l'animation, des projets multimédias et des interfaces DVD, principalement dans les secteurs de la mode, de l'art et de l'architecture. Ils ont reçu plusieurs récompenses, dont le Lápiz de Acero, le prix de graphisme le plus prestigieux du pays. Leurs créations ont été publiées en Colombie et à l'étranger.

Our Fall05 line blends embellished details, the use of vivid retro prints and Latin pop culture references such as religious imagery, to create distinctive pieces with unparalleled style.

PENSAMIENTO TRASATLÁNTICO CONTEMPORÁNEO

Pensamiento Trasatlántico Contemporáneo es un ciclo de conferencias que reúne a pensadores de lado y lado del océano, dispuestos a recorrer los bordes de los discursos filosóficos, estéticos, históricos y políticos para desencubrir en la travesía de los lenguajes de hoy aquellas derivas que pueden dar cuenta de lo que todavía cabe esperar a lo largo de itinerarios sin garantías, abiertos a lo imprevisible.

Maurizio Ferraris (Universidad de Turín) **Encuentros Cercanos con Jacques Derrida** 24 DE ABRIL DE 2007 a las 6 pm.

Francisco Ortega y Bruno Mazzoldi
(CES - U. Nacional de Colombia) y (U. de Nariño) **Seguridad Aterradora - A Propósito del IV Avatar de Vishnu** 14 DE MAYO DE 2007 a las 6 pm.

Félix Duque (U. Autónoma de Madrid) **Escatología Filosófica: La Paradoja del Idioma Universal** 5 DE JUNIO DE 2007 a las 6 pm.

Domingo Hernández (U. de Salamanca) **Hackers, Hacktivistas, Artivistas y Otras Especies Fronterizas** 26 DE JUNIO DE 2007 a las 6 pm.

CENTRO DE EVENTOS Y CONVENCIONES DE LA
BIBLIOTECA LUIS ÁNGEL ARANGO
BANCO DE LA REPÚBLICA, BOGOTÁ, D.C.

ENTRADA LIBRE

BOG

MIRADAS
España · Colombia

BANCO DE LA REPÚBLICA
BIBLIOTECA LUIS ÁNGEL ARANGO

Pensar

def: B|CUARTOPISO

3. "Pensamiento Trasatlántico Contemporáneo" poster, 2007, Embassy of Spain in Colombia

4–5. "Lounge.co 2005" CD packaging, 2005, Mélodie Lounge
Photo Diana Montoya

LOUNGE.CO 2005

6. "Ciclo de Cine Español 2007"
poster, 2007, Embassy of Spain
in Colombia

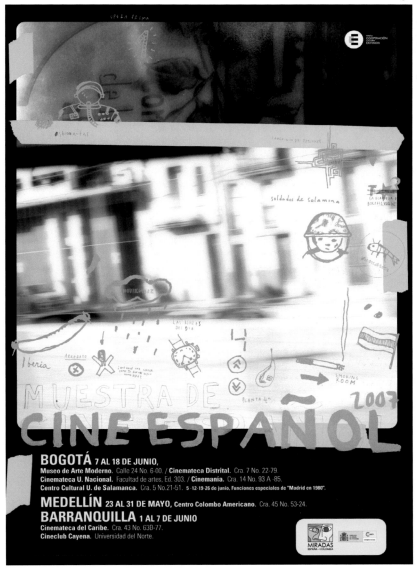

5

*1978, Argentina, www.22-10-78.com

DAMIÁN DI PATRIZIO

1

2

Damián Di Patrizio started his career as a graphic designer in 1999 at Brokers DDB. He subsequently worked for a number of agencies before moving to Italy, where he served as art director at Sonar Studio, attending to clients such as Adobe and ABB. In 2005 he left for Spain to work at Frontiera Diligent, a Barcelona-based studio where he created designs for Banco Sabadell and Caixa Catalunya, among others. Di Patrizio has been widely published in Europe and Asia. His works have appeared in the Spanish magazine *Visual* and *NTMY Editorial Victionary* from Hong Kong. He has received numerous industry accolades including the Gold Medal at the El Diente Festival, and an Art Directors Club award for his campaign for Organ Donations for the Buenos Aires Mayor in 2005. He currently lives and works in Buenos Aires.

Damián Di Patrizio begann 1999 seine berufliche Laufbahn als Grafikdesigner bei Brokers DDB. Anschließend arbeitete er für eine Reihe von Agenturen, bevor er schließlich nach Italien übersiedelte, wo er als Art Director für das Sonar Studio tätig war und Kunden wie Adobe und ABB betreute. 2005 zog er nach Spanien, um bei Frontiera Diligent zu arbeiten, ein Studio mit Sitz in Barcelona, wo er unter anderem Designs für die Banken Banco Sabadell und Caixa Catalunya entwarf. Di Patrizios Arbeiten wurden in großem Umfang in Europa und Asien ausgestellt und erschienen zudem im spanischen Magazin *Visual* und im *NTMY Editorial Victionary* in Hong Kong. Er hat zahlreiche Auszeichnungen erhalten, darunter die Goldmedaille des Festivals *El Diente* sowie die Auszeichnung des Art Directors Club für seine Organspenden-Kampagne in Buenos Aires 2005. Zurzeit lebt und arbeitet er in Buenos Aires.

Damián Di Patrizio a commencé sa carrière de graphiste en 1999 chez Brokers DDB. Il a ensuite travaillé pour plusieurs agences avant de partir en Italie, où il a été directeur artistique chez Sonar Studio, et a travaillé avec des clients comme Adobe et ABB. En 2005, il est parti en Espagne pour travailler chez Frontiera Diligent, un studio barcelonais où il a créé des graphismes pour Banco Sabadell et Caixa Catalunya, entre autres. Il a beaucoup été publié en Europe et en Asie. Ses œuvres sont apparues dans le magazine espagnol *Visual* et dans *NTMY Editorial Victionary* à Hong Kong. Il a reçu de nombreuses récompenses de ses pairs, notamment la médaille d'or du festival *El Diente*, et un prix de l'Art Directors Club pour sa campagne en faveur de la donation d'organes, réalisée en 2005 pour la mairie de Buenos Aires. Actuellement, il vit et travaille à Buenos Aires.

1. **"Mirror Soul"** CD cover,
2005, Mirror Soul/Dj

2. **"Mundo"** catalogue cover,
2006, Sooft

3. **"Chase"** poster, 2006,
self-promotion

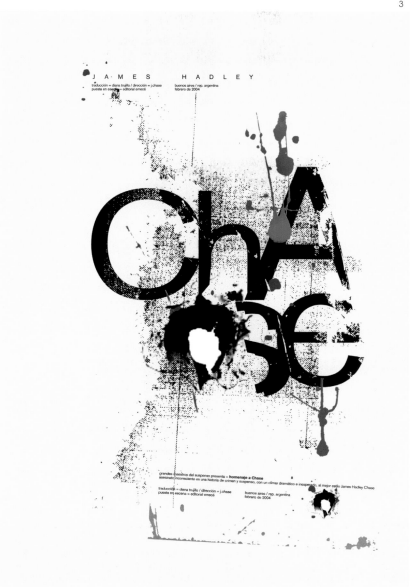

*1951, Venezuela

AIXA DÍAZ MILANO

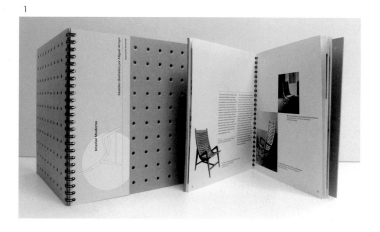

1

1. "Arroyo: Interior Moderno"
exhibition catalogue (Miguel Arroyo),
Sala Trasnocho Arte Contacto

2. "Carpeta Macma" poster,
2000, Museo de Arte Contemporáneo
de Maracay Mario Abreu

3. "25 Salón de Arte Aragua"
exhibition poster and program,
2000, Museo de Arte Contemporáneo
de Maracay Mario Abreu

Aixa Días is without doubt one of the most important graphic design veterans in Venezuela. A graduate of the Escuela de Artes Visuales Cristóbal Rojas in Caracas, she also studied literature at the Universidad Católica Andrés Bello. Her career started at the Museo de Arte Contemporáneo, where she worked as an assistant to the legendary designer Nedo M.F. She later took on a teaching job at the Instituto Prodiseño, and to opened her own studio in 1995, concentrating on editorial design. Días has served as the art director for the magazines *Actual* and *Folios*, and has created numerous art catalogues for galleries and museums, including for the Museo de Bellas Artes, Galería de Arte Nacional, Museo de Arte Contemporáneo de Caracas, Museo de Arte Colonial and Museo de Arte Contemporáneo de Maracay.

Aixa Días gehört zweifelsohne zu den wichtigsten Grafikdesign-Veteranen in Venezuela. Sie schloss ihr Studium an der Escuela de Artes Visuales Cristóbal Rojas in Caracas ab und studierte zudem Literatur an der Universidad Católica Andrés Bello. Ihre berufliche Laufbahn begann am Museo de Arte Contemporáneo, wo sie für den legendären Designer Nedo M.F. als Assistentin arbeitete. Später übernahm sie eine Stelle als Dozentin am Instituto Prodiseño und eröffnete1995 ihr eigenes Studio mit Schwerpunkt Editorial Design. Días ist als Art Director für die Magazine *Actual* und *Folios* beschäftigt und hat zahlreiche Kunstkataloge für Galerien und Museen entworfen, zum Beispiel für das Museo de Bellas Artes, die Galería de Arte Nacional, das Museo de Arte Contemporáneo de Caracas, das Museo de Arte Colonial und das Museo de Arte Contemporáneo de Maracay.

Aixa Días occupe sans aucun doute une place de choix parmi les vétérans du graphisme au Venezuela. Diplômée de l'école d'arts visuels Cristóbal Rojas de Caracas, elle a également étudié la littérature à l'Universidad Católica Andrés Bello. Sa carrière a commencé au Museo de Arte Contemporáneo, où elle a été l'assistante du graphiste légendaire Nedo M.F. Elle a ensuite été professeure à l'institut Prodiseño, puis elle a ouvert son propre studio en 1995, et s'est spécialisée dans le design éditorial. Elle a été directrice artistique pour les magazines *Actual* et *Folios*, et a créé de nombreux catalogues d'art pour des galeries et des musées, notamment pour le Museo de Bellas Artes, la Galería de Arte Nacional, le Museo de Arte Contemporáneo de Caracas, le Museo de Arte Colonial et le Museo de Arte Contemporáneo de Maracay.

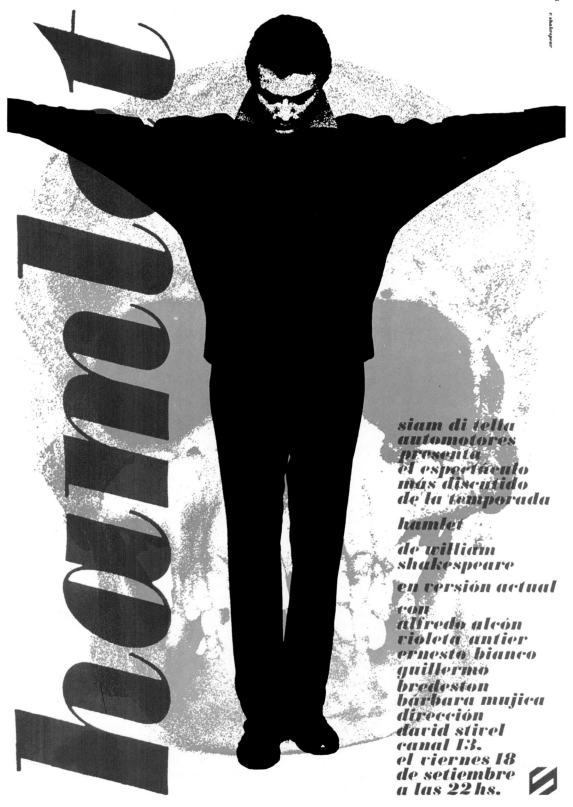

3. "Temaikèn Zoo"
visual identity and signage, 2000

3

4. "Subte" Buenos Aires Underground visual identity and signage, 2006

*1998, Argentina, www.doma.tv

DOMA

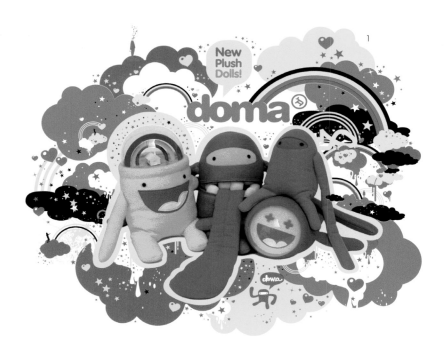

1. "Doma Plush ArtToys"
promotional illustration, 2005
Design Mariano Barbieri,
Julian Pablo Manzelli,
Matias Vigliano, Orilo Blandini

Doma emerged in 1988 to become one of the most radical graphic design groups in Argentina, working under the motto, "action – reaction". The group of leading graphic designers, illustrators, film makers and musicians met at the Universidad de Buenos Aires, where they explored synergies through experimentation with constructive results. In recent years, Doma has created motion graphics for clients such as MTV Latino, VH1, and Sony AXN. The group has continued to push the boundaries of experimental installation art, exhibiting their range of plush vinyl toys in a number of renowned galleries and museums. "To understand society as a big laboratory, allows us to detect its reactions over a number of stimuli. We live in a particular moment where a cycle of change can kick-start a chain of action."

Doma entstand 1988 und wurde zu einem der radikalsten Unternehmen für Grafikdesign in Argentinien, das sich dem Wahlspruch „Aktion – Reaktion" verschrieben hat. Die Gruppe aus führenden Grafikdesignern, Illustratoren, Filmemachern und Musikern traf sich an der Universidad de Buenos Aires, wo sie mit Synergien experimentierten und konstruktive Ergebnisse erzielten. In den letzten Jahren hat Doma überwiegend Motion-Grafiken für Kunden wie MTV Latino, VH1 und Sony AXN entwickelt. Die Gruppe versucht weiterhin, die Grenzen von experimentellen Installationen zu erproben, und stellt ihre Kollektion über plüschige Vinylspielzeuge in einer Reihe von renommierten Galerien und Museen aus. „Wenn wir die Gesellschaft als ein großes Laboratorium verstehen, können wir durch eine Anzahl von Anreizen ihre Reaktionen aufdecken. Wir leben in einem bestimmten Moment, in dem eine Folge von Veränderungen eine Kettenreaktion in Gang setzen kann."

Doma est né en 1988 et est devenu l'un des groupes de graphisme les plus radicaux d'Argentine. Sa devise est « action – réaction » Les membres de ce groupe de graphistes, illustrateurs, réalisateurs et musiciens d'exception se sont rencontrés à l'Universidad de Buenos Aires, où ils ont obtenu des résultats constructifs en explorant les synergies à travers l'expérimentation. Ces dernières années, Doma a créé des animations pour des clients tels que MTV Latino, VH1 et Sony AXN. Le groupe a continué de repousser les limites de l'art d'installation expérimental, et a exposé son arsenal de somptueux jouets en vinyle dans de nombreuses galeries et de nombreux musées renommés. « Nous voyons la société comme un grand laboratoire. Cela nous permet de détecter ses réactions à différents stimuli. Nous vivons à une époque où le cycle du changement peut déclencher une chaîne d'action. »

2. "Roni Surfer" numbered
screen-printing exhibition
poster (UstedContento), 2003
Design Mariano Barbieri,
Julian Pablo Manzelli,
Matias Vigliano, Orilo Blandini

3. "Tirita Munies" numbered
screen-printing poster, 2005
Design Mariano Barbieri,
Julian Pablo Manzelli,
Matias Vigliano, Orilo Blandini

*1997, Brazil, www.egdesign.com.br

EG.DESIGN

1

1. "Rio 92" logo, 1992,
The United Nations Conference
on Environment and Development
Design Evelyn Grumach
Awards Rio 92 logo national
competition (winner); Excellence sea
visual identity category, 2nd Design
Biennial, Curitiba, 1992; 4th Graphic
Design Biennial, ADG, São Paulo,
1998; exhibition *ESDI 30 anos*, Rio de
Janeiro, 1993; exhibition *Brasil Faz
Design*, São Paulo/Rio, 1995; exhibition
*Singular and Plural…almost there…th.
last 50 years of Brazilian design*, gallery
Tomie Ohtake, São Paulo, 2002

Born in Rio de Janeiro, Evelyn Grumach is one of the most experienced designers in her country, having graduated from ESDI, the first undergraduate design course in Latin America. In 1992 she won the competition to design the logo for the United Nations Conference on Environment and Development, also known as the Earth Summit. With a strong focus on corporate identity, sign design, and editorial, she opened her own studio, eg.design, in 1997. For over a decade, she has been responsible for the entire brand design for the publishing house Civilização Brasileira, as well as many editorial projects for Editora Record. Among her numerous awards, she has won the International Graphic Design Prize from the Art Directors Club from Barcelona.

Evelyn Grumach stammt gebürtig aus Rio de Janeiro und ist eine der versiertesten Designerinnen Brasiliens. Sie erhielt ihre Ausbildung an der ESDI, eine der ältesten Designschulen Lateinamerikas. 1992 gewann sie den Wettbewerb für den Entwurf des Logos der Konferenz der Vereinten Nationen über Umwelt und Entwicklung, häufig auch als Erdgipfel bezeichnet. Mit den Schwerpunkten Corporate Identity, Sign Design und Editorial Design eröffnete sie 1997 ihr eigenes Studio eg.design. Seit über zehn Jahren ist sie verantwortlich für das gesamte Markendesign des Verlagshauses Civilização Brasileira sowie für viele Editorial-Projekte für Editora Record. Neben ihren zahlreichen Auszeichnungen bekam sie den internationalen Preis für Grafikdesign des Art Directors Club in Barcelona verliehen.

Née à Rio de Janeiro et diplômée de l'ESDI, le premier programme de graphisme de deuxième cycle en Amérique latine, Evelyn Grumach fait partie des graphistes les plus expérimentés de son pays. En 1992, elle a gagné le concours pour la création du logo de la conférence des Nations Unies sur l'environnement et le développement, également connue sous le nom de Sommet de la Terre. Elle est spécialisée en identité d'entreprise, conception de panneaux de signalisation et design éditorial. Elle a ouvert son propre studio, eg.design, en 1997. Elle a été responsable de toute l'identité de marque de la maison d'édition Civilização Brasileira pendant plus de dix ans, ainsi que de nombreux projets éditoriaux pour Editora Records. Parmi ses nombreuses récompenses, on peut citer le prix International Graphic Design de l'Art Directors Club de Barcelone.

2. "Baile na Roça" poster, 2003, Projeto Portinari
Design Evelyn Grumach
Assistant Fernanda Garcia

3. "Senac Fashion and Design Summer Trends" visual identity and applications, 2005
Design Evelyn Grumach
Assistant Fernanda Garcia

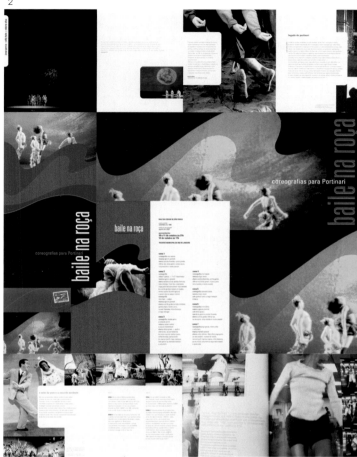

***1990, Ecuador, www.elpobrediablo.com**

EL POBRE DIABLO

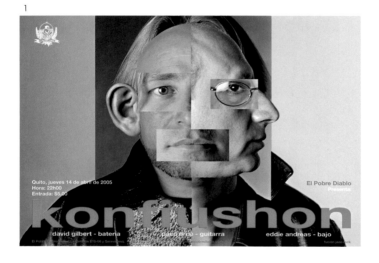

1

Quito, jueves 14 de abril de 2005
Hora: 22h00
Entrada: $5.00

El Pobre Diablo
Presenta

Konfiushon

david gilbert - batería paco arce - guitarra eddie andreas - bajo

1. "Konfiushon" poster, 2005
Design/photo Pepe Avilés

2. "Hasta la vista, Baby!" poster, 2000
Design Pepe Avilés, Juan Lorenzo
Barragán, Ana Fernández

Having established a brand and a form of work that distinguishes itself from any other design studio, El Pobre Diablo is one of the most unique creative initiatives in the whole continent. Originally built as a bar and restaurant in 1990, El Pobre Diablo has, from its beginning, consistently promoted art events and exhibitions. Along with El Conteiner, a dedicated production space, El Pobre Diablo has been the hub for the creative scene in Quito since 2002. Moreover, the venue has also generated its own series of posters and publications through its creative director and movie aficionado Pepe Avilés. With a strong sense of humour, his work has gained international attention and has been widely published. They have received the national arts award Quit Sato for their contribution to the art community.

El Pobre Diablo steht für eine Marke und Arbeitsweise, die sich von jedem anderen Designstudio unterscheiden, und ist daher eine auf dem gesamten Kontinent einzigartige kreative Initiative. Ursprünglich 1990 als Bar und Restaurant gebaut, hat El Pobre Diablo von Anfang an immer wieder Kunstveranstaltungen und Ausstellungen gefördert. In Gemeinschaft mit El Conteiner, einer engagierten Produktionsumgebung, ist El Pobre Diablo seit 2002 der Mittelpunkt der kreativen Szene in Quito, Ecuador. Zudem hat der Veranstaltungsort durch seinen Kreativchef und Filmliebhaber Pepe Avilés seine eigene Plakatserie und Publikationen entwickelt. Seine besonders humorvollen Arbeiten fanden internationale Anerkennung und wurden vielerorts veröffentlicht. Die Gruppe El Pobre Diablo hat die nationale Kunstauszeichnung Quit Sato für ihren Beitrag zur Kunstszene erhalten.

El Pobre Diablo est une initiative unique en Amérique latine. Ce studio de graphisme a créé une marque et une façon de travailler qui le distingue de tous les autres. En 1990, El Pobre Diablo était un bar-restaurant, qui depuis ses débuts a toujours proposé des événements artistiques et des expositions. Avec El Conteiner, un espace consacré à la production, depuis 2002 El Pobre Diablo est une véritable plateforme pour le monde de la création à Quito. Le local a également produit sa propre série d'affiches et de publications, grâce à son directeur artistique, Pepe Avilés, un féru de cinéma. Son travail, qui ne manque certainement pas d'humour, a attiré l'attention au niveau international et a été publié partout. El Pobre Diablo a reçu la récompense artistique nationale Quit Sato pour sa contribution à la communauté artistique.

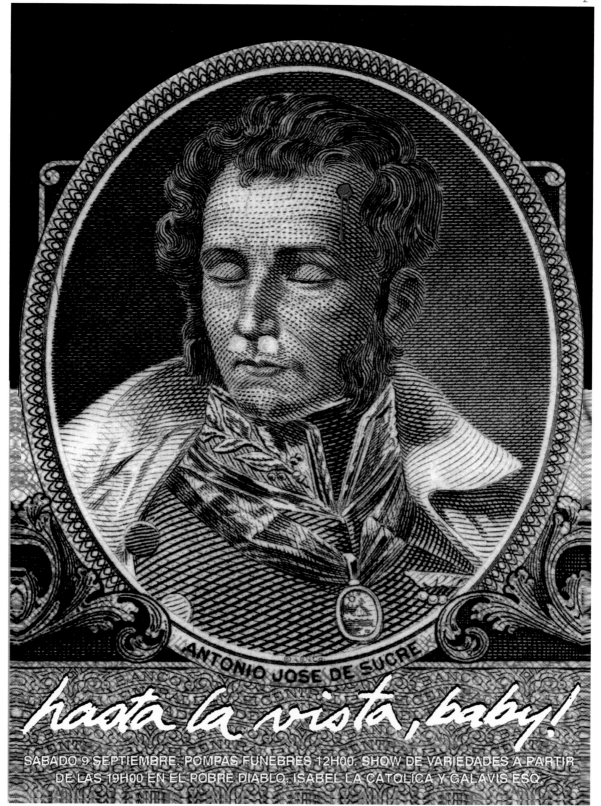

ANTONIO JOSE DE SUCRE

hasta la vista, baby!

SABADO 9 SEPTIEMBRE. POMPAS FUNEBRES 12H00. SHOW DE VARIEDADES A PARTIR DE LAS 19H00 EN EL POBRE DIABLO. ISABEL LA CATOLICA Y GALAVIS ESQ.

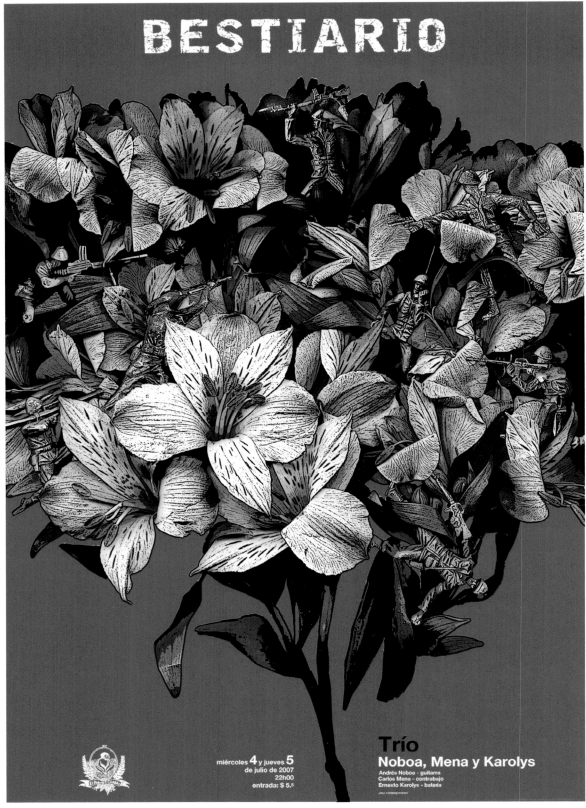

3

BESTIARIO

miércoles **4** y jueves **5**
de julio de 2007
22h00
entrada: $ 5.⁵

Trío
Noboa, Mena y Karolys
Andrés Noboa - guitarra
Carlos Mena - contrabajo
Ernesto Karolys - batería

Jazz contemporáneo

. "Bestiario" poster, 2002
Design/illustration Pepe Avilés

. "Primera y segunda vuelta
(segunda edición)" poster
and catalogue cover, 2007
Production El Pobre Diablo
and Experimentos Culturales
Design Pepe Avilés,
Ana Lucía Garcés
Illustration Manuel Kingman

. "Jazz Rock" poster, 1994
Illustration Alexis Moreano

4

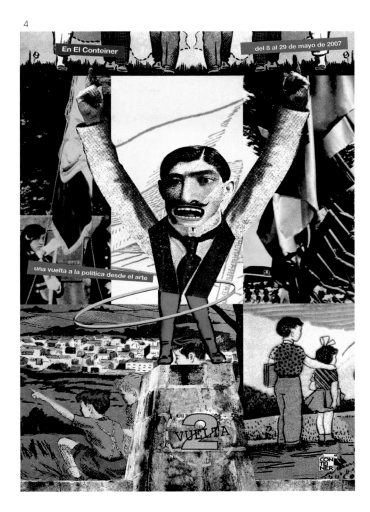

5

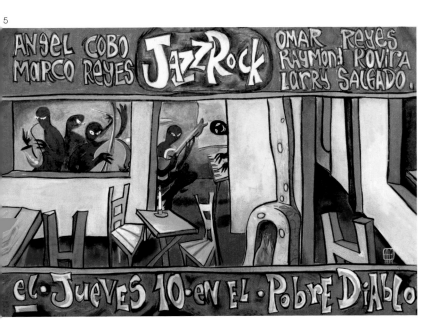

ELASTIC PEOPLE

1

Led by Puerto Rican creative director Carlos Perez, Elastic People is a world class full-service design agency, working for some of the leading names in the music industry, including Ricky Martin, Mana and Daddy Yankee. Even though its offices are based in Miami, the studio's visual language has a veritable Latin American stamp on it. Working in the realm of art direction and photography through to interactive and music video production, Elastic People have created a phenomenal reputation for delivering outstanding creative quality. With a solid background of experience in advertising, Perez worked for a number of agencies in California and Florida before deciding to open his own design consultancy, with the mission of delivering the whole creative package to his clients.

Unter der Leitung des puertoricanischen Kreativchefs Carlos Perez ist Elastic People als universale Designagentur von Weltklasse bekannt, zu deren Kunden aus der Musikbranche unter anderem Ricky Martin, Mana und Daddy Yankee gehören. Obwohl sich ihre Büros in Miami befinden, ist die visuelle Sprache der Agentur eindeutig lateinamerikanisch geprägt. Die Agentur Elastic People arbeitet in den Bereichen Art Direction und Fotografie sowie in der interaktiven und musikalischen Videoproduktion und erreicht einen hervorragenden Ruf für ihre überragende kreative Qualität. Mit seinen umfangreichen Erfahrungen in der Werbebranche arbeitete Perez für verschiedene Agenturen in Kalifornien und Florida, bevor er sich entschloss, seine eigene Designagentur zu gründen und seinen Kunden ein kreatives Gesamtpaket anzubieten.

Dirigée par le directeur de la création portoricain Carlos Perez, Elastic People est une agence de design de niveau international, qui propose une gamme complète de services et travaille pour quelques-uns des plus grands noms de la musique, notamment Ricky Martin, Mana et Daddy Yankee. Bien que ses bureaux se trouvent à Miami, le langage visuel de ce studio possède une âme véritablement latino-américaine. Spécialisé dans le domaine de la direction artistique et de la photographie, ainsi que de la production de clips vidéo et de vidéos interactives, Elastic People a une réputation bien établie pour l'excellente qualité créative de ses propositions. Carlos Perez possède une solide expérience de la publicité. Il a travaillé pour plusieurs agences en Californie et en Floride avant de décider d'ouvrir son propre cabinet de conseil en graphisme, et s'est donné pour mission de remettre à ses clients des solutions créatives complètes clé en main.

1. "Amar es combatir"
CD packaging, 2006,
Maná, Warner Music

2

4

3

2. "El Cartel: The Big Boss"
website, 2007, Daddy Yankee,
Interscope Records

3. "Miami Film Festival" logo, 2007

4. "Talento de Barrio" logo, 2006,
Daddy Yankee, Interscope Records

5. "Black and White Tour" poster,
2007, Ricky Martin, Sony International

6. "Ricky Martin MTV Unplugged"
CD packaging, 2006, Ricky Martin,
Sony International, MTV

*1995, Mexico, www.eramostantos.com.mx

ÉRAMOS TANTOS

1. **"Chacahua"** poster for documentary film, 2003, Centro de Capacitación Cinematográfica

2. **"Surfology"** Illustration for magazine, 2007, Picnic Magazine

A mixture of modern and retro, with loads of colourful illustrations has been the main signature of Éramos Tantos, the creative collective of designers Manuel Cañibe, Christian Cañibe and Héctor Barrera. Founded in Mexico City in 1995, their works have been applauded by a number of national and international clients. Notable projects for MTV Latinoamérica and Paramount Pictures have also helped to raise their profile in recent years. With a modern approach to the country's popular artistic expression, they have created profound and innovative pieces in print and interactive design, and their work has been published in *Communication Arts* (USA), *Étapes Graphiques* (France) and *Shift* (Japan). They have also received the Promax and BDA awards for Latin America.

Éramos Tantos, das 1995 gegründete gemeinschaftliche Kreativstudio der Designer Manuel Cañibe, Christian Cañibe und Héctor Barrera, zeichnet sich durch eine Mischung aus Moderne und Retro sowie einer geballten Ladung farbenfroher Illustrationen aus. Die Arbeiten der Designer haben bei etlichen nationalen und internationalen Kunden viel Beifall gefunden. Auch die bemerkenswerten Projekte für MTV Latinoamérica und Paramount Pictures haben in den letzten Jahren dazu beigetragen, das Profil des Studios zu verbessern. Durch ihren modernen Umgang mit dem gängigen künstlerischen Ausdruck des Landes haben die Designer tiefschürfende und innovative Werke in Druck und interaktivem Design geschaffen, die in *Communication Arts* (USA), *Étapes Graphiques* (Frankreich) und *Shift* (Japan) veröffentlicht wurden. Zudem haben sie die Auszeichnungen Promax und BDA für Lateinamerika erhalten.

Les graphistes Manuel Cañibe, Christian Cañibe et Héctor Barrera composent le collectif créatif Éramos Tantos. Leur style caractéristique est un mélange de moderne et de rétro, agrémenté d'une foule d'illustrations hautes en couleur. Le collectif s'est créé à Mexico en 1995, et leurs œuvres ont été applaudies par de nombreux clients nationaux et internationaux. Des projets remarquables menés ces dernières années pour MTV Latinoamérica et Paramount Pictures ont également contribué à leur réputation. Avec leur approche moderne de l'expression artistique populaire mexicaine, ils ont créé des œuvres profondes et innovantes dans le design éditorial et interactif, et leur travail a été publié dans *Communication Arts* (États-Unis), *Étapes Graphiques* (France) et *Shift* (Japon). Ils ont également reçu des prix Promax et BDA pour l'Amérique latine.

3

3. "La Gran Familia Mexicana"
series of postcards for diary,
2007, self-promo

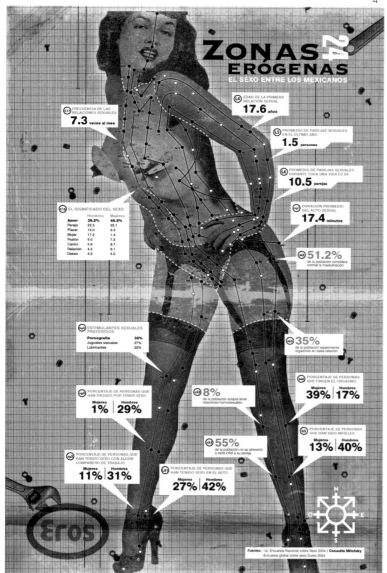

4. "Zonas Erógenas"
Illustration for magazine,
2006, Picnic Magazine

5. "Con Los Dorados de Villa"
film DVD cover, 2005,
Alameda Films/Filmhouse

6. "Muestra de óperas primas
del CCC" film festival poster,
2005, Centro de Capacitación
Cinematográfica

5

6

PACO ESTRELLA

1

2

Francisco Estrella is mostly known for his minimalist poster designs, which usually consist of a simple hand-drawn illustration and a strong central theme connecting all elements. A graduate from the Universidad Autónoma Metropolitana in Azcapotzalco, Mexico City, Estrella is a founding member of the graphic design magazine Matiz: a publication that was for a long time an important reference in the region, featuring national and international content. He started his career in Guadalajara, where he worked at Hematoma, a groundbreaking creative collective that took modern graphics to the streets of Mexico. Besides running his design office, Estrella currently serves as director of Manifesto (manifesto.com.mx), an institution that promotes alternative art and music.

Francisco Estrella ist vor allem für sein minimalistisches Plakatdesign bekannt, das normalerweise aus einer einfachen, von Hand gezeichneten Illustration und einem zentral dominierenden Thema besteht, das alle Elemente miteinander verbindet. Estrella schloss sein Studium an der Universidad Autónoma Metropolitana in Azcapotzalco, Mexico City, ab und ist Gründungsmitglied des Grafikdesign-Magazins Matiz. Diese Publikation war lange Zeit eine wichtige Referenz in der Region und stellte nationale sowie interna-tionale Inhalte vor. Estrella begann seine berufliche Laufbahn in Guadalajara, wo er bei Hematoma arbeitete, einem wegweisendes Kreativstudio, das moderne Grafiken in das Straßenbild von Mexiko brachte. Neben der Leitung seines Designbüros ist Estrella zurzeit als Direktor von Manifesto (manifesto.com.mx) tätig, einer Institution zur Förderung alternati-ver Kunst und Musik.

Francisco Estrella est connu avant tout pour ses affiches minimalistes, qui consistent habituellement en une illustration toute simple dessinée à la main et en un thème central fort qui relie tous les éléments. Diplômé de l'Universidad Autónoma Metropolitana d'Azcapotzalco, à Mexico, Paco Estrella est membre fondateur de Matiz, un magazine de graphisme qui a longtemps été une référence importante en Amérique latine, traitant du graphisme au Mexique et à l'étranger. Il a commencé sa carrière à Guadalajara, où il a travaillé chez Hematoma, un collectif créatif d'avant-garde qui a fait descendre le graphisme moderne dans les rues de Mexico. En plus de diriger son agence de graphisme, Paco Estrella est actuellement le directeur de Manifesto (manifesto.com.mx), une institution qui promeut l'art et la musique alternatifs.

1. "El Dia en que mi Guadalajara
se fue al cielo" sorrowful anniversary
poster of the explosion, 2003,
Hematoma Collective
Photo Sergio González Vargas

2. Ilustration for film special issue,
Replicante Magazine

3. "Tovar" CD cover,
Nopal Beat Records
Art direction: Paco Estrella
Design Paco Estrella, Israel Ramírez

4. "Rigo" poster, 2003,
Hematoma Collective

5. "Arena Mutek" poster, 2003, Mutek

*1969, Brazil, www.caotica.com.br

LEONARDO EYER

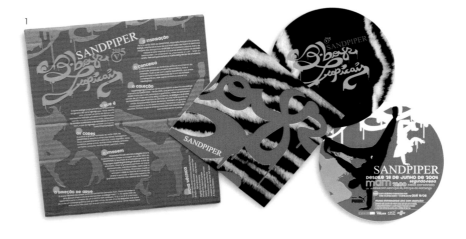

1

1. **"B-boys Tropicais"** promotional material, 2004, Sandpiper
Art direction Leonardo Eyer, Batman Zavareze
Design Leonardo Eyer, Adriano Motta, Christiano Calvet, Gustavo Lacerda

Leonardo Eyer has had a meteoric career in design, having gained both national and international experience. He has worked for some of the big recording companies in Brazil, as well a number of local fashion brands and the prestigious Deborah Colker Dance Company. Eyer studied at the Faculdade da Cidade in Rio de Janeiro, subsequently attending the School of Visual Arts in New York. He founded his own design practice, Caótica, in 1996. Eyer has created editorial design for various magazines, including *BIG*, *V* and *Brazil Inspired*. His work has been exhibited at the National Fine Arts Museum, in Rio de Janeiro. Eyer was also responsible for designing the visual identity for the Brazilian pavilion at the Expo 2000.

Leonardo Eyer hat im Design eine steile Karriere vorgelegt und dabei national und international viele Erfahrungen sammeln können. Er hat für einige der großen Aufnahmestudios in Brasilien gearbeitet sowie für eine Reihe von regionalen Modemarken und die prestigeträchtige Deborah Colker Dance Company. Eyer studierte an der Faculdade da Cidade in Rio de Janeiro und besuchte anschließend die School of Visual Arts in New York. 1996 gründete er sein eigenes Designstudio Caótica. Eyer hat für verschiedene Magazine am Editorial Design gearbeitet, darunter für *BIG*, *V* und *Brazil Inspired*. Seine Werke wurden im Landesmuseum der Schönen Künste in Rio de Janeiro ausgestellt. Er war zudem verantwortlich für die Visual Identity des brasilianischen Pavillons auf der Expo 2000.

Leonardo Eyer a eu une carrière fulgurante dans le design, et son expérience est à la fois nationale et internationale. Il a travaillé pour quelques-unes des grandes sociétés de production musicale du Brésil, ainsi que pour plusieurs marques de mode locales et pour la prestigieuse compagnie de danse Deborah Colker. Il a étudié à la Faculdade da Cidade de Rio de Janeiro, puis à l'École des arts visuels de New York. Il a créé sa propre agence de graphisme, Caótica, en 1996. Il a travaillé sur des projets de design éditorial pour plusieurs magazines, notamment *BIG*, *V* et *Brazil Inspired*. Ses œuvres ont été exposées au Museu Nacional de Belas Artes. Il a également créé l'identité visuelle du pavillon brésilien pour Expo 2000.

2. "Laranja Mecânica"
exhibition program

3. "Tribalistas" CD, DVD and
promotional material, 2004, EMI Brazil
Assistant Gustavo Lacerda,
Eliane Lazzaris
Illustration Vik Muniz

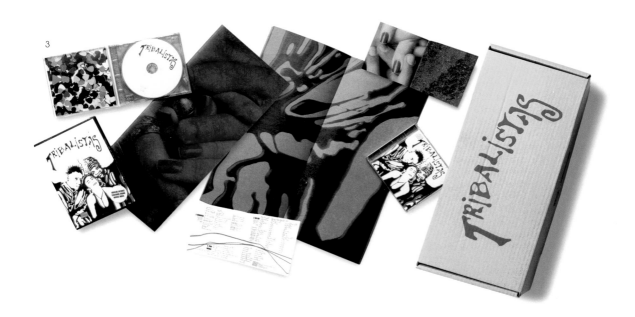

*1948, Brazil, www.saopaulocriacao.com.br

RAFIC FARAH

Rafic Farah trained as an architect at FAU/USB, before setting up his studio, São Paulo Criação, in 1980, where he acts both as designer and photographer, working with clients mostly in the fashion, publishing and cultural industries. He has designed for numerous national brands and created graphic projects for a number of magazines including *Around*, *Circuit*, *Trip* and *TPM*. Farah has also received worldwide recognition for designing a range of furniture. He has recently exhibited in the Art Directors Club in New York, and his works have been selected for the International Poster Festival in Chaument, France, the Ginza Graphic Gallery in Tokyo, and for the *Designmai* exhibition in Berlin, among a host of others.

Rafic Farah wurde an der FAU/USP in São Paulo als Architekt ausgebildet, bevor er 1980 sein Studio São Paulo Criação eröffnete. Er arbeitet als Designer und Fotograf und findet seine Kunden überwiegend in Mode, Verlag und Kultur. Farah hat für zahlreiche nationale Marken entworfen und Grafikprojekte für einige Magazine durchgeführt, wie zum Beispiel für *Around*, *Circuit*, *Trip* und *TPM*. Außerdem brachte die Gestaltung einer Möbelserie ihm weltweite Anerkennun gein. Seine Werke wurden vor kurzem im Art Directors Club in New York ausgestellt und sind zudem unter anderem für das internationale Plakatfestival in Chaument, Frankreich, für die Ginza Graphic Gallery in Tokio und für die Ausstellung *Designmai* in Berlin ausgewählt worden.

Rafic Farah a étudié l'architecture à la FAU/USP avant de créer son agence São Paulo Criação en 1980, où il est à la fois graphiste et photographe. Ses clients sont principalement dans les domaines de la mode, de l'édition et de la culture. Il a travaillé pour de nombreuses marques nationales et a créé des projets graphiques pour de nombreux magazines, notamment *Around*, *Circuit*, *Trip* et *TPM*. Sa ligne de meubles lui a valu une reconnaissance mondiale. Il a récemment exposé à l'Art Directors Club de New York, et ses œuvres ont été sélectionnées pour le Festival international de l'affiche de Chaumont, en France, le festival Ginza Graphic Gallery de Tokyo, et pour l'exposition *Designmai* de Berlin, entre de nombreux autres événements.

30 POSTERS ON ENVIRONMENT AND DEVELOPMENT THE UNITED NATIONS RIO CONFERENCE '92
SPONSORS: CIA. SUZANO DE PAPEL E CELULOSE • BCSD • SUPPORT: MESULA • VARIO • FEDERAL EXPRESS • RENART • ORGANIZED BY DESIGN RIO PROMOTION CENTER • FELIPE TABORDA • AXIS DESIGN RIO

1. **"Museu do Futebol"** poster and logo, 2006, Fundação Roberto Marinho, Soccer Museum of Brazil

2. **"30 Posters on Environment and Development"** poster, 1992, The United Nations Conference on Environment and Development (Eco-92)

3. **"Árvore Lateral"**, Museu da Língua Portuguesa

4. **"Negras Fit"** postcard, 1995, Fit fashion brand

5. **"Fit"** logo, 1990, Fit fashion brand

3

5

*1955, Brazil, www.19design.com.br

HELOISA FARIA

1

Carnaval

Heloisa Faria (b. 1955) is the head of 19 Design, a design firm based in Rio de Janeiro, which until 2004 enjoyed a fruitful partnership with Evelyn Grumach and Ana Luisa Escorel. Long experienced in the field, Faria has trained in both product and graphic design, and has worked with legendary designer Aloisio Magalhães. In 2004 she created 19 Editora as a publishing division of her office. She has built a solid career in the field of exhibitions and in the cultural sectors, producing a great number of acclaimed visual identities and catalogues. She has been awarded the IF Communication Design Award and the VII Graphic Design Biennial Award in 2004 for her impressive work on the catalogue for the exhibition *Carnaval*. Her works have been widely exhibited in Brazil and abroad.

Heloisa Faria (geb. 1955) ist die Leiterin des Design-Unternehmens 19 Design, das seinen Sitz in Rio de Janeiro hat und bis 2004 eine fruchtbare Partnerschaft mit Evelyn Grumach und Ana Luisa Escorel genießen konnte. Faria konnte umfangreiche Erfahrungen in der Branche gewinnen, unterrichtete in Produkt- und Grafikdesign und arbeitete mit dem legendären Designer Aloisio Magalhães zusammen. 2004 gründete sie zudem 19 Editora als Verlagszweig ihres Unternehmens. Im Bereich Ausstellungen und im kulturellen Sektor baute sie sich eine solide Karriere auf, führte eine große Anzahl an Projekten über Visual Identity durch und produzierte Kataloge. Ihre Werke wurden mit dem IF Communication Design ausgezeichnet sowie 2004 mit dem VII. Grafikdesign-Biennale für ihre eindrucksvolle Arbeit zu dem Katalog für die Ausstellung *Carnaval*. Außerdem wurden ihre Arbeiten in Brasilien und im Ausland veröffentlicht.

Heloisa Faria (née en 1955) est la directrice de 19 Design, une société de graphisme basée à Rio de Janeiro, qui jusqu'à 2004 était engagée dans un partenariat fructueux avec Evelyn Grumach et Ana Luisa Escorel. Heloisa Faria bénéficie d'une longue expérience, et elle a étudié la conception de produit et le graphisme avec le graphiste légendaire Aloisio Magalhães, avec lequel elle a également travaillé. En 2004, elle a créé 19 Editora, un département d'édition au sein de son agence. Elle s'est forgé une solide carrière dans le domaine des expositions et de la culture, et a créé un grand nombre d'identités visuelles et de catalogues qui ont été plébiscités. Elle a reçu des prix iF Design (catégorie communication) et de la VIIe Biennale du graphisme en 2004 pour son travail impressionnant sur le catalogue de l'exposition *Carnaval*. Ses œuvres ont fait l'objet de nombreuses expositions au Brésil et à l'étranger.

1. "Carnaval" logo and catalogue,
2004, Goethe Institut
Design Hugo Rafael, Claudia Berger,
Rômulo Lima

2. "Art From Africa"
exhibition poster and catalogue,
2003–2004, Goethe Institut

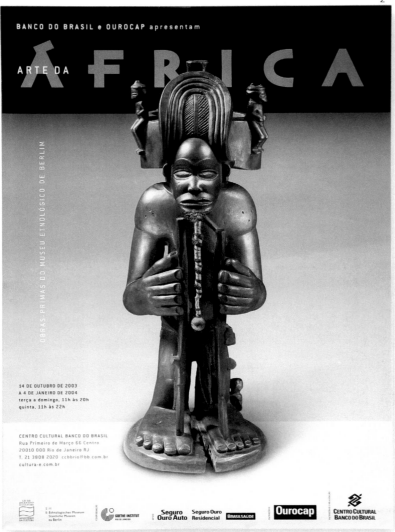

*1957, Brazil, www.kikofarkas.com.br

KIKO FARKAS

1

Kiko Farkas studied architecture at the FAU in São Paulo before leaving the country in 1979 to study at the Art Students League in New York. Farkas subsequently gained experience working as an art director for a number of magazines and newspapers in his hometown. In 1987 he became independent, forming his own design consultancy Máquina Estúdio, which has focused on institutional, cultural and editorial design. In the last two decades Farkas' work has been highly applauded in the design community, and in 2005, his office worked on an umbrella brand identity for the Brazilian government, creating the standard export label for the Industry and Commerce Ministry. Since 2003, Máquina Estúdio has been responsible for producing all the graphic communication material for the São Paulo Symphony Orchestra.

Kiko Farkas studierte Architektur an der FAU in São Paulo, bevor er das Land 1979 verließ, um ein Studium an der Art Students League in New York aufzunehmen. Praktische Erfahrungen sammelte er in seiner Arbeit als Art Director für eine Reihe von Zeitschriften und Zeitungen in seiner Heimatstadt. 1987 machte er sich selbständig und gründete sein eigenes Designbüro Máquina Estúdio, das sich auf institutionelles und kulturelles Design sowie Editorial Design konzentriert. In den letzten beiden Jahrzehnten wurden Farkas Werke von der Designerszene begeistert gefeiert. 2005 erarbeitete das Büro eine Dachmarke für die brasilianische Regierung und entwarf das Standard-Exportlabel für das Industrie- und Handelsministerium. Seit 2003 ist Máquina Estúdio für alle Grafikentwürfe für die Kommu nikationsmaterialien des Symphonieorchesters von São Paulo verantwortlich.

Kiko Farkas a étudié l'architecture à la FAU, à São Paulo, avant de quitter le pays en 1979 pour étudier à l'Art Students League de New York. Il a ensuite acquis de l'expérience en tant que directeur artistique pour plusieurs magazines et journaux dans sa ville natale. En 1987, il s'est lancé en indépendant et a créé son propre cabinet de conseil en graphisme, Máquina Estúdio, spécialisé dans le graphisme institutionnel, culturel et éditorial. Ces vingt dernières années, le travail de Kiko Farkas a été très applaudi par la communauté des graphistes et, en 2005, son agence a travaillé sur l'identité ombrelle du gouvernement brésilien, et a créé le label d'export standard pour le ministère de l'Industrie et du Commerce. Depuis 2003, Máquina Estúdio a produit toute la communication graphique de l'Orchestre symphonique de São Paulo.

1. "São Paulo Symphony Orchestra"
poster series, 2003/04/05/06,
Orquestra Sinfônica do Estado
de São Paulo (Osesp)
Design/illustration Kiko Farkas
Assistance Máquina Estúdio team

218

2. "Hermeto campeão"
Film poster, 1981, Saruê Filmes

3. "Brasil"
Brazilian identity for international
tourism, 2005, Embratur
(Empresa Brasileira de Turismo)

4. "II Festival Fotoptica-MIS de Video
Brasil" poster, 1984

*1990, Argentina, www.filenifileni.com

FILENI FILENI

1

Graphic designer Martín Fileni would define his methodology as a cohesion of creativity, experience, imagination, strategy and value. Founded 17 years ago, Fileni Fileni is one of the major international design consultancies in Argentina, based in Buenos Aires. His studio currently attends to clients in South America, Europe and Asia. Obsessed with the creation of basic visual concepts, and discovering effective ways to transmit them, Fileni Fileni's strength has been the creation of large-scale displays and communication systems for public spaces, such as airports, cities, supermarkets and shopping centres. Together with architect and partner Karina Shebar, Fileni Fileni has been one of the fastest growing and award-winning design consultancies in the whole region.

Der Grafikdesigner Martín Fileni würde seine Methodik als ein starkes Geflecht von Kreativität, Erfahrung, Fantasie, Strategie und Wert definieren. Fileni Fileni wurde vor 17 Jahren in Buenos Aires gegründet und gehört zu den bedeutendsten internationalen Designagenturen in Argentinien. Das Studio betreut gegenwärtig Kunden in Südamerika, Europa und Asien. Besessen von der Schaffung grundlegender visueller Konzepte und der Entdeckung effektiver Vermittlungswege, liegen die Stärken von Fileni Fileni in der Entwicklung von Großbildschirmen und Kommunikationssystemen für große öffentliche Plätze wie Flughäfen, Städte, Supermärkte und Einkaufszentren. Gemeinsam mit der Architektin und Partnerin Karina Shebar hat sich Fileni Fileni zu einer der am schnellsten wachsenden Designagenturen in der gesamten Region entwickelt und wurde mit mehreren Preisen ausgezeichnet.

Le graphiste Martín Fileni pourrait définir sa méthodologie comme un ensemble cohérent de créativité, d'expérience, d'imagination, de stratégie et de valeurs. Créé il y a 17 ans à Buenos Aires, Fileni Fileni est l'un des plus grands cabinets de conseil en graphisme d'Argentine. Actuellement, la clientèle du cabinet vient d'Amérique du Sud, d'Europe et d'Asie. Chez Fileni Fileni, on a l'obsession des concepts visuels fondamentaux, et de la découverte de moyens efficaces pour les transmettre. Le cabinet est surtout connu pour ses projets à grande échelle et pour ses systèmes de communication pour les espaces publics : aéroports, villes, supermarchés et centres commerciaux. L'architecte Karina Shebar est associée de Fileni Fileni, qui est l'un des cabinets de graphisme à la croissance la plus rapide de tout le sous-continent, et a remporté de nombreux prix.

1. "Paseo Los Trapenses" sign system,
2003, Paseo Los Trapenses, Chile
Art direction Martin Fileni
Design Juan Mendióroz

2. "300 años de San Isidro"
visual identity for the 300th anniversary
of the city of San Isidro, 2005
Art direction Martin Fileni
Design Juan Mendióroz

*1942, Argentina, www.fontana-d.com

RUBÉN FONTANA

1

LE PAARC

Gran Premio de Pintura, XXXIII Bienal de Venecia 1966
Exposición de sus obras organizada por Ver y Estimar.
Instituto T. Di Tella, Florida 936. Del 1 al 20 de agosto

1. "Le Parc" poster, 1966,
Instituto Torcuato Di Tella
Design Juan Carlos Distéfano,
Rubén Fontana

2. "Olivetti Diseño y Producto"
conference poster, 1968,
Instituto Torcuato Di Tella
Design Juan Carlos Distéfano,
Rubén Fontana, Carlos Soler

3. "Polecello" poster, 1969,
Instituto Torcuato Di Tella
Design Juan Carlos Distéfano,
Rubén Fontana, Carlos Soler

Led by Rubén Fontana, Fontana Diseño has been one of the most reputable design firms in Argentina, working mainly on the development and implementation of corporate identity systems. In addition to his professional role, Rubén Fontana has also been a key figure in promoting awareness of design throughout the country. He was responsible for incorporating the study of typography at the Universidad de Buenos Aires, where he served his professorship until 1997. He has lectured widely in universities around the world, including Canada, Spain and The Netherlands. Fontana has both won and judged several awards in Europe and the US, receiving, amongst others, the Excellence Prize by the Association Typographique Internationale. His graphic work is part of the permanent collection at MoMA in New York.

Unter der Leitung von Rubén Fontana gehört Fontana Diseño zu den angesehensten Designstudios in Argentinien, dessen Schwerpunkt auf der Entwicklung und Umsetzung von Corporate Identity-Systemen liegt. Neben seiner professionellen Rolle ist Rubén Fontana auch eine zentrale Figur, um das Bewusstsein für Design in seinem Lande zu fördern. Er war für die Einführung des Studienfachs Typografie an der Universidad de Buenos Aires verantwortlich, wo er bis 1997 einen Lehrstuhl innehatte. Fontana dozierte an Universitäten auf der ganzen Welt, darunter in Kanada, Spanien und den Niederlanden. Er hat mehrere Preise in Europa und den USA erhalten und war als Jurymitglied tätig. Unter anderem wurde er mit dem Excellence Prize durch die Association Typographique Internationale ausgezeichnet. Seine Grafikarbeiten sind Teil der Sammlung des MoMA in New York.

Dirigée par Rubén Fontana, Fontana Diseño est l'une des sociétés de graphisme les plus renommées en Argentine, et travaille principalement sur la création et la mise en œuvre de systèmes d'identité d'entreprise. Parallèlement à ses activités professionnelles, Rubén Fontana joue également un rôle central dans la promotion du graphisme dan tout le pays. C'est lui qui a ajouté la typographie aux matières étudiées à l'Universidad de Buenos Aires, où il a enseigné jusqu'à 1997. Il a donné de nombreux cours magistraux dan des universités du monde entier, notamment au Canada, en Espagne et aux Pays-Bas. Rubén Fontana a remporté de nombreuses récompenses en Europe et aux États-Unis, en tre autres le prix d'Excellence de l'Association typographique internationale. Il aussi été juré pour de nombreux prix. Ses œuvres graphiques font partie de la collection permanente du MoMA de New York.

2

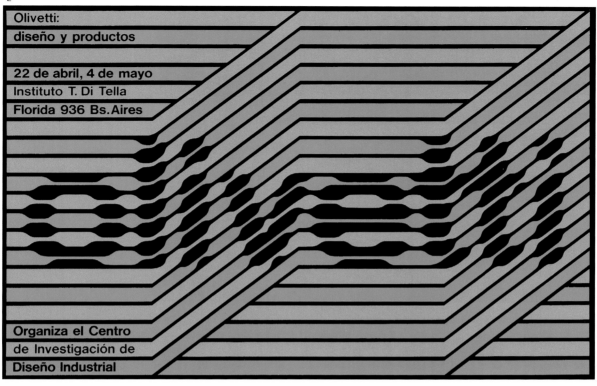

Olivetti:

diseño y productos

22 de abril, 4 de mayo
Instituto T. Di Tella
Florida 936 Bs. Aires

Organiza el Centro
de Investigación de
Diseño Industrial

3

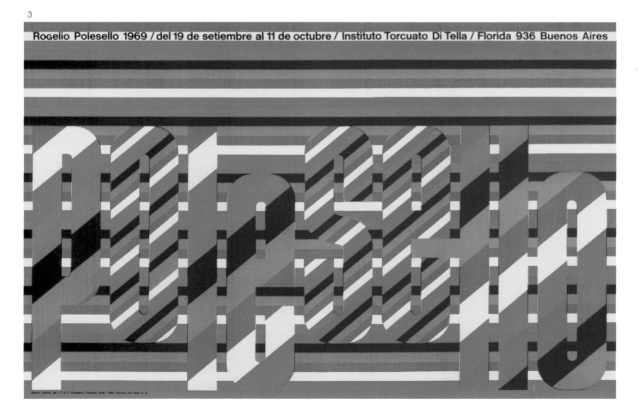

Rogelio Polesello 1969 / del 19 de setiembre al 11 de octubre / Instituto Torcuato Di Tella / Florida 936 Buenos Aires

LA NACION

4

4. "La Nacion" newspaper redesign, 2000, La Nacion

5. "Full" corporate identity, 2005, YPF

6. "Telecom" logo, 1998, Telecom Argentina

7. "TipoGráfica Magazine" editorial design, 2005

5

6

tpG | tipoGráfica
OCTUBRE, NOVIEMBRE. BUENOS AIRES, ARGENTINA

Diseño María del Valle Ledesma El público recrea la trinidad
Tipografía Emily King El innovador dúo del diseño holandés
Color José Luis Caivano y Mabel López Retórica del negro, blanco y rojo
Ensayo Donald Norman El futuro de la educación
Historia Klaus Weber ¡Viva Gropi!

tpG 04/05

tpG | tipoGráfica
DICIEMBRE, ENERO, FEBRERO, MARZO. BUENOS AIRES, ARGENTINA

Diseño tipográfico Felix Arnold Tipografía y cartografía
Diseño y género Raquel Pelta El tiempo de las mujeres
Diseño Carolina Rojas Alain Le Quernec o el afiche como enfermedad crónica
Contexto Valeria Mejía Malvenido Bush
Ensayo Yves Zimmermann El sujeto como proyecto

tpG 05/05

HISTORIA

¡Viva Gropi!

Los obsequios que los alumnos entregaban a sus profesores estuvieron, en su mayoría, dedicados al favorito, Walter Gropius. Los regalos de la Bauhaus son un valioso documento que recrea parte de la vida de los miembros de la escuela.

ENSAYO

El sujeto como proyecto

Este análisis sobre el diseño de la imagen corporativa gráfica y la imagen no gráfica propone un exhaustivo recorrido sobre el concepto de diseño. Las diferencias que plantean el modo de ser y el modo de aparecer de una empresa indican que es posible diseñar algo más allá de lo sígnico u objetal.

*1954, Uruguay, www.rodolfofuentes.com

RODOLFO FUENTES

1. "Poemas / Samantha Navarro"
CD booklet, 2003,
Perro Andaluz Records
Photo Blanca Valdéz

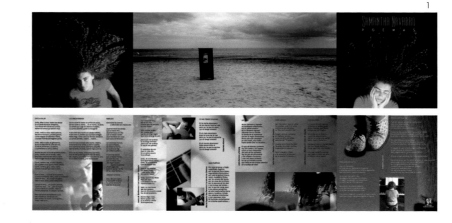

1

As a designer and photographer, Rodolfo Fuentes has always had strong ties with the recording and publishing industry in Uruguay, where he started to run his own design practice in 1970. Entirely self taught he became an activist in his early professional days, later cofounding the Asociación de Diseñadores Gráficos Profesionales del Uruguay. Fuentes's works belong to the permanent collection of The Israel Museum in Jerusalem and Le Louvre in Paris among many others. Publications that have featured his work include *Novum* in Germany, *Design Art* in Taiwan, *TipoGráfica* in Argentina, *Greatis* in Russia and *Idea* in Japan. He was also one of the selected designers for the exhibition *30 Posters on the Environment & Development,* as part of the 1992 United Nations Environmental Summit in Rio de Janeiro.

Als Designer und Fotograf hatte Rodolfo Fuentes immer starke Bindungen zu der Schallplatten- und Verlagsbranche in Uruguay, wo er 1970 sein eigenes Designstudio gründete. Der reine Autodidakt wurde in seiner frühen beruflichen Laufbahn zum Aktivisten und später zum Mitbegründer der Asociación de Diseñadores Gráficos Profesionales del Uruguay. Fuentes Arbeiten gehören unter anderem zu den ständigen Sammlungen des Israel Museum in Jerusalem und des Louvre in Paris. Außerdem wurden seine Arbeiten in Publikationen wie *Novum* in Deutschland, *Design Art* in Taiwan, *TipoGráfica* in Argentinien, *Greatis* in Russland und *Idea* in Japan veröffentlicht. Er gehörte zu den ausgewählten Designern für die Ausstellung *30 Posters on the Environment & Development,* die 1992 im Rahmen der Konferenz der Vereinten Nationen über Umwelt und Entwicklung in Rio de Janeiro stattfand.

En tant que graphiste et photographe, Rodolfo Fuentes a toujours entretenu des liens étroits avec les maisons de disques et les maisons d'édition uruguayennes. Il a créé sa propre agence de graphisme en 1970. Complètement autodidacte, il est devenu activiste au début de sa carrière professionnelle puis a cofondé l'Asociación de Diseñadores Gráficos Profesionales del Uruguay. On peut trouver des œuvres de Rodolfo Fuentes dans les collections permanentes du Musée d'Israël à Jérusalem et au Louvre de Paris, entre autres. Elles sont également apparues dans de nombreuses publications, notamment *Novum* en Allemagne, *Design Art* à Taiwan, *TipoGráfica* en Argentine, *Greatis* en Russie et *Idea* au Japon. Il a fait partie des graphistes sélectionnés pour l'exposition *30 Posters on the Environment & Development,* dans le cadre du Sommet de l'environnement des Nations Unies à Rio de Janeiro, en 1992.

"Impunidad" poster, 2004, BICM

"Fomento a la Lectura" poster, 006, Coctel Camaleón

"Taller de Cine" poster, 2005, niversidad de Oriente

3

4

2

ESTUDIO GARCÍA BALZA

1

GEORGES **MÉLIÈS** XXIIIº CONCURSO DE CORTOMETRAJES

1. **"Secreto"** short film festival poster, 2007, Georges Méliès

2. **"Marq"** logo and poster, 1998, Museo de Arquitectura de la Ciudad de Buenos Aires (Sociedad Central de Arquitectos)

Under the leadership of architect and designer Roberto García Balza and designer Marcela Gonzalez, the Estudio García Balza was founded in 1994, and has strived to create and implement broad communication strategies and design programmes, working from visual identity and interactive design to product and architecture. An interdisciplinary group of professionals that range from architects to multimedia designers based in Buenos Aires seeks to create global design concepts rather than working on single graphic design solutions. They have won several awards in Argentina and abroad, and both García Balza and Gonzales have lectured widely on their integrated approach to communication and design at universities and conferences in Europe and in the USA.

Estudio García Balza wurde 1994 von dem Architekten und Designer Roberto García Balza und von dem Designer Marcela Gonzalez in Argentinien gegründet. Sie wollen ausgehend von der Visual Identity über interaktives Design bis hin zu Produktdesign und Architektur umfassende Kommunikationsstrategien und Designprogramme entwickeln und durchführen. Estudio García Balza ist eine interdisziplinäre Gruppe von professionellen Architekten und Multimedia-Designern mit Sitz in Buenos Aires, die lieber an der Entwicklung globaler Design-Konzepte als an einzelnen Grafikdesign-Lösungen arbeitet. Das Studio ist mehrfach in Argentinien und im Ausland ausgezeichnet worden. Sowohl García Balza als auch Gonzales haben Vorlesungen an Universitäten und Konferenzen in Europa und in den USA über ihren ganzheitlichen Ansatz zu Kommunikation und Design gehalten.

Estudio García Balza a été créé en 1994 à Buenos Aires et, sous la houlette de l'architecte et graphiste Roberto García Balza et de la graphiste Marcela Gonzalez, le studio crée et met en œuvre des stratégies de communication et des programmes de graphisme d'envergure dans les domaines de l'identité visuelle, du design interactif, de la conception de produit et de l'architecture. Il s'agit d'un groupe pluridisciplinaire qui rassemble entre autres des architectes et des graphistes multi médias, et qui cherche à créer des concepts de design globaux plutôt que de travailler sur des solutions graphiques isolées. L'équipe a remporté plusieurs récompenses en Argentine et à l'étranger, et Roberto García Balza et Marcela Gonzalez ont donné de nombreuses conférences sur leur approche intégrée de la communication et du graphisme en tant qu'invités d'universités et de congrès en Europe et aux États-Unis.

Sociedad Central de Arquitectos

LE CORBUSIER

Marq

Junio 2001 / Museo de arquitectura

NO
CHE
FRAN
CE
SA
BAFICI
2007

NOCHE FRANCESA - BAFICI 2004

"Noche Francesa 07"
promotional postcard for film festival,
2007, Aires Festival Internacional de
Cine Independiente,
Embassy of France in Buenos Aires

"Noche Francesa 04"
promotional postcard for film festival,
2004, Aires Festival Internacional de
Cine Independiente,
Embassy of France in Buenos Aires

"Semana del Cine Francés"
Film festival poster, 2003,
Embassy of France in Buenos Aires

"Semana del Cine Francés"
Film festival poster, 2007,
Embassy of France in Buenos Aires

"Semana del Cine Francés"
Film festival poster, 2004,
Embassy of France in Buenos Aires

5

6

7

*1962, Mexico, www.gonzalogarciabarcha.com

GONZALO GARCÍA BARCHA

1

Gonzalo García Barcha, currently resides in Paris, where he creates innovative visual title designs for the movie industry, examples include *Great Expectations, Y Tu Mamá También, Things You Can Tell Just By Looking at Her* and *A Little Princess*. García Barcha studied graphic design and, as a researcher and authority on ancient Mexican typography, has lectured widely in Latin America, and created some original fonts inspired by the country's traditional symbols and shapes. Before working as a title designer, García Barcha gained experience working as an illustrator and art director for numerous book publishers, magazines and newspapers in Mexico.

Gonzalo García Barcha hat zurzeit seinen Wohnsitz in Paris, wo er innovatives Titeldesign für die Filmindustrie entwickelt. Beispiele dafür sind *Great Expectations, Y Tu Mamá También, Things You Can Tell Just By Looking at Her* und *A Little Princess*. García Barcha studierte Grafikdesign und hielt zudem als Forscher und Experte über antike mexikanische Typografie Vorlesungen in ganz Lateinamerika. Er schuf einige eigene Schriftarten, wobei er sich von den traditionellen Symbolen und Formen Mexikos inspirieren ließ. Bevor er als Titeldesigner tätig wurde, sammelte García Barcha Erfahrungen in seiner Arbeit als Illustrator und Art Director für verschiedene Buchverlage, Zeitschriften und Zeitungen in Mexiko.

Gonzalo García Barcha réside actuellement à Paris, où il crée des graphismes innovants pour les titres de films, par exemple pou *Great Expectations, Y Tu Mamá También, Things You Can Tell Just By Looking at Her* et *A Little Princess*. Graphiste de formation, il est également chercheur et spécialiste de la typographie mexicaine ancienne, et a donn de nombreuses conférences sur ce sujet en Amérique latine. Il a créé des polices de caractères originales inspirées des symboles et signes traditionnels mexicains. Avant de concevoir des visuels de titres professionnellement, il a acquis de l'expérience en tant qu'illustrateur et directeur artistique chez de nombreuses maisons d'édition, magazines et journaux mexicains.

1. "Amaranta", "Escritorio",
"Fundación del nuevo cine
latinoamericano" corporate identity,
1987, Fundación del Nuevo Cine
Latinoamericano
Design Estudio El Equilibrista

2. "Ciudad Perra" call for submission
poster, 1998, Maria Guerra
Photo Pía Elizondo
Typeface Fiberfont by Gonzalo
García Barcha and Rodrigo Toledo

3. "Un Buen Sueño" poster,
1998, Homage to Eliseo Diego,
Alacamán Editor

JAVIER GARZÓN

1

Javier Garzón belongs to the new breed of young Colombian graphic designers, having studied at the Universidad Jorge Tadeo Lozano in the capital Bogotá. Typically from his generation, Garzón has worked intensely on a variety of media, from web to editorial, from motion graphics to print design. Having gained experience with a number of advertising agencies, he has developed a visual language with a strong commercial sense that is balanced with his own artistic approach, which he considers a mixture of styles using illustration, photography, typography and art. His most favourite work has been created for a number of bands and artists in the music industry, where he has produced entire identities and promotional vehicles from logo to video clip.

Javier Garzón gehört zu der neuen Generation junger kolumbianischer Grafikdesigner. Er schloss sein Studium an der Universidad Jorge Tadeo Lozano in der Hauptstadt Bogotá ab. Ganz typisch für seine Generation ist seine intensive Arbeit mit verschiedensten Medien wie z.B. Webdesign, Editorial Design, Motion-Grafiken und Print Design. Nachdem er zunächst bei verschiedenen Werbeagenturen eigene Erfahrungen sammeln konnte, hat er eine visuelle Sprache mit einer starken kommerziellen Prägung entwickelt, die sich mit seinem eigenen künstlerischen Ansatz im Gleichgewicht befindet. Die dabei verwendete Stilmischung enthält Elemente aus Illustration, Fotografie, Typografie und Kunst. Seine beliebtesten Arbeiten sind für verschiedene Musikbands und Künstler in der Musikindustrie entworfen worden, für die er das gesamte Identity-Design und Promotionsmaterial vom Logo bis zum Videoclip entwarf.

Javier Garzón appartient à la nouvelle génération de graphistes colombiens qui ont étudié à l'Universidad Jorge Tadeo Lozano de la capitale, Bogota. Résolument ancré dans son époque, il a travaillé sur des supports très variés, d'Internet aux imprimés, des graphismes animés au graphisme éditorial. Grâce à l'expérience qu'il a acquise chez plusieurs agences de publicité, il s'est construit un langage visuel commercialement très efficace, équilibré par sa propre sensibilité artistique, qu'il définit comme un mélange de styles utilisant l'illustration, la photographie, la typographie et l'art. Ses projets favoris étaient destinés à des groupes ou artistes du secteur de la musique, pour lesquels il a créé des identités visuelles complètes, du véhicule de promotion jusqu'au logo, en passant par le clip vidéo.

1. **"Divagash"** CD artwork, 2005

2. **"Stereofriends"** music video
and poster, 2004

*1994, Ecuador, www.latin-brand.com

GIOTTO /
LATINBRAND

For over a decade, Giotto has been the synonym for brothers Silvio and Sandro, after they opened their own design studio in the capital Quito. Their portfolio of poster and logo designs gained attention in the design community, and after a couple years of fruitful collaboration, they pair started to receive invitations for countless features in international books and magazines. Their work has been recognised nationally and internationally, featuring in the *Graphis Poster Annual*, *World Graphic Design*, *Communications Arts*, Bienal del Afiche Político in Belgium, and at the Bienal Iberoamericana del Cartel en Bolivia. With a string of awards for their political posters, the multidisciplinary duo continues to produce high quality work for corporate identity and visual communication projects.

Seit über zehn Jahren ist Giotto das Synonym für die Brüder Silvio und Sandro, nachdem sie in der ecuadorianischen Hauptstadt Quito ihr eigenes Designstudio eröffnet hatten. Ihre Plakat- und Logo-Entwürfe haben in der Welt des Designs Beachtung gefunden, und nach einigen Jahren der erfolgreichen Zusammenarbeit erhielten die beiden Designer immer öfter Einladungen für zahllose Beiträge zu internationalen Büchern und Magazinen. Ihre Arbeiten werden national und international beachtet und in *Graphis Poster Annual*, *World Graphic Design* und *Communications Arts*, sowie auf der Biennale des politischen Plakates in Belgien und der iberoamerikanischen Plakat-Biennale in Bolivien veröffentlicht. Das interdisziplinäre Duo hat eine Reihe von Auszeichnungen für ihre politischen Plakate erhalten und entwickelt weiterhin hochwertige Arbeiten für gemeinschaftliche Projekte im Bereich Corporate Identity und visuelle Kommunikation.

Depuis plus de dix ans, Giotto ce sont les frères Silvio et Sandro, qui ont ouvert leur propre agence de graphisme dans la capitale, Quito. Leur portfolio d'affiches et de logos a attiré l'attention de la communauté du graphisme et, après quelques années de collaboration fructueuse, ils ont commencé à recevoir des invitations pour apparaître dans une multitude de livres et de magazines du monde entier. Leur travail est reconnu dans tout le pays, mais aussi à l'étranger, et a été sélectionné par *Graphis Poster Annual*, *World Graphic Design*, *Communications Arts*, la Biennale de l'affiche politique en Belgique, et la Biennale ibéro-américaine de l'affiche en Bolivie. Avec à leur actif tout un chapelet de récompenses pour leurs affiches politiques, ce duo pluridisciplinaire continue de produire un travail de grande qualité pour des projets d'identité d'entreprise et de communication visuelle.

1. "YogaStudio" visual identity and posters, 2006

2. "Teatro Nacional Sucre" identity redesign and poster series, 2006, Fundación Teatro Nacional Sucre

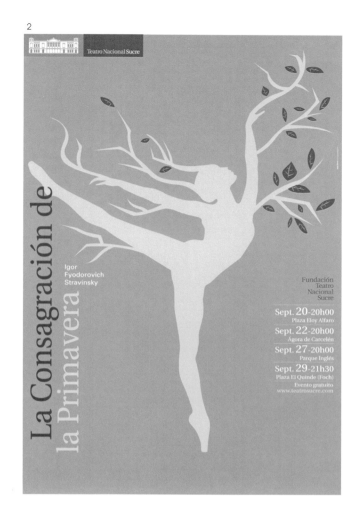

*1955, Venezuela

LUIS GIRALDO

1

1. "Josémaría Escrivá (1902–1975)" centenary commemorative edition, 2002, Ediciones Vértice

2. "Declaración de los Derechos del Libro" calendar, 2006, Asociación de Industriales de Artes Gráficas de Venezuela, Editorial ExLibris

A highly experienced graphic designer based in the capital city of Caracas, Luis Giraldo is probably one of the most talented designers working with typography, having produced countless challenging typographic projects, always pushing the boundaries of its common sense usage. His style and approach was undoubtedly influenced by pioneers Nedo M.F. and Gerd Leufert, with whom Giraldo collaborated on a number of editorial projects. He went solo in the late 70s, during which time he also started teaching at the Instituto de Diseño Neumann, the Prodiseño and at the Instituto de Diseño Darias. Together with another renowned designer, Alvaro Sotillo, Giraldo collaborated on the publication *Biodiversidad en Venezuela*, which, in 2003, received the Medal of Honour at the Leipzig International Book Fair in Germany.

Als sehr erfahrener Grafikdesigner mit Sitz in Venezuelas Hauptstadt Caracas ist Luis Giraldo wahrscheinlich einer der talentiertesten Designer, die mit Typografie arbeiten. Er hat bereits zahllose anspruchsvolle typografische Objekte geschaffen und versucht dabei, über die normale Anwendung hinauszugehen. Sein Stil und Ansatz sind zweifellos durch die Pioniere Nedo M.F. und Gerd Leufert beeinflusst worden, mit denen Giraldo während einer Reihe von Editorial-Projekten zusammenarbeitete. In den späten siebziger Jahren machte er sich selbständig und begann auch mit seiner Lehrtätigkeit an den Einrichtungen Instituto de Diseño Neumann, Prodiseño und Instituto de Diseño Darias. Zusammen mit Alvaro Sotillo, einem weiteren berühmten Designer, arbeitete Giraldo an der Publikation *Biodiversidad en Venezuela*, die 2003 auf der Internationalen Leipziger Buchmesse in Deutschland mit der Ehrenmedaille ausgezeichnet wurde.

Luis Giraldo, basé à Caracas, la capitale vénézuélienne, est un graphiste très expérimenté. Il est probablement l'un des typographes les plus talentueux, et a travaillé sur une multitude de projets ambitieux, toujours en repoussant les limites de l'utilisation courante de la typographie. Son style et sa démarche ont sans aucun doute subi l'influence des pionniers Nedo M.F. et Gerd Leufert, avec qui il a collaboré sur plusieurs projets éditoriaux. Il a commencé sa carrière solo à la fin des années 1970, en même temps qu'il a commencé à enseigner à l'Instituto de Diseño Neumann, à Prodiseño et à l'Instituto de Diseño Darias. Il a collaboré avec un autre graphiste renommé, Alvaro Sotillo, sur la publication *Biodiversidad en Venezuela*, qui a reçu la médaille d'honneur du Salon international du livre 2003 de Leipzig, en Allemagne.

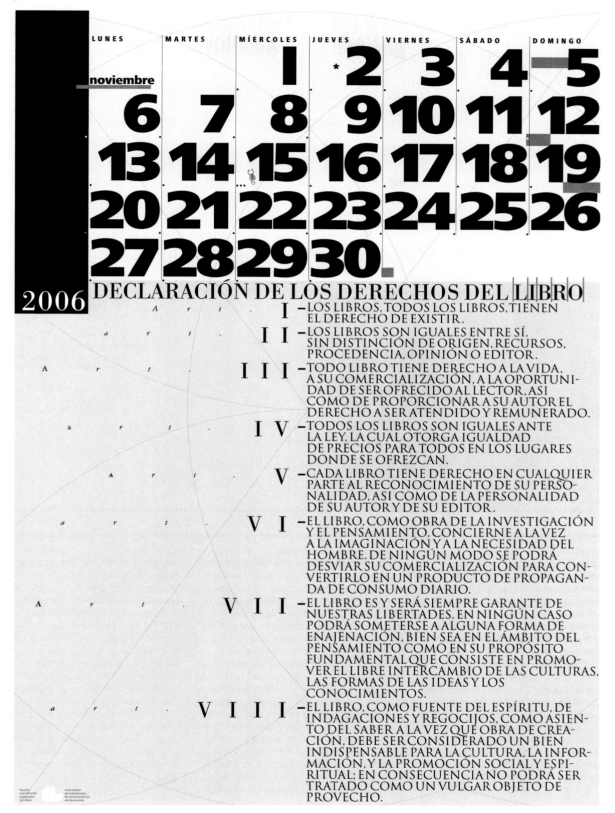

LUNES	MARTES	MÍERCOLES	JUEVES	VIERNES	SÁBADO	DOMINGO	
noviembre			1 *	2	3	4	5
6	7	8	9	10	11	12	
13	14	15	16	17	18	19	
20	21	22	23	24	25	26	
27	28	29	30				

2006

DECLARACIÓN DE LOS DERECHOS DEL LIBRO

Art. **I** – LOS LIBROS, TODOS LOS LIBROS, TIENEN EL DERECHO DE EXISTIR.

art. **II** – LOS LIBROS SON IGUALES ENTRE SÍ, SIN DISTINCIÓN DE ORIGEN, RECURSOS, PROCEDENCIA, OPINIÓN O EDITOR.

Art. **III** – TODO LIBRO TIENE DERECHO A LA VIDA, A SU COMERCIALIZACIÓN, A LA OPORTUNIDAD DE SER OFRECIDO AL LECTOR, ASI COMO DE PROPORCIONAR A SU AUTOR EL DERECHO A SER ATENDIDO Y REMUNERADO.

art. **IV** – TODOS LOS LIBROS SON IGUALES ANTE LA LEY, LA CUAL OTORGA IGUALDAD DE PRECIOS PARA TODOS EN LOS LUGARES DONDE SE OFREZCAN.

Art. **V** – CADA LIBRO TIENE DERECHO EN CUALQUIER PARTE AL RECONOCIMIENTO DE SU PERSONALIDAD, ASI COMO DE LA PERSONALIDAD DE SU AUTOR Y DE SU EDITOR.

art. **VI** – EL LIBRO, COMO OBRA DE LA INVESTIGACIÓN Y EL PENSAMIENTO, CONCIERNE A LA VEZ A LA IMAGINACIÓN Y A LA NECESIDAD DEL HOMBRE. DE NINGÚN MODO SE PODRÁ DESVIAR SU COMERCIALIZACIÓN PARA CONVERTIRLO EN UN PRODUCTO DE PROPAGANDA DE CONSUMO DIARIO.

Art. **VII** – EL LIBRO ES Y SERÁ SIEMPRE GARANTE DE NUESTRAS LIBERTADES. EN NINGÚN CASO PODRÁ SOMETERSE A ALGUNA FORMA DE ENAJENACIÓN, BIEN SEA EN EL ÁMBITO DEL PENSAMIENTO COMO EN SU PROPÓSITO FUNDAMENTAL QUE CONSISTE EN PROMOVER EL LIBRE INTERCAMBIO DE LAS CULTURAS, LAS FORMAS DE LAS IDEAS Y LOS CONOCIMIENTOS.

art. **VIII** – EL LIBRO, COMO FUENTE DEL ESPÍRITU, DE INDAGACIONES Y REGOCIJOS, COMO ASIENTO DEL SABER A LA VEZ QUÉ OBRA DE CREACIÓN, DEBE SER CONSIDERADO UN BIEN INDISPENSABLE PARA LA CULTURA, LA INFORMACIÓN, Y LA PROMOCIÓN SOCIAL Y ESPIRITUAL; EN CONSECUENCIA NO PODRÁ SER TRATADO COMO UN VULGAR OBJETO DE PROVECHO.

Diseño
Luis Giraldo
Impresión
Ex Libris
Asociación
de Industriales
de Artes Gráficas
de Venezuela

*1937, Argentina, www.gonzalezruizdesign.com.ar

GUILLERMO GONZÁLEZ RUIZ

1. "La Terraza" film poster,
1964, Instituto de Cine Argentino,
Berlin Festival

2. "El Idolo" film poster,
1965, Instituto de Cine Argentino,
Berlin Festival

3. "La Ribera de Buenos Aires"
architecture magazine cover, 2001,
Sociedad Central de Arquitectos

Guillermo Gonzáles Ruiz was born in the city of Chascomús, and is an important and long standing figure in the graphic design field in Argentina. He graduated as an architect from the Universidad de Buenos Aires (UBA) in 1965, almost a decade after he had already started to work in the field, and in 1972 was responsible for the signage design for the whole capital. Soon after, he established his own practice in 1973, and later in 1984 he created the Graphic Design course at UBA. Gonzáles Ruiz's book *Estudio de Diseño*, became a best seller in Argentina. He has been featured in various international publications such as *Graphis, Idea Graphic Design* and *Novum Gebrauchsgraphik,* and some of his graphic works are in the permanent collection of the Stedelijk Museum in Amsterdam.

Guillermo Gonzáles Ruiz wurde in der Stadt Chascomús geboren und stellt eine wichtige und langjährige Persönlichkeit im Fachgebiet Grafikdesign in Argentinien dar. Er schloss 1965 sein Architekturstudium an der Universidad de Buenos Aires (UBA) ab, fast ein Jahrzehnt, nachdem er bereits in diesem Bereich zu arbeiten begonnen hatte. 1972 war er für das Design der Beschilderung der gesamten Hauptstadt verantwortlich. Ein Jahr später machte er sich selbständig und führte 1984 den Lehrgang Grafikdesign an der UBA ein. Gonzáles Ruiz' Buch *Estudio de Diseño* wurde zu einem Bestseller in Argentinien. Er wurde in verschiedenen internationalen Publikationen, wie zum Beispiel *Graphis, Idea Graphic Design* und *Novum Gebrauchsgraphik* vorgestellt. Einige seiner Grafikarbeiten sind in der ständigen Sammlung des Stedelijk Museums in Amsterdam enthalten.

Guillermo Gonzáles Ruiz est né à Chascomús. C'est depuis longtemps un personnage important dans le secteur du graphisme en Argentine. Il a reçu son diplôme d'architecture de l'Universidad de Buenos Aires (UBA) en 1965, presque dix ans après avoir commencé à travailler dans ce domaine, et en 1972 il s'est occupé de la conception de la signalisation de toute la capitale. Il a créé sa propre agence en 1973, et en 1984 il a créé le programme d'études de graphisme de l'UBA. Son livre *Estudio de Diseño*, est un best-seller en Argentine. Il est apparu dans des publications internationales telles que *Graphis, Idea Graphic Design* et *Novum Gebrauchsgraphik*, et certaines de ses œuvres graphiques font partie de la collection permanente du Musée Stedelijk d'Amsterdam.

**Sociedad Central
de Arquitectos**

Fundada el 18 de marzo de 1886

**Revista
de Arquitectura
Nº 201**

Fundada el 15 de abril de 1904

La ribera

Buenos Aires / Junio de 2001
$ 12 / ISSN 0327-330x

Tapa: "El río y la ribera".
Guillermo González Ruiz, arq.

SCA

*1977, Chile, www.cristiangonzalezsaiz.com

CRISTIÁN GONZÁLEZ SÁIZ

1

Cristián González Sáiz is a Chilean graphic designer and typographer. He graduated in graphic design from the Universidad Finis Terrae, where he currently teaches. González Sáiz started working very early as a typographer at Diseñadores Asociados, a prestigious design consultancy in Chile. Soon after, he gained the position of art director at the Ce Diseña design agency. In October 2005 he founded his own firm, Brandi, with the aim of working on a broader graphic communication strategy. Since then he has produced designs for national brands such as Molymet, Brantmayer, CCNI, OWAR and MIRA. Amongst his many projects to date, González Sáiz has also published a book, *Proyecto Demo: Australis*, in collaboration with designer Daniel Berczeller. In 2008 he established his own design studio, Gonzales.

Cristián González Saíz ist ein chilenischer Grafikdesigner und Typograf. Er studierte Grafikdesign an der Universidad Finis Terrae, wo er zurzeit unterrichtet. González Saíz begann sehr früh seine berufliche Laufbahn als Typograf bei Diseñadores Asociados, ein prestigeträchtiges Designunternehmen in Chile. Nur wenig später konnte er die Stelle des Art Directors bei der Designagentur Ce Diseña besetzen. Im Oktober 2005 gründete er seine eigene Firma Brandi, mit dem Ziel, an einer umfassenderen Strategie für Grafikkommunikation zu arbeiten. Seitdem hat er für nationale Marken entworfen, wie zum Beispiel für Molymet, Brantmayer, CCNI, OWAR und MIRA. Neben seinen vielen weiteren Projekten veröffentlichte González Saíz in Zusammenarbeit mit dem Designer Daniel Berczeller das Buch *Proyecto Demo: Australis*. In 2008 gründete er sein eigenes Design-Studio Gonzales.

Cristián González Saíz est un graphiste et typographe chilien. Il est diplômé en graphisme de l'Universidad Finis Terrae, où il enseigne actuellement. Il commencé à travailler très tôt comme typographe chez Diseñadores Asociados, un prestigieux cabinet de graphisme chilien. Peu de temps après, il a décroché un poste de directeur artistique à l'agence de graphisme Ce Diseña. En octobre 2005, il a créé sa propre société, Brandi, dans le but de travailler sur une conception plus large de la stratégie de communication. Il a depuis créé des projets pour des marques chiliennes comme Molymet, Brantmayer, CCNI, OWAR et MIRA. Parmi ses nombreux projets, on peut citer entre autres son livre *Proyecto Demo: Australis*, en collaboration avec le graphiste Daniel Berczeller. Il a créé son propre studio en 2008, Gonzalez.

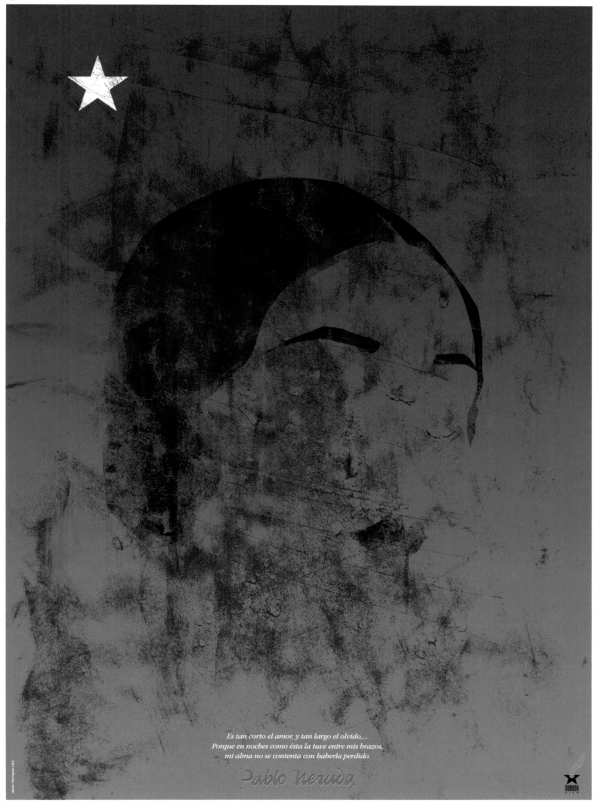

*Es tan corto el amor, y tan largo el olvido,...
Porque en noches como ésta la tuve entre mis brazos,
mi alma no se contenta con haberla perdido.*

Pablo Neruda

3. "La Diablita" advertising,
La Diablita Cantina

4. "La Moresca (Primavera Verano)"
menu cover, 2007,
La Moresca Restaurant

5. "La Moresca (Otoño Invieno)"
menu, 2006, La Moresca Restaurant

6. "Derechos de la Naturaleza"
poster, Hematoma Collective

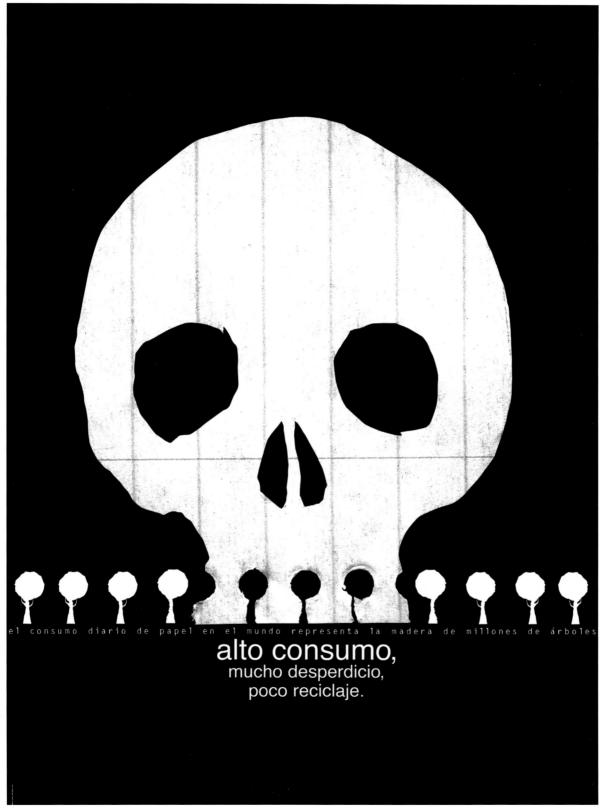

el consumo diario de papel en el mundo representa la madera de millones de árboles

alto consumo,
mucho desperdicio,
poco reciclaje.

JOSÉ ALBERTO HERNÁNDEZ

1

2

Designer and photographer José Alberto Hernández is a native of Costa Rica. A graduate in fine arts from the Universidad de Costa Rica, Hernández has worked in his own design studio since 2004, developing projects mainly for the cultural and artistic sectors. A lover of illustration and photography, his creations have been widely exhibited internationally, including at the Museum of Contemporary Arts in Los Angeles and at the museum of the Inter-American Development Bank in Washington, in the United States, the Taipei Fine Arts Museum in Taiwan, the Museo de Arte Moderno in the Dominican Republic and at the Centro de Artes Visuales in Yucatán, Mexico. Hernández's current projects include redesigning the identity for the city San José Posible.

Der Designer und Fotograf José Alberto Hernández stammt gebürtig aus Costa Rica. Nach Abschluss seines Studiums der Bildenden Kunst an der Universidad de Costa Rica leitet er seit 2004 ein eigenes Designstudio und entwickelt hauptsächlich Projekte für kulturelle und künstlerische Bereiche. Er liebt Illustrationen und Fotografie, und seine Werke wurden international ausgestellt, zum Beispiel im Museum of Contemporary Arts in Los Angeles und im Museum der Inter-American Development Bank in Washington, USA, im Taipei Fine Arts Museum, Taiwan, im Museo de Arte Moderno, Dominikanische Republik, und im Centro de Artes Visuales in Yucatán, Mexiko. Hernández' laufende Projekte beinhalten auch die Neugestaltung der städtischen Identität von San José Posible.

José Alberto Hernández est un graphiste et photographe né au Costa Rica. Il est diplômé en beaux-arts de l'Universidad de Costa Rica, et a créé sa propre agence de graphisme en 2004. Il y travaille principalement sur des projets pour les secteurs de la culture et des arts. Amant de l'illustration et de la photographie, ses créations ont fait l'objet de nombreuses expositions dans le monde entier, notamment au Museum of Contemporary Arts de Los Angeles et au Museum of the Inter-American Development Bank de Washington, aux États-Unis, au Musée des Beaux-Arts de Taipei à Taiwan, au Museo de Arte Moderno de la République dominicaine et au Centro de Artes Visuales du Yucatán, au Mexique. L'un de ses projets actuels est la nouvelle identité de la ville San José Posible.

3

CRMUSICA

1. "Cuelga en el Farolito"
exhibition poster, 2007,
Centro Cultural de España

2. "Kriptonita" art exhibition poster,
2004, Centro Cultural de España

3. "6 x 2 = 13" concert poster
series, 2005, CR Música,
Centro Cultural de España

4. "Miedo de lo que Quiero"
film festival poster, 2005–2006,
Centro Cultural de España

4

JOSÉ ALBERTO HERNÁNDEZ **257**

HULA HULA

1

1. "Imperialismo" poster,
Hematoma Collective

2. "Taxi" promotional illustration
for typography (Bicolor),
Mexico Design magazine

Hula Hula is a full service design consultancy of Quique Ollervides and Cha!, born in 1974 and 1968 respectively. Formed in 1996, this creative consultancy has for more than a decade created an extensive portfolio of works in very distinctive areas, from package to editorial, and from visual identity to illustration, serving high profile clients such as Cartoon Network, MTV, L'Oréal, Doritos, Televisa, Canal Once and a large number of recording companies in the country. Ollervides also lectures on typography, whilst Cha! also pursues a career in music. Together with colleague Jorge Alderete and artist Clarisa, the pair manages Kong, a gallery and shop in Mexico City, dedicated entirely to the exhibition and sale of graphic design products.

Hula Hula ist ein Designberatungsunternehmen mit umfassendem Service, das 1996 von Quique Ollervides und Cha! (geb. 1974 bzw. 1968) in Mexiko gegründet wurde. Dieses kreative Unternehmen hat in mehr als zehn Jahren ein umfangreiches Portfolio an Arbeiten in sehr unterschiedlichen Bereichen geschaffen, vom Verpackungsdesign über Editorial Design und Visual Identity bis hin zu Illustrationen. Zu den Kunden zählen so bekannte Auftraggeber wie Cartoon Network, MTV, L'Oréal, Doritos, Televisa, Canal Once und viele Aufnahmestudios des Landes. Ollervides ist zudem als Dozent für Typografie tätig, während Cha! eine Musikkarriere verfolgt. In Zusammenarbeit mit ihrem Kollegen Jorge Alderete und der Künstlerin Clarisa leitet das Paar die Galerie und das Geschäft Kong in Mexico City, das sich der Ausstellung und dem Verkauf von Grafikdesign-Produkten widmet.

Hula Hula est le cabinet de conseil en solutions de graphisme clé en main de Quique Ollervides et Cha!, nés respectivement en 1974 et 1968. Cette agence créée en 1996 s'est construit un portefeuille bien garni de projets dans des domaines très variés, de l'emballage à l'éditorial et de l'identité visuelle à l'illustration, pour des clients d'envergure comme Cartoon Network, MTV, L'Oréal, Doritos, Televisa, Canal Once et plusieurs grandes maisons de disques mexicaines. Quique Ollervides enseigne également la typographie, et Cha! poursuit une carrière dans la musique. Avec leur collègue Jorge Alderete et l'artiste Clarisa, le duo gère Kong, une galerie-boutique située à Mexico, entièrement consacrée à l'exposition et à la vente de produits liés au graphisme.

3

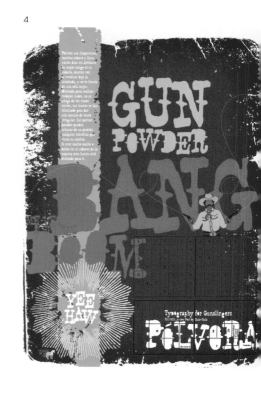

4

3. "Muerto de Amor" poster,
self-promotion

4. "Pólvora" promotional
poster for typography (Pólvora), T26

5 Various CD packaging projects,
"Chido" (Liquits); "Wow" (Fobia);
"Lupitología" (La Lupita);
"Flores de Alquiler" (La Quinta
Estación); "Rosa Venus" (Fobia);
"El Pop ha muerto" (Kabah); "Natalia
Lafourcade" (Natalia Lafourcade)

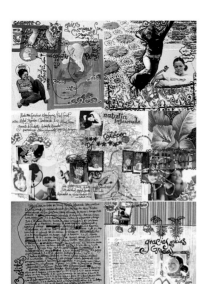

5

IDEAS FRESCAS

1

Ideas Frescas, established in 2000, is a women-led design studio directed by sisters and partners Frida Larios and Gabriela Larios. Frida has an MA in Communication Design from Central Saint Martins School of Art and is currently an associate lecturer in graphic design at the University of the Arts in London. Gabriela has an MA in Graphic Design at the University of the Arts in London. Aside from their design career, both partners are former national athletes, having represented El Salvador at international events in beach volleyball and cycling, respectively. Motivated by a celebration of their roots, Ideas Frescas produces a constant supply of fresh ideas that are shaping a new Salvadorean visual identity. They have received countless design prizes and have been extensively published.

Bei dem im Jahre 2000 gegründeten Studio Ideas Frescas handelt es sich um ein rein frauengeführtes Designstudio, das von den Schwestern und Teilhaberinnen Frida Larios und Gabriela Larios geleitet wird. Frida hat einen MA in Kommunikationsdesign an der Central Saint Martins School of Art erworben und ist zurzeit Lehrbeauftragte für Grafikdesign an der University of the Arts in London. Gabriela hat einen MA in Grafikdesign an der University of the Arts in London abgeschlossen. Neben ihren Design-Karrieren waren die beiden früher auch Athletinnen, die El Salvador auf internationalen Beachvolleyball- bzw. Radsport-Wettkämpfen vertreten haben. Motiviert durch ihre kulturellen Wurzeln produziert Ideas Frescas ständig neuartige Ideen, die eine neue Visual Identity für El Salvador schaffen. Die Arbeiten des Studios haben zahllose Designpreise erhalten und sind umfangreich veröffentlicht worden.

Ideas Frescas est un studio de graphisme dirigé par deux femmes, les sœurs Frida et Gabriela Larios. Frida est titulaire d'une maîtrise en graphisme et communication de la Central Saint Martins School of Art, et est actuellement professeure adjointe de graphisme à l'Université des Arts de Londres. Gabriela est titulaire d'une maîtrise de graphisme de la même université. Les deux sœurs sont aussi d'anciennes athlètes de niveau national, et elles ont représenté le Salvador lors de compétitions internationales de volley-ball et de cyclisme. Leur motivation principale est la célébration de leurs racines et Ideas Frescas produit un flux continu de nouvelles idées qui donnent forme à la nouvelle identité visuelle du Salvador. Les sœurs Larios ont reçu une multitude de récompenses de graphisme, et leur travail est apparu dans de nombreuses publications.

"Thinking Types" posters
bstract calligraphic forms
ased on typographers quotes),
ersonal work

"New Maya Glyphs" booklet,
ersonal work based on Maya
eroglyphs (description,
ap, wood decking prototype,
ctionary, guidebook,
ayfinding sign and pictograms)

IDeO

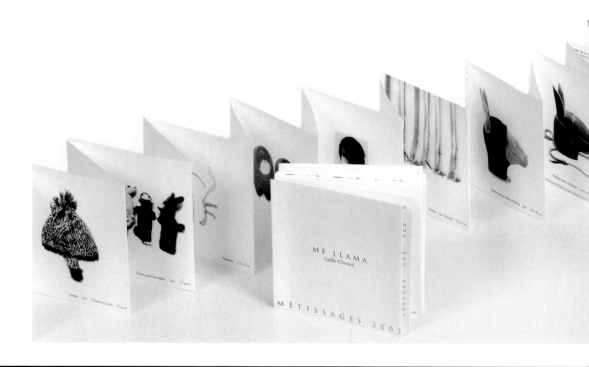

Ideo Comunicadores was formed in 2000 by Yvette Lolas and Daniela Svagelj to develop visual communication for editorial, cultural enterprises and publicity. Head of the creative team, Yvette Lolas studied architecture, fashion and graphic design in Miami. She then moved to Chile where she served as art director for a number of advertising agencies, including Young & Rubicam and Leo Burnett. She then returned to Peru to work for the local associated agency of Publicis, where she led the design studio and direct marketing department. Also with a strong background in advertising, Daniela Svagelj graduated in communication from the Universidad de Lima before going on to study art history at the Ecole du Louvre in Paris. She currently serves as art director for Ideo Comunicadores.

Ideo Comunicadores wurde im Jahre 2000 von Yvette Lolas und Daniela Svagelj gegründet, um visuelle Kommunikation für Verlage, kulturelle Einrichtungen und den Werbebereich zu entwickeln. Die Leiterin des Kreativteams, Yvette Lolas, studierte Architektur, Mode und Grafikdesign in Miami, USA. Danach zog sie nach Chile, wo sie als Art Director für verschiedene Werbeagenturen tätig war, zum Beispiel für Young & Rubicam und Leo Burnett. Sie kehrte schließlich nach Peru zurück und arbeitete für die lokal angegliederte Agentur Publicis, wo sie das Designstudio und die Marketingabteilung leitete. Auch Daniela Svagelj sammelte umfangreiche Erfahrungen im Werbebereich. Sie schloss den Studiengang Kommunikation an der Universidad de Lima ab, bevor sie Kunstgeschichte an der Ecole du Louvre in Paris studierte. Zurzeit ist sie als Art Director für Ideo Comunicadores tätig.

Yvette Lolas et Daniela Svagelj ont créé Ideo Comunicadores en 2000 afin de développer des concepts de communication pour les secteurs de l'édition, des entreprises culturelles et de la publicité. Yvette Lolas, la responsable de l'équipe de création, a étud l'architecture, la mode et le graphisme à Miami. Elle est ensuite allée au Chili, où elle a été directrice artistique chez plusieurs agenc de publicité, dont Young & Rubicam et Leo Burnett. Elle est ensuite retournée au Pérou travailler pour l'agence locale partenaire de Publicis, où elle a dirigé le studio de graphism et le service de marketing direct. Daniela Svagelj possède également une expérience solide de la publicité. Elle est diplômée en communication de l'Universidad de Lima, et a ensuite étudié l'histoire de l'art à l'École du Louvre de Paris. Elle est actuellement directrice artistique chez Ideo Comunicadores.

1. "Me llama" exhibition catalogue
for Gaëlle Chotard, 2002,
Galería L'imaginaire
Design Daniela Svagelj

2. "Clásicos Tocan Jazz" concert
poster, 2003, Alianza Francesa
Design Yvette Lolas

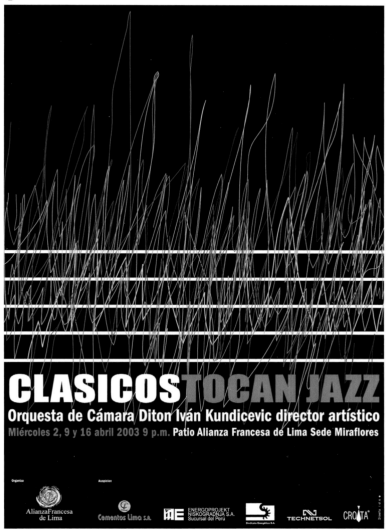

3. "Verónica Wiese" art catalogue,
2005, Verónica Wiese
Design Yvette Lolas
Collaboration Daniela Svagelj

*1999, Mexico, www.ideograma.com

IDEOGRAMA

1

1. "Volaris" corporate identity, 2006
Design Carl Forssell, Mariana Leegi,
Juan Carlos Fernández

2. Various logos, 2004
Design Juan Carlos Cué,
Marilú Dibildox, Juan Carlos
Fernández, Carl Forssell,
Alejandra García, Mariana Leegi,
Daniel Markus, Susanne Ortiz,
Josep Palau, Ricardo Ríos

3. "Comunidad" logo, 2004
Design Juan Carlos Fernández

4. "Homestyles" logo, 2002
Design Susanne Ortiz,
Juan Carlos Fernández

Established in 1999, Ideograma is a forward thinking graphic design studio based in Cuernavaca, in the state of Morelos. The studio employs a multidisciplinary team who work on a wide range of branding and design projects. At the helm is Juan Carlos Fernández, a graduate from the Universidad Iberoamericana and the Art Center College of Design in California, where he specialised in corporate identity. Fernández gained industry experience working at Addison and Siegel & Gale. Partner and designer Josep Palau, also a graduate of the same university, later specialised in business at the Rotterdam School of Management in the Netherlands, and the Manchester Business School in the UK. Palau also had long professional stints with the Walt Disney in Mexico and Bristol-Myers Squibb.

Ideograma ist ein zukunftsorientiertes Studio für Grafikdesign mit Sitz in Cuernavaca im Bundesstaat Morelos in Zentralmexiko. Das Studio wurde 1999 gegründet und beschäftigt ein fachübergreifendes Team, das verschiedenste Branding- und Design-Projekte durchführt. Die Leitung obliegt Juan Carlos Fernández, einem Absolventen der Universidad Iberoamericana und des Art Center College of Design in Kalifornien, wo er sich auf Corporate Identity spezialisierte. Fernández sammelte viel Branchenerfahrung während seiner Tätigkeit bei Addison und Siegel & Gale. Sein Partner ist der Designer Josep Palau, der sein Studium an der gleichen Universität abschloss und zusätzlich Studiengänge in Wirtschaft an der Rotterdam School of Management in den Niederlanden und an der Manchester Business School in Großbritannien absolvierte. Palau arbeitete lange Zeit bei Walt Disney in Mexiko und bei Bristol-Myers Squibb.

Ideograma est une agence de graphisme avant-gardiste créée en 1999 à Cuernavaca, dans l'état de Morelos. Son équipe pluridisci-plinaire y travaille sur un vaste éventail de pro jets de stratégie de marque et de graphisme. C'est Juan Carlos Fernández qui la dirige. Il est diplômé de l'Universidad Iberoamericana et de l'Art Center College of Design de Californie, où il s'est spécialisé dans l'identité d'entreprise. Il a acquis de l'expérience dans le secteur en travaillant chez Addison et chez Siegel & Gale. Son associé, le graphiste Josep Palau, également diplômé de la même université, s'est plus tard spécialisé dans la gestion d'entreprise à l'École de gestion de Rotterdam, aux Pays-Bas, et à la Manchester Business School au Royaume-Uni. Josep Palau a collaboré plusieurs fois avec la Walt Disney à Mexico et avec Bristol-Myers Squibb.

impulso

RETO *tu reencuentro*

Cuernavaca *florece*

Hábitat

Pastelandia
La felicidad de compartir

Asociación Mexicana de Comunicadores

AMCO

Redes
Marcas con Estrategia

Ultrafemme

Markus
tecno logics

Comunidad

*1995, Argentina, www.imagenhb.com

IMAGEN HB

Hernán Berdichevsky is not just a designer, but is also a leading figure in the design community in Buenos Aires; through which he has championed the philosophy that good design can help to build a better society. A graduate from the Universidad de Buenos Aires, Berdichevsky designed the visual identity for the first Bienal de Arte Joven, and in 1997 founded ImagenHB, his design consultancy in Buenos Aires. Together with designer Gustavo Ariel Stecher, he has worked on the grand project of developing and promoting the Argentinean national identity, leading to a much acclaimed exhibition and the subsequent launch of a new brand. He has designed for a number of clients in Chile, Uruguay and the United States. Berdichevsky has taught at the Universidad de Buenos Aires, and his works have been widely published worldwide.

Hernán Berdichevsky ist nicht nur ein Designer, sondern auch eine führende Persönlichkeit in der Designszene von Buenos Aires. Er vertritt die Philosophie, dass gutes Design beim Aufbau einer besseren Gesellschaft helfen kann. Als Absolvent der Universidad de Buenos Aires entwarf Berdichevsky die Visual Identity für die erste Bienal de Arte Joven. 1997 gründete er ImagenHB, sein Designbüro in Buenos Aires. Zusammen mit dem Designer Gustavo Ariel Stecher arbeitete er an dem bedeutenden Projekt der Entwicklung und Förderung der nationalen Identität Argentiniens, das zu einer gefeierten Ausstellung und der anschließenden Einführung einer neuen Handelsmarke führte. Berdichevsky hat für viele Kunden in Chile, Uruguay und in den USA entworfen und war als Dozent an der Universidad de Buenos Aires tätig. Seine Arbeiten wurden weltweit ausgestellt.

Hernán Berdichevsky n'est pas seulement un graphiste, mais aussi une personnalité de premier rang dans la communauté du graphisme à Buenos Aires, où il a défendu l'idée selon laquelle le graphisme peut contribuer à l'évolution de la société. Diplômé de l'Universidad de Buenos Aires, il a conçu l'identité visuelle de la première Biennale de l'art jeune et, en 1997, a créé ImagenHB, son cabinet de conseil en graphisme à Buenos Aires. Il a travaillé avec le graphiste Gustavo Ariel Stecher sur le projet ambitieux de la création et de la promotion de l'identité nationale argentine, ce qui a abouti à une exposition très applaudie et au lancement d'une nouvelle marque. Il a travaillé pour de nombreux clients au Chili, en Uruguay et aux États-Unis. Hernán Berdichevsky a enseigné à l'Universidad de Buenos Aires, et ses travaux ont été publiés dans le monde entier.

. **Character design**, 2006,
epsol YPF, Argentina

. **"La Cantillana"** signage design,
006–2007, La Cantillana, Chile

. **"Daimler Chrysler"** graphics for
pplication on the wall, 2005–2006,
aimler Chrysler Argentina

IN JAUS

1

Located in Buenos Aires, In Jaus is probably one of the most versatile creative studios working today. With a roster of clients such as Arcor, Playboy, Radio Disney, Coca-Cola, EMI International, Editorial Atlantida, and Bodegas Bianchi, it is easy to see how the studio has developed such a high reputation with its strong portfolio in broadcast design. Offering a very dense and dynamic visual aesthetic, the group specialises in print, broadcast, production, advertising and visual identity. Dedicated to delivering an outstanding visual quality, In Jaus' strength lies in its ability to combine striking concepts with precise art direction. Their ad works for *Playboy* have been highly acclaimed not only for tasteful sensuality, but for great concepts and consistent quality of execution throughout the campaign.

Das Studio In Jaus hat seinen Sitz in Buenos Aires und ist wahrscheinlich eines der vielseitigsten Kreativstudios der Branche. Der Blick auf Kundennamen wie Arcor, Playboy, Radio Disney, Coca-Cola, EMI International, Editorial Atlantida und Bodegas Bianchi lässt leicht erkennen, wie das Studio mit seinem hervorragenden Portfolio für Broadcast Design einen solch guten Ruf gewinnen konnte. Die Gruppe bietet eine sehr dichte und dynamische visuelle Ästhetik mit den Schwerpunkten Druck, TV & Radio, Produktion, Werbung und Corporate Identity. In Jaus fordern sich überragende visuelle Qualität ab, und ihre Stärken liegen in der Fähigkeit, eindrucksvolle Konzepte mit einer präzisen und künstlerischen Leitung umzusetzen. Die Werbearbeiten des Studios für *Playboy* haben große Anerkennung gefunden, nicht nur wegen ihrer geschmackvollen Sinnlichkeit, sondern auch wegen der großartigen Konzepte und der gleichbleibend erstklassigen Ausführung während der gesamten Kampagne.

Située à Buenos Aires, In Jaus est probablement l'une des agences de création actuelles les plus polyvalentes. Avec une liste de clients tels que Playboy, Arcor, Radio Disney, Coca-Cola, EMI International, Editorial Atlantida et Bodegas Bianchi, il est facile de comprendre comment l'agence s'est forgé son excellente réputation dans l'habillage multimédia. Le groupe propose une esthétique visuelle très dense et dynamique, et s'est spécialisé dans les publications imprimées, l'habillage TV, la production, la publicité et l'identité visuelle. In Jaus se donne pour mission de livrer à ses clients une qualité visuelle exceptionnelle, et sa force réside dans sa capacité à allier concepts frappants et direction artistique méticuleuse. Ses publicités pour *Playboy* ont été très applaudies, non seulement pour leur sensualité raffinée, mais aussi pour l'originalité des concepts et la qualité avec laquelle toute la campagne a été exécutée.

FashionTv
New season

1. "La maison de la house"
double CD packaging, Fashion TV

2. "Black and white" posters,
Fashion TV

3. "HTV Musica" poster, HTV

4. "Latino CD" visual identity
and applications, Much Music

4

INTERFACE DESIGNERS

1. **"Gesto"** contemporary dance and performance magazine

2. **"Coexistence"** poster, Museum of the Seam, Jerusalem
Design Andre de Castro

3. **"Prêmio Design"** poster for a design competition in São Paulo, 2002, Museu da Casa Brasileira

4. **"O Brasil na Copa"** poster, 2006, Football World Cup 2006 (Germany)
Design André de Castro, Sergio Liuzzi

Established in 1988 by architect Sergio Liuzzi (b. 1950) and designer André de Castro (b. 1963), Interface Designers, based in Rio de Janeiro, has always been at the forefront of avant-garde design. With more than two decades in the business, the studio's works are included in the archives of the Museé de la Publicité, in the Louvre in Paris, the Museum of Decorative Arts in Hamburg, and in the private collection of Merrill C. Berman in the United States. They have been widely published in the United States, Brazil, Europe and Japan, and have featured in books like *Logotypes of the World* and *Breaking the Rules*, and also in magazines such as *Design Magazine* (UK) and *Linea Grafica* (Italy). Their work has also featured in several exhibitions including the Graphic Design Biennial in the Czech Republic, Bulgaria and Poland.

Interface Designers wurde 1988 von dem Architekten Sergio Liuzzi (geb. 1950) und dem Designer André de Castro (geb. 1963) gegründet. Das Studio hat seinen Sitz in Rio de Janeiro und ist bereits seit der Gründung führend im Avantgarde-Design. Nach mehr als zwei Jahrzehnten des Bestehens sind die Arbeiten des Studios in den Archiven bedeutender Museen enthalten, darunter im Museé de la Publicité, im Louvre in Paris, im Museum für Kunst und Gewerbe in Hamburg und in der privaten Sammlung von Merrill C. Berman in den USA. Sie wurden in Brasilien, Europa, Japan und in den USA veröffentlicht und erschienen in Büchern wie *Logotypes of the World* und *Breaking the Rules* sowie in Zeitschriften wie *Design Magazine* (Großbritannien) und *Linea Grafica* (Italien). Die Werke wurden außerdem in verschiedenen Ausstellungen gezeigt, z.B. auf den Grafikdesign-Biennalen in der Tschechischen Republik, Bulgarien und Polen.

Créée en 1988 à Rio de Janeiro par l'architecte Sergio Liuzzi (né en 1950) et le graphiste André de Castro (né en 1963), l'agence Interface Designers a toujours été à l'avant-garde dans son domaine. Vingt ans plus tard, la production de l'agence figure aux archives du Musée de la publicité, au Louvre de Paris, au Musée des Arts décoratifs de Hambourg, et dans la collection privée de Merrill C. Berman aux États-Unis. Leurs œuvres ont beaucoup été publiées aux États-Unis, au Brésil, en Europe et au Japon, et ont figuré dans des ouvrages comme *Logotypes of the World* et *Breaking the Rules*, ainsi que dans des magazines tels que *Design Magazine* (Royaume-Uni) et *Linea Grafica* (Italie). Elles ont également figuré dans plusieurs expositions, notamment la Biennale du graphisme en République tchèque, en Bulgarie et en Pologne.

2

COEXISTENCE

3

Prêmio Design Museu da Casa Brasileira

4

*1958, Brazil, www.estudioinfinito.com.br

RUTH KLOTZEL

1

Ruth Klotzel comes from São Paulo and graduated from the FAU at USP in 1982. She opened her own design consultancy, Estúdio Infinito, in 1990, producing a variety of work for both the public and private sectors. She has also been teaching for almost a decade and is currently the Vice President of Icograda (International Council of Graphic Design Associations). As an active founding member and director of ADG Brasil (Graphic Designers Association), Klotzel has lectured widely on the subject of graphic design. She has served as the judge at international events such as the Design Biennial in Slovenia and the Eco-Poster Design Triennial in Ukraine, and has curated a number of exhibitions on graphic design. Her work has been published in Brazil, Japan, United States and Italy.

Ruth Klotzel kommt aus São Paulo und schloss 1982 ihr Studium an der Fakultät für Architektur und Stadtplanung an der Universität von São Paulo ab. Sie eröffnete 1990 ihre eigene Design-Beratung Estúdio Infinito und produziert seitdem vielfältige Arbeiten für den öffentlichen und privaten Sektor. Klotzel war fast zehn Jahre lang als Dozentin tätig und ist zurzeit Vizepräsidentin des Icograda (International Council of Graphic Design Associations). Als aktives Gründungsmitglied und Leiterin der ADG Brasil (Verband der Grafikdesigner) hat sie über das Thema Grafikdesign unzählige Vorträge gehalten. Klotzel war Jurymitglied auf internationalen Veranstaltungen wie zum Beispiel der Design-Biennale in Slowenien und der Eco-Poster Design-Triennale in der Ukraine. Außerdem kuratierte sie eine Reihe von Ausstellungen für Grafikdesign. Ihre Arbeiten wurden in Brasilien, Japan, Italien und den USA veröffentlicht.

Ruth Klotzel est originaire de São Paulo et a obtenu son diplôme de la FAU à l'USP en 1982. En 1990, elle a ouvert son propre cabinet de conseil en graphisme, Estúdio Infinito. Elle travaille dans des domaines très divers pour les secteurs public et privé. Elle enseigne également depuis bientôt dix ans et est actuellement vice-présidente de l'Icograda (Conseil international des associations de graphisme). En tant que membre fondateur actif de l'ADG Brésil (association de graphistes), elle a donné de nombreuses conférences sur le thème de la conception graphique. Elle a été juge pour des événements internationaux tels que la Biennale du design en Slovénie et la Triennale de la création d'écoaffiche en Ukraine, et elle a été commissaire de nombreuses expositions sur le graphisme. Ses œuvres ont été publiées au Brésil, au Japon, aux États-Unis et en Italie.

1. **"Mulher"** visual identity and
promotional material for event, 2001
Production Rogério Nicolau

2. **"Sampa"** artwork for book,
2004, 450th anniversary of São Paulo

*2003, Colombia, www.kontra.ws

KONTRA

1

ENCANTADORA GRAFICA POPULAR

Kontra was founded in 2003 in the city of Santiago de Cali, and is the studio of graphic artist and designer Francisco Garzón. Born in 1982, Garzón graduated from the Universidad del Valle, where he developed a keen interest in education, working on a number of projects for local universities. His graphic developments consist of a strong blend of typography, illustration, colour and movement. Within the last few years, Garzón has worked on editorial, web design and corporate identity, also producing a lot of experimental graphics that have been exhibited at *SUB*, *Grafica Masiva*, and *Desfase*, among other events in Colombia. The theme of "information overload", combined with a passion for street and pop culture reflect prominently in his personal work.

Bei Kontra handelt es sich um das Studio des Grafikkünstlers und Designers Francisco Garzón, das 2003 in der Stadt Santiago de Cali in Kolumbien gegründet wurde. Garzón (geb. 1982) schloss sein Studium an der Universidad del Valle ab, wo er großes Interesse an Bildungsarbeit entwickelte und eine Reihe von Projekten für regionale Universitäten durchführte. Seine Grafikarbeiten enthalten eine intensive Mischung aus Typografie, Illustration, Farbe und Bewegung. Während der letzten Jahre hat Garzón im Bereich Editorial Design, Webdesign und Corporate Identity gearbeitet sowie eine große Anzahl von experimentellen Grafiken geschaffen, die neben anderen Veranstaltungen in Kolumbien bei *SUB*, *Grafica Masiva* und *Desfase* ausgestellt wurden. In seinen persönlichen Arbeiten kommt dem Thema "Informationsüberfluss" ein besondere Rolle zu, und er kombiniert es mit seiner Leidenschaft für Street Art und Popkultur.

L'artiste graphique et designer Francisco Garzón a créé son agence Kontra en 2003 à Santiago de Cali. Né en 1982, il est diplômé de l'Universidad del Valle, où il a développé un grand intérêt pour l'éducation et a travaillé sur plusieurs projets pour des universités locales. Ses concepts graphiques sont un mélange efficace de typographie, d'illustration, de couleur et de mouvement. Ces dernières années, il a travaillé dans les domaines du design éditorial, du design de sites web et de l'identité d'entreprise, et a produit de nombreuses œuvres graphiques expérimentales qui ont été présentées aux expositions *SUB*, *Grafica Masiva* et *Desfase*, entre autres événements qui ont eu lieu en Colombie. Le thème de la surcharge d'informations et la passion des cultures pop et urbaine prédominent dans son travail.

2

3

4

1. "El Popular" digital banner,
2006, www.populardelujo.com

2. "Lyto" postcard, 2006, self-promo

3. "Kontra en Desfase 2" artwork
for catalogue, 2006, Desfase 2

4. "Revolución Cultural" poster,
2006, Revista Picnic

*1958, Argentina

PABLO KUNST

1. "Huellas Latinoamericanas"
exhibition poster, 2005,
Centro de Diseño, Rosario, Argentina

2. "O Cinema Brasileiro em Cartaz"
exhibition poster (Fernando Pimenta
Poster Design), 2006, Centro de
Diseño, Rosario, Argentina

3. "La calle es testigo de..." poster,
2005, 2nd Iberoamerican Poster
Biennial in Bolivia

Born in Rosario, on the eastern side of Argentina, Pablo Kunst is one of the country's leading names in poster design. In addition to writing and editing books on the subject, his works have been exhibited nationally and internationally, including at the International Biennial of the Poster in Mexico, First Art Fax in Beijing, China, and the XII International Poster Biennial in Finland. Kunst has also been strongly committed to developing awareness of design practises in education throughout the region; having founded the Design Centre of Rosario, as well as the first Graphic Design undergraduate course in his native city. Moreover, he is an active member of Icograda (International Council of Graphic Design Associations) and has lectured in Brazil, Chile, Cuba, Mexico and China.

Pablo Kunst wurde in Rosario im östlichen Teil Argentiniens geboren und ist einer der führenden Persönlichkeiten des Plakatdesigns des Landes. Neben dem Schreiben und Herausgeben von Büchern zu diesem Thema wurden seine Arbeiten national und international ausgestellt, darunter auf der internationalen Plakatbiennale in Mexiko, First Art Fax in Beijing, und auf der XII. internationalen Plakatbiennale in Finnland. Kunst setzte sich außerdem stark für die Entwicklung des Bewusstseins über Umsetzung des Designs in der regionalen Bildungsarbeit ein und gründete das Designzentrum von Rosario sowie den ersten Lehrgang in Grafikdesign in seiner Heimatstadt. Zudem ist er ein aktives Mitglied im Icograda (International Council of Graphic Design Associations) und war in Brasilien, Chile, Kuba, Mexiko und China als Dozent tätig.

Né à Rosario, dans l'est de l'Argentine, Pablo Kunst est l'un des grands noms argentins de la conception d'affiches. Il a écrit et édité plusieurs livres sur ce sujet, et ses œuvres ont été exposées en Argentine et à l'étranger, notamment à la biennale internationale de l'affiche de Mexico, First Art Fax à Pékin, en Chine, et à la XIIe Biennale internationale de l'affiche en Finlande. Il a également été très actif dans la sensibilisation aux pratiques de graphisme dans l'éducation. Il a fondé le Centre de graphisme de Rosario, ainsi que le premier programme de conception graphique pour les étudiants de premier cycle dans sa ville natale. Il est de plus un membre actif de l'Icograda (Conseil international des associations de graphisme) et a donné des conférences au Brésil, au Chili, à Cuba, au Mexique et en Chine.

4. "Selva de papel"
self-promotion poster, 2005,
La Silueta Ediciones/Minimal Café
Paper architecture Manuel Romero

*2001, Costa Rica, www.lacabezacr.com

LACABEZA
estudio

CIUDAD
CANIBAL

MÚSICA
CIUDAD
CANIBAL

CABINA
CIUDAD
CANIBAL

LA MOVIL
CIUDAD
CANIBAL

DEPORTES
CIUDAD
CANIBAL

1

Priscilla Aguirre (b.1971) trained in fine arts at the Universidad de Costa Rica, where she specialised in painting. Soon after, she received a scholarship to study screen printing at the Universidad de San Carlos in Mexico. After working as an art director at McCann Ericksson, she formed Lacabeza in 2001, a design studio with Argentinean collaborator Walter Calienno (b.1960). Since then she has mainly worked for the music industry, cultural and editorial sectors. Lacabeza's work for the national label Papaya Music has been widely recognised and, in 2004, Aguirre started to push her own design brand, creating series of products. Lacabeza has actively worked to promote the image and culture of Costa Rica, representing its natural and cultural diversity.

Priscilla Aguirre (geb.1971) erhielt ihre Ausbildung in bildender Kunst an der Universidad de Costa Rica, wo sie sich auf Malerei spezialisierte. Nur wenig später erhielt sie ein Stipendium, um Siebdruckverfahren an der Universidad de San Carlos in Mexiko zu studieren. Nachdem sie zunächst als Art Director bei McCann Ericksson tätig war, gründete sie 2001 zusammen mit ihrem argentinischen Mitarbeiter Walter Calienno (geb.1960) das Designstudio Lacabeza. Seitdem hat sie überwiegend für die Musikbranche sowie für kulturelle und redaktionelle Bereiche gearbeitet. Lacabezas Entwürfe für die lokale Marke Papaya Music haben weithin Beachtung gefunden. 2004 führte Aguirre ihre eigene Designmarke ein und kreierte ganze Produktserien. Durch die grafische Darstellung der natürlichen und kulturellen Vielfalt von Costa Rica hat Lacabeza das Image und die Kultur ihres Heimatlandes aktiv fördern können.

Priscilla Aguirre (née en 1971) a étudié les beaux-arts à l'Universidad de Costa Rica, où elle s'est spécialisée en peinture. Peu de temps après, elle recevait une bourse pour étudier la sérigraphie à l'Université de San Carlos au Mexique. Après avoir été directrice artistique chez McCann Ericksson, elle a créé l'agence de graphisme Lacabeza en 2001, avec son collaborateur Walter Calienno (né en 1960). Depuis, elle travaille principalement pour les secteurs de la musique, de la culture et de l'édition. Le travail que Lacabeza a réalisé pour la maison de production costaricaine Papaya Music a bénéficié d'une large reconnaissance et, en 2004, Priscilla Aguirre a commencé à lancer sa propre marque de graphisme en créant une série de produits. Lacabeza a travaillé activement à la promotion de l'image et de la culture du Costa Rica, en représentant sa diversité naturelle et culturelle.

1. "Ciudad Canibal" logo, 2007, young and informative radio program

2. "Física" book cover, Editorial ST

3. "Perrozompopo" CD cover, 2007, Papaya Music

FÍSICA
BACHILLERATO

Ramón Ávila Anaya
Miguel Ángel García Licona
Manuel Rodríguez López

GUTO LACAZ

1

Guto Lacaz was born in São Paulo where he graduated in architecture, and soon established his own art studio called Arte Moderna, through which he has dedicated his time to a wide range of activities that include graphics, illustration, stage design, exhibitions, and editorial design. In the 80's Lacaz worked as the art editor for *Via Cinturato, Pirelli* and *AZ* magazines. He has been nominated as one the ten best graphic designers in the country by *Graphic Design Magazine*, and has judged at the Type Directors Club Awards in New York. He has been a regular contributor to a handful of magazines and, in 2000, he published his own sketch book, *Desculpe a Letra* (Sorry for my Writing). Lacaz lists humour and surprise as his main characteristics.

Guto Lacaz stammt gebürtig aus São Paulo, wo er sein Studium in Architektur abschloss. Bald darauf gründete er sein eigenes Kunststudio mit Namen Arte Moderna, wo er seine Zeit den verschiedensten Aktivitäten widmete wie z.B. Grafik, Illustration, Bühnenbildern, Ausstellungen und Editorial Design. Während der achtziger Jahre arbeitete Lacaz als Kunstredakteur für die Magazine *Via Cinturato, Pirelli* und *AZ*. Er wurde vom *Graphic Design Magazine* als einer der zehn besten Grafikdesigner des Landes nominiert und nahm als Jurymitglied bei den Type Directors Club Awards in New York teil. Er wirkte regelmäßig bei einer Reihe von Magazinen mit und veröffentlichte 2000 sein eigenes Skizzenbuch *Desculpe a Letra*. Lacaz zählt Humor und Überraschung zu seinen wichtigsten Eigenschaften.

Guto Lacaz est né à São Paulo, où il a obtenu son diplôme d'architecture, et n'a pas tardé à créer sa propre agence de graphisme, Arte Moderna, où il a consacré son temps à un vaste éventail d'activités, notamment le graphisme, l'illustration, la conception de décors, les expositions et le design éditorial. Dans les années 1980, il a été directeur artistique pour les magazines *Via Cinturato, Pirelli* et *AZ*. *Graphic Design Magazine* l'a nommé l'un des dix meilleurs graphistes du pays, et il a été juge pour les Type Directors Club Awards de New York. Il a collaboré régulièrement à une demi-douzaine de magazines et, en 2000, il a publié son livre de croquis, *Desculpe a Letra* (Pardon pour mon écriture). Selon lui, ses principales caractéristiques sont l'humour et la surprise.

2

24ª Mostra
Internacional
de Cinema
São Paulo

24th São Paulo
International
Film Festival

Guto Lacaz

"Encontros Improváveis"
…ogram, 2005, Centro Cultural Banco
… Brasil São Paulo
…oncept/production Carlos Careqa
…P Edson Kumasaka

"Mostra Internacional de Cinema
e São Paulo" film festival poster,
…00, Mostra Internacional de
…nema de São Paulo

"I Salão Aberto"
…go for exhibition, 2004, Cooperativa
…s Artistas Visuais do Brasil

3

I SALÃO ABERTA

LAIKA

1. "Primer congreso nacional
de arquitectos" poster, 1964
Design Carlos González Ramirez

2. "Primer festival del disco libro
cubano" poster, 1968
Design Carlos González Ramirez

3. "F1" poster, 2007, self-promo
Art direction Carlos González Ríos
Design Luiz Alberto Zavaleta Lores

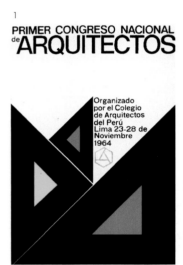

1

PRIMER CONGRESO NACIONAL
de ARQUITECTOS

Organizado
por el Colegio
de Arquitectos
del Perú
Lima 23-28 de
Noviembre
1964

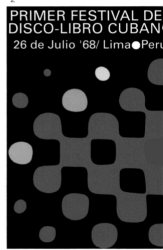

2

PRIMER FESTIVAL DE
DISCO-LIBRO CUBAN
26 de Julio '68/ Lima ● Peru

Laika is a design and advertising agency founded by one of the most respected graphics professionals in Peru, Carlos González Ramirez (b.1936). After a long period in advertising, González Ramirez opened his own practice in 1998, soon after joining partners Carola González Rios (b.1968) and Carlos González Rios (b.1974) to form Imadis. Laika was created in 2006 as a full service agency that serves most of the important brands in the country. With an extensive collection of book and magazine covers to his name, González Ramirez's most famous works are undoubtedly his posters, such as *El Che Guevara, Primer Festival del Disco Libro Cubano* and *Primer Congreso Nacional de Arquitectos,* and the identity for Copa Los Andes.

Bei Laika handelt es sich um eine Design- und Werbeagentur, die von Carlos González Ramirez (geb.1936) gegründet wurde, einem der angesehensten Grafikexperten in Peru. Nach einer langen Schaffenszeit im Werbebereich eröffnete González Ramirez zusammen mit seinen Partnern Carola González Rios (geb.1968) und Carlos González Rios (geb.1974) 1998 sein eigenes Studio Imadis. Laika wurde 2006 als Agentur mit umfassendem Service ins Leben gerufen, die viele der wichtigsten Marken des Landes betreut. Neben einer beträchtlichen Sammlung an Bücher- und Zeitschriftencovern bestehen González Ramirez' berühmteste Werke zweifelsohne aus Plakaten wie *El Che Guevara, Primer Festival del Disco Libro Cubano* und *Primer Congreso Nacional de Arquitecto*s sowie der Visual Identity von Copa Los Andes.

Laika est une agence de graphisme et de publicité qui a été créée par l'un des graphistes les plus respectés du Pérou, Carlo González Ramirez (né en 1936). Après une longue période dans la publicité, il a ouvert sa propre agence en 1998, peu après avoir rejoint ses partenaires Carola González Rios (née en 1968) et Carlos González Rios (né er 1974) pour former Imadis. Laika a été créée en 2006. Elle propose un service complet à ses clients, la plupart des grandes marques d pays. Carlos González Ramirez a à son actif une collection impressionnante de couvertu res de livres et de magazines, mais ses œuvr les plus connues sont sans aucun doute ses affiches : *El Che Guevara, Primer Festival del Disco Libro Cubano* et *Primer Congreso Nacional de Arquitectos,* ainsi que l'identité du tournoi de golf Copa Los Andes.

*1930, Venezuela

JOHN LANGE

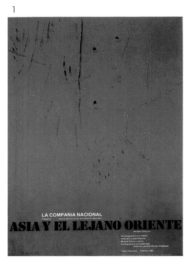

1. "Asia y el Lejano Oriente" poster, 1985, Victor Valera, La Compañía Nacional de Teatro

2. "La Quema de Judas" poster, 1972, Gente de Cine C.A.

John Lange is a popular figure in the design community in Venezuela, having worked extensively as both artist and curator during his long career. Born in Caracas, Lange belongs to the generation that helped to promote the awareness of professional graphic design and art. He studied screen printing and engraving at Luisa Palacios' studio in the capital before moving to Mexico City, where he studied drawing. Lange is best known for his poster designs for both ballet spectacles and theatre productions, notably for theatre company El Nuevo Grupo, as well as for his art direction on the magazine M, which lasted for almost two decades. Among other activities, Lange has also served as director of the Instituto de Diseño Neumann, the first ever design school in Venezuela, where he taught for several years.

John Lange arbeitete während seiner langen beruflichen Laufbahn als Künstler und Kurator und ist eine populäre Persönlichkeit der Designbüro in Venezuela. Lange wurde in Caracas geboren und gehört zu der Generation, die dem professionellen Grafikdesign und der Kunst zu größerem Bewusstsein im Land verholfen hat. Er lernte in der Hauptstadt im Studio von Luisa Palacios Druckgrafik und Gravur, bevor er schließlich nach Mexico City zog, wo er Grafik studierte. Lange ist am bekanntesten für sein Plakatdesign zu Opernaufführungen und Theaterproduktionen, vor allem für das Theaterensemble El Nuevo Grupo sowie für seine Arbeit als Art Director bei dem Magazin M, die er fast zwei Jahrzehnte lang ausführte. Neben anderen Aktivitäten war Lange auch als Leiter des Instituto de Diseño Neumann tätig, die erste Schule für Design in Venezuela, wo er für mehrere Jahre unterrichtete.

John Lange est une personnalité dans la communauté du graphisme au Venezuela. Au cours de sa longue carrière, il a beaucoup travaillé en tant qu'artiste ou commissaire d'exposition. Né à Caracas, John Lange appartient à la génération qui a contribué à sensibiliser le public aux métiers du graphisme et de l'art. Il a étudié la sérigraphie et la gravure au studio de Luisa Palacios dans la capitale avant de déménager à Mexico, où il a étudié le dessin. Il est surtout connu pour les affiches qu'il a réalisées pour des ballets et des pièces de théâtre, notamment pour la compagnie de théâtre El Nuevo Grupo, ainsi que pour son travail en tant que directeur artistique du magazine M, qui a existé pendant près de vingt ans. Entre autres activités, John Lange a également été directeur de l'Instituto de Diseño Neumann, la toute première école de design du Venezuela, où il a enseigné plusieurs années.

4

"**Vasarely**" poster, 1977, Museo de
[Art]e Contemporáneo de Caracas

"**Revista M #57**" magazine cover,
[19]77, Corimon y Empresas Filiales

REVISTA M / 57

VAS A RELY
[MU]SEO DE ARTE CONTEMPORANEO DE CARACAS / NOVIEMBRE 1977

MARCOS LARGHERO

1

Based in Montevideo, Marcos Larghero is a graphic design veteran in his native Uruguay, through a multidisciplinary approach that extends to photography, product design, ceramics and illustration. One of the founding members of the Uruguayan Association of Professional Graphic Designers, Larghero is also a partner in the design consultancy Barra (other cofounders include Jorge de Arteaga, José Prieto, Jorge Sayagués and Gustavo Wojciechowski). Throughout his career, Larghero has undertaken a number of major projects in corporate identity and product design for many of the leading industries established in the country. Since 1996 he has been a professor of corporate identity at the Universidad ORT Uruguay, and in 2002 he received the coveted Morosoli de Plata for his contribution to the design profession in the country.

Marcos Larghero hat seinen Sitz in Montevideo und ist in seinem Heimatland Uruguay ein Veteran des Grafikdesigns, nicht zuletzt durch seinen interdisziplinären Ansatz, der Fotografie, Produktdesign, Keramik und Illustration integriert. Larghero gehört zu den Gründungsmitgliedern des Uruguayischen Verbandes der professionellen Grafikdesigner und ist zudem noch ein Partner in dem Design-Beratungsunternehmen Barra (weitere Mitbegründer sind Jorge de Arteaga, José Prieto, Jorge Sayagués und Gustavo Wojciechowski). Während seiner beruflichen Laufbahn hat Larghero mehrere bedeutende Projekte im Bereich Corporate Identity und Produktdesign für viele führende Branchen des Landes durchgeführt. Seit 1996 ist er als Professor für Corporate Identity an der Universidad ORT Uruguay tätig. 2002 erhielt er für seinen Beitrag zum Beruf des Designers im Land den begehrten Preis Morosoli de Plata.

Marcos Larghero est un vétéran du graphisme dans son Uruguay natal. Il est basé à Montevideo, et sa démarche pluridisciplinaire englobe la photographie, la conception de produit, la céramique et l'illustration. Il est l'un des membres fondateurs de l'Association uruguayenne des graphistes professionnels, et e également associé dans le cabinet de desig Barra (qui compte parmi ses autres membres fondateurs Jorge de Arteaga, José Prieto, Jorge Sayagués et Gustavo Wojciechowski). Tout au long de sa carrière, il s'est chargé de nombreux projets d'envergure dans les domaines de l'identité d'entreprise et de la conception de produit pour la plupart des grandes entreprises installées dans le pays. Il est professeur d'identité d'entreprise à l'Universidad ORT Uruguay depuis 1996, et a reçu en 2002 le prix très convoité Morosoli de Plata pour sa contribution aux métiers du graphisme dans le pays.

2

3

4

5

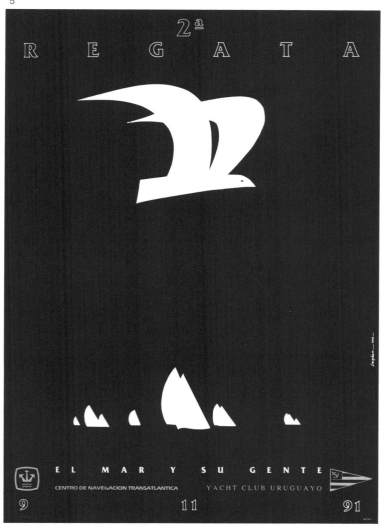

1. "Festiva" logo, 1995

2. "Frimiguel/Bilbao-España"
logo for meat products, 2004

3. "Sol Latino" logo for travel agency,
1996

4. "La Flor del Itapebí Editorial" logo,
1996

5. "Regata" poster, 1991,
Centro de Navegación Transatlantica

*1942, Chile, www.larrea.cl

VICENTE LARREA

1

1. "Illapu" record cover for
Andine music, 1971, Discoteca
del Cantar Popular (Dicap)
Photo Eugene Harris
Design Vicente Larrea,
Antonio Larrea, Luis Albornoz

2. "Estadio Víctor Jara" poster,
2003, Fundación Víctor Jara
Photo Antonio Larrea
Design Vicente Larrea,
Antonio Larrea, Luis Albornoz

3. "Ya no Basta con Rezar" film poster
1972, film by Aldo Francia
Design Vicente Larrea, Luis Albornoz

4. "Allende y Neruda" postcard,
2004, Fundación Pablo Neruda
Photo Sara Facio
Illustration Luis Albornoz,
Vicente Larrea

Vicente Larrea is considered to be one of the masters of Chilean graphic design. His distinctive print work, widely acknowledged as having a major influence on later generations, was part of what is considered the creation of much of the country's graphic school, going from 1963 to 1973, a period during which he created numerous posters for a wide range of clients and events. Moreover, Larrea's iconic logos are synonymous with *Nueva Música Chilena*, for which he created the typographic family of *Quilapayún* and *Inti Illimani*. He currently runs his combined design practice and print studio, where he tries to merge artistic creation with the production process. Larrea lectures frequently and his work has been widely exhibited and awarded. He is an arts graduate from the Universidad de Chile.

Vicente Larrea wird als einer der Meister des chilenischen Grafikdesigns betrachtet. Seine unverwechselbaren Druckarbeiten von 1963 bis 1973 hatten bedeutenden Einfluss auf nachfolgende Generationen und trugen wesentlich zur Schaffung der Grafikschule des Landes bei. In dieser Periode kreierte er auch zahlreiche Plakate für viele Kunden und Veranstaltungen. Zudem sind Larreas Logos gleichbedeutend mit *Nueva Música Chilena*, für die er die Typografie von *Quilapayún* und *Inti Illimani* schuf. Zurzeit leitet er sein kombiniertes Druck- und Designstudio, wo er versucht, künstlerische Gestaltung mit dem Produktionsprozess zu vereinigen. Larrea ist häufig als Dozent tätig, und seine Arbeiten wurden in großem Umfang ausgestellt und prämiert. Er erhielt seine Ausbildung in Kunst an der Universidad de Chile.

Vicente Larrea est considéré comme l'un des maîtres du graphisme chilien. Son travail sur support imprimé, très original, a eu une grande influence sur les générations suivantes, et a contribué à la création de ce qui allait être l'école de graphisme chilienne, de 1963 à 1973, une période pendant laquelle il a créé de nombreuses affiches pour un vast éventail de clients et d'événements. Ses logos emblématiques sont de plus étroitement associés au mouvement de la nouvelle musique chilienne, pour lequel il a créé les familles de polices de caractères *Quilapayún* et *Inti Illimani*. Il dirige actuellement son agence de graphisme/studio d'impression, où il essaie de fusionner les processus de création et de production artistique. Il donne fréquemment des conférences, et ses œuvres ont reçu de nombreuses récompenses et ont fait l'objet de nombreuses expositions. Vicente Larrea e diplômé en art de l'Universidad de Chile.

2

3

4

*1957, Brazil, www.crama.com.br

RICARDO LEITE

Ricardo Leite studied design at the Federal University of Rio de Janeiro, and journalism at the Estácio da Sá University. He has been teaching for more than ten years, has written a book, *Ver é Compreender* (To See is to Understand), and runs his own design consultancy, Crama Design Estratégico, in his hometown. Since 1991 his studio has specialised in brand building, corporate identity programmes, interior design, and marketing material. In addition, Leite has long been involved in the music industry, having designed literally hundreds of album covers for most of the biggest names in the national music scene. He is frequently invited as a lecturer to universities and conferences in Brazil and abroad.

Ricardo Leite studierte Design an der Universidade Federal do Rio de Janeiro sowie Journalismus an der Universidade Estácio da Sá. Er ist seit mehr als zehn Jahren als Dozent tätig, hat ein Buch mit dem Titel *Ver é Compreender* (Sehen ist Verstehen) geschrieben und leitet in seiner Heimatstadt sein eigenes Design-Beratungsunternehmen Crama Design Estratégico. Seit 1991 spezialisiert sich sein Studio auf Markenbildung, Corporate Identity-Programme, Raumgestaltung und Marketing-Material. Darüber hinaus ist Leite bereits seit langem in der Musikbranche tätig und hat buchstäblich Hunderte von Schallplatten-Covers für die meisten großen Namen der nationalen Musikszene entworfen. Er wird häufig von Universitäten und Konferenzen in Brasilien und im Ausland eingeladen, um Vorlesungen zu halten.

Ricardo Leite a étudié le design à l'Universidade federal do Rio de Janeiro, et le journalisme à l'Universidade Estácio da Sá. Il enseigne depuis plus de dix ans, a écrit le livre *Ver é Compreender* (Voir c'est comprendre), et dirige son propre cabinet de design, Crama Design Estratégico, dans sa ville natale. Depuis 1991, son studio s'est spécialisé dans la stratégie de marque, les programmes d'identité d'entreprise, l'architecture d'intérieur et les documents de marketing. Ricardo Leite est actif dans le secteur de la musique depuis longtemps. Il a conçu des centaines de couvertures d'album pour la plupart des grands noms de la scène musicale brésilienne. Il est fréquemment invité comme intervenant dans des universités et pour des conférences au Brésil et à l'étranger.

, "Francisco" CD box set
packaging, 2004, BMG Brazil
art direction Ricardo Leite,
Rafael Ayres
Designer Ana Cotta
Photo Bruno Veiga

, "Construção" CD box set
packaging, 2001, Universal Music
art direction Ricardo Leite,
Rafael Ayres
Designer Eduardo Varela
Production Tátil Design

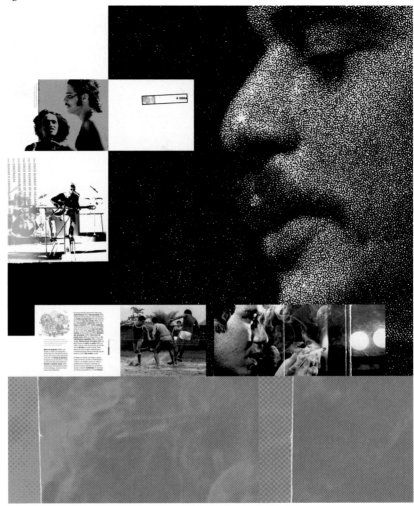

3. "Inspirações para Design de Moda
(Fashion Design Inspirations)"
fashion trend book, 2005, SENAI Cetiqt
Art direction Ricardo Leite,
Rafael Ayres
Design Helena Guedes
Illustration Igor Machado,
Júlia Rocha

. "Ver é Compreender" book,
003, Editora Senac Rio
ext/Concept Ricardo Leite
rt direction Ricardo Leite
esign/Illustration Carol Santos,
Crama Design team
hoto Ricardo Azoury

4

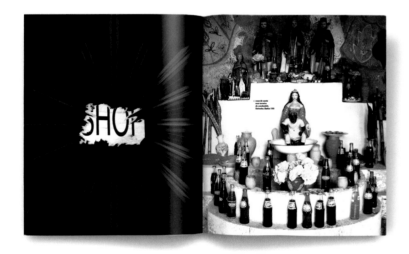

GERD LEUFERT

1

German born Gerd Leufert has, probably, one of the most unique design careers in the whole world. After studying design in Hannover and Munich, he became chief designer at the studio Bayerisches Bild, before immigrating to Venezuela in 1951, where he developed countless graphic and art activities, including a lectureship at the Universidad Central and Instituto de Diseño Neumann. He also worked for McCann, where he met long-time friend and collaborator Nedo M.F. In the late 50s, Leufert was appointed art director for the magazine *El Farol*, which he elevated to become a major reference in the region. During this period he also curated the design collection at Museo de Bellas Artes. In 1990, he was recognised for his remarkable contribution to the field at the Premio Nacional de Artes Plásticas in 1990.

Die Designerkarriere des gebürtigen Deutschen Gerd Leufert ist wahrscheinlich weltweit einzigartig. Nachdem er in Hannover und München Design studiert hatte, wurde er Chefdesigner beim Studio Bayerisches Bild. 1951 emigrierte er nach Venezuela, wo er zahllose Grafiken entwickelte und künstlerische Aktivitäten ausübte, darunter eine Dozentur an der Universidad Central und am Instituto de Diseño Neumann. Er arbeitete außerdem für McCann, wo er seinen langjährigen Freund und Kollegen Nedo M.F. traf. In den späten 50er Jahren wurde Leufert zum Art Director des Magazins *El Farol* ernannt, das sich unter seiner Leitung zum Maßstab in der Region Lateinamerika entwickelte. Während dieser Zeit war er auch als Kurator für die Designausstellung im Museo de Bellas Artes tätig. 1990 wurde er für seinen bemerkenswerten Beitrag in der Fachrichtung Design auf dem Premio Nacional de Artes Plásticas ausgezeichnet.

Gerd Leufert est Allemand de naissance, et a probablement l'une des carrières de graphiste les plus originales du monde. Après avoir étudié le graphisme à Hanovre et à Munich, il est devenu graphiste en chef du studio Bayerisches Bild, avant d'immigrer au Venezuela en 1951, où il a poursuivi une multitude d'activités dans les domaines de l'art et du graphisme, dont un poste d'enseignant à l'Universidad Central et à l'Instituto de Diseño Neumann. Il a également travaillé pour McCann, où il a rencontré son ami et collaborateur Nedo M.F. À la fin des années 1950, il a été nommé directeur artistique du magazine *El Farol*, et l'a hissé au statut de référence majeure en Amérique latine. Pendant cette période, il a également été conservateur de la collection de graphisme du Museo de Bellas Artes. En 1990, sa remarquable contribution au secteur du graphisme a été récompensée par un Prix national d'arts plastiques.

2

3

1. "Museo de Bellas Artes"
logo, 1960

2. "Museo de Arte la Rinconada"
logo, 1983

3. "Instituto de Diseño Neumann"
logo, 1968

4. Logo, 1961

5. "Hotel Caracas Milton"
logo, 1969

6. "Museo Jesús Soto"
logo, 1970

7. "Universidad Simón Bolívar"
logo, 1969

8. "Bicentenario Simón Bolívar"
logo, 1979

9. "Monte Ávila Editores"
logo, 1968

10. "Instituto Autónomo
Aeropuerto Internacional
de Maiquetía Simón Bolívar"
logo, 1974

11. "Carlos Celis Arquitectos"
logo, 1969

4

5

6

7

8

9

10

11

*1955, Brazil, www.ricolins.com

RICO LINS

1

1. "BIG Magazine Brazilian issue"
magazine cover and party invitation,
1999, BIG Magazine New York
Art/creative direction Rico Lins
Design Rico Lins
Assistant Dagmar Rizollo
Photo Fernando Lazslo
Awards The New York Art Directors
Club (Silver), 2000; Brasil Fa Design
Selection, SP–Milan 2000

Rico Lins certainly ranks among the best Brazilian designers of all time. He graduated from the ESDI in Rio de Janeiro before moving to Paris in 1979, where he worked for the newspapers *Le Monde* and *Libération,* and publishers Hachette and Gallimard. After receiving his MA from the Royal College of Art in London in 1987 he moved to New York, where he works as the art director for the recording company CBS. Since 1990 he has worked for vast number of clients, including BMG, RCA, WEA, *Time, Newsweek, The New Yorker* and *The New York Times.* Lins has received awards from the Society of Publication Designers and the New York Art Directors Club, among many others. He has served on numerous award judging panels and currently runs his activities from his design consultancy in São Paulo.

Rico Lins gehört zweifellos zu den besten brasilianischen Designern aller Zeiten. Er schloss sein Studium an der ESDI in Rio de Janeiro ab, bevor er 1979 nach Paris zog, wo er für die Zeitungen *Le Monde* und *Libération* sowie für die Verlage Hachette und Gallimard arbeitete. 1987 erhielt er am Royal College of Art in London den Titel Master of Arts und zog daraufhin nach New York um, wo er als Art Director für den Hörfunk- und Fernsehsender CBS tätig war. Seit 1990 hat er für eine große Anzahl an Kunden gearbeitet, u.a. BMG, RCA, WEA, *Time, Newsweek, The New Yorker* und *The New York Times.* Lins hat viele Auszeichnungen erhalten, zum Beispiel von der Society of Publication Designers und dem New York Art Directors Club, und war bei zahlreichen Preisverleihungen selbst Mitglied der Jury. Zurzeit leitet er seine Aktivitäten von seinem Design-Beratungsunternehmen in São Paulo aus.

Rico Lins est très certainement l'un des meilleurs graphistes brésiliens de tous les temps. Il a obtenu son diplôme de l'ESDI de Rio de Janeiro avant de déménager à Paris en 1979, où il a travaillé pour les journaux *Le Monde* et *Libération,* et les maisons d'édition Hachette et Gallimard. Après avoir reçu sa maîtrise du Royal College of Art de Londres en 1987, il a déménagé à New York, où il a été directeur artistique chez la maison de production CBS. Depuis 1990, il a travaillé pour une multitude de clients, dont BMG, RCA, WEA, *Time, Newsweek, The New Yorker* et *The New York Times.* Entre autres nombreux prix, il a été récompensé par la Society of Publication Designers et par le New York Art Directors Club. Rico Lins a été juré pour de nombreux prix, et mène actuellement ses activités depuis son cabinet de graphisme à São Paulo.

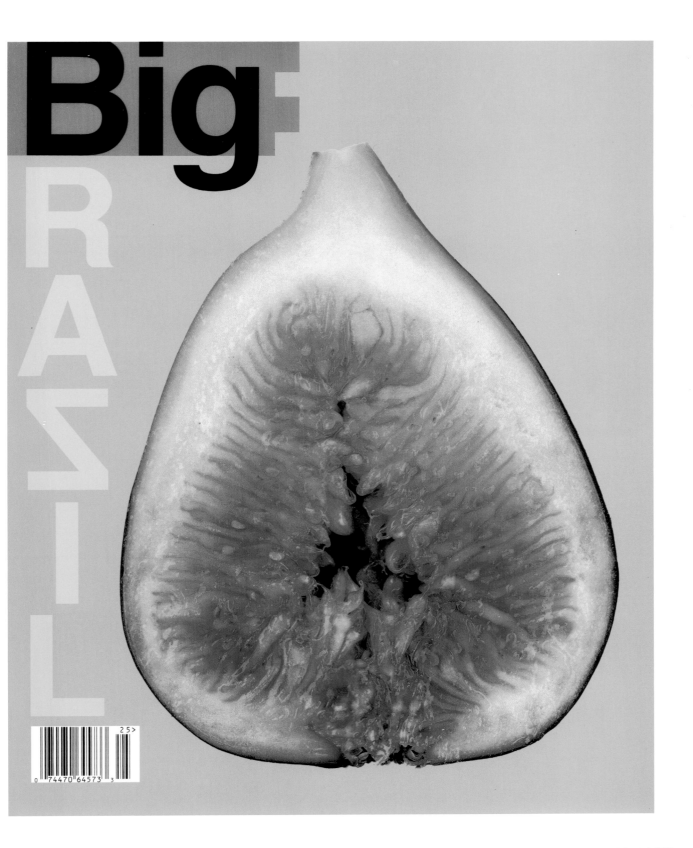

Big

BRASIL

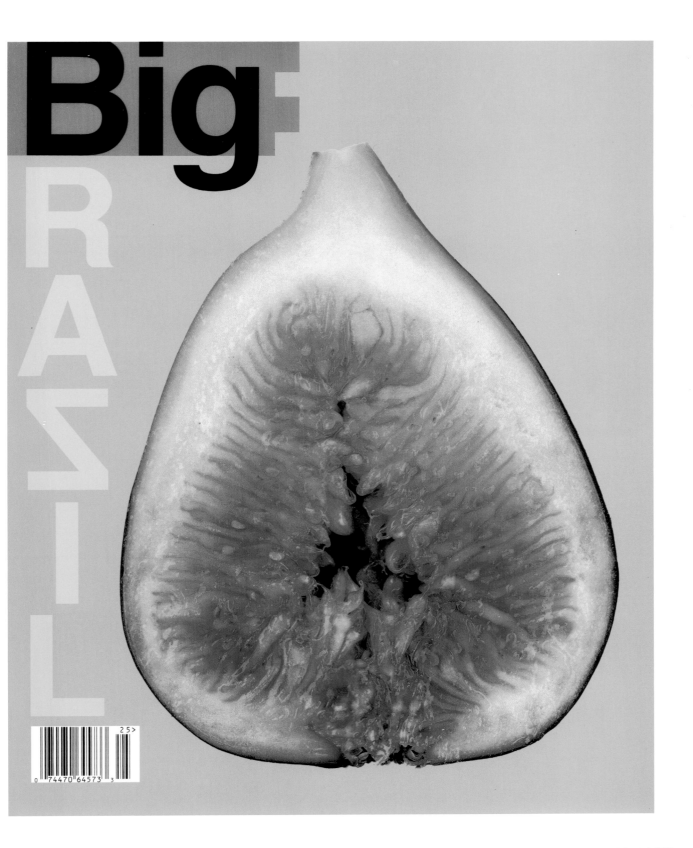

0 74470 64573 3 2 5>

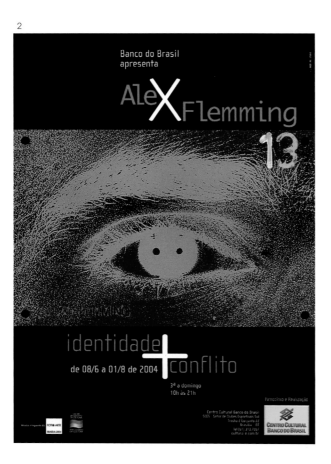

2. "Alex Flemming – Identity and Conflict" visual identity for exhibition, 2004, Centro Cultural Banco do Brasil
Art/creative direction Rico Lins
Design Rico Lins, Renata Reis (Arte Educação/CCBB)

3. "Panamericana 96 Graphic" poster, 1996, Escola Panamericana de Arte & Design, São Paulo
Agency W/Brasil
Art direction Rico Lins + Studio
Design Rico Lins
Photo Fábio Ribeiro

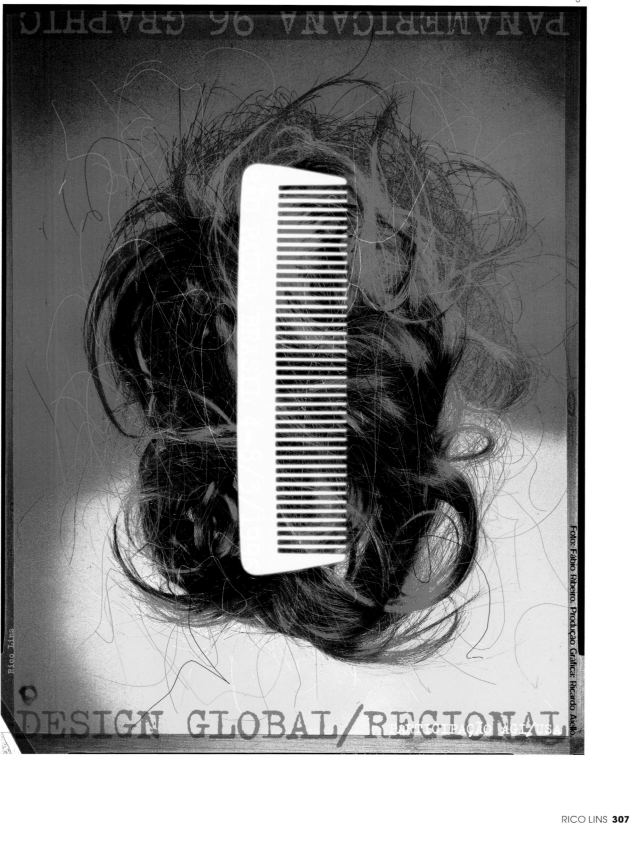

*1967, Ecuador, www.marialoor.com

MARIA LOOR

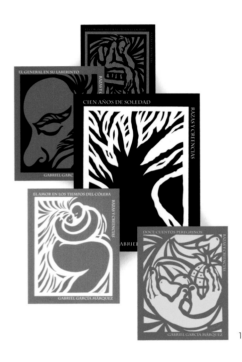

1. "Razas & Creencias" poster series on Latin American culture based on the books by Gabriel García Márquez **Awards** Bo Bernstein Award, RISD

2. "Homenaje al Diseñador Gráfico" poster, 2006

Maria Loor has had a long career in advertising at JWT Ecuador before eventually shifting to focus on graphic design. Educated in the country and at the Rhode Island School of Design in the United States, Loor spent time working in New York with Roger van den Bergh (Onoma Design) on the corporate identity manual for the Metropolitan Transportation Authority (MTA), and on the identity programme for Bellsouth at the Atlanta Olympic Games. In 1994 she returned to her country to open her own studio, concentrating mainly on corporate identity and package design. She created the academic curriculum for the design course at the Universidad Casa Grande, where she also has also taught a number of subjects, and her works have been published in *Revista Papagayo* and *Inforbooks*, among many others.

Maria Loor hatte bereits eine lange berufliche Laufbahn im Werbebereich bei JWT Ecuador hinter sich, bevor sie sich schließlich dem Grafikdesign zuwandte. Nach ihrer Ausbildung in Ecuador und an der Rhode Island School of Design in den USA verbrachte Loor einige Zeit in New York und arbeitete zusammen mit Roger van den Bergh (Onoma Design) am Corporate Identity-Leitfaden für die Metropolitan Transportation Authority (MTA) sowie an der Visual Identity für Bellsouth bei den Olympischen Spielen in Atlanta. 1994 kehrte sie in ihr Heimatland zurück und gründete ein eigenes Studio, mit dem sie sich überwiegend auf Corporate Identity und Verpackungsdesign konzentriert. Loor erstellte den akademischen Lehrplan für den Lehrgang Design an der Universidad Casa Grande, wo sie auch in einigen Fachgebieten unterrichtete. Ihre Arbeiten wurden unter anderem in *Revista Papagayo* und *Inforbooks* veröffentlicht.

Maria Loor a mené une longue carrière dans la publicité chez JWT Ecuador avant de se réorienter vers le graphisme. Elle a étudié en Équateur et à la Rhode Island School of Design aux États-Unis. Elle a travaillé à New York avec Roger Van den Bergh (Onoma Design) sur le manuel d'identité d'entreprise de la Metropolitan Transportation Authority (MTA – transports métropolitains new-yorkais), et sur le programme d'identité de BellSouth pour les Jeux olympiques d'Atlanta. Elle est retournée dans son pays natal en 1994 pour ouvrir sa propre agence, qui se consacre principalement aux domaines de l'identité d'entreprise et de la conception d'emballages. Elle a créé le programme universitaire de graphisme de l'Universidad Casa Grande, où elle a également enseigné plusieurs matières, et ses travaux ont été publiés dans *Revista Papagayo* et *Inforbooks*, entre de nombreuses autres publications.

UN HOMENAJE AL DISEÑADOR GRÁFICO

*1972, Mexico, www.bdmark.com

SARA LUNA

1. "III Simposium Internacional de Escultura" conference catalogue, 2004, Museo de las Artes, México

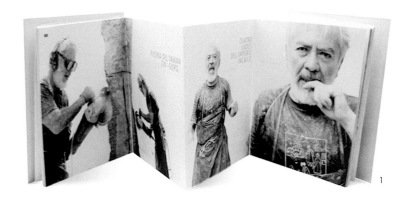

1

Trained at the Universidad Autónoma Metropolitana in Azcapotzalco, Mexico City, designer Sara Luna is one of the founding members of *Matiz*, the famed magazine on international graphic design. One of her most recognised works has been the AIGA poster *Mexican Design/New Visions*. Whilst working at Vértice Comunicación she served as art director for Honda, working on a number of campaigns and promotional pieces before joining Colectivo Hematoma, the innovative design group based in the city of Guadalajara. Luna currently runs BD Mark, where she leads a small team of professionals, designing mainly for cultural projects. Over the last few years her studio has collaborated with the Universidad de Guadalajara, and has attracted clients in Mexico and United States.

Die Designerin Sara Luna wurde an der Universidad Autónoma Metropolitana in Azcapotzalco, Mexico City, ausgebildet und gehört zu den Gründungsmitgliedern von *Matiz*, dem berühmten Magazin des internationalen Grafikdesigns. Eines ihrer bekanntesten Werke ist das AIGA-Plakat *Mexican Design/New Visions*. Während ihrer Arbeit bei Vértice Comunicación war sie auch als Art Director für Honda tätig und führte eine Reihe von Kampagnen und Werbeprojekte durch. Später schloss sie sich dem Colectivo Hematoma an, einer innovative Gruppe von Designern mit Sitz in Guadalajara. Luna leitet zurzeit BD Mark, wo sie ein kleines professionelles Team führt, das überwiegend Designprojekte im kulturellen Bereich durchführt. Während der letzten Jahre konnte ihr Studio in Zusammenarbeit mit der Universidad de Guadalajara viele Kunden aus Mexico und den USA gewinnen.

Sara Luna a étudié à l'Universidad Autónoma Metropolitana d'Azcapotzalco, à Mexico. Elle est l'un des membres fondateurs de *Matiz*, le célèbre magazine de graphisme international. L'une de ses œuvres les plus acclamées est l'affiche *Mexican Design/New Visions* qu'elle a réalisée pour l'AIGA. Pendant qu'elle travaillait chez Vértice Comunicación, elle a été directrice artistique chez Honda et a contribué à de nombreuses campagnes et projets promotionnels avant de rejoindre Colectivo Hematoma, le collectif de graphisme avant-gardiste basé à Guadalajara. Sara Luna dirige actuellement BD Mark, où une petite équipe de professionnels travaille principalement sur des projets culturels. Ces dernières années, son studio a collaboré avec l'Universidad de Guadalajara, et a attiré des clients mexicains et américains.

2. "Mano a mano" poster,
Hematoma Collective

3. "Mexican Design/New Visions"
poster, 1999, Matiz magazine

4. "Gestionando y Avanzando"
selected poster at the Istituto
Europeo di Design for the exhibition
"Abranla que lleva bala", Spain

5. Promotional flyer, 2003, DJ Gotzilla

2

3

mexican design / new visions

4

5

MACA

Maca is the pseudonym of designer Gustavo Wojciechowski, born in the capital Montevideo and a leading figure in the development of typography in Uruguay. In 1993 he was a founding member of the iconic design office Barra, where he stayed until going solo in 2000. Since 1996 Wojciechowski has also been a professor of graphic design at the Universidad ORT Uruguay, and his priceless contribution to the field in the country was acknowledged with the Morosoli de Plata prize in 2006. His book *Tipografía, Poemas & Polacos* received the Certificate of Typographic Excellence from the Type Directors Club from New York. Maca has also published three children's books, *Bichos, ABCDario* and *Do Re Mi*.

Maca ist das Pseudonym des Designers Gustavo Wojciechowski, der in der uruguayischen Hauptstadt Montevideo geboren wurde und eine führende Persönlichkeit in der Entwicklung der dortigen Typografie ist. 1993 gehörte er zu den Gründungsmitgliedern von Barra, dem Designbüro mit Kultstatus, wo er bis zum Jahr 2000 blieb und sich dann selbständig machte. Seit 1996 ist Wojciechowski zudem Professor für Grafikdesign an der Universidad ORT Uruguay. Sein unschätzbarer Beitrag zum Fachgebiet Design in Uruguay wurde 2006 mit dem Preis Morosoli de Plata gewürdigt. Wojciechowskis Buch *Tipografía, Poemas & Polacos* erhielt das Certificate of Typographic Excellence vom Type Directors Club in New York. Außerdem hat Maca drei Kinderbücher mit den Titeln *Bichos, ABCDario* und *Do Re Mi* produziert.

Maca est le pseudonyme du graphiste Gustavo Wojciechowski, né dans la capitale, Montevideo. Il est l'une des principales figures du développement de la typographie en Uruguay. En 1993, il a été l'un des membres fondateurs de la grande agence de design Barra, où il est resté jusqu'à ce qu'il se lance en indépendant en 2000. Depuis 1996, il est également professeur de graphisme à l'Universidad ORT Uruguay, et sa contribution inestimable au secteur du graphisme uruguayen lui a valu un prix Morosoli de Plata en 2006. Son livre, *Tipografía, Poemas & Polacos*, a reçu le Certificate of Typographic Excellence du Type Directors Club de New York. Maca a également publié trois livres pour enfants, *Bichos, ABCDario* et *Do Re Mi*.

1. "Lola Press #15" magazine cover
and back-cover, 2001, Lola Press,
Montevideo, Uruguay

2. "Tipografía, Poemas & Polacos"
book cover, Editorial Argonauta,
Argentina

3. "Intercambios" poster, 1997,
ADG Uruguay, Icograda

4. "Paginas de Guarda" magazine
cover, 2006, Editoras del Calderón,
Buenos Aires, Argentina

*1968, Bolivia, www.machicaodesign.com

SUSANA MACHICAO

Trained in communication, Susana Machicao Pacheco spent a number of years working in advertising at Grey Bolivia, where she realised her true graphic talent whilst working in their creative department. In her own words, she believes that "it is vital for the creative professional to reinvent him/herself in order to succeed". Having published a vast quantity of diverse material, she remains adamant for her work not to be categorised either as advertising or graphic art, rather advocating diversification as the key to gaining experience and developing professional insight. Over 14 years Machicao Pacheco has led four creative teams in Bolivia and currently runs her own design consultancy in La Paz.

Susana Machicao Pacheco absolvierte eine Ausbildung in Kommunikation und war zunächst etliche Jahre im Werbebereich von Grey Bolivia tätig, wo sie während ihrer Arbeit in der Kreativabteilung ihr wahres Talent für Grafik erkannte. Ihren eigenen Worten zufolge glaubt sie, dass „es für den kreativen Experten unerlässlich ist, sich selbst neu zu definieren, um Erfolg zu haben". Machicao Pacheco hat eine große Menge unterschiedlicher Werke veröffentlicht und besteht darauf, dass ihre Arbeiten nicht als Werbe- oder Grafikkunst klassifiziert werden, sondern tritt ein für vielfältigste und breit gestreute Erfahrungen als Schlüssel für professionellen Ausdruck. Mehr als 14 Jahre lang hat sie vier Kreativteams in Bolivien geleitet und führt zurzeit ihr eigenes Design-Beratungsunternehmen in La Paz.

Susana Machicao Pacheco a étudié la communication. Elle a travaillé plusieurs années dans la publicité, au service création de Grey Bolivia, où elle a révélé un vrai talent de graphiste. Selon ses propres termes, elle pense que « pour réussir, il est vital que tout professionnel de la création se réinvente constamment ». Elle a publié de nombreux travaux très divers, et insiste toujours sur le fait que son travail ne doit pas être étiqueté, ni comme publicité ni comme art graphique. Elle pense au contraire que la diversification est essentielle pour acquérir de l'expérience et pour développer un vrai savoir-faire professionnel. En quatorze ans, Susana Machicao Pacheco a dirigé quatre équipes de création en Bolivie, et elle dirige actuellement son propre cabinet de graphisme à La Paz.

4

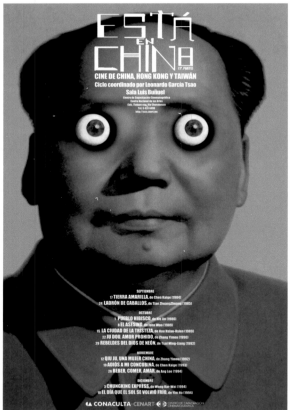

5

6

4. "Está en Chino"
poster, 2004, Centro de Capacitación
Cinematográfica

5. "Festejos de Muertos"
poster, 2005,
Universidad del Claustro de Sor Juana

6. "Voces Interiores"
poster, 1998,
Universidad Autónoma Metropolitana

7. "Memorias del Horror"
póster, 2005,
Universidad del Claustro de Sor Juana

8. "Fosfenos"
póster, 2002, Conaculta-IMCINE

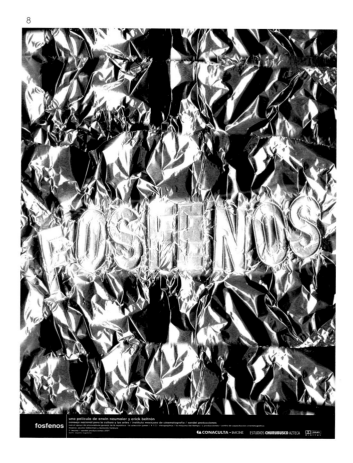

8

7

*1968, Mexico, www.lafeciega.com

DOMINGO NOÉ MARTÍNEZ

1

1. "Simbad" magazine
(art direction, typography design),
2004, Editorial Versus, Spain
Art direction Yolanda Garibay,
Domingo Noé Martínez
Photo Hartmut Pohling,
Japan Photo Archive

Domingo Noé Martínez is the lead designer at the Mexico City based Estudio La Fe Ciega, which he founded together with partner Yolanda Garibay in 2000. Trained as a graphic designer at the Universidad Autónoma Metropolitana, Noé Martínez gained experience in editorial design; he was notably responsible for the redesign of the Latin American editions of *Harper's Bazaar* and *Marie Claire*, as well as national titles such as *Casa Viva*, and *Vuelo* from Mexicana de Aviación. He also served as editor and art director for *Matiz*, the pioneering Mexican magazine on international graphic design. His works have been published in *Etapes Graphiques* in France, *Communication Arts* and *Step* in the United States and *ARC Design* in Brazil.

Domingo Noé Martínez ist der führende Designer des Studios La Fe Ciega mit Sitz in Mexico City, das er 2000 mit seiner Partnerin Yolanda Garibay gründete. Er wurde an der Universidad Autónoma Metropolitana zum Grafikdesigner ausgebildet und sammelte zunächst Erfahrungen im Editorial Design. Er war in besonderem Maße für die Neugestaltung der lateinamerikanischen Ausgaben von *Harper's Bazaar* und *Marie Claire* verantwortlich sowie für nationale Titel wie *Casa Viva* und *Vuelo* von Mexicana de Aviación. Noé Martínez arbeitete zudem als Editor und Art Director für *Matiz*, das bahnbrechende mexikanische Magazin des internationalen Grafikdesigns. Seine Arbeiten wurden in *Etapes Graphiques* (Frankreich), in *Communication Arts* und *Step* (USA) und in *ARC Design* (Brasilien) veröffentlicht.

Domingo Noé Martínez est le graphiste en chef de l'Estudio La Fe Ciega de Mexico, studio qu'il a fondé en 2000 avec sa partenaire Yolanda Garibay. Il a étudié le graphisme à l'Universidad Autónoma Metropolitana, et a par la suite acquis de l'expérience dans le design éditorial. Il a notamment été responsable du remodelage des éditions latino-américaines de *Harper's Bazaar* et *Marie Claire*, ainsi que de titres nationaux comme *Casa Viva*, et *Vuelo* de la compagnie aérienne Mexicana de Aviación. Il a également été rédacteur en chef et directeur artistique pour *Matiz*, le magazine mexicain avant-gardiste de graphisme international. Ses travaux ont été publiés dans *Étapes Graphiques* en France, *Communication Arts* et *Step* aux États-Unis et *ARC Design* au Brésil.

"Lo Sufro Pero lo Gozo"
poster (Los pecados capitales
de la Ciudad de México), 2004
Design/typography Colectivo
independiente, Estudio la fe ciega,
Domingo Noé Martínez

. "Pedro Páramo" poster (story by
Mexican writer Juan Rulfo), 2005
Design/illustration Colectivo
independiente, Estudio la fe ciega,
Domingo Noé Martínez

. Siticker for self-promotion, 2002
Design Estudio la Fe Ciega
Art direction Yolanda Garibay,
Domingo Noé Martínez

3

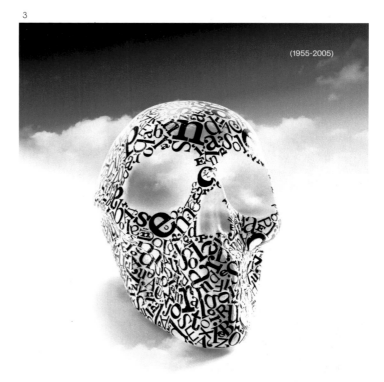

(1955-2005)

PEDRO PÁRAMO
de Juan Rulfo

2

4

estudio la fe ciega

estudio la fe ciega

MARCELO MARTINEZ

Passionate about illustration and cartoon, Marcelo Martinez graduated from Faculdade da Cidade in Rio de Janeiro. It wasn't long before he began to receive attention through his work for humour magazines such as *MAD* and *Bundas* in Brazil. Following a string of awards in Brazil and abroad, in 1996 he co-founded Porto + Martinez together with Bruno Porto, producing many works for *Print Magazine, Supon Books,* and *Rockport.* Porto + Martinez have exhibited in Argentina at the Latin American Graphic Arts Expo in Buenos Aires, and at the Graphic Design Biennial in São Paulo. Martinez's prolific activities include being an active member of the ADG Brasil (Graphic Designers Association); running his own design studio, Laboratório Secreto, and teaching at the School of Visual Arts at UniverCidade in Rio de Janeiro.

Marcelo Martinez' Leidenschaft gehört der Illustration und dem Cartoon. Er schloss sein Studium an der Faculdade da Cidade in Rio de Janeiro ab und fand schon bald darauf Beachtung durch seine Arbeit für humoristische Magazine wie zum Beispiel *MAD* und *Bundas* in Brasilien. Nach einer Reihe von Auszeichnungen in Brasilien und im Ausland gründete er 1996 zusammen mit Bruno Porto das Studio Porto + Martinez und produzierte viele Arbeiten für das Magazin *Print*, für *Supon Books* und *Rockport.* Die Arbeiten von Porto + Martinez wurden in Argentinien auf der Latin American Graphic Arts Expo in Buenos Aires ausgestellt sowie auf der Grafikdesign-Biennale in São Paulo. Neben weiteren produktiven Aktivitäten ist Martinez aktives Mitglied der ADG Brasil (Verband der Grafikdesigner). Er führt sein eigenes Designstudio Laboratório Secreto und lehrt an der School of Visual Arts der UniverCidade in Rio de Janeiro.

Passionné d'illustration et de dessins animés, Marcelo Martinez est diplômé de la Faculdade da Cidade de Rio de Janeiro. Ses réalisations pour des magazines d'humour brésiliens tels que *MAD* et *Bundas* n'ont pas tardé à attirer l'attention. Après avoir raflé toute une série de prix au Brésil et à l'étranger il a cofondé Porto + Martinez en 1996 avec Bruno Porto, et a beaucoup travaillé pour *Print Magazine* et les maisons d'édition *Supon Books* et *Rockport.* Porto + Martinez ont exposé leurs œuvres en Argentine à l'exposition Latin American Graphic Arts de Buenos Aires, et à la biennale du graphisme de São Paulo. Marcelo Martinez est un membre actif d'ADG Brésil (association de graphistes). Il dirige sa propre agence de graphisme, Laboratório Secreto, et enseigne à l'École des arts visuels d'UniverCidade, à Rio de Janeiro.

1. "Almanaque do Futebol" book,
2006, Editora Casa da Palavra
Assistant João Ferraz
Photography Marcello Theobald,
MacGyver PhotoStudio,
personal collections

2. "Bela Noite para voar" book cover,
2006, Editora Relume Dumará
Assistant João Ferraz
Awards VIII Brazilian Graphic Design
Biennial 2006

3. "Um velho que lia romances
de amor" book cover, 2005,
Editora Relume Dumará
Assistant João Ferraz

4. "Diário de um killer sentimental"
book cover, 2006, Editora Relume
Dumará
Assistant João Ferraz

5. "1280 Almas" book cover, 2005,
Editora Ediouro
Assistant João Ferraz
Illustration Renato Alarcão
Awards VIII Brazilian Graphic Design
Biennial 2006

2

3

4

5

*1973, Argentina, www.martinowww.com.ar

OCTAVIO MARTINO

1

Based in Córdoba, Octavio Martino studied design at the Instituto Aguas de la Cañada and art at the Universidad Nacional de Córdoba, having gained much experience in advertising before dedicating himself purely to graphic design. In 1998 he created the corporate identity for the acclaimed Centro Cultural de España in the city, and was responsible for its complete design programme for eight years. In 2000 and 2001 he worked as a creative director for the Mayor of Córdoba, creating the complete identity for the city's botanic garden, the national museum of fine arts, and the city market. In 2003 he was a Finalist at the Icograda Graphic Design Biennial in Osaka, Japan, and in 2004 he received a Silver Medal at the International Biennial of the Poster in Mexico.

Octavio Martino hat seinen Sitz in Córdoba, und studierte sowohl Design am Instituto Aguas de la Cañada als auch Kunst an der Universidad Nacional de Córdoba. Nachdem er zunächst viele Erfahrungen im Werbebereich gesammelt hatte, widmete er sich schließlich ganz dem Grafikdesign. 1998 schuf er die Corporate Identity für das Centro Cultural de España der Stadt und war über einen Zeitraum von acht Jahren für dessen gesamte Designplanung verantwortlich. In den Jahren 2000 und 2001 arbeitete er als Kreativchef für den Bürgermeister von Córdoba und erstellte die gesamte visuelle Identität für den botanischen Garten, für das Nationalmuseum der schönen Künste und den Markt der Stadt. 2003 war er ein Finalist bei der Icograda Grafikdesign-Biennale in Osaka, und 2004 erhielt er eine Silbermedaille auf der Internationalen Plakatbiennale in Mexiko.

Basé à Córdoba, Octavio Martino a étudié le graphisme à l'Institut Aguas de la Cañada et l'art à l'Universidad Nacional de Córdoba. Il a acquis une grande expérience dans la publicité avant de se consacrer exclusivement au graphisme. En 1998, il a créé l'identité visuelle du Centro Cultural de España de la ville, et s'est chargé de tout son programme de graphisme pendant huit ans. En 2000 et 2001, il a été le directeur de la création pour la Ville de Córdoba, et a créé l'identité du jardin botanique, du musée national des beaux-arts et du marché de la ville. En 2003 il a été finaliste à la Biennale du graphisme Icograda d'Osaka, au Japon, et en 2004 il a reçu une médaille d'argent à la Biennale internationale de l'affiche de Mexico.

2

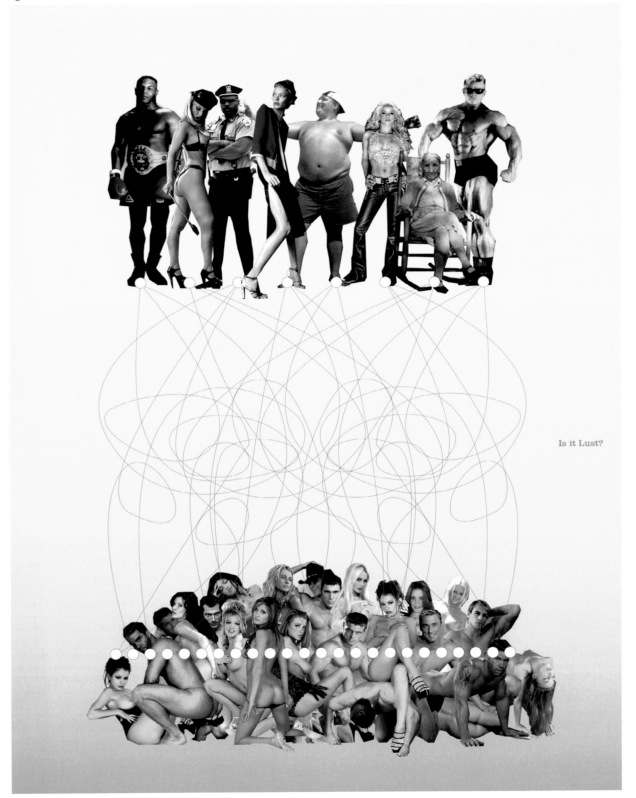

Is it Lust?

1. "Pattern" magazine cover, 2004, CCEC (Centro Cultural de España Cordoba), Argentina

2. "Is it Lust?" film and creativity magazine, 2004, SPÑ (shots), Spain

3. "Is it Love?" film and creativity magazine, 2004, SPÑ (shots), Spain

4. "Dripping" poster, 2004
Awards VIII International Poster Biennial in Mexico (Silver)

4

5. "Origami" cultural program, 2005, CCEC (Centro Cultural de España Cordoba), Argentina

RUBEN MARTINS

1

2

bozzano

Known as one of the key figures in the historical development of graphic design in Brazil Ruben Martins began his career as an artist in the 50s, when he and a group of fellow artists left for Bahia intending to create a new movement. He returned to São Paulo in 1958, and together with Alexandre Wollner, Geraldo de Barros, and soon after, Karl Heinz Bergmiller from Germany, he launched what is acknowledged to be the oldest design studio is Brazil, Forminform. In 1960, whilst continuing his design works, he studied under the leadership of Tomás Maldonado at MAN. Martins returned to Bahia later that year, this time setting out to create the visual identity for a variety of governmental agencies and state-run industries. In 1968 he fell victim to cancer at the early age of 39.

Ruben Martins wird als eine der Schlüsselfiguren in der Entwicklungsgeschichte des Grafikdesigns in Brasilien angesehen. Er begann seine künstlerische Karriere in den fünfziger Jahren, als er mit einer Gruppe von Künstlern in den Bundesstaat Bahia zog und beabsichtigte, eine neue Bewegung ins Leben zu rufen. Er zog 1958 nach São Paulo zurück und gründete zusammen mit Alexandre Wollner, Geraldo de Barros und wenig später mit Karl Heinz Bergmiller aus Deutschland das Studio Forminform, das als das älteste Designstudio Brasiliens bekannt ist. Während seiner Designarbeit studierte er 1960 unter der Führung von Tomás Maldonado an der MAN. Martins kehrte im gleichen Jahr nach Bahia zurück und machte sich daran, die Visual Identities für mehrere Regierungsbehörden und staatliche Unternehmen zu kreieren. Im Jahr 1968 starb er im Alter von nur 39 Jahren an einer Krebserkrankung.

Ruben Martins est l'un des principaux acteurs du développement du graphisme au Brésil. Il a commencé sa carrière en tant qu'artiste dans les années 1950, lorsqu'il part à Bahia avec un groupe de compagnons pour créer un nouveau mouvement. Il revient à São Paulo en 1958 et, avec Alexandre Wollner, Geraldo de Barros et, peu après, l'Allemand Karl Heinz Bergmiller, il lance le studio de graphisme le plus ancien du Brésil, Forminform. En 1960, tout en continuant de travailler dans le graphisme, il étudie sous la direction de Tomás Maldonado au MAN. Il retourne à Bahia la même année, cette fois pour créer l'identité visuelle de plusieurs organismes gouvernementaux et d'entreprises publiques. En 1968, il décède victime d'un cancer à l'âge de 39 ans.

1. **"Açolux"** logo, Aço Lux Pereira
da Costa Indústria e Comércio

2. **"Bozzano"** logo, 1960, Bozzano S.A.

3. **"Casa Almeida"** poster,
1965, Casa Almeida & Irmão

4. **"Tropical"** logo,
1966, Companhia Tropical de Hotéis

5. **"Margenroth"** logo,
1967, Margenroth Leoni & Cia.

6. **"Banco Bahiano da Produção"**
logo, 1966

7. **"Brasiljuta"** logo, 1966

8. **"Abecip"** logo,
1966, Associação Brasileira das
Entidades de Crédito Imobiliário
e Poupança

3

4

5

6

7

8

MASA

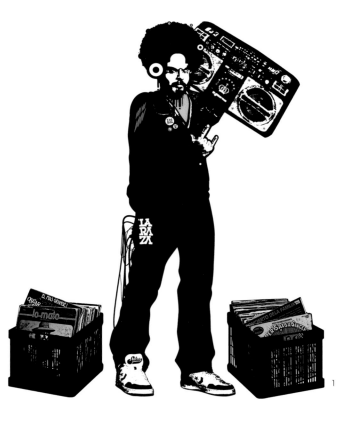

1. "MASA Artist Summer-Fall" t-shirt, advertising, CD packaging, and applications, 2006, Upperplayground, Fifty24SF, USA
Creative direction Matt Revelli (Upperplayground) and MASA

2. "DelaSOUL" illustration for concert, 2005, No-Domain, Sonar Music Festival, Spain

Formed in 1997, MASA is the creative studio of Miguel Vásquez (b.1975). With a vibrant and colourful portfolio of commissioned work, MASA is probably the most international design and graphic art practice operating in Venezuela today. Creating a unique fusion of graphics that combine urban and folklore references, MASA has put his creative stamp on a diverse range of projects, including Ronaldinho T-shirts for Nike, hotel rooms for the Hotel Fox in Copenhagen, an artwork covered car for Volkswagen, and numerous other avant-garde creations such as snowboards, record covers and fashion illustrations. Vásquez has received several awards and his print and motion work has been exhibited in Tokyo, Paris, New York, Barcelona, Copenhagen, México, Puerto Rico and Madrid.

Bei MASA handelt es sich um das 1997 gegründete Kreativstudio von Miguel Vásquez (geb.1975). Mit seinem dynamischen und bunten Portfolio ist MASA in Venezuela wahrscheinlich das Design- und Grafikstudio mit den meisten internationalen Kontakten. Durch seine einzigartigen Grafiken, die urbane und volkstümliche Bezüge miteinander verbinden, hat das Studio schon den verschiedensten Produktreihen seinen kreativen Stempel aufgedrückt. Dazu gehören Ronaldinho T-Shirts für Nike, Hotelzimmer für das Hotel Fox in Kopenhagen, ein künstlerisch gestaltetes Auto für Volkswagen sowie zahlreiche weitere Avantgarde-Kreationen wie zum Beispiel Snowboards, Plattenhüllen und Mode-Illustrationen. Vásquez hat mehrere Auszeichnungen erhalten, und seine Werke wurden in Tokio, Paris, New York, Barcelona, Kopenhagen, Mexiko, Puerto Rico und Madrid ausgestellt.

Créé en 1997, MASA est le studio de création de Miguel Vásquez (né en 1975). Avec un portfolio de commandes coloré et dynamique, MASA est probablement l'agence de design et de graphisme la plus internationale du Venezuela actuel. MASA crée des graphismes qui sont le résultat d'une fusion unique de références urbaines et folkloriques, et a apposé son sceau créatif sur des projets très variés, notamment des t-shirts Ronaldinho pour Nike, des chambres pour le Hotel Fox de Coppenhague, une voiture couverte de dessins pour Volkswagen, et de nombreuses autres créations d'avant-garde telles que des planches de snowboard, des couvertures de disques et des illustrations de mode. Miguel Vásquez a reçu plusieurs récompenses et ses œuvres imprimées ou d'animation ont été exposées à Tokyo, Paris, New York, Barcelone, Copenhague, Mexico, Puerto Rico et Madrid.

2

3. "Logoland" logo collection, 2002–2007

4. "Absolut Vodka Latin America" advertising campaign, 2005
Creative direction Gunner & Asociados

5. "IMATACA Room 115" interior design graphics, 2005, Volkswagen Germany
Agency EventLabs
Photo Die Photodesigner.de
Copy hotel room inspired by the Amazon (Venezuela–Brazil) at Fox Hotel for the release of the VW Fox auto in Copenhagen, Denmark

ABSOLUT AMIGOS INVISIBLES.

ABSOLUT® VODKA. 40% ALC/VOL. DISTILLED FROM GRAIN. ABSOLUT VODKA COUNTRY OF SWEDEN & LOGO AND ABSOLUT BOTTLE DESIGN ARE TRADEMARKS OWNED BY V&S VIN & SPRIT AB. DISTRIBUÍDO POR TAMAYO & CIA. S.A. EL CONSUMO EN EXCESO ES DAÑINO PARA LA SALUD.
www.absolut.com/icon

5

*1977, Argentina, www.xcolittx.com.ar

PABLO MATHON

1. "Japanese wall" Jappan Issue magazine, 2005, Argentina

Pablo Mathon (aka xCOLITTx) is a street artist, illustrator and designer based in Buenos Aires. He started producing highly illustrated fanzines at the early age of 15, and soon realised his inspiration and direction in urban aesthetic design. He later studied at the Universidad de Buenos Aires before completing the graphic design course at the Universidad de Palermo. Since then he has spent time with many underground and punk bands, an experience that led him to develop his own visual language. Today he incorporates his unique style and approach to produce some stunning graphics for the music and fashion industry. Mathon's roster of clients include the Bridger Conway Agency, *D-mode* magazine, and EMI music in Argentina.

Pablo Mathon (alias xCOLITTx) ist ein Street-Art-Künstler, Illustrator und Designer mit Sitz in Buenos Aires. Er begann bereits im Alter von 15 Jahren mit der Erstellung von Fanzeitschriften voll mit Illustrationen und erkannte bald seinen Hang zum urban-ästhetischen Design, das ihn inspirierte. Später studierte er an der Universidad de Buenos Aires und absolvierte einen Lehrgang über Grafikdesign an der Universidad de Palermo. Seitdem war Mathon viel mit Underground- und Punkbands zusammen und entwickelte durch diese Erfahrungen seine eigene visuelle Sprache. Heute prägt sein einzigartiges Stil in das Design von verblüffenden Grafiken für die Musik- und Modeindustrie. Zu Mathons Kunden gehören Bridger Conway Agency, *D-mode* Magazin und EMI Music in Argentinien.

Pablo Mathon (aussi connu sous le pseudonyme xCOLITTx) est un artiste urbain, illustrateur et graphiste basé à Buenos Aires. Il a commencé à réaliser des fanzines très illustrés dès l'âge de 15 ans, et a vite concrétisé son inspiration et son orientation dans un graphisme à l'esthétique urbaine. Plus tard, il a étudié à l'Universidad de Buenos Aires, avant de se diplômer en graphisme à l'Universidad de Palermo. Il a depuis fréquenté de nombreux groupes punks et underground, une expérience qui l'a conduit à construire son propre langage visuel. Aujourd'hui son style unique et sa démarche originale lui servent à produire de superbes graphismes pour l'industrie de la musique et de la mode. Pablo Mathon compte parmi ses clients Bridger Conway Agency, le magazine *D-mode*, et EMI Music en Argentine.

2. **"Football"** SLASH magazine special
feature on football, 2004,
Design Associati Srl.

3. **"Clinch"** promotional poster
for music band, 2004,
Photo Valeria Lopardo

4. **"Cruelty Free Wear"** poster,
2003, Invictuscfw (vegan wear)

3

2

4

*1972, Ecuador, www.belenmena.com

BELÉN MENA

1. "Restaurant Opa"
corporate identity, 2004

Belén Mena's work can be best defined as an expression of her intimate approach to nature and her country's culture. Running a design consultancy in Quito, Mena has always captured the pulse of Ecuadorian society and culture, designing with intense colours, strong lines, always conscious of the many levels of communication she is trying to achieve. Her serendipitous approach to each project often leads to unexpected solutions. Her work for Imprenta Mariscal has won several awards in the country and abroad. Mena's book *Pachanga*, on insect patterns translated into graphic expression, is an example of her vivid creativity. She has been published extensively, including in *Graphis* and *Communication Arts*, and has also exhibited in Europe and Latin America.

Belén Menas Werke können am besten als Ausdruck ihrer intimen Annäherung an Natur und Kultur ihres Landes definiert werden. Als Leiterin eines Design-Beratungsunternehmens in Quito fängt Mena den Puls der ecuadorianischen Gesellschaft und Kultur ein, und ihre Entwürfe voller intensiver Farben und strenger Linien machen die vielen Ebenen der Kommunikation bewusst, die sie erreichen will. Ihre geschickte Annäherung an jedes Projekt führt häufig zu unerwarteten Lösungen. Ihre Arbeiten für Imprenta Mariscal haben im In- und Ausland mehrere Auszeichnungen erhalten. Menas Buch *Pachanga*, in dem die Muster von Insekten in grafische Ausdrücke übertragen werden, ist beispielhaft für ihre impulsive Kreativität. Ihre Arbeiten wurden in großem Umfang veröffentlicht, darunter in *Graphis* und *Communication Arts*, und zudem in Europa und Lateinamerika ausgestellt.

Le travail de Belén Mena peut se définir comme une expression de son approche intime de la nature et de la culture de son pays. Elle dirige un cabinet de graphisme à Quito, et a toujours capté et retransmis le pouls de la société et de la culture équatoriennes. Ses œuvres regorgent de couleurs intenses, de lignes solides, et elle est toujours consciente des multiples niveaux de communication qu'elle essaie d'actionner. Elle laisse une part de hasard dans son approche de chaque projet, ce qui conduit souvent à des solutions inattendues. Son travail pour Imprenta Mariscal a remporté plusieurs récompenses en Équateur et à l'étranger. Son livre, *Pachanga*, sur la traduction des motifs propres aux insectes dans l'expression graphique, est un bon exemple de son intense créativité. Elle a été publiée dans de nombreux magazines, notamment dans *Graphis* et *Communication Arts*, et a également exposé en Europe et en Amérique latine.

sociedad:hombre/society:man

sociedad:mujer/society:woman

sociedad:matrimonio/society:marriage

sociedad:política/society:politics

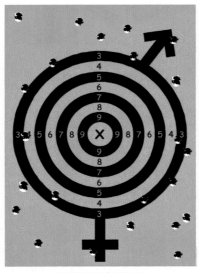

sociedad:sexo/society:sex

sociedad:amor/society:love

2. "Sociedad" poster series
Design Belén Mena, Silvio Giorgi

PEPE MENÉNDEZ

1. "Francofonía" festival poster, 2007

2. "Joven Estampa" award poster 2007, Premio La Joven Estampa

Pepe Menéndez trained as a graphic designer at the Instituto Superior de Diseño (ISDI) in Havana, and since 1999 has been art director at the Casa de las Américas (House of the Americas). During his tenure he has coordinated the design work for a large number of national and international cultural events in the city. He also serves as the vice-president of the Comité Prográfica Cubana, a national graphic designers association, and his work has been widely exhibited in Cuba and abroad. Menéndez' works have featured in a number of publications and books, such as *World Graphic Design* by Geoffrey Caban, *Diseño Gráfico Latinoamericano* by Rómulo Moya Peralta and *World Wide Identity* by Robert L.Peters. In his spare time, Menéndez is an avid collector of Cuban posters, portraying his national visual heritage.

Pepe Menéndez erhielt seine Ausbildung zum Grafikdesigner am Instituto Superior de Diseño (ISDI) in Havanna und ist seit 1999 als Art Director bei Casa de las Américas tätig, wo er die Designarbeit für eine große Anzahl nationaler und internationaler Kulturereignisse in der Stadt koordiniert hat. Er arbeitet zudem als Vizepräsident des Comité Prográfica Cubana, ein nationaler Verband der Grafikdesigner. Seine Werke wurden in Kuba und im Ausland in großem Umfang ausgestellt. Menéndez' Arbeiten sind in einer Reihe von Publikationen und Büchern veröffentlicht worden, z.B. in *World Graphic Design* von Geoffrey Caban, *Diseño Gráfico Latinoamericano* von Rómulo Moya Peralta und *World Wide Identity* von Robert L.Peters. In seiner Freizeit ist Menéndez ein begeisterter Sammler kubanischer Plakate, die sein nationales visuelles Erbe porträtieren.

Pepe Menéndez a étudié le graphisme à l'Instituto Superior de Diseño (ISDI) de La Havane, et est directeur artistique à la Casa de las Américas (Maisons des Amériques) depuis 1999. C'est dans ce poste qu'il a coordonné l'aspect graphisme d'un grand nombre d'événements culturels nationaux et internationaux dans la ville. Il est également vice-président du Comité Prográfica Cubana, une association nationale de graphistes, et son travail a beaucoup été exposé à Cuba et à l'étranger. Ses œuvres sont apparues dans de nombreux ouvrages et publications, notamment *World Graphic Design* de Geoffrey Caban, *Diseño Gráfico Latinoamericano* de Rómulo Moya Peralta et *World Wide Identity* de Robert L.Peters. Pendant ses loisirs, Pepe Menéndez est un collectionneur enthousiaste d'affiches cubaines, qui représentent l'héritage visuel de son pays.

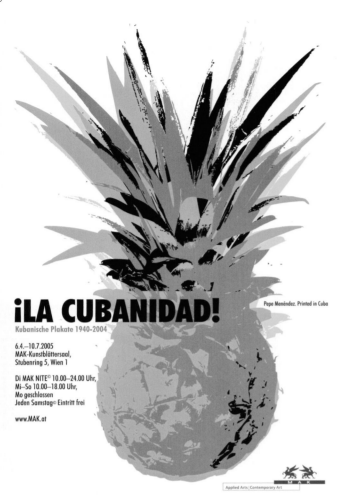

3. "La Cubanidad" exhibition poster, 2005, MAK Museum, Austria

4. "Cultural Rights" exhibition poster, 2004, Ministerio de Relaciones Exteriores de España

4

*1978, Brazil, www.retina78.com.br

CHRISTIANO MENEZES

Christiano Menezes is the head of Retina 78, a Rio de Janeiro-based design studio that has been conquering the market with a wide variety range of identity and editorial works for the fashion, recording and cultural industries. With an exotic curriculum vitae that includes forays into church restoration and studying for an unofficial design degree (Menezes was approved to study communication but found himself attending design classes instead), he went on to work with some of Brazil's music icons, the likes of Zeca Pagodinho, Antônio Carlos Jobim and Milton Nascimento. He also produced editorial designs for some of the top magazines including *Vogue, Trip* and *S/N°*. With a passion for illustration, Menezes creates a unique blend of design and graphic art to give his work a great sense of balance. After spending three years working at Universal Music, he founded his own practice in 2003.

Christiano Menezes ist der Leiter von Retina 78, ein Designstudio mit Sitz in Rio de Janeiro, das mit seiner großen Bandbreite an Corporate Identity und Editorial Design für die Modeindustrie, für Aufnahmestudios und den Kulturbereich den Markt erobert hat. Zu seinem Lebenslauf gehört ein Abstecher in die Kirchenrestaurierung, bevor er seinen inoffiziellen Abschluss in Design machte (Menezes war für den Studiengang Kommunikation zugelassen, doch er nahm stattdessen an Designkursen teil). Er arbeitete mit einigen brasilianischen Musik-Ikonen wie zum Beispiel Zeca Pagodinho, Antônio Carlos Jobim und Milton Nascimento zusammen. Weiterhin führte er Projekte in Editorial Design für einige Top-Magazine durch, z.B. *Vogue, Trip* und *S/N°*. Mit seiner Leidenschaft für Illustration schafft Menezes eine einzigartige Mischung aus Design und Grafikkunst, die seine Arbeiten in perfektem Gleichgewicht erscheinen lässt. Nachdem er drei Jahre lang für Universal Music tätig war, gründete er 2003 sein eigenes Studio.

Christiano Menezes est à la tête de Retina 78, un studio de graphisme basé à Rio de Janeiro qui a conquis le marché avec une grande variété de projets éditoriaux et d'identité pour les industries de la mode, de la culture et des maisons de disques. Il a un parcours exotique, qui comprend des incursions dans le monde de la restauration d'églises. Il a fait des études de graphisme en dehors du parcours officiel (il était censé étudier la communication, mais a préféré les classes de graphisme), et il a travaillé avec des icônes de la musique brésilienne, comme Zeca Pagodinho, Antônio Carlos Jobim et Milton Nascimento. Il s'est également chargé de plusieurs projets de design éditorial pour quelques-uns des plus grands magazines, notamment *Vogue, Trip* et *S/N°*. Christiano Menezes est passionné d'illustration, et son art est une alliance unique de design et de graphisme qui donne un sentiment de grand équilibre. Après avoir travaillé trois ans chez Universal Music, il a fondé sa propre agence en 2003.

1. "Naked Lunch" book cover,
2005, Ediouro
Design assistant Chico de Assis

2. "Pessoas que não conheço,
lugares que nunca vi"
book cover, 2007, Ediouro
Design assistant Chico de Assis

3. "Rio Botequim" book cover,
2006, Casa da Palavra
Design Christiano Menezes,
Chico de Assis
Photo Leandro Pagliaro

4. "Brasilidades" editorial design,
2004, BNDES
Design Christiano Menezes,
Chico de Assis, Leo Froes

5

5. "Sandra de Sá, Soul Brazuca" box
set packaging, 2004, Universal Music
Design Christiano Menezes
Photos Christiano Menezes,
Jeferson Mello

6. "Detonautas Roque Clube" CD
and poster, 2004, Warner Music Brazil
Art direction Christiano Menezes,
Cristina Portella
Photo Marcos Hermes

6

ESTUDIO MONITOR

1. "Chroma, de lo lúdico
a lo sensible" audio-visual festival
invitation, 2005–2006, Chroma

Estudio Monitor is one of the most suc-
cessful creative studios to emerge out of
Mexico in the last decade. Founded in 2002,
it is a full service design agency based in
Guadalajara, producing works on a wide
range of projects from print and visual iden-
tity to multimedia and motion graphics. In a
relatively short space of time the studio has
showcased its strengths in the appropriate
use of colour and vector illustration, imple-
menting a very modern visual language to
its posters, CD covers, T-shirts and big format
prints for murals. Their clients include the
Universidad de Guadalajara, British Embassy,
El Informador, Patronato Guggenheim GDL,
Nike and Revo Skateboards, among others.
Estudio Monitor has been frequently pub-
lished in Latin America.

Estudio Monitor ist eines der erfolgreichs-
ten mexikanischen Kreativstudios der letzten
zehn Jahre. Es wurde 2002 als Designagentur
mit umfassendem Angebot in Guadalajara
gegründet und führt umfangreiche Projekte
wie Druckarbeiten und Visual Identity oder
Multimedia-Design bis hin zum Motion-Design
durch. In relativ kurzer Zeit bewies das Studio
seine Stärken durch innovativen Einsatz von
Farben und Vektor-Illustrationen. Darin setzte
es eine sehr moderne visuelle Sprache in
seinen Plakaten, CD-Covers, T-Shirts und groß-
formatigen Wandbildern um. Zu den Kunden
zählen unter anderem die Universidad de
Guadalajara, die Britische Botschaft, *El
Informador*, Patronato Guggenheim GDL,
Nike und Revo Skateboards. Estudio Monitor
hat in Lateinamerika häufig Ausstellungen.

Estudio Monitor est l'un des studios de
création les plus brillants qui aient émergé au
Mexique ces dix dernières années. Créé en
2002, c'est une agence de graphisme basée
à Guadalajara qui propose des projets de
graphisme clé en main. On y travaille sur une
grande variété de projets, depuis les supports
imprimés et l'identité visuelle jusqu'au multi-
média et à l'animation. En relativement peu
de temps, le studio a fait preuve d'un grand
talent dans l'utilisation de la couleur et de
l'illustration vectorielle, et a appliqué à ses
affiches, couvertures de CD, t-shirts et papiers
peints un langage visuel très moderne. Le
studio compte parmi ses clients l'Universidad
de Guadalajara, l'ambassade de Grande-
Bretagne, le journal *El Informador*, Patronato
Guggenheim GDL, Nike et Revo Skateboards,
entre autres. Estudio Monitor a fait l'objet de
nombreuses publications en Amérique latine.

2. "Wall04" poster, 2006, self-promotion

3

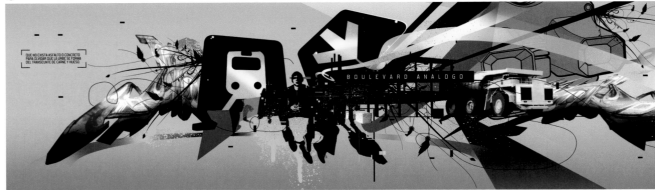

QUE NO EXISTA ASFALTO O CONCRETO
PARA OLVIDAR QUE LA URBE SE FORMA
DEL TRANSEÚNTE DE CARNE Y HUESO

BOULEVARD ANALOGO

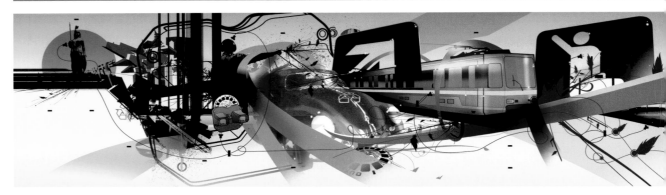

4

3. "Boulevard Análogo"
giant format posters (3 x 14 m),
2006, city of Jalisco government

4. "Mutek México GDL"
(Festival Internacional de Música
Canada-México) graphic identity,
2005, Secretaria de cultura,
Nopalbeat Records, Mutek

5. "Futbol con Angel"
product launch poster (Nike Aero 90),
2005, Nike, Hematoma Collective

5

*2003, Ecuador, www.wearemono.com

MONO

1. "M Magazine" cover

2. "Vrain Damage" poster, Monotono Records

These days, Mono probably represents the most international approach to visual communication in Ecuador. With experience working in Germany, Japan, United States and Spain, Jaime Nuñez del Arco is the principal of Mono, a creative boutique based in Guayaquil, southwest of the capital Quito. With a strong contemporary visual approach, his fusion design and illustrational work for commercial and cultural institutions has been widely presented, including at the Re:Up Gallery in San Francisco, Filesharing Gallery in Berlin, and at the Bienal Internacional de Arte de Cuenca, in his country. Nuñez del Arco currently works on his creative publication *Tomala!* and *Ecuador Creative Labs*, as well as for his own music label Monotono Records. He teaches at the Escuela Politecnica del Litoral in Guayaquil.

Mono präsentiert in Ecuador die visuelle Kommunikation wahrscheinlich so international wie nie zuvor. Das Kreativstudio mit Sitz in Guayaquil, südwestlich der Hauptstadt Quito, wird von Jaime Nuñez del Arco geleitet, der umfangreiche Erfahrungen in Deutschland, Japan, USA und Spanien gesammelt hat. Seine Melange aus Design und Illustrationen für kommerzielle und kulturelle Institutionen sind mit ihrer starken zeitgenössischen visuellen Sprache unter anderem in der Re:Up Gallery in San Francisco, der Filesharing Gallery in Berlin und auf der Bienal Internacional de Arte de Cuenca in seinem Heimatland zu sehen. Nuñez del Arco arbeitet zurzeit an seiner kreativen Publikation *Tomala!* und *Ecuador Creative Labs* sowie für sein eigenes Plattenlabel Monotono Records. Er unterrichtet an der Escuela Politecnica del Litoral in Guayaquil.

Aujourd'hui, Mono représente probablement la démarche de communication visuelle la plus internationale en Équateur. Jaime Nuñez del Arco a travaillé en Allemagne, au Japon, aux États-Unis et en Espagne, et est le directeur de Mono, une boutique créative de Guayaquil, au sud-ouest de la capitale Quito. Avec une approche visuelle très contemporaine, son travail qui fusionne design et illustration pour des institutions commerciales et culturelles a fait l'objet de nombreuses expositions, notamment à la galerie Re:Up de San Francisco, à la galerie Filesharing de Berlin, et à la Biennale internationale d'art de Cuenca dans son pays. Il travaille actuellement sur son magazine de création, *Tomala!* et sur *Ecuador Creative Labs*, ainsi que pour sa propre maison de disques, Monotono Records. Il enseigne à l'Escuela Politecnica del Litoral à Guayaquil.

3. "Place Book" book spread,
Place Book, Spain

4. "Ciclo sencillo" invitation,
Monotono Records

3

vrain damage
DJ vassago + animaciones
en vivo_sábado 23_22:00
El gran cacao (Imbabura y Panamá)_$3

4

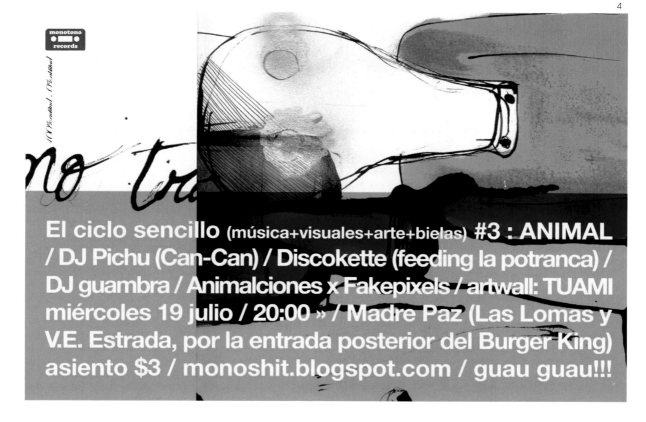

El ciclo sencillo (música+visuales+arte+bielas) #3 : ANIMAL
/ DJ Pichu (Can-Can) / Discokette (feeding la potranca) /
DJ guambra / Animalciones x Fakepixels / artwall: TUAMI
miércoles 19 julio / 20:00 » / Madre Paz (Las Lomas y
V.E. Estrada, por la entrada posterior del Burger King)
asiento $3 / monoshit.blogspot.com / guau guau!!!

*1956, Mexico

GERMÁN
MONTALVO

1. "Ecology" ecology exhibition poster, 1999, Ginza Graphic Gallery, Japan

2. "Paraíso seguro" poster, 2002

3. "Celia Cruz" concert poster, 1997

Germán Montalvo has been working for over 30 years, having started his career as a packaging designer for the pharmaceutical industry. His later collaboration with photographer Mariana Yampolski, resulted in a series of children's books on the subject of sex education in Mexico. Earlier, Montalvo studied at the Scuola del Libro in Milan under the professorship of Albe Steiner; it was during this period that he decided to rethink his career aims as a designer. Returning home, he joined Imprenta Madero to work alongside legendary designer Vicente Rojo. Montalvo's posters have received awards at such prestigious events as the Festival del Nuevo Cine Latinoamericano de La Habana, and the Biennial Colorado International Invitational Poster Exhibition. In addition he has also exhibited in Japan and is a professor of design at the Universidad de las Américas Puebla.

Germán Montalvo arbeitet bereits seit mehr als 30 Jahren im Design. Zunächst war er Verpackungsdesigner für die Pharmaindustrie und arbeitete dann mit der Fotografin Mariana Yampolski zusammen. Gemeinsam entwickelten sie eine Kinderbuchserie zum Thema Sexualpädagogik in Mexiko. Zuvor studierte Montalvo an der Scuola del Libro in Mailand bei Professor Albe Steiner. Zu dieser Zeit überdachte er auch seine beruflichen Ziele als Designer, kehrte in sein Heimatland zurück und fing bei Imprenta Madero an, wo er mit dem legendären Designer Vicente Rojo zusammenarbeitete. Seine Plakate wurden auf prestigeträchtigen Veranstaltungen wie dem Festival del Nuevo Cine Latinoamericano de La Habana und der Biennial Colorado International Invitational Poster Exhibition ausgezeichnet und auch in Japan ausgestellt. Er ist Professor für Design an der Universidad de las Américas Puebla.

La carrière de Germán Montalvo a débuté il y a plus de 30 ans, alors qu'il travaillait dans la conception d'emballages pour l'industrie pharmaceutique. Par la suite, sa collaboration avec la photographe Mariana Yampolski a donné naissance à une série de livres pour enfants sur le sujet de l'éducation sexuelle, publiée au Mexique. Un peu plus tôt, il avait étudié à la Scuola del Libro à Milan, sous la direction d'Albe Steiner. C'est pendant cette période qu'il a décidé de réorienter sa carrière vers le graphisme. À son retour, il a rejoint Imprenta Madero pour travailler avec le graphiste légendaire Vicente Rojo. Ses affiches ont reçu des récompenses prestigieuses, notamment au Festival del Nuevo Cine Latinoamericano de La Habana, et à la biennale Colorado International Invitational Poster Exhibition. Il a de plus exposé au Japon, et il est professeur de graphisme à l'Universidad de las Américas Puebla.

3

3. **"Enero"** calendar illustration, 2006, Watchavato

4. **"Amura"** magazine redesign, 2006, Real Estate Medios

4

*1951, Venezuela, www.johnmoore.com.ve

JOHN MOORE

1. "Amaliwaka"
conference poster, 2002
Awards Sociedad de Impresores
de Miami 2003; International Biennial
of the Poster in Mexico, nominee
2004; Collection of the Museo
de la Estampa Carlos Cruz-Diez

2. Calendar, 2000, Asociación
de Industriales de Ates Gráficas
de Venezuela.
Awards "Gráfica de Oro"
IX Concurso Latinoamericano
de Productos Gráficos (Theobaldo
de Nigris) Argentina, 2001

3. "Makiritare" Venezuelan pavillion
poster, EXPO 2000 Hannover
Awards Collection of the Museo
de la Estampa Carlos Cruz-Diez

Born in Caracas, John Moore studied graphic design at the Instituto de Diseño Neumann and later at the School of Visual Arts in New York. He worked for a long time in the animation industry, receiving over a dozen awards for his short films. Moore is one of the most experienced designers in the country. He started out in advertising at FCB, JWT and Leo Burnett, before opening his own design practice in 1993, where he has developed complex corporate identity programs, including for the national botanic garden. He was also responsible for creating the identity for the Venezuelan pavilion at the Expo 2000 Hanover in Germany. An awarded typographer, Moore is also a frequent lecturer in Venezuela and currently the creative director for *Criteria* publishing. His works have been published internationally.

Geboren in Caracas, studierte John Moore Grafikdesign am Instituto de Diseño Neumann und später an der School of Visual Arts in New York. Er arbeitete längere Zeit für Trickfilmstudios und erhielt über ein Dutzend Auszeichnungen für seine Kurzfilme. Moore ist einer der erfahrensten Designer Venezuelas. Er begann seine Tätigkeit im Werbebereich bei FCB, JWT und Leo Burnett, bevor er 1993 sein eigenes Designbüro eröffnete, wo er komplexe Programme zur Corporate Identity entwickelte, zum Beispiel für den nationalen botanischen Garten. Er entwickelte zudem die visuelle Identität des Pavillons von Venezuela auf der Expo 2000 in Hannover. Als anerkannter Typograf hält Moore häufig Vorlesungen in Venezuela und arbeitet zurzeit als Kreativchef für den Verlag *Criteria*. Seine Arbeiten wurden international veröffentlicht.

Né à Caracas, John Moore a étudié le graphisme à l'Instituto de Diseño Neumann puis à la School of Visual Arts de New York. Il a longtemps travaillé dans l'animation, et a reçu plus d'une douzaine de récompenses pour ses courts-métrages. Il est l'un des graphistes les plus expérimentés du pays. Il a commencé dans la publicité chez FCB, JWT et Leo Burnett, avant d'ouvrir sa propre agence de graphisme en 1993, où il a développé des programmes d'identité d'entreprise complexes, notamment pour le jardin botanique national. C'est également lui qui a créé l'identité du pavillon vénézuélien à l'Expo 2000 de Hanovre en Allemagne. En tant que typographe, John Moore a reçu plusieurs récompenses. Il donne fréquemment des conférences au Venezuela et est actuellement le directeur de la création des éditions *Criteria*. Ses œuvres ont été publiées dans de nombreux pays.

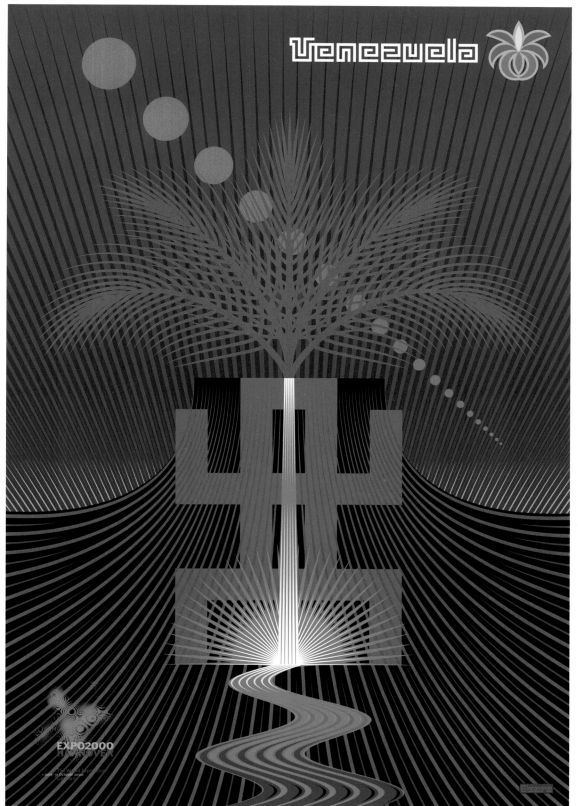

JOHN MOORE **359**

*1970, Mexico

JOSÉ MANUEL MORELOS

1

2

3

José Manuel Morelos is an artist-turned de-signer, trained at the Universidad Veracruzana in Veracruz, on the east coast of Mexico, where he specialised in advertising and communication. Morelos is known mostly for his politically oriented posters, often featuring religious and revolutionary subjects. He employs a variety of typographic techniques and materials to create an impressive sense of balance. A leading light in the new generation of poster designers, Morelos' output has been prolific, having created for an astonishing number of cultural events, celebrations, theatre plays and others. His work has been widely shown in recent years, including at biennials and triennials in Mexico, Russia, China, Bulgaria and Japan. Morelos currently serves as a professor at the Instituto de Artes Plásticas at Universidad Veracruzana,

José Manuel Morelos ist Designer und Künstler, ausgebildet an der Universidad Veracruzana in Veracruz und spezialisiert auf Werbung und Kommunikation. Morelos kennt man vor allem wegen seiner politisch orientierten Plakate mit häufig religiösen und revolutionären Themen. Dafür setzt er vielfältige typografische Techniken und Materialien ein und schafft so eine be-eindruckende Ausgeglichenheit. In der neuen Generation der Plakatdesigner ist er eine führende Persönlichkeit. Er ist überaus produktiv und arbeitet unter anderem für Kulturveranstaltungen, Festlichkeiten und Theateraufführungen. Seine Arbeiten wurden in den letzten Jahren vielerorts ausgestellt, darunter auf Biennalen und Triennalen in Mexiko, Russland, China, Bulgarien und Japan. Er lehrt zurzeit als Professor am Instituto de Artes Plásticas an der Universidad Veracruzana.

José Manuel Morelos est un artiste qui est devenu graphiste. Il a étudié à l'Universidad Veracruzana de Veracruz, sur la côte est du Mexique, où il s'est spécialisé dans la publicité et la communication. Morelos est surtout connu pour ses affiches politiques, qui traitent souvent de sujets religieux et révolutionnaires. Il utilise un vaste éventail de techniques typogra-phiques et de matériaux qui, une fois combi-nés, donnent un profond sentiment d'équilibre. Chef de file de la nouvelle génération des créateurs d'affiches, Morelos a été très prolifi-que, et a travaillé pour un nombre étonnant d'événements culturels, de célébrations et de pièces de théâtre, entre autres. Son travail a beaucoup été exposé ces dernières années, notamment lors de biennales et triennales au Mexique, en Russie, en Chine, en Bulgarie et au Japon. Il enseigne actuellement à l'Instituto de Artes Plásticas et à l'Universidad Veracruzana.

5

4

*1964, Ecuador, www.trama.ec

RÓMULO MOYA PERALTA

1. **"XI Bienal"** logo for cultural event, 1998, Bienal de Arquitectura de Quito, Colegio de Arquitectos del Ecuador

1

Rómulo Moya Peralta was born in Argentina, and moved to Ecuador at the age of eleven. Trained as designer and architect at the Universidad Central del Ecuador, Moya Peralta is a key disseminator of the subjects he studied, both as practitioner and editor of several publications. He is also a founding member of the faculty of architecture and design at the Universidad Católica in Quito, where he taught editorial design. He has already created over 500 book covers, and is the author of the first book on graphic design in the country, *Logos – 30 Años de Diseño Gráfico Ecuatoriano*, and has written a further 12 titles on photography, design and architecture in the region. Moya Peralta has been a juror at countless events and is the principal of Trama, a design studio and publishing house.

Rómulo Moya Peralta wurde in Argentinien geboren und zog im Alter von elf Jahren nach Ecuador. Nach seiner Ausbildung zum Designer und Architekten an der Universidad Central del Ecuador ist Moya Peralta ein Multiplikator für seine beiden Studienfächer – sowohl als Praktiker als auch als Herausgeber verschiedener Publikationen. Außerdem gehört er zu den Gründungsmitgliedern der Fakultät Architektur und Design an der Universidad Católica in Quito, wo er Editorial Design lehrte. Moya Peralta hat bereits mehr als 500 Bucheinbände entworfen und ist der Autor des ersten Buches über Grafikdesign im Land, *Logos – 30 Años de Diseño Gráfico Ecuatoriano*. Darüber hinaus hat er 12 weitere Titel über Fotografie, Design und Architektur in der Region verfasst. Moya Peralta dient bei zahllosen Wettbewerben als Jurymitglied und leitet das Designstudio und Verlagshaus Trama.

Rómulo Moya Peralta est né en Argentine et est parti vivre en Équateur à l'âge de onze ans. Il a étudié le graphisme et l'architecture à l'Universidad Central del Ecuador. Il joue un grand rôle dans le rayonnement de ces matières, en tant que professionnel et en tant qu'éditeur de plusieurs publications. Il est également l'un des membres fondateurs de la faculté d'architecture et de graphisme de l'Universidad Católica de Quito, où il a enseigné le design éditorial. Il a également créé plus de 500 couvertures de livres, et il est l'auteur du premier livre de graphisme du pays, *Logos – 30 ans de graphisme équatorien*. Il a ensuite écrit 12 autres titres sur la photographie, le graphisme et l'architecture en Amérique latine. Il a été juré pour une multitude de manifestations et dirige Trama, un studio de graphisme et maison d'édition.

2. "El Diseñador frente al Espejo"
poster for the celebration
of the World Graphics Day, 2006

3. "XIV BAQ" poster series,
1998, Bienal Panamericana
de Arquitectura de Quito,
Colegio de Arquitectos del Ecuador

EL DISEÑADOR FRENTE AL ESPEJO/ DÍA INTERNACIONAL DEL DISEÑADOR GÁFICO 2006

3

*1973, Cuba

FABIÁN MUÑOZ DÍAZ

1. "Premio de diseño gráfico Eduardo Muñoz Bachs" award poster given to Alfredo Rostgaard, 2004, Unión de Escritores y Artistas de Cuba (UNEAC)

2. "Homage to Bachs" poster, 2006

Fabián Muñoz Díaz was brought up in a family of artists, having design legend, Eduardo Muñoz Bachs not just as a reference, but also as a father and teacher. He developed a passion for drawing and sketching from a very early age, and as a teenager used to publish his work almost on a daily basis in the local newspaper. He graduated from the Universidad La Havana in communication and started his career working on editorial and advertising, for which he has won a handful of awards, before following in his father's footsteps by illustrating for children's books and posters. Defining the best qualities of his father's work as "synthesis and grace", he has produced a number of posters for the Cuban Institute of Art and Cinema (ICAIC), and his work has been exhibited in Brazil and in the United Kingdom.

Fabián Muñoz Díaz wuchs in einer Künstlerfamilie auf, und ihm diente die Design-Legende Eduardo Muñoz Bachs nicht nur als Referenz, sondern war ihm auch Vater und Lehrer. Er entwickelte schon im frühen Alter seine Leidenschaft fürs Zeichnen und Skizzieren und veröffentlichte bereits als Teenager seine Arbeiten fast täglich in der örtlichen Zeitung. Er schloss sein Studium in Kommunikation an der Universidad La Havana ab und begann seine berufliche Laufbahn in den Bereichen Editorial Design und Werbung. Darin erhielt er einige Auszeichnungen, bevor er schließlich in die Fußstapfen seines Vaters trat und Illustrationen für Kinderbücher und Poster entwarf. Er bezeichnete die Qualität der Arbeiten seines Vaters als „Synthese und Anmut" und erstellte mehrere Plakate für das Cuban Institute of Art and Cinema (ICAIC). Seine Arbeiten wurden in Brasilien und in Großbritannien ausgestellt.

Fabián Muñoz Díaz est né dans une famille d'artistes. Le légendaire graphiste Eduardo Muñoz Bachs est pour lui non seulement une référence, mais aussi un père et un professeur. Sa passion pour le dessin et les croquis s'est révélée à un très jeune âge, et lorsqu'il était adolescent ses œuvres étaient publiées chaque jour ou presque dans le journal local. Il est diplômé en communication de l'Universidad La Havana, et a commencé sa carrière dans le design éditorial et la publicité, domaines dans lesquels il a reçu une poignée de récompenses, avant de marcher sur les traces de son père en créant des illustrations pour des livres pour enfants et des affiches. Selon lui, les meilleures qualités de l'œuvre de son père sont « la synthèse et la grâce ». Il a créé de nombreuses affiches pour l'Institut cubain d'art et de cinéma (ICAIC), et ses œuvres ont été exposées au Brésil et au Royaume-Uni.

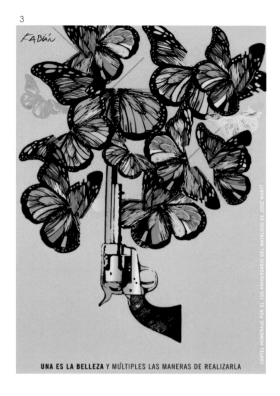

3. "Una es la Belleza"
poster advertising for the 150th
aniverssary of José Martí, 2003,
Comité Prográfica de Cuba

4. "Divina Desmesura" film poster,
2004, Instituto Cubano del Arte e
Industria Cinematográficos (ICAIC)

5. "Cuba Autos Antiguos" book cover,
2003, Editorial Arte y Literatura

*2000, Argentina, www.nahon.com.ar

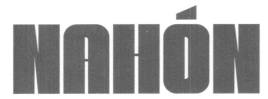

2

1. "Help Whale" logo,
2006, Greenpeace

2. "Fluid" logo,
2007, Fluid night club

3. "647" logo,
2007, 647 night club

1

3

Nahón belongs to the new breed of graphic design studios that emerged in the last decade. Shaped by a modern interpretation to the meaning of Latin culture, the studio has imbued a greater sense of internationalism to its visual language. Defining themselves as a creative "boutique", a term often used to define small creative powerhouses, Nahón has worked for several fashion clients, developing concepts, art directing photo shoots and creating graphics. With a strong style that combines typographic and illustrational overlays on photographic editorials, the boutique went on to produce their own fashion magazine entitled *Catalogue*, which displays the latest trends through a highly graphic-oriented approach. The studio is based in the capital Buenos Aires.

Nahón gehört zu der neuen Generation von Grafikdesignstudios, die im letzten Jahrzehnt in Argentinien entstanden. Geprägt durch seine moderne Interpretation der lateinamerikanischen Kultur war das Studio in seiner visuellen Sprache international gefärbt. Das Studio definiert sich selbst als kreative „Boutique", eine Bezeichnung, die oft für kleine kreative Unternehmen gebraucht wird. Das Nahón-Team hat für mehrere Kunden in der Modebranche gearbeitet, indem sie Konzepte entwickelten, Fotoaufnahmen künstlerisch leiteten und Grafiken erstellten. Mit ihrem überzeugenden Stil, der typografische Überlagerungen und Illustrationen auf Fotografien kombiniert, produzierte die Boutique ihr eigenes Modemagazin mit dem Titel *Catalogue,* das die neuesten Trends durch eine sehr grafikorientierte Annäherung zeigt. Das Studio hat seinen Sitz in der Hauptstadt Buenos Aires.

Nahón appartient à la nouvelle génération de studios de graphisme qui est apparue au cours de la dernière décennie. Le studio s'est formé sur une interprétation moderne de la signification de la culture latine, et a donné à son langage visuel une dimension très internationale. L'équipe du studio le définit comme une « boutique » créative. C'est un terme souvent employé pour désigner les petites sociétés de création très dynamiques. Nahón a travaillé pour plusieurs clients dans le secteur de la mode, sur le développement de concepts, la direction artistique de séances de photo et la création de graphismes. Avec un style solide qui combine typographie et superpositions d'illustrations sur des articles photographiques, la boutique a créé son propre magazine de mode, *Catalogue,* qui présente les dernières tendances avec une démarche très axée sur le graphisme. Le studio est basé à Buenos Aires, la capitale.

4. "Catalogue"
fashion magazine,
2007, Nahón

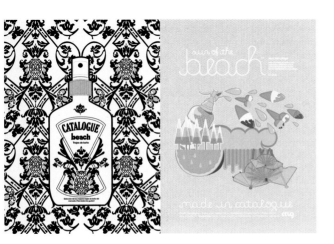

*1955, Chile, www.naranjo.cl

JULIÁN NARANJO

1

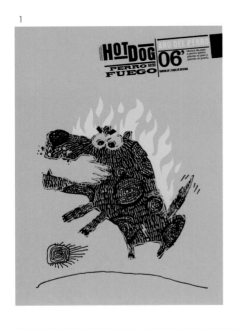

1. "Año del perro"
(The Year of the Dog) poster, 2006

2. "Veredas de Taconeo Lunar"
theatre play poster, 2003

Julián Naranjo Donoso is the founder and head of design at Naranjo BrandDesign, a consultancy he initiated in capital city of Santiago. After graduating from the Universidad de Chile in 1978, Naranjo started his career as a designer in California, USA, working for Design Group West in San Diego, among other companies. His works have been widely exhibited and internationally published, including *Communication Arts, Idea Magazine, Print, AIGA, Graphics* and *ADLA*. In 1992 he was part of the exhibition *30 Posters for the Environment*, as part of the United Nations conference on the environment. He currently runs his studio in Chile and his works range from total corporate identity to package design for both national and international clients.

Julián Naranjo Donoso ist Gründer und Chefdesigner des Beratungsunternehmens Naranjo BrandDesign, das er in der Hauptstadt Santiago de Chile gründete. Nach seinem Studienabschluss an der Universidad de Chile 1978 begann Naranjo seine berufliche Laufbahn als Designer in Kalifornien und arbeitete neben anderen Unternehmen für die Design Group West in San Diego. Seine Arbeiten sind in großem Umfang ausgestellt und international veröffentlicht worden, zum Beispiel in *Communication Arts, Idea Magazine, Print, AIGA, Graphics* und *ADLA*. 1992 nahm er an der Ausstellung *30 Posters for the Environment* teil, die im Rahmen der UN-Konferenz über Umwelt und Entwicklung durchgeführt wurde. Er leitet zurzeit sein Studio in Chile, wo er verschiedene Projekte von Corporate Identity bis zum Verpackungsdesign für nationale und internationale Kunden durchführt.

Julián Naranjo Donoso est le fondateur et le directeur du graphisme de Naranjo BrandDesign, un cabinet qu'il a créé à Santiago, la capitale du Chili. Après avoir obtenu son diplôme de l'Universidad de Chile en 1978, il a commencé sa carrière de graphiste en Californie, aux États-Unis, en travaillant entre autres chez Design Group West à San Diego. Ses œuvres ont fait l'objet de nombreuses expositions et publications, notamment dans *Communication Arts, Idea Magazine, Print, AIGA, Graphics* et *ADLA*. En 1992, il a participé à l'exposition *30 Posters for the Environment* dans le cadre de la conférence des Nations Unies sur l'environnement. Il dirige actuellement son studio au Chili et travaille dans plusieurs domaines, des projets clé en main d'identité d'entreprise à la conception d'emballage, pour des clients chiliens ou étrangers.

BASADA EN TEXTOS DE
PEDRO LEMEBEL

VEREDAS DE TACONEO LUNAR

DIRECCION: MAGALY RIVANO

INTERPRETES: ESTEFANIA COHEN, CESAR ALARCON,
TANIA LASCAR, GABRIEL ALDUNATE,
CHRISTIAN MICHAELSEN, RICARDO HERRERA Y LUIS YAÑEZ
MUSICA: ALEJANDRO MIRANDA
ESCENOGRAFIA-ILUMINACION: RODRIGO RUIZ
VESTUARIO: JORGE GONZALEZ
FOTOGRAFIA: MARIO VIVADO

GOBIERNO DE CHILE
FONDART

·TEDAT·

DISEÑO GRAFICO: NARANJO SADLER DESIGN

NEDO M.F.

El Farol

One of the pioneers of Venezuelan graphic design, Nedo M.F. was originally born in Italy and studied fine arts in Milan. He moved to Venezuela in 1950 where he began his illustrious career. Whilst working in advertising, he met his friend and collaborator Gerd Leufert, with whom he revolutionised the famous magazine *El Farol* in the late 50s. From 1962 to 1967 he created for the publication *CAL (Critica, Arte y Literatura)*, which is considered one of his most important bodies of work, and often acknowledged for its originality and avant-garde approach in both editorial and graphics. Nedo's works have been awarded and exhibited all over the world, and for nearly three decades he has taught at the Escuela de Artes Visuales Cristóbal Rojas.

Einer der Pioniere des Grafikdesigns in Venezuela, Nedo M.F., wurde in Italien geboren und studierte bildende Kunst in Mailand. 1950 zog er nach Venezuela, wo er seine glänzende berufliche Laufbahn begann. Während seiner Arbeit im Werbebereich traf er seinen Freund und Kollegen Gerd Leufert, mit dem er in den späten fünfziger Jahren das berühmte Magazin *El Farol* revolutionierte. Von 1962 bis 1967 arbeitete er für die Publikation *CAL (Critica, Arte y Literatura)*, die als eines seiner wichtigsten Werke angesehen wird und für ihre Originalität und ihr avant-gardistisches Profil in den Bereichen Editorial Design und Grafik anerkannt ist. Nedos Arbeiten haben Auszeichnungen erhalten und sind weltweit ausgestellt worden. Er lehrt seit fast drei Jahrzehnten an der Escuela de Artes Visuales Cristóbal Rojas.

Nedo M.F. est né en Italie et a étudié les beaux-arts à Milan. Il est l'un des pionniers du graphisme vénézuélien. C'est en 1950 qu'il est arrivé au Venezuela et que sa carrière légendaire a commencé. Alors qu'il travaillait dans la publicité, il a rencontré son ami et collaborateur Gerd Leufert, avec qui il a révolutionné le célèbre magazine *El Farol* à la fin des années 1950. De 1962 à 1967, il a créé pour la revue *CAL (Critica, Arte y Literatura)*. L'originalité et l'avant-gardisme de sa production éditoriale et graphique à cette période en font l'une des plus importantes de sa carrière. Les œuvres de Nedo M.F. ont été récompensées et exposées dans le monde entier, et il a enseigné à l'Escuela de Artes Visuales Cristóbal Rojas pendant près de trente ans.

1. "El Farol #243" magazine cover,
1973, Creole Petroleum Corporation

2. "Alfabeto reversible"
typography, 1972

3. "Quien le tiene miedo al lobo"
poster, 1965,
Comité Cultural Venezolano

4. "Alfabeto Caligráfico"
typography, 1965

5. "Museo de Arte Contemporáneo
de Caracas" logo, 1974

6. "Ipostel" logo, 1979,
Instituto Postal Telegráfico

3

4

5

6

NEGRO

2

1

Alive

Negro's approach to design would be a good indicator for the energy and mood of the new generation of Argentinean designers: vibrant, dynamic, and willing to make a difference. Founded in 2002 by Ariel de Lisio, the studio's rapid growth has led to the opening of further offices in Buenos Aires and Caracas in Venezuela. Their irreverent visual style and humoristic touch are key signifiers in their creations, which involve print, motion, illustration, product and web design. Their T-shirts on rock n' roll bands and historical figures have been widely acclaimed for their simplicity and good taste. Focused on strong concepts rather than complicated designs, de Lisio has led his team to create several award winning visual communication pieces in a short period of time.

Negros Annäherung an Design ist ein guter Indikator für die Energie und Stimmung der neuen Designergeneration in Argentinien: lebhaft, dynamisch und bereit, etwas zu bewegen. Von Ariel de Lisio 2002 gegründet, hat die rasante Entwicklung des Studios schon bald zur Eröffnung weiterer Büros in Buenos Aires und Caracas in Venezuela geführt. Der respektlose visuelle Stil und humoristische Ansatz des Negro-Teams sind Hauptmerkmale ihrer Arbeiten, die Printmedien, Motion-Design, Illustration sowie Produkt- und Webdesign mit einschließen. Ihre T-Shirts mit Motiven von Rock'n'Roll-Bands und historischen Figuren sind wegen ihrer Einfachheit und geschmackvollen Gestaltung allgemein anerkannt. Indem er auf starke Konzepte anstatt auf komplizierte Designs setzt, konnte de Lisio mit seinem Team in kurzer Zeit einige Werke im Bereich der visuellen Kommunikation entwickeln, die bereits ausgezeichnet wurden.

Negro a une approche du graphisme qui est un bon indicateur de l'énergie et de l'esprit de la nouvelle génération des graphistes argentins : de la vitalité, du dynamisme et la volonté de faire bouger les choses. Créé en 2002 par Ariel de Lisio, ce studio a eu une croissance rapide qui a conduit à l'ouverture de bureaux à Buenos Aires et à Caracas, au Venezuela. Le style visuel irrévérencieux et les notes d'humour sont des signifiants essentiels dans les créations de Negro, qui concernent les documents imprimés, l'animation, l'illustration et la conception de produits et de sites web. Leurs t-shirts sur les groupes de rock et les personnages historiques ont été très applaudis pour leur simplicité et leur bon goût. Ariel de Lisio préfère les concepts forts aux dessins compliqués, et sous sa direction son équipe a créé en peu de temps plusieurs projets de communication récompensés par divers prix.

3

1. "Jaydee Alive" logo,

2. "Loco" visual identity

3. "2021" conference poster

4. "Jaydee" visual identity

4

*1970, Mexico, www.ericolivares.com

ERIC OLIVARES

1

Eric Olivares is an all round designer, illustrator, performance and new media artist. After studying at the Instituto Nacional de Bellas Artes, he went on to specialise in digital art at the Universitat Pompeu Fabra in Barcelona. Returning to his native Mexico, Olivares would soon become acknowledged as one of the most versatile designers of his generation, working with multidisciplinary teams, striving to utilise the latest design technologies to produce effective communication campaigns. His offline work expands to corporate identity, poster design, typography and advertising, and he has closely worked with institutions in the United States, Canada and Europe. His works have been exhibited at the Museum of Design in Switzerland, and at the Syndicat National des Graphistes in France.

Eric Olivares ist Allround-Designer, Illustrator, Performance- und New Media-Künstler. Nachdem er sein Studium am Instituto Nacional de Bellas Artes abgeschlossen hatte, spezialisierte er sich an der Universitat Pompeu Fabra in Barcelona auf digitale Kunst. Olivares kehrte schließlich in sein Heimatland Mexiko zurück und wurde bald als einer der vielseitigsten Designer seiner Generation bekannt, der zusammen mit interdisziplinären Teams die neuesten Designtechnologien nutzt, um effektive Kommunikationskampagnen zu produzieren. Seine Offline-Arbeiten umfassen Corporate Identity, Plakatdesign, Typografie und Werbung, und dafür arbeitet er eng mit Institutionen in den USA, Kanada und Europa zusammen. Seine Werke wurden im Museum für Gestaltung in der Schweiz sowie im Syndicat National des Graphistes in Frankreich ausgestellt.

Eric Olivares est un graphiste complet, illustrateur et artiste de performance travaillant aussi sur les nouveaux médias. Après avoir étudié à l'Instituto Nacional de Bellas Artes, il s'est spécialisé en art numérique à l'Universitat Pompeu Fabra de Barcelone. Lorsqu'il est retourné au Mexique, Eric Olivares a rapidement été reconnu comme l'un des graphistes les plus polyvalents de sa génération. Il a travaillé avec des équipes pluridisciplinaires et a essayé d'utiliser les dernières technologies en matière de graphisme pour produire des campagnes de communication efficaces. En dehors de son travail pour le web, il s'occupe également d'identité d'entreprise, de création d'affiches, de typographie et de publicité, et il a travaillé en étroite collaboration avec des organismes américains, canadiens et européens. Ses œuvres ont été exposées au Museum für Gestaltung en Suisse et au Syndicat National des Graphistes en France.

2. "Goethe Institut 30" cultural
event poster, Goethe Institut Mexico

3. "Ábranla que Lleva Bala"
exhibition poster, 1995, Istituto
Europeo di Design, Casa de América

4. "¿Donde Estás Corazón?"
TV series logo, Argos Comunicación,
Tele Mundo

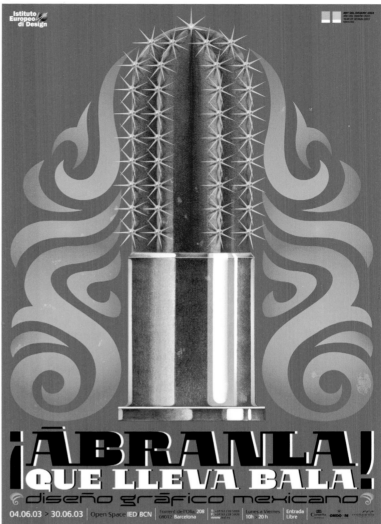

*1977, Argentina, www.patriciooliver.com.ar

PATRICIO OLIVER

With less than a decade of experience in the field, Patricio Olivier is one of the newest revelations to come out of Argentina's graphic design community. Olivier emerged on the scene with a developed visual personality through his use of highly coloured and illustrated material. His early album designs for Diosque (Sony BMG), along with his fashions show invitations for UNMO, Kostume and Leandro Dominguez received rave reviews, leading to bigger offers, which Olivier has taken on in the music and fashion industry. His works have been frequently published in Argentina, notably his series of postcards and printed programmes for the Mutek Electronic Music Festival. Olivier currently runs his design practice in the capital Buenos Aires.

Mit weniger als zehn Jahren Berufserfahrung ist Patricio Olivier eine der neuesten Entdeckungen im argentinischen Grafikdesign. Als Olivier in der Designszene erschien, hatte er schon seinen visuellen Stil entwickelt, für den er farbintensive und illustrierte Materialien einsetzt. Seine frühen Alben-Entwürfe für Diosque (Sony BMG) sowie seine Modeschau-Einladungen für UNMO, Kostume und Leandro Dominguez wurden von der Kritik hochgelobt und führten zu größeren Aufträgenaus der Musik- und Modebranche. Seine Arbeiten wurden mehrmals in Argentinien ausgestellt, besonders seine Serie von Postkarten und gedruckten Programmen für das Mutek Electronic Music Festival. Olivier leitet zurzeit sein eigenes Designbüro in der Hauptstadt Buenos Aires.

Avec moins d'une dizaine d'années d'expérience dans le secteur, Patricio Olivier est l'une des toutes dernières révélations de la communauté des graphistes argentins. Il est arrivé dans le cénacle avec une personnalité visuelle très aboutie qui s'exprime par l'utilisation d'images très colorées et d'illustrations. Ses créations pour les albums de Diosque (Sony BMG), ainsi que ses invitations à des défilés de mode pour UNMO, Kostume et Leandro Dominguez ont reçu des critiques enthousiastes, ce qui lui a amené des propositions de plus en plus importantes auxquelles il a répondu dans les industries de la musique et de la mode. Ses œuvres ont beaucoup été publiées en Argentine, notamment sa série de cartes postales et de programmes imprimés pour le festival Mutek Electronic Music. Patricio Oliver dirige actuellement son agence dans la capitale, Buenos Aires.

1. "DejaVu" flyers, 2006, Niceto Club

2. "Mutek BA 06" postcards
and printed program, 2006,
Mutek Electronic Music Festival

*1979, Brazil, www.ozdesign.com.br

OZ DESIGN

1. "Ministério da Saúde" identity system, 2004, Brazilian Health Ministry
Design Ronald Kapaz

2. "UOL" identity system (redesign), 2004, UOL, web portal
Design Ronald Kapaz

3. "Zoo" identity system, 2004, São Paulo Zoo
Design Giovanni Vannucchi

1

2

3

Founded in 1979 by graphic designers André Poppovic, Giovanni Vannucchi and Ronald Kapaz, OZ Design is a consultancy based in São Paulo, acting within the broad remit of implementing communication approaches for their clients, developing projects in visual identity, interiors, packaging, product and promotional design. With a strong belief that content, form and expression are the catalysts for strong brands, OZ Design have been highly awarded for their works for clients such as ABN Amro Bank, Cargil, Coca-Cola, Kimberly-Clark, Michelin and Wal-Mart. Their interests have been focused on the visual manifestation of cultural phenomena, and the positioning of successful campaigns and products. In 2007 the group was selected as the best design agency in Brazil for the second year.

OZ Design wurde 1979 durch die Grafikdesigner André Poppovic, Giovanni Vannucchi und Ronald Kapaz gegründet und ist ein Beratungsbüro mit Sitz in São Paulo, Brasilien. Das Designstudio entwickelt für seine Kunden neue Ansätze in der Kommunikation und führt Projekte über Visual Identity, Raumgestaltung, Verpackungsdesign sowie Produkt- und Werbedesign durch. OZ Design ist davon überzeugt, dass Inhalt, Form und Ausdruck die Katalysatoren für kraftvolle Marken sind, und ihre Arbeiten bekamen hochrangige Auszeichnungen. Zu den Kunden zählen ABN Amro Bank, Cargil, Coca-Cola, Kimberly-Clark, Michelin und Wal-Mart. Die Interessen des Design-Teams konzentrieren sich auf die visuelle Fixierung kultureller Phänomene und auf die Positionierung erfolgreicher Kampagnen und Produkte. 2007 wurde die Gruppe bereits zum zweiten Mal als beste Designagentur in Brasilien ausgewählt.

Créé en 1979 par les graphistes André Poppovic, Giovanni Vannucchi et Ronald Kapaz, OZ Design est un cabinet basé à São Paulo, dont le vaste domaine d'action est la mise en œuvre de démarches de communication par la création de projets d'identité visuelle, de promotion, d'architecture d'intérieur, d'emballages et de produits. L'équipe croit fermement que le contenu, la forme et l'expression sont des catalyseurs pour les marques fortes, et OZ Design a reçu des récompenses prestigieuses pour des projets réalisés pour ABN-Amro Bank, Cargil, Coca-Cola, Kimberly-Clark, Michelin et Wal-Mart. Le cabinet s'intéresse surtout à la manifestation visuelle des phénomènes culturels, et au positionnement de produits et campagnes à succès. En 2007, l'équipe a été sélectionnée comme meilleure agence de graphisme du Brésil pour la seconde fois.

4

4. "Mar de Homens" book,
2006, Editora Terra Virgem
Art direction André Poppovic
Design Lucio Luz, André Senra,
Bruno Vilardo, Carolina Olson

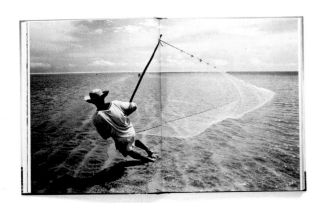

*1958, Honduras, www.elmanpadilla.com

ELMAN PADILLA

1

2

Elman Padilla studied graphic design in Miami and later at the Pratt Institute in New York, before furthering his qualifications at the Graphic Media Development Centre in the Hague, Holland and at the Universidad Pontificia Bolivariana in Medellín, Colombia. He is a founding member of the Honduran Photographers Association and the International Academy of the Visual Arts. In addition he has lectured in his country, at the Universidad José Cecilio del Valle, and currently teaches at the Higher Colleges of Technology in Abu Dhabi. Padilla has managed his design consultancy since 1990, with a focus on corporate identity and local advertising. His photographic works have been internationally awarded.

Elman Padilla studierte zunächst Grafikdesign in Miami und später am Pratt Institute in New York, und erweiterte dann seine Qualifikationen am Graphic Media Development Centre in Den Haag, Holland, und an der Universidad Pontificia Bolivariana in Medellín, Kolumbien. Er gehört zu den Gründungsmitgliedern der Honduran Photographers Association und der International Academy of the Visual Arts. Darüber hinaus hielt er in seinem Heimatland an der Universidad José Cecilio del Valle Vorlesungen und lehrt zurzeit am Higher Colleges of Technology in Abu Dhabi. Padilla leitet seit 1990 sein Designstudio, mit den Schwerpunkten auf Corporate Identity und lokaler Werbung. Seine fotografischen Arbeiten sind international ausgezeichnet worden.

Elman Padilla a étudié le graphisme à Miami puis au Pratt Institute de New York, avant de continuer sa formation au Graphic Media Development Centre de La Haye, en Hollande, et à l'Universidad Pontificia Bolivariana de Medellín, en Colombie. Il est l'un des membres fondateurs de l'Association de photographes honduriens et de l'International Academy of the Visual Arts. Il a de plus enseigné dans son pays, à l'Universidad José Cecilio del Valle, et il enseigne actuellement au Higher College of Technology d'Abu Dhabi. Depuis 1990, Elman Padilla dirige son cabinet de graphisme spécialisé dans l'identité d'entreprise et la publicité locale. Ses œuvres photographiques ont reçu des récompenses internationales.

1. "Chisme (Gossip). Asedios Críticos" exhibition artwork, 2006, Centro Americano, Museo MADC San José

2. "Piropo (Flirtatious Remark). Asedios Críticos" exhibition artwork, 2006, Centro Americano, Museo MADC San José

3. "Malvenidos/Bienvenidos" (Welcome/Unwelcome) poster, 2007, personal work

4. "Inglés. Odialo, ámalo, háblalo!" (English. Hate it, love it, speak it!) exhibition artwork, 2007, Ars Latina

*1945, Mexico, www.carlospalleiro.com.mx

CARLOS PALLEIRO

1. "El Sindykato" record cover, 1972, Discos Sondor

2. "Yo También Soy Hijo de Pedro Páramo" celebration poster, 2005, Grupo de Diseño Gráfico Salón Rojo

1

Born in the Uruguayan capital city of Montevideo, Carlos Palleiro is one of the most respected designers in the country. His legendary works include the graphic design for the 1971 electoral campaign *Frente Amplio* and also for Club de Teatro de Montevideo and Centro de Navegación Transatlántica. Having also worked largely in Argentina, and now residing in Mexico, Palleiro's main focus has been editorial design for books and magazines, notably through his special collaboration with Editorial Planeta and Siglo XXI Editores, for whom he has designed countless book covers. He has also created pieces for various music labels in Mexico and has also been a juror for the International Biennial of the Poster in Mexico. Palleiro currently divides his time between his role as art director for Ediciones SM whilst teaching at the Universidad Iberoamericana Puebla.

Carlos Palleiro wurde in Montevideo, der Hauptstadt von Uruguay geboren und ist einer angesehensten Designer des Landes. Zu seinen legendären Arbeiten gehören die Grafikdesignprojekte für die Wahlkampagne *Frente Amplio* 1971 sowie für Club de Teatro de Montevideo und Centro de Navegación Transatlántica. Er arbeitete größtenteils in Argentinien und lebt nun in Mexiko. Der Schwerpunkt in Palleiros Arbeit liegt im Editorial Design für Bücher und Magazine. Dabei arbeitet er vor allem mit Editorial Planeta und Siglo XXI Editores zusammen, für die er zahllose Bucheinbände entworfen hat. Außerdem hat er Arbeiten für verschiedene Plattenfirmen in Mexiko erstellt und war Mitglied der Jury für die internationale Plakatbiennale in Mexiko. Palleiro verbringt gegenwärtig seine Arbeitszeit als Art Director für Ediciones SM und lehrt zudem an der Universidad Iberoamericana Puebla.

Né à Montevideo, la capitale uruguayenne, Carlos Palleiro est l'un des graphistes les plus respectés du pays. Parmi ses œuvres légendaires, on peut citer la campagne électorale de 1971, *Frente Amplio*, ou le travail réalisé pour le Club de Teatro de Montevideo et le Centro de Navegación Transatlántica. Il a également beaucoup travaillé en Argentine, et réside actuellement au Mexique. Il s'est surtout intéressé au design éditorial de livres et de magazines, notamment à travers sa collaboration avec Editorial Planeta et Siglo XXI Editores, pour qui il a créé une multitude de couvertures de livres. Il a également réalisé des créations pour plusieurs maisons de disques mexicaines, et a été juré pour la Biennale internationale de l'affiche de Mexico. Il partage actuellement son temps entre son rôle de directeur artistique pour Ediciones SM et son rôle d'enseignant à l'Universidad Iberoamericana Puebla.

YO TAMBIÉN SOY HIJO DE **PEDRO PÁRAMO**
1955 - 2005 DE JUAN RULFO

3

Viví en el monstruo,
y le conozco las entrañas
JOSÉ MARTÍ
1853 · 2003

Diseño gráfico: Carlos Fabelo, México, 2003

4

. "José Martí"
50th anniversary poster, 2003,
Grupo de Diseño Gráfico Salón Rojo

. "El evangelio de las maravillas"
film poster, 1998,
Amaranta y Gardenia Producciones

. "Donde arde el fuego nuestro los
olimareños" record cover,
1980, Discos Fotón

. "Zitarrosa si te vas" record cover,
1980, Discos Fotón

5

6

PARANOIA CORP

1

1. "Black Beat" visual identity and motion graphics, 2006, Black Beat
Illustration/design Juan Rivera
Motion graphics Frank Zamora
Production Cleveland Cooper, Sound Loyd Sutherland

2. "Supernova" visual identity and poster, 2006, VEXCO
Illustration/design Juan Rivera
Production Juan Rivera, Miguel Lombardo (Alquimia Group), Giancarlo Thompson (Mandela)

As a response to chaos theory, three young Panamanian artists, Juan Rivera, Frank Zamora, and Cleveland Cooper, decided to form a creative practice in search of a new balance. Together the trio have worked for international banks, non-profit organisations, music festivals, fashion designers and magazines; producing print, motion, editorial, advertising and interactive design since 2002. Renowned for the high quality of their output, they are also frequent collaborators with many of the best photographers, animators and artists in the country, always setting out to create a very unique and original approach to each assignment. Since the launch of Paranoia Concept Lab Rivera and Zamora have respectively taken on the creative roles as art director and multimedia director.

Als eine Antwort auf die Chaos-Theorie beschlossen die drei jungen, panamaschen Künstler Juan Rivera, Frank Zamora und Cleveland Cooper, auf der Suche nach einer neuen Ausgeglichenheit ein Kreativstudio zu gründen. Das Trio ist seit 2002 gemeinsam für internationale Banken, gemeinnützige Organisationen, Musikfestivals, Modedesigner und Modezeitschriften tätig und entwirft Printmedien, Motion-Design, Editorial Design, Werbedesign sowie interaktives Design. Sie sind berühmt für ihre qualitativ hohen Leistungen und arbeiten zudem häufig mit vielen der besten Fotografen, Trickfilmzeichner und Künstler des Landes zusammen. Dabei nähern sie sich stets auf einzigartige und originelle Weise an die jeweilige Aufgabe an. Seit Gründung von Paranoia Concept Lab haben Rivera und Zamora die kreativen Rollen des Art Directors bzw. Multimedialeiters übernommen.

En réponse à la théorie du chaos, trois jeunes artistes panaméens, Juan Rivera, Frank Zamora, et Cleveland Cooper, ont décidé de créer une agence créative pour partir à la recherche d'un nouvel équilibre. Ensemble, le trio a travaillé pour des banques internationales, des organisations à but non lucratif, des festivals de musique, des créateurs et des magazines de mode. Ils produisent des projets dans les domaines de l'impression, de l'animation, du design éditorial, de la publicité et du design interactif depuis 2002. Ils sont réputés pour la grande qualité de leur travail, et ils collaborent fréquemment avec tous les plus grands photographes, animateurs et artistes du pays. Ils cherchent toujours à inventer une démarche tout à fait unique et originale pour chaque projet. Depuis le lancement de Paranoia Concept Lab Juan Rivera et Frank Zamora assument respectivement les rôles de directeur artistique et de directeur multimédia

SUPERNOVA

SI EL AMOR NO ACEPTA COMPETENCIAS, ENTONCES CHILIEMOS

CONVIVENCIA DE DOWNHILL
SABADO.18.FEBRERO.06
CLAYTON / 11:00 AM - ETC
SE PREMIARA LA TOTALIDAD
Y LO ESPONTANEO

*1941, Mexico

ANTONIO PÉREZ ÑIKO

1. "Frankenstein" film poster,
2005 Revista AGR Coleccionistas
de Cine de Madrid

2. "Moby Dick" film poster,
2005, Revista AGR Coleccionistas
de Cine de Madrid

3. "Por qué se suicidan las hojas
cuando se sienten amarillas"
poster, 2004, centenary of
Pablo Neruda

Now a resident in Mexico, Antonio Pérez "Ñiko" was born and educated in Cuba, and belongs to the select group of designers that have solidified the poster movement in the country. He started out at the ICAIC in 1968, first designing posters for Cuban and foreign films before going on to create political posters as part of the revolutionary campaigns of the 60s and 70s. Ñiko's most famous works have been exhibited at international biennials in Brno (Czechoslovakia), Florence (Italy) and Warsaw (Poland). His film posters have received prizes at Filmexpo in Canada, and at the Cannes International Film Festival in France. He has published numerous articles on graphic design and has sat on competition juries in Cuba and abroad. He has also worked as a professor at the Universidad Veracruzana.

Antonio Pérez „Ñiko" wurde in Kuba geboren und ausgebildet, lebt aber derzeit in Mexiko. Er gehört zu der ausgewählten Gruppe von Designern, über die sich die Plakatbewegung im Land etablieren konnte. Er begann seine Tätigkeit 1968 bei ICAIC, wo er zunächst Plakate für kubanische und ausländische Filme entwarf und später politische Plakate als Teil der revolutionären Kampagnen der sechziger und siebziger Jahre kreierte. Ñikos berühmteste Arbeiten wurden auf den internationalen Biennalen in Brno (Tschechoslowakei), Florenz (Italien) und Warschau (Polen) ausgestellt. Seine Filmposter wurden auf der Filmexpo in Kanada sowie auf dem internationalen Filmfestival in Cannes ausgezeichnet. Er hat zahlreiche Artikel über Grafikdesign veröffentlicht und war Jurymitglied bei Wettbewerben in Kuba und im Ausland. Zudem war er als Professor an der Universidad Veracruzana tätig.

Antonio Pérez «Ñiko» réside actuellement au Mexique, mais est né et a grandi à Cuba. Il appartient au groupe mythique des graphistes qui ont consolidé le mouvement des affiches dans le pays. Pour lui, tout a commencé en 1968 à l'ICAIC, ou il a créé des affiches pour des films cubains et étrangers avant de se mettre à l'affiche politique dans le cadre des campagnes révolutionnaires des années 1960 et 1970. Ses œuvres les plus célèbres ont été exposées lors de biennales internationales à Brno (République tchèque) Florence (Italie) et Varsovie (Pologne). Ses affiches de film ont été récompensées à Filmexpo au Canada, et au Festival international du film de Cannes. Il a publié de nombreux articles sur le graphisme et a été juré pour des concours à Cuba et à l'étranger. Il a également été professeur à l'Université Verocruzana.

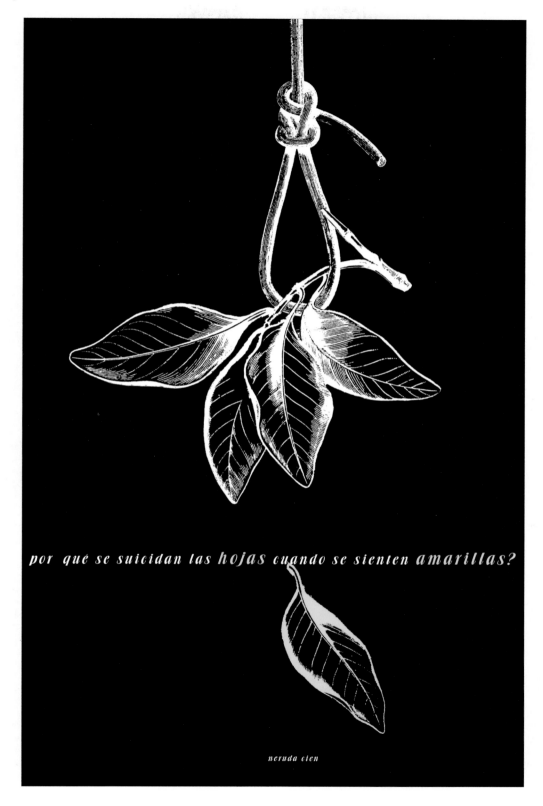

por qué se suicidan las *hojas* cuando se sienten *amarillas?*

neruda cien

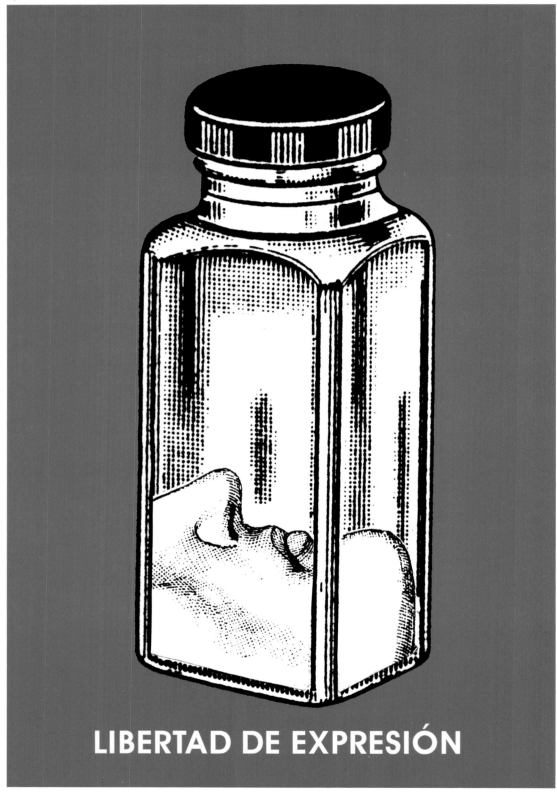

LIBERTAD DE EXPRESIÓN

"Libertad de expresión"
poster, 2003, personal work

**"Una profunda mirada al mundo
de hoy"** poster, 2005,
Centro de Diseño Amarillo de Xalapa

"Ahorro de energía"
poster, 2003, personal work

5

6

una profunda mirada al mundo de hoy

*1961, Dominican Republic, www.lperiche.com

LOURDES PERICHE

1. "Arquitexto"
architecture magazine, 1986
Editors Lourdes Periche,
Carmen Ortega
Photo Francisco Manosalvas

hard rock cafe

Lourdes Periche Agencia Creativa opened its doors in 1990, as a multidisciplinary creative studio, working with architects, designers, copyrighters and photographers. With a focus on editorial, corporate design and advertising, the Santo Domingo-based office is led by architect Lourdes Periche, a former editor of the architecture magazine *Arquitexto*. A Graduate from the Universidad Nacional Pedro Henríquez Ureña, she is a self-taught graphic artist and has edited and designed for the nationally acclaimed publication *La Ciudad del Ozama*, in celebration of the 500 years of Santo Domingo's history. She has also received multiple awards for her work, including three prizes for the national educational campaign by Agencia Española de Cooperación Internacional.

Das Studio Lourdes Periche Agencia Creativa öffnete 1990 seine Türen als interdisziplinäres Kreativstudio, dessen Team aus Architekten, Designern, Werbetextern und Fotografen besteht. Mit den Schwerpunkten Editorial Design, Corporate Design und Werbung wird das Studio mit Sitz in Santo Domingo (Dominikanische Republik) von der Architektin Lourdes Periche geleitet, einer ehemaligen Herausgeberin des Architektenmagazins *Arquitexto*. Periche erhielt ihre Ausbildung an der Universidad Nacional Pedro Henríquez Ureña. Sie ist eine autodidaktische Grafikkünstlerin und brachte zur Feier der 500-jährigen Geschichte von Santo Domingo die landesweit gefeierte Publikation *La Ciudad del Ozama* heraus, für die sie auch das Design entwickelte. Außerdem hat sie mehrere Auszeichnungen für ihre Arbeit erhalten, darunter drei Preise für die nationale Bildungskampagne durch Agencia Española de Cooperación Internacional.

Lourdes Periche Agencia Creativa a ouvert ses portes en 1990. C'est un studio créatif pluridisciplinaire qui compte dans ses rangs des architectes, des graphistes, des rédacteurs publicitaires et des photographes. Le bureau de Saint-Domingue est spécialisé dans le design éditorial et commercial et la publicité, et est dirigé par l'architecte Lourdes Periche, ancienne rédactrice en chef du magazine d'architecture *Arquitexto*. Diplômée de l'Universidad Nacional Pedro Henríquez Ureña, cette graphiste autodidacte a créé et édité l'ouvrage acclamé *La Ciudad del Ozama*, publié à l'occasion des 500 ans d'histoire de Saint-Domingue. Elle a également reçu de nombreuses récompenses pour son travail, notamment trois prix pour la campagne d'information nationale de l'Agencia Española de Cooperación Internacional.

2. "Budget Office" report, 2005,
Domenican Republic Government
Design Lourdes Periche,
Cynthia Matos
Photo Fernando Calzada,
Francisco Manosalvas

3. "Cuatro Visiones de Arquitectura
Contemporánea" book, 2004
Authors Carmen Ortega,
Michelle Valdez
Editor Arquitexto
Photo Francisco Manosalvas

ANTONIO PEZZINO

2

1

Antonio Pezzino is a member of a select group of professionals considered to have pioneered the graphic design field in Uruguay. He was born and raised in Córdoba in Argentina, where he completed his studies at the Academia de Bellas Artes José Figueroa Alcorta, before going to Spain to study at the Real Academia de Belas Artes de San Fernando in Madrid. As an artist Pezzino painted in a number of locations and studios during the 40s and 50s in Argentina and Bolivia, before returning to Uruguay where he enjoyed a collaborative period with artist Torres García in Montevideo. Pezzino later travelled back to Europe to study in France, Italy and Spain. Upon his final return, he settled into a professional career, working for the major publishers and record industries. Pezinno died in Montevideo in 2004, and in 2006 his work was declared as a national treasure.

Antonio Pezzino ist Mitglied einer ausgewählten Gruppe von professionellen Designern, die als Wegbereiter des Grafikdesigns in Uruguay gelten. Er wurde in Córdoba in Argentinien geboren, wo er seine Kindheit und Jugend verbrachte. Seine Ausbildung erhielt er an der Academia de Bellas Artes José Figueroa Alcorta, bevor er dann nach Spanien zog, um dort an der Real Academia de Belas Artes de San Fernando in Madrid zu studieren. Pezzino malte als Künstler während der vierziger und fünfziger Jahre in verschiedenen Orten und Studios in Argentinien und Bolivien. Danach siedelte er nach Uruguay über, um mit dem Künstler Torres García in Montevideo zusammenzuarbeiten. Pezzino studierte später in Frankreich, Italien und Spanien weiter. Mit seiner endgültigen Rückkehr nach Uruguay schlug er die Profilaufbahn ein und arbeitete für die bedeutendsten Verlage und Aufnahmestudios des Landes. Er starb 2004 in Montevideo. 2006 wurde sein Werk zum nationalen Kulturgut erklärt.

Antonio Pezzino fait partie du cercle très restreint des pionniers du graphisme en Uruguay. Il est né à Córdoba, en Argentine, où il a étudié à l'Academia de Bellas Artes José Figueroa Alcorta, avant de partir étudier en Espagne à la Real Academia de Bellas Artes de San Fernando de Madrid. En tant que peintre, il a exercé son art dans de nombreux lieux et studios dans les années 1940 et 1950 en Argentine et en Bolivie, avant de retourner en Uruguay où il a travaillé un temps en collaboration avec l'artiste Torres Garcia à Montevideo. Il a ensuite voyagé en Europe pour étudier en France, en Italie et en Espagne. À son retour, il s'est lancé dans une carrière professionnelle, et a travaillé pour de grandes maisons d'édition et de disques. Antonio Pezzino est décédé à Montevideo en 2004, et en 2006 son œuvre a été déclarée trésor national.

1. "Navidad" Christmas postage stamp, 1975, Correo del Uruguay

2. "El guardian del sepulcro/ Um fenix demasiado frecuente" theatre poster, 1959, Taller de Teatro

3. "Entre buyes no hay cornadas" theatre poster and program, 1963

4. "French Week" film festival program, 1959, Cine Club Uruguay

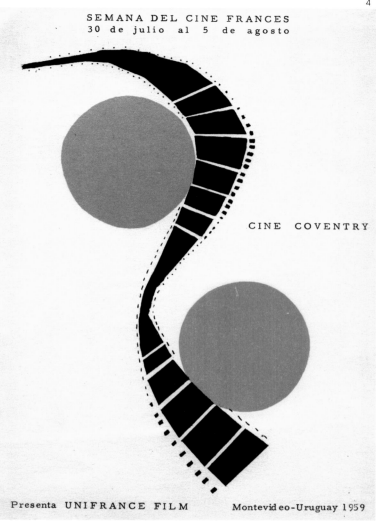

4

3

*1950, Brazil, www.pimentadesign.com

FERNANDO PIMENTA

1. "Mostra do Cinema Suíço"
(Swiss Film Festival) poster,
1983, Museu de Arte Moderna
do Rio de Janeiro (MAM)
Photo Alexandre Souza Lima

2. "Contos Eróticos"
film poster, 1979, Embrafilme
Photo Jorge Laurito

1

março a setembro de 1983

Rio de Janeiro native and Copacabana born Fernando Pimenta studied at the National School of Fine Arts, before starting his career journey in illustration for architecture, paint over textile, screen-printing for packaging, and later customised typography. In the early 70's he consolidated his illustration portfolio, and after working for various advertising agencies, he took on the creative directorship at Embrafilme, the national film agency, where he conceived more than 300 campaigns for Brazilian films. In 1983 he started his own agency, continuing to devote his talents to national film releases. Pimenta has been widely acknowledged for creating a strong visual identity during a time of rapid growth in the national cinema. In 1992 he founded Pimenta Design, which he still runs today, focusing mostly on sign design and corporate identity.

Fernando Pimenta wurde in Rio de Janeiro an der Copacabana geboren und studierte an der National School of Fine Arts. Seine Karriere führte ihn über Illustrationen für Architektur und das Übermalen von Textilien bis hin zum Siebdruck für Verpackungen und später zur kundenspezifischen Typografie. In den frühen siebziger Jahren festigte er sein Illustrations-Portfolio, und nachdem er für verschiedene Werbeagenturen gearbeitet hatte, übernahm er die Rolle des Kreativchefs bei Embrafilme, der nationalen Filmagentur, wo er mehr als 300 Kampagnen für brasilianische Filme konzipierte. 1983 eröffnete er seine eigene Agentur und widmete sein Talent weiterhin dem nationalen Filmgeschäft. Pimenta wurde große Anerkennung zuteil, weil er während des rapiden Wachstums der Filmbranche des Landes die visuelle Identität nachhaltig mitentwickelte. Er gründete 1992 das Studio Pimenta Design, das er auch heute noch führt und sich dabei überwiegend auf Sign Design und Corporate Identity konzentriert.

Originaire de Rio de Janeiro et né à Copacabana, Fernando Pimenta a étudié à la National School of Fine Arts avant de commencer sa carrière dans l'illustration pour l'architecture, la peinture sur tissu, la sérigraphie pour les emballages, et plus tard la typographie personnalisée. Au début des années 1970, il a étoffé son portfolio d'illustrations et, après avoir travaillé pour différentes agences de publicité, il est devenu directeur de la création chez Embrafilme, l'agence nationale du film, où il a conçu plus de 300 campagnes pour des films brésiliens. Il a créé sa propre agence en 1983, et a continué à consacrer son talent aux sorties de films brésiliens. Fernando Pimenta est largement reconnu pour avoir créé une identité visuelle forte à une époque de croissance rapide du cinéma brésilien. Il a fondé Pimenta Design en 1992, qu'il dirige toujours, et travaille principalement sur la création de panneaux de signalisation et sur l'identité d'entreprise.

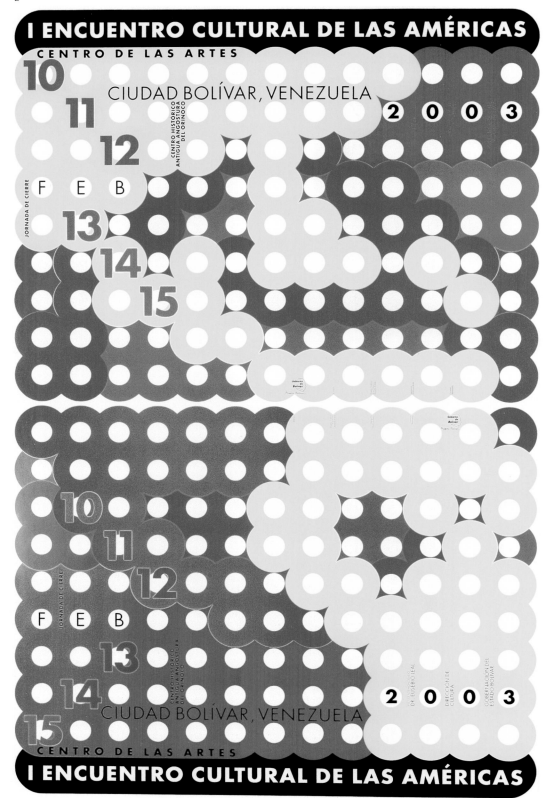

I ENCUENTRO CULTURAL DE LAS AMÉRICAS

CENTRO DE LAS ARTES

10
11
12

CIUDAD BOLÍVAR, VENEZUELA

2003

CENTRO HISTÓRICO ANTIGUA ANGOSTURA DEL ORINOCO

F E B

JORNADA DE CIERRE

13
14
15

I ENCUENTRO CULTURAL DE LAS AMÉRICAS

CENTRO DE LAS ARTES

10
11
12

F E B

JORNADA DE CIERRE

CENTRO HISTÓRICO ANTIGUA ANGOSTURA DEL ORINOCO

13
14
15

CIUDAD BOLÍVAR, VENEZUELA

2003

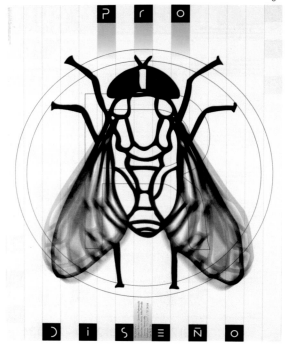

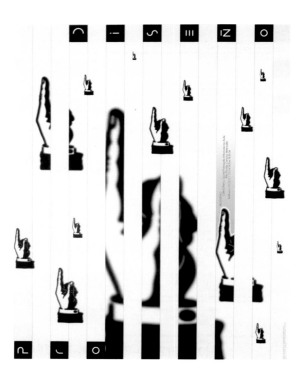

3. "Mosca-Calavera-Mano"
poster series, 1996, ProDiseño,
Escuela de comunicación visual
CCS-VEN
Collaboration Gabriela Fontanillas

4. "Salón Michelena" poster,
2003, 50 Salón de Artes Visuales,
Centro de Las Artes,
Gobierno del Estado Bolívar
Design Ariel Pintos, Annella Armas

*1946, Venezuela

SANTIAGO POL

1. "100 años del Primero de Mayo" poster, 1996, PCV

2. "XI Congreso Nacional de Recursos Humanos" poster, 1992

3. "Feliz Cumpleaños Johanes", poster, 2000

Award-winning Venezuelan designer Santiago Pol was born in Barcelona, and pursued his studies in fine arts both in Caracas and Paris, before embarking on one of the most successful careers in the region, gaining international acclaim for his continual output of poster designs during the course of three decades. Pol's work has been exhibited in Japan, Czech Republic, United States, Russia and Finland, and belongs to the permanent graphic design collection of the Metropolitan Museum of Art in New York, The Israel Museum in Jerusalem, and The Library of Congress in Washington DC among others. He belongs to the International Council of Graphic Design in London, Union des Arts Decoratifs de Paris and the International Alliance of Graphic Artists. Pol currently lectures at the Universidad Nacional Experimental de Yaracuy in Venezuela.

Der preisgekrönte venezolanische Designer Santiago Pol wurde in Barcelona geboren und ging seinen Studien der bildenden Kunst sowohl in Caracas als auch in Paris nach. Daraufhin schlug er eine der erfolgreichsten Karrieren des Landes ein und errang im Verlauf von drei Jahrzehnten internationale Anerkennung für seine konstante Arbeitsleistung im Plakatdesign. Pols Arbeiten wurden in Japan, der Tschechischen Republik, USA, Russland und Finnland ausgestellt und gehören unter anderem zur ständigen Designsammlung des Metropolitan Museum of Art in New York, des Israel Museums in Jerusalem und der Library of Congress in Washington, DC. Er ist Mitglied des International Council of Graphic Design in London sowie der Union des Arts Decoratifs de Paris und der International Alliance of Graphic Artists. Pol lehrt zurzeit an der Universidad Nacional Experimental de Yaracuy in Venezuela.

Le graphiste vénézuélien primé Santiago Pol est né à Barcelone et a étudié les beaux-arts à Caracas et à Paris avant de commencer l'une des carrières les plus réussies d'Amérique latine. Ses affiches ont reçu un accueil critique enthousiaste pendant trente ans. Ses œuvres ont été exposées au Japon, en République tchèque, aux États-Unis, en Russie et en Finlande, et elles font partie de la collection permanente de graphisme du Museum of Metropolitan Art de New York, de l'Israel Museum de Jérusalem et de la Washington DC National Library, entre autres. Il est membre de l'International Council of Graphic Design de Londres, de l'Union des Arts Décoratifs de Paris et de l'International Alliance of Graphic Artists. Santiago Pol enseigne actuellement à l'Universidad Nacional Experimental de Yaracuy au Venezuela.

3

4. "Fundación Marcel Marceau" poster, 1998

5. "Valle D'Aosta – Animals and their environment" poster, 2001

5

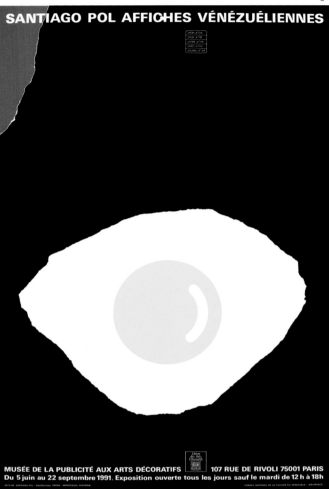

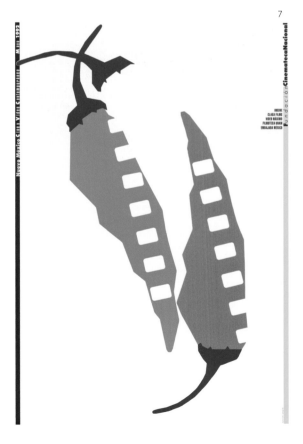

6. "Affiches Vènezuèliennes"
exhibition poster, 1991

7. "Nuevo Mexico Cine y Video"
film festival poster, 1992

*1975, Cuba

NELSON PONCE

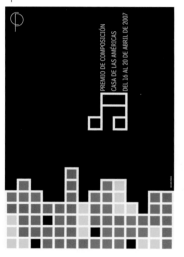

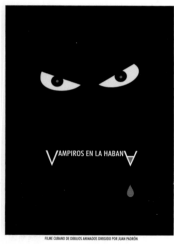

1. "Premio de Composición"
poster, 2007, Casa de las Américas

2. "Vampiros en La Habana"
Cuban animated film poster, 1999,
Instituto Cubano de Arte e Industria
Cinematografica (ICAIC)

A graduate in visual communication from the Instituto Superior de Diseño (ISDI) in Havana in 1998, Nelson Ponce has been part of the new wave in graphic design on the island, uniting the tradition of graphic design excellence in the country with a forward looking perspective. Having acquired experience in the digital field, he has also designed multimedia and web interfaces for Citmatel, the local information technology company. His most recognised work has been created at the Casa de las Américas (House of the Americas), where he has designed the identity and posters for the numerous events produced by the institution. Ponce's work has been acclaimed in Brazil, Mexico, United States, New Zeeland, and other countries.

Nelson Ponce schloss 1998 seinen Studiengang der Visuellen Kommunikation am Instituto Superior de Diseño (ISDI) in Havana ab und gehört seitdem zu der neuen Generation von Künstlern auf der Insel, die das traditionelle Grafikdesign im Land mit einer zukunftsorientierten Perspektive verbinden. Mit seinen Erfahrungen im digitalen Bereich entwickelte er zudem Multimedia- und Web-Interfaces für Citmatel, einem lokalen Unternehmen der Informationstechnologie. Seine bekanntesten Arbeiten schuf er im Casa de las Américas, wo er die Corporate Identity und Plakate für zahlreiche Veranstaltungen entwarf, die von der Institution ausgerichtet wurden. Ponces Werke wurden in Brasilien, Mexiko, in den USA, Neuseeland und weiteren Ländern Anerkennung gefeiert.

Diplômé en communication visuelle de l'Instituto Superior de Diseño (ISDI) de La Havane en 1998, Nelson Ponce a fait partie de la nouvelle vague du graphisme à Cuba, et a réuni la tradition d'excellence dans le graphisme du pays à une perspective tournée vers l'avenir. Il a également de l'expérience dans le domaine du numérique, et a conçu des interfaces multimédias et Internet pour Citmatel, la société des technologies de l'information locale. C'est à la Casa de las Américas (Maison des Amériques) qu'il a réalisé ses œuvres les plus reconnues. Il a conçu l'identité et les affiches des nombreux événements qu'organise cette institution. Son travail a été acclamé au Brésil, au Mexique, aux États-Unis, en Nouvelle-Zélande et dans de nombreux autres pays.

3. "Festival Internacional del Cine Pobre" film festival poster, 2005, Instituto Cubano de Arte e Industria Cinematografica (ICAIC)

4. "Festival Internacional del Cine Pobre" film festival poster, 2006, Instituto Cubano de Arte e Industria Cinematografica (ICAIC)

5. "The H" magazine spread, 2007, The H

POZO MARCIC ENSEMBLE

1. "Viva el Arte" poster series, 2002, Minera Escondida

1

Nevenka Marcic studied design at the Valparaíso Catholic University before joining forces with Patricio Pozo, a graduate of the Parsons School of Design, to form Pozo Marcic Ensemble in 1998, a design consultancy specialised in visual identity, editorial design and cultural enterprises. Since then, the pair have worked on a number of high profile projects, including creating the visual identity for the hotel chain Explora, which received the award, Premio Identidad País, Chile Diseño 2005, and all visual communication pieces for a number of cities in the beautiful region of Patagonia, including the famous Easter Island. Other clients include Telefónica, Córpora, MARQ*, TVN, and 180 magazine. Pozo and Marcic have also taught at the Universidad Diego Portales and the Catholic University.

Nevenka Marcic studierte Design an der katholischen Universität Valparaíso in Chile. 1998 schloss sie sich mit Patricio Pozo zusammen, einem Absolventen der Parsons School of Design, und gründete das Studio Pozo Marcic Ensemble, eine Designberatung mit den Schwerpunkten Visual Identity, Editorial Design und kulturelle Unternehmungen. Seitdem haben die beiden viele Projekte durchgeführt, z.B. die Entwicklung der Visual Identity für die Hotelkette Explora, die 2005 mit dem Premio Identidad País Chile Diseño, ausgezeichnet wurde, sowie Werke im Bereich der visuellen Kommunikation für eine Reihe von Städten in der schönen Region Patagonien, einschließlich der berühmten Osterinsel. Zu den weiteren Kunden zählen Telefónica, Córpora, MARQ*, TVN und 180 Magazine. Pozo und Marcic lehrten außerdem an der Universidad Diego Portales und an der katholischen Universität.

Nevenka Marcic a étudié le graphisme à l'Universidad Católica de Valparaíso avant de faire équipe avec Patricio Pozo, diplômé de la Parsons School of Design de New York, et de créer Pozo Marcic Ensemble en 1998, un cabinet de graphisme spécialisé dans l'identité visuelle, le design éditorial et les entreprises culturelles. Le duo a depuis travaillé sur de nombreux projets d'envergure, notamment la création de l'identité visuelle de la chaîne d'hôtels Explora, qui a reçu la récompense Premio Identidad País Chile Diseño 2005, et toute la communication de nombreuses villes dans la magnifique région de la Patagonie, dont la célèbre île de Pâques. Ils comptent aussi parmi leurs clients Telefónica, Córpora, MARQ*, TVN, et le magazine 180. Patricio Pozo et Evenka Marcic ont également enseigné à l'Université Diego Portales et à l'Université Católica.

2. "**Memoria anual**" book,
2004, Minera Escondida

3. "**The Clinic**" newspaper,
1998–2001, The Clinic

*1962, Paraguay, www.celesteprieto.com

CeLeSte PRieto

1

1. "Semana de Teatro"
poster for theatre week,
2005, Ciclo de teatro Internacional,
Centro Paraguayo de Teatro

Architect turned designer, Celeste Prieto is probably the most internationally recognised designer in Paraguay, where, since 1994 she has operated her own design practice Celeste Prieto Diseño. In 2000, she was one of 22 designers from all around the world to be selected for the book and poster exhibition at Mois du Graphisme d'Echirolles: *Graphic Artists Around the World* in France, which featured a wide range of work exploring social, political, and religious themes. She has been a frequent lecturer, including at the Ecole Intuit-Lab in Paris, where she has specialised in her favourite topic of Ethnic Design. In addition, Prieto has served on juries for a number of conferences and biennials, including at the International Biennial of the Poster in Mexico.

Die Architektin und Designerin Celeste Prieto ist wahrscheinlich die international bekannteste Designerin in Paraguay. Sie leitet bereits seit 1994 ihr eigenes Designstudio Celeste Prieto Diseño. In Jahre 2000 gehörte sie zu den 22 Designern, die weltweit für die Buch- und Plakatausstellung Mois du Graphisme d'Echirolles: *Graphic Artists Around the World* in Frankreich ausgewählt wurden, wo eine große Auswahl von Werken mit sozialen, politischen und religiösen Themen zu sehen waren. Sie war zudem häufig als Dozentin tätig, darunter an der Ecole Intuit-Lab in Paris, wo sie sich auf ihr Lieblingsthema Ethnisches Design spezialisierte. Darüber hinaus war Prieto bei einigen Konferenzen und Biennalen als Jurymitglied, zum Beispiel auf der internationalen Plakatbiennale in Mexiko.

Architecte avant de devenir graphiste, Celeste Prieto est probablement la graphiste paraguayenne la plus internationalement reconnue. Elle dirige sa propre agence de graphisme depuis 1994, Celeste Prieto Diseño. En 2000, elle faisait partie des 22 graphistes sélectionnés dans le monde entier pour l'exposition du Mois du graphisme d'Échirolles : *Graphistes autour du monde*, qui présentait un vaste éventail d'œuvres explorant les thèmes de la société, de la politique et de la religion. Elle a fréquemment enseigné, notamment à l'École Intuit-Lab de Paris, où elle s'est spécialisée dans son domaine préféré, le graphisme ethnique. Celeste Prieto a de plus été jurée pour de nombreuses conférences et biennales, et notamment à la Biennale internationale de l'affiche de Mexico.

2. **"Mujer y Politica"** conference poster, 1999, Secretaría de la Mujer del Paraguay y la Agencia Española de Cooperación Internacional

3. **"Besame"** ballet play poster, 2005, Ballet Clásico y Moderno de la Municipalidad de Asunción

2

*1996, Argentina, www.pumpd.com.ar

PUMP DESIGN

1. "Pop City"
music festival flyer series, 2004

Pump Design is a multidisciplinary studio based in Buenos Aires that sets out to create strategic communication programmes through corporate identity development, websites, illustration and photography. With over a decade of experience in diverse areas, they have been dedicated to generating solutions within a framework of aesthetic excellence; contributing clarity to their graphic pieces through creative ideas and precise execution. Their list of clients has included the Techint Organization, Tenaris, Endesa, Quilmes Brewing, Tecpetrol, Elevage Hotels, PepsiCo and Zivals. The studio and its directors, Lucas and Mauro López, have been extensively published in the region and have won several awards, including the American Design Award for their own website.

Pump Design ist ein interdisziplinäres Designstudio mit Sitz in Buenos Aires, das als Schwerpunkt strategische Kommunikationsprogramme durch Corporate Identity-Entwicklung, Websites, Illustrationen und Fotografie schafft. Mit einer über zehnjährigen Erfahrung in verschiedensten Gebieten entwickelt das Designerteam ästhetisch hochwertige Lösungen. Ihre kreativen Ideen setzen sie in präzisen Ausführungen um. Zu ihren Kunden zählen Techint Organization, Tenaris, Endesa, Quilmes Brewing, Tecpetrol, Elevage Hotels, PepsiCo und Zivals. Die Studioleiter Lucas und Mauro López sind zusammen mit ihrem Team in der Region in großem Umfang veröffentlicht worden und haben mehrere Auszeichnungen erhalten, darunter den American Design Award für ihre eigene Website.

Pump Design est un studio pluridisciplinaire basé à Buenos Aires, qui crée des programmes stratégiques de communication en travaillant sur le développement de l'identité d'entreprise, les sites web, l'illustration et la photographie. Le studio a plus d'une dizaine d'années d'expérience dans différents domaines et cherche avant tout à produire des solutions dans un cadre d'excellence esthétique, avec une clarté qui vient de la créativité des idées et de la précision de leur exécution. Le studio compte parmi ses clients Techint Organization, Tenaris, Endesa, Quilmes Brewing, Tecpetrol, Elevage Hotels, PepsiCo et Zivals. Pump Design et ses directeurs, Lucas et Mauro López, ont fait de nombreuses apparitions dans les publications locales et ont remporté de nombreuses récompenses, notamment le prix American Design pour leur propre site Internet.

*2000, Argentina, www.punga.tv

PUNGA

1

After studying graphic design at Universidad de Buenos Aires, Tomás Diegues kick-started his career by working for various credited design and advertising agencies in Argentina, before joining the Doma design group. In 2000 Tomás Diegues set up his own practice under the name of Punga Visual Consorcio, collaborating with movie directors, artists and designers, with the aim of creating for all mediums, from print to film. This very contemporary approach led them to work heavily for the local music industry, as well for major global clients such as Nike, Sony Pictures Television International, Microsoft Zune, MTV US, MTV Lat, and Discovery Europe. Among others, Punga has received awards at El Diente and the US International Film and Video Festival.

Nachdem er an der Universidad de Buenos Aires sein Studium in Grafikdesign beendet hatte, begann Tomás Diegues seine Karriere bei verschiedenen bekannten Design- und Werbeagenturen in Argentinien, bevor er sich schließlich der Designgruppe Doma anschloss. Im Jahre 2000 eröffnete Tomás Diegues in Zusammenarbeit mit Filmregisseuren, Künstlern und Designern sein eigenes Designstudio namens Punga Visual Consorcio mit dem Ziel, vom Druck bis zum Film für alle Medien zu entwerfen. Dieser sehr zeitgemäße Ansatz führte dazu, dass die Gruppe überwiegend für die regionale Musikbranche arbeitet sowie für bedeutende globale Kunden wie zum Beispiel Nike, Sony Pictures Television International, Microsoft Zune, MTV US, MTV Lat und Discovery Europe. Neben weiteren Auszeichnungen hat Punga Preise bei El Diente und dem US-amerikanischen internationalen Film- und Videofestival erhalten.

Après avoir étudié le graphisme à l'Universidad de Buenos Aires, Tomás Diegues a lancé sa carrière en travaillant pour différentes agences de graphisme et de publicité renommées en Argentine, avant de rejoindre le groupe de graphisme Doma. Il a créé sa propre agence en 2000, Punga Visual Consorcio, et travaille avec des réalisateurs de films, des artistes et des graphistes afin de créer des œuvres pour tous les supports, de l'imprimé au film. Cette démarche très contemporaine a conduit l'équipe à beaucoup travailler pour l'industrie musicale locale, ainsi que pour de grands clients comme Nike, Sony Pictures Television International, Microsoft Zune, MTV US, MTV Lat et Discovery Europe. Punga a reçu des récompenses au festival El Diente et à l'US International Film and Video Festival, entre autres.

1. "The Golden Monguis"
Illustration and objects, 2003
3D Lautaro Ciro Papagno

2. "Letraset" poster, 2002

3. "Suicide Goma" illustration,
2005, D-mode magazine

4. "Anarchy in the sky with diamonds"
magazine cover, 2003, Atypica mag.

*1974, Brazil

ELAINE RAMOS

1. "Brazilian Graphic Design: the 60s" book, 2006, Cosac Naify
Production Letícia Mendes

2. "Brazilian Design Before Design Existed" book, 2005, Cosac Naify
Production Letícia Mendes
Awards VIII Brazilian Graphic Design Biennial; Museu da Casa Brasileira 2005 (best publication); 48th Jabuti Award 2006 (nominee)

Elaine Ramos is a graphic designer based in the metropolis of São Paulo. Her vast experience in the editorial field, coupled with a strong focus on book production led her to head the design department of the leading art publisher in Brazil, Cosac Naify. There in 2004 she set up an editorial department to produce publications on design, with a special focus on the national scene. Under her art direction, the publisher has released a handful of nationally acclaimed books, including *O Design Brasileiro antes do Design* (Brazilian Design Before Design Existed) and *O Design Gráfico Brasileiro: Anos 60* (Brazilian Graphic Design: the 60s). Ramos has been widely awarded in the national editorial arena.

Elaine Ramos ist Grafikdesignerin mit Sitz in der Metropole São Paulo. Ihre umfangreichen Erfahrungen im Verlagsbereich mit Schwerpunkt Buchproduktion brachten ihr die Leitung der Designabteilung bei Cosac Naify ein, dem führenden brasilianischen Kunstverlag. 2004 eröffnete sie ein Verlagsbüro, das sich auf Publikationen über Design spezialisiert, wobei die nationale Szene im Mittelpunkt steht. Unter ihrer künstlerischen Leitung hat der Verleger mehrere landesweit gelobte Bücher herausgebracht, z.B. *O Design Brasileiro antes do Design* (Brasilianisches Design, bevor Design existierte) und *O Design Gráfico Brasileiro: Anos 60* (Brasilianisches Grafikdesign: Die 60er Jahre). Ihre Arbeiten wurden landesweit in der Verlagsbranche ausgezeichnet.

Elaine Ramos est une graphiste basée dans la métropole de São Paulo. Sa vaste expérience dans le domaine de l'édition, axée sur la production de livres, l'a conduite à diriger le service de graphisme de la plus grande maison d'édition d'art du Brésil, Cosac Naify. C'est là qu'elle a créé en 2004 un service consacré à la production de publications sur le graphisme, avec un accent sur la scène brésilienne. La maison d'édition a publié sous sa direction artistique une poignée d'ouvrages qui ont reçu des louanges dans tout le pays, notamment *O Design Brasileiro antes do Design* (Le graphisme brésilien avant l'invention du graphisme) et *O Design Gráfico Brasileiro: Anos 60* (Le graphisme brésilien : les années 1960). Elaine Ramos a reçu de nombreuses récompenses dans le domaine de l'édition au Brésil.

3

4

*1967, Brazil, www.muti.cx

MUTi RANDOLPH

1

ZOO SESSIONS

JONAS ROCHA + CONVIDADOS SEGUNDAS NO MELT RUA RITA LUDOLF 47 LEBLON ENTRADA R$ 5

1-3. "Zoo Sessions" illustration and design, 2000, Zoo Records/Deluxe

Based in Rio de Janeiro, Muti Randolph has been a very early adopter of computer graphics applied to design, and his three-dimensional approach has led him to create for some of the biggest and innovative clients in the country. Blending graphics and architecture has become one of his trademarks and the design of the nightclub D-Edge in São Paulo has become a worldwide reference in the field. The 3D nature of his work has pushed him to contribute regularly for television and the performing arts. A passionate music lover, Randolph has not only designed for underground bands but has also created a software application that synchronises music and graphics for projections in live performance. Moreover he has designed stages for a number of fashion shows and operas in the country, including the acclaimed Melissa Gallery.

Muti Randolph hat seinen Sitz in Rio de Janeiro und brachte schon sehr früh Computergrafiken in sein Design ein. Sein dreidimensionaler Ansatz hat ihn zu Entwürfen für einige der größten und innovativsten Kunden des Landes geführt. Die Mischung aus Grafik und Architektur ist eines seiner Markenzeichen geworden, wobei das Design des Nachtclubs D-Edge in São Paulo für sein Design zur weltweiten Referenz wurde. Wegen der Dreidimensionalität seiner Arbeiten arbeitet er immer wieder auch fürs Fernsehen und die darstellenden Künste. Als passionierter Musikliebhaber war Randolph nicht nur für Underground-Bands tätig, sondern er schuf auch eine Software, die Musik und Grafiken für Projektionen in Live-Konzerten synchronisiert. Darüber hinaus gestaltete er dieBühnenbilder für verschiedene Modenschauen und Opern im Land, z.B. die gefeierte Melissa Gallery.

Basé à Rio de Janeiro, Muti Randolph a adopté très tôt le graphisme assisté par ordinateur, et son approche tridimensionnelle l'a conduit à créer pour quelques-uns des clients les plus importants et les plus innovants du Brésil. L'une de ses caractéristiques est le mélange du graphisme et de l'architecture, et la conception de la discothèque D-Edge de São Paulo est devenue une référence mondiale en la matière. La nature 3D de ses œuvres l'a poussé à travailler régulièrement pour la télévision et les arts du spectacle. Muti Randolph est un passionné de musique, et il a non seulement créé pour des groupes underground, mais il a aussi créé un logiciel qui synchronise musique et graphisme pour des projections en direct. Il a de plus conçu les décors de nombreux défilés de mode et opéras au Brésil, notamment Melissa Gallery.

deluxe jonas + luiz pareto + gustavo tatá
6 de julho 23:59 R$10 barman club rua belford roxo 58b house music deluxe

deluxe jonas rocha + gustavo tatá + marcos morcerf
12 de outubro 23:59 R$10 barman club rua belford roxo 58b cheese-free house music

4

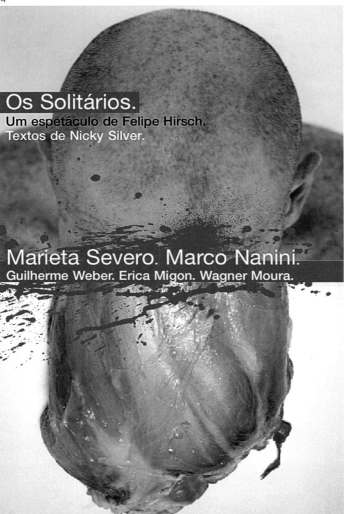

Os Solitários.
Um espetáculo de Felipe Hirsch.
Textos de Nicky Silver.

Marieta Severo. Marco Nanini.
Guilherme Weber. Erica Migon. Wagner Moura.

4. "Os Solitários" visual identity for theatre play, 2004

5. "Quem Tem Medo de Virginia Woolf?" visual identity for theatre play, 2003

6. "Os cães ladran mas a Caravana não pára" CD launch visual identity, 1997, Planet Hemp, Sony Music Brazil

1º ato Pterodátilos 2º ato Homens Gordos de Saia

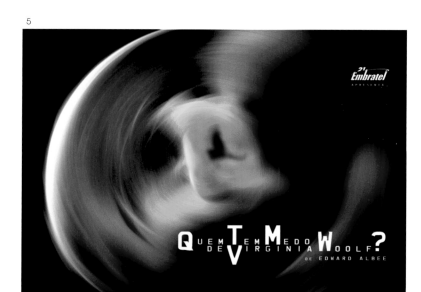

RDYA

1. "Navarro" visual identity
and applications, 2004–2005,
Navarro Market Research

1

Ricardo Drab founded RDYA (Ricardo Drab y Asociados) in 1996, with a personal conviction that design can create a channel through which ideas and new forms of communication can evolve into strong and clear messages. As creative director of RDYA, he has been in charge of several projects for national and multinational companies, ranging from print to screen, having served clients such as Philips, Yahoo, MTV and Fox International Channels. Since 2001, Drab has published two books on design and visual culture, *Lenguage* and *Diseño + Ideas*. His many talks and lectures throughout the country have broadened the debate on the potential for design to integrate into the expression and the visual language of Argentina, which is being explored by the new generation of professionals to which he belongs to.

Ricardo Drab gründete 1996 das Studio RDYA (Ricardo Drab y Asociados) aus der persönlichen Überzeugung heraus, dass Design ein Weg ist, durch den sich Ideen und neue Kommunikationsformen zu starken und klaren Botschaften entwickeln können. Als Kreativchef von RDYA hat er die Verantwortung über mehrere Projekte für nationale und multinationale Unternehmen aus der Druck- und Filmbranche. Zu seinen Kunden zählen Philips, Yahoo, MTV und Fox International Channels. Seit 2001 hat Drab die beiden Bücher *Lenguage* und *Diseño + Ideas* zum Thema Design veröffentlicht. In seinen vielen landesweiten Vorträgen schafft er einen breiten Austausch über die Frage, ob sich Design in den Ausdruck und die visuelle Sprache Argentiniens integrieren kann. Diese Frage wird von der neuen Generation professioneller Designer erörtert, der auch er angehört.

Ricardo Drab a créé RDYA (Ricardo Drab y Asociados) en 1996, avec la conviction personnelle que le graphisme peut créer un canal grâce auquel les idées et les nouvelles formes de communication peuvent se transformer en messages clairs et puissants. En tant que directeur de la création de RDYA, il a été responsable de plusieurs projets sur des supports très divers pour des sociétés argentines et internationales telles que Philips, Yahoo, MTV et Fox International Channels. Depuis 2001, Ricardo Drab a publié deux livres sur le graphisme et la culture visuelle, *Lenguage* et *Diseño + Ideas*. Les nombreuses conférences qu'il a données dans tout le pays ont élargi le débat sur l'intégration du graphisme dans l'expression et le langage visuel de l'Argentine, que la nouvelle génération de graphistes à laquelle il appartient est en train d'explorer.

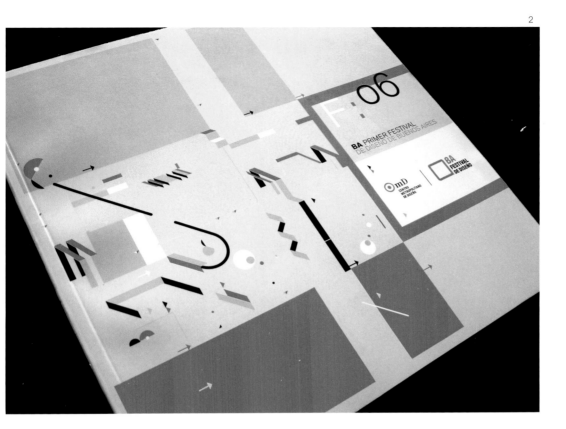

2. **"BA Design Festival"** visual identity and applications, 2006, Centro Metropolitano de Diseño

3. **"NIU Book – Argentine Graphic Design Studios"** editorial design, curation, and art direction, 2007, Centro Metropolitano de Diseño

*1976, Colombia, www.lefthandside.com

MARCELA RESTREPO

1

Marcela Restrepo is a graphic designer based in Medellin, the third largest Colombian city. She trained at the local Universidad Pontificia Bolivariana, and today runs her own design consultancy. After working as a senior designer in Australia, she returned to her homeland to start a series of creative ventures, commencing with her studio, and culminating with the foundation of the web portal *LEFThandSIDE*, which aims to showcase left-handed artists from all around the world. She is also a founding member of Manzanazeta. com and news editor for the creative web-site Uailab.com. All these enterprises have brought Restrepo's work to industry acclaim, and in 2005 she was awarded the national prize *Lápiz de Acero* in the Internet category.

Marcela Restrepo ist Grafikdesignerin in Medellín, der drittgrößten Stadt Kolumbiens. Sie schloss ihre Ausbildung an der örtlichen Universidad Pontificia Bolivariana ab und leitet heute ihre eigene Designberatung. Nachdem sie zunächst als Senior-Designerin in Australien tätig war, kehrte sie in ihr Heimatland zurück und arbeitete an verschiedenen kreativen Projekten. Diese begannen mit der Eröffnung ihres eigenen Studios und gipfelten in der Gründung des Web-Portals *LEFThandSIDE* für linkshändige Künstler aus aller Welt. Sie ist Mitbegründerin von Manzanazeta.com und als Nachrichtenredakteurin für die kreative Website Uailab.com tätig. Diese Unternehmungen brachten Restrepo in der Branche viel Beachtung ein. 2005 wurde ihr die nationale Auszeichnung *Lápiz de Acero* in der Kategorie Internet verliehen.

Marcela Restrepo est une graphiste basée à Medellín, la troisième ville de Colombie. Elle a étudié à l'Universidad Pontificia Bolivariana de la ville, et dirige aujourd'hui son propre cabinet de graphisme. Après avoir occupé un poste de graphiste sénior en Australie, elle est retournée dans sa patrie pour se lancer dans une série d'entreprises de création. Elle a commencé par créer son studio, puis le portail Internet *LEFThandSIDE*, qui présente des artistes gauchers du monde entier. Elle est également l'un des membres fondateurs de Manzanazeta.com et rédactrice pour le site Internet créatif Uailab.com. Toutes ces activités ont valu à Marcela Restrepo les faveurs du secteur du graphisme, et en 2005 elle a reçu le prix national *Lápiz de Acero* dans la catégorie Internet.

1. "Reina del Hogar"
illustration series, Manzanazeta,
Kings & Queens edition

2. "Noche de Copas" promotional
poster illustration, Manzanazeta

3. "Royal Auction"
illustration series, Manzanazeta,
Kings & Queens edition

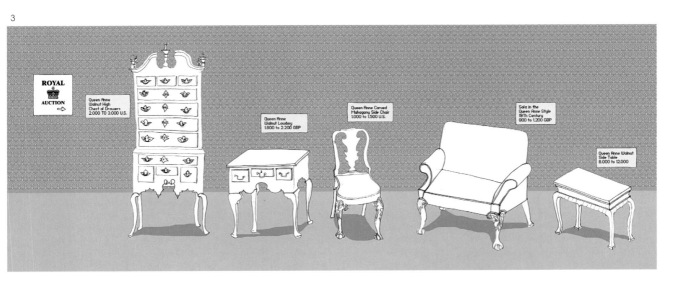

REVOLVER

1

1. "Valla Publicitaria – Coca-Cola"
versión #2" illustration, 2006
Concept/design Ricky Salterio
Awards Interprétanos Coca-Cola
Art Contest (winner)

Peter Novey and Ricky Salterio both studied Fine Arts from the Savannah College of Art & Design in the United States before opening their design agency Revolver in 2002. Since 2001, they have published the graphic design magazine *El Revolver*, which received an award for editorial design in *How* magazine's 2003 International Design Competition. With a string of global accolades to their name, including the publication of 60 of their works in *Logos from North to South America* (Index, 2006), along with an in-depth analysis of their methodology in Rodney J. Moore's book *Design Secrets: Layout – 50 Real-Life Projects Uncovered* (Rockport, 2004), Revolver has gained the reputation of being one of Latin America's most creative contemporary studios.

Sowohl Peter Novey als auch Ricky Salterio studierten bildende Kunst an dem Savannah College of Art & Design in den USA, bevor sie in 2002 ihre Design-Agentur Revolver eröffneten. Seit 2001 geben sie das Grafikdesign-Magazin *El Revolver* heraus, das bei dem 2003 International Design Competition der Zeitschrift *How* einen Preis für Editorial Design erhielt. Die beiden Designer können eine Reihe von weltweiten Auszeichnungen vorweisen. Mit der Veröffentlichung von 60 ihrer Werke in *Logos from North to South America* (Index, 2006) sowie einer gründlichen Analyse ihrer Methodik in Rodney J. Moore's Buch *Design Secrets: Layout – 50 Real-Life Projects Uncovered* (Rockport, 2004), hat Revolver den Ruf als eines der kreativsten zeitgenössischen Studios in Lateinamerika erlangt.

Peter Novey et Ricky Salterio ont tous deux étudié les Beaux-Arts au Savannah College of Art and Design aux États-Unis avant d'ouvrir leur agence de graphisme Revolver en 2002. Ils publient le magazine de graphisme *El Revolver* depuis 2001, pour lequel ils ont reçu un prix de design éditorial lors de l'édition 2003 du concours international de design du magazine *How*. Ils ont reçu de nombreuses marques d'approbation, dont la publication de 60 de leurs œuvres dans *Logos from North to South America* (Index, 2006), ainsi qu'une analyse détaillée de leur méthodologie dans le livre de Rodney J. Moore *Design Secrets: Layout – 50 Real-Life Projects Uncovered* (Rockport, 2004). Revolver est considéré comme l'un des studios les plus créatifs de l'Amérique latine actuelle.

2. "David Carson en Panamá"
poster, 2004
Concept Peter Novey, Ricky Salterio
Design Peter Novey
Illustration Julio Ortega

3. "Brisas Amador"
logo, 2004, Centro Comercial
Turístico Brisas Amador
Concept/design Ricky Salterio

4. "Revista El Revolver #4"
magazine cover, 2002,
Revolver design magazine
Concept/design Peter Novey,
Ricky Salterio

RIOSECO GAGGERO

1. "Toyo Ito Made in Italy" book, 2004, Abacco Archittetura

Constanza Gaggero Silva graduated in 2003 from UDP before specialising in typography at the Catholic University in Santiago. She is the partner of designer Juan Pablo Rioseco Romero, also a graduate of the Catholic University and teacher at UDP. The combined their talents in 2002 for form Rioseco & Gaggero, a design consultancy with strong focus on editorial and sign design, and have since then been recognised for their designs for national and international magazines and events, including the *Big Magazine* issue on Chile, the catalogue and visual identity for the Chilean Architecture Biennial, the design of the exhibition for the III Ibero-American Architecture Biennial in Santiago, and the complete design of Revista Dossier.

Constanza Gaggero Silva schloss ihr Studium an der UDP 2003 ab, bevor sie sich an der Katholischen Universität in Santiago auf Typografie spezialisierte. Sie ist die Partnerin des Designers Juan Pablo Rioseco Romero, ebenfalls Absolvent der gleichen Uni und zudem Lehrer an der UDP. Die beiden Designer begannen 2002 ihre Zusammenarbeit und gründeten Rioseco & Gaggero, eine Designberatung mit den Schwerpunkten Editorial- und Sign Design. Seitdem sind sie für ihre Arbeiten für nationale und internationale Magazine und Veranstaltungen bekannt, darunter die chilenische Ausgabe des *Big Magazine*, Katalog und visuelle Identität der Architekturbiennale in Chile, das Design der Ausstellung für die III. Iberoamerikanische Architekturbiennale in Santiago sowie das gesamte Design des Revista-Dossiers.

Constanza Gaggero Silva s'est diplômée de l'UDP en 2003, avant de se spécialiser dans la typographie à l'Universidad Católica de Santiago. Elle est la partenaire du graphiste Juan Pablo Rioseco Romero, également diplômé de l'Universidad Católica et enseignant à l'UDP. Ils ont combiné leurs talents en 2002 pour créer Rioseco & Gaggero, un cabinet de graphisme spécialisé dans le design éditorial et les panneaux de signalisation. Le duo s'est depuis forgé une réputation grâce aux projets réalisés pour des événements et magazines nationaux et internationaux, notamment le numéro de *Big Magazine* sur le Chili, le catalogue et l'identité visuelle de la Biennale d'architecture chilienne, l'exposition pour la IIIe Biennale d'architecture ibéro-américaine de Santiago, et la totalité de Revista Dossier.

2

2. "El Libro del Bebé" book,
2002, Ediciones B Chile
Design Constanza Gaggero
Authors Constanza Gaggero,
Gabriela Precht

3. "DH Building" signage system,
2005, DH Empresas
Architecture Luis Fernando Mira
Photo Tomás Cobo

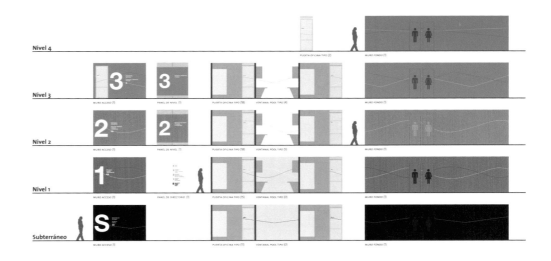

3

*2005, Argentina, www.rockinstrumentsite.com.ar

ROCK INSTRUMENT BUREAU

1

1. **"Landia"** book,
2007, Landia Agency

2. **"Colón"** theatre magazine,
2006, Teatro Colón

3. **"Pink"** fashion logo,
2006, P!nk P!nk

Founded by Roy Garcia, Rock Instrument Bureau is a young creative studio that houses the talents of Sebastián D'Ovidio, Romina Ganovelli and Javier Auguste. With years of collective experience in advertising agencies like BBDO, DDB and LOWE in Argentina and Spain, the group has managed campaigns for a number of high profile clients such as ESSO, Philips, and Cinecolor, winning a series of awards including a Gold Lion at the Cannes International Advertising Festival. Coming mostly from the well-known Universidad de Buenos Aires, in 2005 they decided to launch their own practice in the capital with a focus on creating a dynamic visual language for books, packaging, motion, and editorial for major clients such as Coca-Cola and Quilmes Brewery.

Das von Roy Garcia gegründete Rock Instrument Bureau ist ein junges Kreativstudio, das die Talente von Sebastián D'Ovidio, Romina Ganovelli und Javier Auguste bündelt. Nachdem die Gruppe zunächst jahrelang gemeinsame Erfahrungen in Werbeagenturen wie BBDO, DDB und Lowe in Argentinien und Spanien gesammelt hatte, führte sie Kampagnen für mehrere wichtige Kunden durch, z.B. ESSO, Philips und Cinecolor. Dafür erhielten sie mehrere Auszeichnungen, z.B. einen Goldenen Löwen beim internationalen Werbefilmfestival in Cannes. Die Designer wurden überwiegend an der namhaften Universidad de Buenos Aires ausgebildet. In 2005 gründeten sie dann ihr eigenes Studio in der Hauptstadt und konzentrierten sich auf die Schaffung einer dynamischen visuellen Sprache für Bücher, Verpackungen, Motion-Design und Editorial Design für bedeutende Kunden wie Coca-Cola und Quilmes Brewery.

Créé par Roy Garcia, Rock Instrument Bureau est un jeune studio de création qui abrite les talents de Sebastián D'Ovidio, Romina Ganovelli et Javier Auguste. Avec des années d'expérience cumulée dans des agences de publicité telles que BBDO, DDB et LOWE en Argentine et en Espagne, le groupe a géré des campagnes pour de nombreux clients prestigieux, notamment ESSO, Philips, et Cinecolor, et a remporté toute une série de récompenses, dont un Lion d'or au Festival international de Cannes de la publicité. Les membres du studio viennent pour la plupart de la célèbre Universidad de Buenos Aires. En 2005 ils décidèrent de lancer leur propre agence dans la capitale en se spécialisant dans la création de langages visuels dynamiques pour les livres, les emballages, l'animation et l'édition pour de grands clients tels que Coca-Cola et Quilmes Brewery.

2

3

*1956, Mexico, www.gabrielarodriguez.com.mx

GABRIELA RODRÍGUEZ

1–2. "Tijuana. La Tercera Nación"
social campaign, 2004
Concept/production/art direction
Antonio Navalón
Design Curaduría (Tijuana)
Direction Gabriela Rodríguez
Curation Marco Granados,
Norma Iglesias
Photo Juan Carlos Lagos
TV spots/radio Luis Rodríguez

With over two decades of experience, Gabriela Rodríguez is one of the most respected graphic designers in Mexico, having built up a diverse portfolio of editorial design, corporate identity, package, social and political campaigns, broadcast, posters and environmental design projects. Amongst her many projects, Rodríguez also promotes graphic design events and international exchanges, working in close collaboration with Australian graphic designer Ken Cato. She has received a vast number of creative awards and her recent works include *The Third Nation*, a cultural project selected for *ARCO '05* in Madrid, and also exhibited in Paris, Mexico City, as well as at the King Juan Carlos I of Spain Center at New York University.

Mit über zwei Jahrzehnten Branchenerfahrung ist Gabriela Rodríguez eine der angesehensten Grafikdesignerinnen in Mexiko. Ihr umfangreiches Portfolio umfasst Arbeiten zu Editorial Design, Corporate Identity, Verpackungsdesign, soziale und politische Kampagnen, Rundfunk, Plakate sowie Projekte über Umwelt. Neben ihren vielen Projekten fördert Rodríguez zudem Veranstaltungen über Grafikdesign und den internationalen Austausch, da sie eng mit dem australischen Grafikdesigner Ken Cato zusammenarbeitet. Sie hat eine große Anzahl kreativer Auszeichnungen erhalten. Zu ihren neuesten Arbeiten zählen *The Third Nation*, ein kulturelles Projekt, das für *ARCO '05* in Madrid ausgewählt und zusätzlich in Paris, Mexico City sowie im Zentrum von König Juan Carlos I. von Spanien an der New York University gezeigt wurde.

Avec plus de vingt ans d'expérience, Gabriela Rodríguez fait partie des graphistes les plus respectés du Mexique. Elle s'est bâti un portfolio très diversifié de projets dans les domaines du design éditorial, de l'identité d'entreprise, de l'emballage, des campagnes à caractère social et politique, de la télévision, des affiches et de l'environnement. Entre autres nombreux projets, elle s'occupe de la promotion d'événements et d'échanges internationaux liés au graphisme, et travaille en étroite collaboration avec le graphiste australien Ken Cato. Elle a reçu une multitude de récompenses pour ses créations, et parmi ses œuvres récentes ont peut citer *The Third Nation*, un projet culturel sélectionné pour l'exposition *ARCO '05* à Madrid et également exposé à Paris, à Mexico et au centre King Juan Carlos I of Spain de l'Université de New York.

2

Grito Creativo
Exposición colectiva
en el muro fronterizo
y en el canal Río Tijuana,
del 20 de abril al 15 de julio
México, 2004

GABRIELA RODRÍGUEZ **435**

*1966, Dominican Republic

ELÍAS ROEDÁN

1

Elías Roedán trained as a designer at the Escuela de Diseño Altos de Chavón, and later at the Parsons School for Design in New York. He subsequently returned to the Dominican Republic, where he worked as art director on a number of successful magazines for the publisher Listín Diario. After that Roedán started to diversify his work, producing corporate and editorial design for some of the biggest companies in the country. In 2000, he redesigned the visual identity of the school he graduated from, and was offered to head the department of graphic design, in which he still lectures. Due to his professional and academic role, Roedán has also been a frequent lecturer and exhibitor in Latin America.

Elías Roedán wurde zunächst an der Schule Diseño Altos de Chavón als Designer ausgebildet und studierte später an der Parsons School for Design in New York. Er kehrte anschließend in die Dominikanische Republik zurück, wo er als Art Director für eine Reihe von erfolgreichen Magazinen des Verlegers Listín Diario tätig war. Danach spannte Roedán in seiner Arbeit einen immer größeren Bogen und entwickelte Corporate- und Editorial Design für einige der größten Unternehmen des Landes. Im Jahre 2000 entwarf er eine neue Visual Identity für die Schule, an der er seine Ausbildung erhielt. Zudem wurde ihm die Leitung des Fachbereichs für Grafikdesign angeboten, an dem er heute noch lehrt. Aufgrund seiner professionellen und akademischen Rolle ist Roedán häufig als Dozent und Aussteller in ganz Lateinamerika tätig.

Elías Roedán a étudié le graphisme à l'Escuela de Diseño Altos de Chavón, puis à la Parsons School for Design de New York. Il est ensuite retourné en République dominicaine, où il a été directeur artistique pour de nombreux magazines des éditions Listín Diario. C'est alors qu'il a commencé à diversifier son travail, en créant des projets de design éditorial et d'entreprise pour certaines des plus grandes sociétés du pays. En 2000, il a remodelé l'identité visuelle de l'école qui lui a remis son diplôme, et s'est vu proposer la direction du département de graphisme, où il enseigne toujours. Étant donné son rôle professionnel et universitaire, il a également donné de fréquentes conférences et expositions en Amérique latine.

1. "Arte Urbano Sarmiento"
big format poster, 2006, Sarmiento

2. "Los 10 Mandamientos" postcard,
2005, La Sederías

3. "Cursos de Verano" poster and
program, 2002, Altos de Chavón
(La Escuela de Diseño)

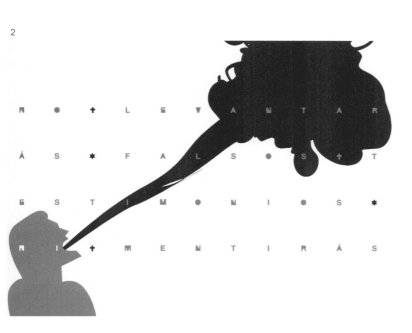

*1932, Mexico

VICENTE ROJO

1

2

1. "Madrid" exhibition catalogue, 1990, Salon de los 16

2. "Neruda Cien" poster, 2004, Mexico

Born in Barcelona and immigrated to Mexico since 1949, Vicente Rojo is a legendary and iconic figure in the graphic design history of the country and indeed throughout the region, with a career that has spanned 40 years in painting, sculpture, and graphic arts. He originally studied sculpture and ceramics in Spain, before relocating to Mexico, where he continued his training in the fine arts, specialising in typography at the Instituto Nacional de Bellas Artes. From the 50s through to the 70s Rojo founded a number of publications, heading numerous artistic departments, along the way. He took on an impressive workload, most notably with Imprenta Madero, where since 1954 he has mentored and collaborated with many of the country's new talents. In 1998 Rojo received a doctorate *Honoris Causa* from the Universidad Nacional Autónoma de México. His works have been exhibited in over 50 countries and he has received countless awards.

Der in Barcelona geborene und 1949 nach Mexiko emigrierte Designer Vicente Rojo ist eine legendäre und ikonenhafte Figur in der Geschichte des Grafikdesigns in Mexiko und darüber hinaus. In seiner bereits seit 40 Jahren andauernden Karriere ist er als Maler, Bildhauer und Grafiker tätig. Er studierte zunächst Bildhauerei und Keramik in Spanien, bevor er sich in Mexiko niederließ und dort seine Ausbildung in der bildenden Kunst fortsetzte, wo er sich am Instituto Nacional de Bellas Artes schließlich auf Typografie spezialisierte. Von den 50er bis zu den 70er Jahren arbeitete er an verschiedenen Veröffentlichungen und leitete nebenbei zahlreiche Fachbereiche für Kunst. Sein Arbeitspensum ist beeindruckend, vor allem für Imprenta Madero, wo er seit 1954 vielen der neuen Talente des Landes ein Mentor ist und mit ihnen arbeitet. 1998 verlieh die Universidad Nacional Autónoma de México Rojo die Ehrendoktorwürde. Seine Arbeiten wurden in über 50 Ländern ausgestellt und haben zahllose Auszeichnungen erhalten.

Vicente Rojo est né à Barcelone et a immigré au Mexique en 1949. C'est un personnage légendaire et emblématique dans l'histoire du graphisme mexicain, et même du continent. Sa carrière a duré 40 ans et a couvert la peinture, la sculpture et les arts graphiques. Il a d'abord étudié la sculpture et la céramique en Espagne, avant de s'établir au Mexique où il a continué d'étudier les beaux-arts. Il s'est spécialisé en photographie à l'Instituto Nacional de Bellas Artes. Des années 1950 aux années 1970, il a créé de nombreuses publications et a dirigé de nombreux services artistiques. Il a abattu une somme de travail considérable, notamment chez Imprenta Madero, où il a été le mentor et le collègue de nombreux jeunes talents mexicains. En 1998, l'Universidad Nacional Autónoma de México lui a décerné un doctorat *honoris causa*. Ses œuvres ont été exposées dans plus de 50 pays, et il a reçu une multitude de récompenses.

3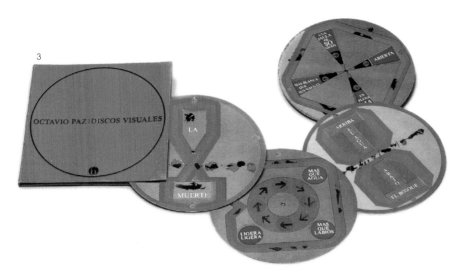

3. "Octavio Paz, Discos Visuales"
CD packaging, 1968

4. "Vista del valle de México"
big format print (150 x 110 cm),
2005, Exhibition in honour to
José María Velasco

4

*1964, Argentina, www.alejandroros.com.ar

ALEJANDRO ROS

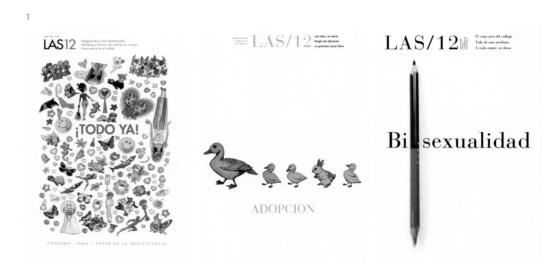

1

Alejandro Ros was born in the Argentinean province of Tucumán, in the northwest of the country. He graduated in graphic design from the Universidad de Buenos Aires, and has since dedicated his career to designing mostly for the music industry and publishing houses. Considered one of the best contemporary designers of his generation, he has received national acclaim for his series of magazine covers for *Radar* and *LAS/12,* and has been highly sought after to produce CD cover designs by major bands in the region. Ros' strong insight into advertising drives his approach to communicate strong messages in his designs. He has always incorporated a refined and minimalist approach, generating an immediate response to the pieces he creates.

Alejandro Ros wurde in der argentinischen Provinz Tucumán im Nordwesten des Landes geboren. Er erhielt seine Ausbildung in Grafikdesign an der Universidad de Buenos Aires und arbeitet seitdem überwiegend für die Musikindustrie und die Verlagsbranche. Ros wird als einer der besten zeitgenössischen Designer seiner Generation betrachtet und hat für seine Serie Magazintitelbildern für *Radar* und *LAS/12* nationale Anerkennung gefunden. Darüber hinaus ist er bei bedeutenden Musikbands in der Region für sein CD-Cover-Design gefragt. Die nachdrückliche Vermittlung von Botschaften in seinen Entwürfen ist auf seine umfangreichen Erfahrungen im Werbebereich zurückzuführen. Mit seinem raffinierten und minimalistischen Ansatz erzeugt er in seinen Werken stets direkte Reaktionen.

Alejandro Ros est né dans la province argentine du Tucumán, dans le nord-ouest du pays. Il a étudié le graphisme à l'Universidad de Buenos Aires, et a depuis consacré sa carrière aux secteurs de la musique et des maisons d'édition. Il est considéré comme l'un des meilleurs graphistes contemporains de sa génération. Sa série de couvertures de magazines pour *Radar* et *LAS/12* a reçu un accueil très chaleureux dans tout le pays, et de grands groupes latino-américains se sont disputé ses services pour les couvertures de leurs CD. Grâce à sa sensibilité proche de la publicité, les œuvres d'Alejandro Ros communiquent des messages forts. Il a toujours adopté une approche raffinée et minimaliste, et ses œuvres génèrent une réponse immédiate.

2

1. "Todo Ya!" (2004), "Adopción"
(2001), "Bisexualidad" (1999)
newspaper supplement,
LAS 12 (Página/12)
Illustration Alina Cazes (Adopción)
Photo Alejandro Ros (Bisexualidad)

2. "Moby Dick"
newspaper supplement cover,
2005, Página/12
Illustration Nicolas Prior

3. "MAF1A",
newspaper supplement cover,
2001, Radar (Página/12)

4. "Rolling Stones en China"
newspaper supplement cover,
2002, Radar (Página/12)

3

todo sobre la biografía de Bernie Ecclestone, el padrino de la Fórmula 1

4

ROLLING STONES EN CHINA

4

5

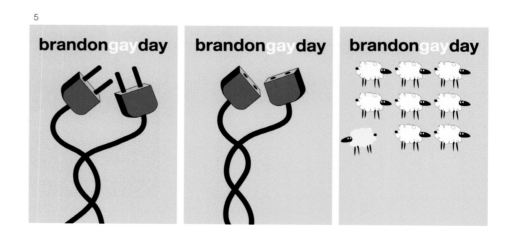

5. **"CDs Fragil"** CD packaging,
2000, Fragil discos

6. **"Brandon Gay Day"** disco flyer, 2003,
Brandon

7. **"Amor Amarillo"** CD packaging,
1993, Gustavo Cerati
Design Alejandro Ros,
Gabriela Malerba

8. **"Segundo"** CD packaging,
2000, Juana Molina
Photo Alejandro Ros

7

8

ALFREDO ROSTGAARD

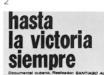

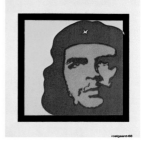

1. **"NO"** poster, 1973,
III Bienal de Artes Gráficas, Colombia

2. **"Hasta la Victoria Siempre"** poster,
1968, Instituto Cubano de Arte e
Industria Cinematografica (ICAIC)

With a striking simplicity of his posters, legendary designer Alfredo González Rostgaard, born in Guantanamo, belongs to movement of post-revolution artists that redefined the Cuban visual language for the generations to come. Trained in the school for applied arts in Santiago de Cuba in the late 50s, Rostgaard worked firstly with abstract painting, causing him to be expelled from the communist youth, later working as a cartoonist, and finally as an poster artist. His numerous posters for the ICAIC (the Cuban Film Institute) and for OSPAAAL (Organization in Solidarity with Africa, Asia and Latin America) have marked an era of political and social change in the region, as well the visual use of revolutionary icons such as Che Guevara and weapons.

Aufgrund seiner einfachen, aber eindrucksvollen Plakate gehört der Designer Alfredo González Rostgaard (geboren im kubanischen Guantanamo) zur Bewegung der postrevolutionären Künstler, die Kubas zeitgenössische visuelle Sprache prägen. Er erhielt in den späten 50er Jahren seine Ausbildung an der Schule für angewandte Kunst in Santiago de Cuba und begann seine berufliche Laufbahn im Bereich abstrakte Malerei — und mit Aktivitäten, die zu seinem Ausschluss aus dem kommunistischen Jugendbund führte. Er arbeitete später als Karikaturist und fand schließlich seine persönliche Nische als Plakatkünstler. Seine zahlreichen Werke zu militärischen Themen und revolutionären Symbolen wie z.B. Che Guevara in Verbindung mit seinen Entwürfen für ICAIC (das kubanische Filminstitut) und OSPAAAL (Organisation in Solidarity with Africa, Asia and Latin America) kennzeichnen eine Ära der politischen und sozialen Veränderungen im Land.

Alfredo González Rostgaard est né a Guantanamo. Il appartient au mouvement d'artistes postrévolutionnaires qui ont défini le langage visuel contemporain de Cuba. Il doit sa légende à ses affiches simples mais saisissantes. Il a étudié à l'École d'arts appliqués de Santiago de Cuba à la fin des années 1950, et a commencé sa carrière dans la peinture abstraite, une activité qui a motivé son renvoi de la ligue des jeunesses communistes. Plus tard, il a migré afin de travailler comme dessinateur de bande dessinée, avant de trouver sa niche personnelle de créateur d'affiches. Ses nombreuses affiches représentant des thèmes militaires et des icônes de la révolution, comme Che Guevara, ainsi que ses créations pour l'ICAIC (l'Institut cinématographique cubain) et pour l'OSPAAAL (Organisation en solidarité avec l'Afrique, l'Asie et l'Amérique latine) ont marqué une ère de changement politique et social dans la région.

3. "La Familia Tot" film poster,
1971, OSPAAAL

4. "Hanoi, Martes 13" film poster,
1967, Instituto Cubano de Arte e
Industria Cinematografica (ICAIC)

5. "Cristo Guerrillero" poster,
1969, OSPAAAL

3

4

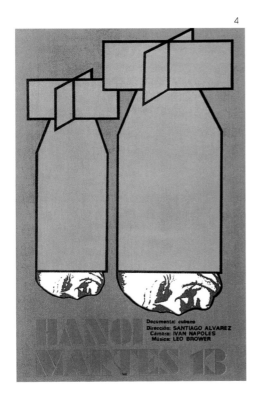

5

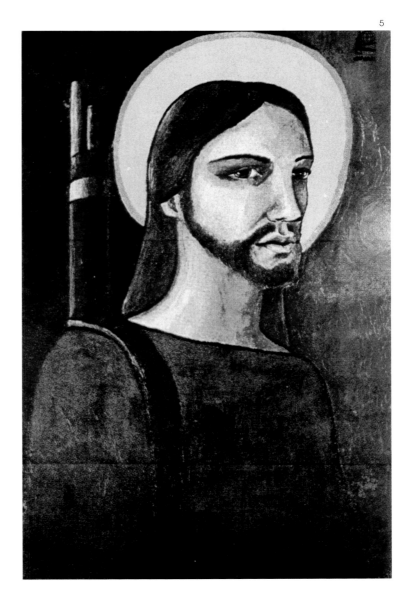

*1969, Mexico

PABLO ROVALO

1. "**Babel**" film poster,
2005, Alejandro González Iñárritú
Design Pablo Rovalo (Zgraphics)

2. "Junge Kunst aus Lateinamerika"
exhibition poster proposal, 1995,
Haus der Kulturen der Welt, Berlin
Design Pablo Rovalo
(Neville Brody Studio)

Pablo Rovalo received immediate attention through his poster design for the award winning film, *Amores Perros* from Mexican director Alejandro González Iñárritu. Originally trained in textile and jewellery design, and art history at the Universidad Iberoamericana, he soon gained a reputation for his elegant use of typography and illustration, having art directed the book *ABCDF – Diccionario Gráfico de la Ciudad de México*, which received the design distinction award by *i-D* magazine. Currently directing studio Zgraphics, Rovalo has focused on developing visual identity and graphic work for the film industry, and his works have been extensively published in Europe and the United States. He is also a close collaborator of Neville Brody in London.

Auf Pablo Rovalo wurde man sofort aufmerksam wegen seines Plakats für den preisgekrönten Film des mexikanischen Regisseurs Alejandro González Iñárritu. Er wurde ursprünglich in Textil- und Schmuckdesign ausgebildet und studierte Kunstgeschichte an der Universidad Iberoamericana, doch er gewann schon bald einen guten Ruf für seinen eleganten Einsatz von Typografie und Illustration, z.B. für das Buch *ABCDF – Diccionario Gráfico de la Ciudad de México*, das vom Magazin *i-D* mit dem Designpreis ausgezeichnet wurde. Zurzeit ist Rovalo beim Studio Zgraphics als Art Director tätig und konzentriert sich auf die Entwicklung von Visual Identity und Grafikarbeiten für die Filmindustrie. Seine Arbeiten sind in großem Umfang in Europa und in den USA veröffentlicht worden, und er ist zudem ein enger Mitarbeiter von Neville Brody in London.

Pablo Rovalo a immédiatement attiré l'attention grâce à son affiche pour *Amores Perros*, le film primé du réalisateur mexicain Alejandro González Iñárritu. Il a tout d'abord étudié la création de tissu et de bijoux et l'histoire de l'art à l'Universidad Iberoamericana, puis s'est forgé une réputation grâce à l'élégance avec laquelle il a utilisé la typographie et l'illustration dans la direction artistique du livre *ABCDF – Dictionnaire graphique de la ville de Mexico*, auquel le magazine *i-D* a décerné un prix de graphisme. Pablo Rovalo dirige actuellement le studio Zgraphics, et s'est spécialisé dans les projets de développement d'identité visuelle et de graphisme pour l'industrie cinématographique. Ses œuvres ont figuré dans de nombreuses publications en Europe et aux États-Unis. Il est également un proche collaborateur de Neville Brody à Londres.

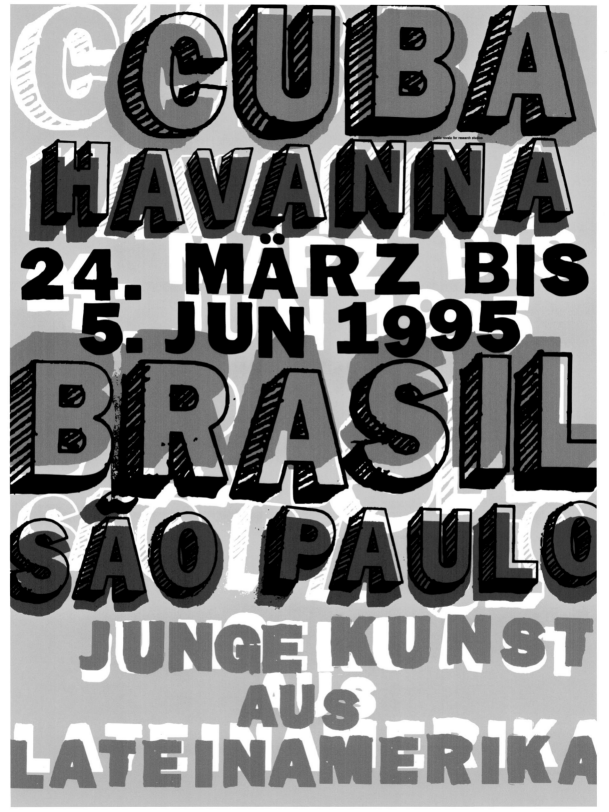

3

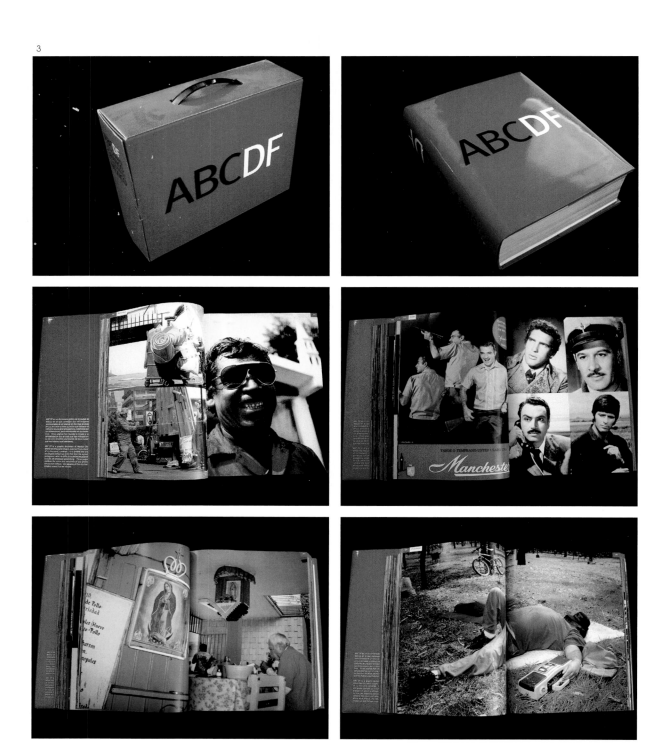

448

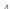

4

5

***1978, Costa Rica, www.originarte.net**

ÓLGER SÁNCHEZ

1

Ólger Sánchez graduated in fine arts in the capital city of San José, where he still lives and works. He started his creative career by designing the online version of the art history department of the national university. From there he moved towards a more personal and graphic design-oriented career that culminated in the solo exhibition at the Spanish Cultural Centre, curated by Luis Fernando Quirós Valverde. He has also been selected as a finalist for a nationwide competition for emerging artists in 2003. Sánchez's design portfolio includes the creation of corporate identity for the Spanish Cultural Centre in Cuadriláteros, the Museo Arte Costarricense, the Museo de Arte y Diseño Contemporáneos (MADC) and ¿Qué, Centroamérica? at the Instituto de México.

Ólger Sánchez schloss sein Studium der bildenden Kunst in San José ab, der Hauptstadt von Costa Rica, wo er immer noch lebt und arbeitet. Er begann seine kreative Karriere mit dem Design der Online-Version für den Fachbereich Kunstgeschichte an der nationalen Universität. Danach wandte er sich mehr dem Grafikdesign zu, was zu der Einzelausstellung im spanischen Kulturzentrum führte, kuratiert von Luis Fernando Quirós Valverde. 2003 wurde Sánchez außerdem zum Finalisten bei einem landesweiten Wettbewerb für junge Künstler ausgewählt. Sein Design-Portfolio enthält die Entwürfe der Corporate Identity für das spanische Kulturzentrum in Cuadriláteros, das Museo Arte Costarricense, das Museo de Arte y Diseño Contemporáneos (MADC) und für ¿Qué, Centroamérica? am Instituto de México.

Ólger Sánchez a étudié les beaux-arts dans la capitale du pays, San José, où il vit et travaille toujours. Il a commencé sa carrière en créant la version en ligne du département d'histoire de l'art de l'université nationale. Il s'est ensuite tourné vers des activités plus personnelles et plus orientées sur le graphisme, et son travail a été couronné par une exposition en solo au Centre culturel espagnol, dont Luis Fernando Quirós Valverde était le commissaire. Il a également été sélectionné pour la finale d'un concours national pour les nouveaux artistes en 2003. Le portfolio de graphisme d'Ólger Sánchez comprend la création de l'identité d'entreprise du Centre culturel espagnol de Cuadriláteros, le Museo de Arte Costarricense, le Museo de Arte y Diseño Contemporáneos (MADC) et ¿Qué, Centroamérica? à l'Instituto de México.

1–2. "Guía Viva" newspaper
supplement cover, 2006,
Periódico La Nación, Costa Rica

3. "Guía Áncora" cultural supplement
cover, 2006, Periódico La Nación,
Costa Rica

DANIEL SCHAFER

1

RODOLFO ABULARACH
JULIO 1974 · ARTES PLASTICAS · GUATEMALA

2

OMAR RAYO EN MACONDO

DEL 11 AL 23 DE JULIO 1974 7A AVE A 3-20. Z9

Daniel Schafer is a true pioneer of the visual arts in Guatemala. Born to American parents, he studied fine arts at the Carnegie Mellon School in Pennsylvania. In 1960 he founded the first contemporary art gallery in the country together with Luis Díaz. At the same time Schafer set up a screen print studio where the exhibition posters were then produced, including for visual artists Juannio, ETC and Macondo. His deep involvement with theatre led him to direct a number of spectacles, whilst at the same time acting as stage designer. In 1975 Schafer moved to the United States to teach at the Boston Architectural Center, eventually returning to Guatemala 17 years later to inspire the younger generation in his studio/gallery DS2. Schafer died in 2004 leaving behind a legacy of remarkable work reflecting a deep love for his nation's culture.

Daniel Schafer ist ein wahrer Pionier der visuellen Kunst in Guatemala. Als Sohn amerikanischer Eltern studierte er bildende Kunst an der Carnegie Mellon School in Pennsylvania. 1960 gründete er zusammen Luis Díaz die erste zeitgenössische Kunstgalerie des Landes. Zur gleichen Zeit eröffnete Schafer ein Druck-Studio, in dem Plakate zu den Ausstellungen produziert wurden, darunter für visuelle Künstler wie Juannio, ETC und Macondo. Seine große Leidenschaft für das Theater führte ihn dazu, bei einigen Stücken Regie zu führen und gleichzeitig als Bühnenbildner tätig zu sein. 1975 zog Schafer in die USA, um am Boston Architectural Center zu unterrichten. 17 Jahre später kehrte er schließlich nach Guatemala zurück, um die jüngere Generation in seinem mit einer Galerie kombinierten Studio DS2 zu inspirieren. Schafer starb 2004 und hinterließ ein Vermächtnis aus außergewöhnlichen Werken, die eine tiefe Liebe zu der Kultur seiner Nation widerspiegeln.

Daniel Schafer est un véritable pionnier des arts visuels au Guatemala. Il est né dans une famille américaine, et a étudié les beaux-arts à la Carnegie Mellon School de Pennsylvanie. En 1960, il a créé avec Luis Díaz la première galerie d'art contemporain du pays. Il a aussi créé en même temps un atelier de sérigraphie où il produisait les affiches des expositions, notamment pour les artistes Juannio, ETC et Macondo. Son engagement profond dans le domaine du théâtre l'a conduit à diriger plusieurs spectacles, tout en remplissant la fonction de décorateur. En 1975, il est parti aux États-Unis pour enseigner au Boston Architectural Center. Il est retourné au Guatemala 17 ans plus tard pour inspirer les jeunes générations depuis son studio/galerie DS2. Daniel Schafer est décédé en 2004. Il laisse en héritage une œuvre remarquable qui exprime l'amour profond qu'il éprouvait pour la culture de son pays.

1. "Rodolfo Abularach"
exhibition poster, 1974,
Escuela de Artes Plásticas

2. "Omar Rayo en Macondo"
exhibition poster, 1974

3. "Batiks de Rosemeri Alberti en
Mocondo" exhibition poster, 1974

4. "Tienda Típica" duty free shop
poster, Tienda Libre

3

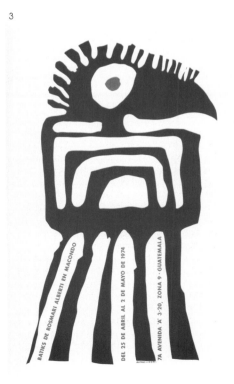

4

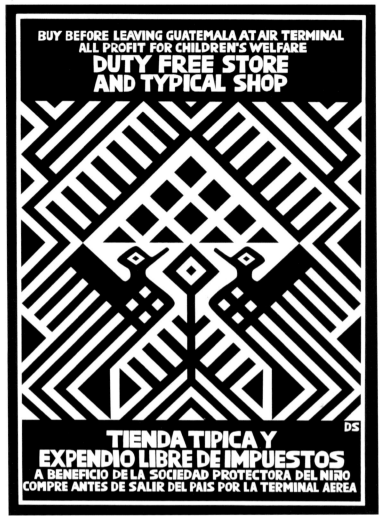

*1960, Uruguay

FIDEL SCLAVO

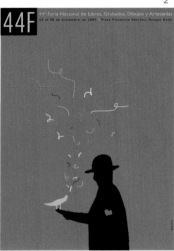

1. "25 Años de Ciencias
de la Comunicación"
celebration poster, 2005,
Universidad Católica de Montevideo

2. "Feria Nacional de Libros,
Grabados, Dibujos y Artesanías"
poster for book fair, 2003,
National Book Fair, Uruguay

3. "La France et la formation de
la culture latino-américaine"
conference poster, 2004, Germany

With his straightforward and minimalist style, artist and graphic designer Fidel Sclavo is probably the most acclaimed contemporary poster designer in Uruguay, having won most of the national design and creative prizes. After studying under Milton Glaser at the School of Visual Arts in New York, he then went on to graduate in architecture and communication at the Universidad Católica de Montevideo, Before setting up his own design practice, Sclavo served as art director for the most prestigious and circulated magazines and newspapers in Uruguay. Between 2000 and 2005, he spent most of the time in Barcelona, concentrating mainly on his fine art, which he has exhibited in New York, Munich, Paris, Berlin, Vienna, Buenos Aires, Madrid and Barcelona. Sclavo currently lives and works in Buenos Aires and Montevideo.

Mit seinem geradlinigen und minimalistischen Stil ist der Künstler und Grafikdesigner Fidel Sclavo wahrscheinlich der bekannteste zeitgenössische Plakatkünstler in Uruguay, der bereits die meisten nationalen und kreativen Auszeichnungen erhalten hat. Nach seinem Studium unter Milton Glaser an der School of Visual Arts in New York machte er seinen Abschluss in Architektur und Kommunikation an der Universidad Católica de Montevideo. Bevor Sclavo sein eigenes Designstudio eröffnete, war er als Art Director für die angesehensten und auflagenstärksten Zeitschriften und Zeitungen in Uruguay tätig. Von 2000 bis 2005 verbrachte er die meiste Zeit in Barcelona und konzentrierte sich hauptsächlich auf seine Kunst, die er in New York, München, Paris, Berlin, Wien, Buenos Aires, Madrid und Barcelona ausstellte. Sclavo lebt und arbeitet zurzeit in Buenos Aires und Montevideo.

Avec son style direct et minimaliste, l'artiste et graphiste Fidel Sclavo est probablement l'un des créateurs d'affiche contemporains les plus appréciés en Uruguay. Il a remporté la plupart des prix de graphisme et de création du pays. Après avoir étudié sous la direction de Milton Glaser à la School of Visual Arts de New York, il a obtenu un diplôme en architecture et en communication de l'Universidad Católica de Montevideo. Avant de créer sa propre agence de graphisme, il a été directeur artistique pour les magazines et les journaux les plus prestigieux et à plus grand tirage d'Uruguay. Entre 2000 et 2005, il a passé la plus grande partie de son temps à Barcelone et s'est intéressé principalement à l'aspect purement artistique de son travail. Ses œuvres ont été exposées à New York, Munich, Paris, Berlin, Vienne, Buenos Aires, Madrid et Barcelone. Fidel Sclavo vit et travaille actuellement à Buenos Aires et à Montevideo.

La France et la formation de la culture
latino-américaine

Internationales Kolloquium Frankreich-Zentrum 26-28 Mai 2004
Beginn: 26 Mai, 16 Uhr s.t. Haus zur Lieben Hand

Teilnehmer: Albert Bensoussan - Raymond Bellour - Walter Bruno Berg

NÚCLEO MÚSICA NUEVA DE MONTEVIDEO, EN SU 40° ANIVERSARIO
EN COLABORACIÓN CON LA ESCUELA UNIVERSITARIA DE MÚSICA
Y LOS INSTITUTOS GOETHE DE MUNICH Y DE MONTEVIDEO

ENSEMBLE AVENTURE
DE ALEMANIA CON LA PARTICIPACIÓN
DE INTÉRPRETES URUGUAYOS

OBRAS DE: CORIÚN AHARONIÁN, FERNANDO CONDON, RUTH CRAWFORD,
GERALD ECKERT, MARIANO ETKIN, NICOLAUS A. HUBER, GYÖRGY
KURTAG, MARIO LAVISTA, GRACIELA PARASKEVAÍDIS,
MATHIAS SPAHLINGER, EDGAR VARÈSE, MARÍA CECILIA
VILLANUEVA Y ALISTAIR ZALDUA.

MARTES 29 Y
MIÉRCOLES 30
DE AGOSTO
20:00 HORAS
SALA ZITARROSA
LA ENTRADA ES LIBRE.

CON EL AMABLE APOYO DE
LA CIUDAD DE FREIBURG
Y EL PATROCINIO DEL
MINISTERIO DE RELACIONES
EXTERIORES DE ALEMANIA.

5

6

7

SIN titulo / taxi

1

Sin Titulo is a design partnership founded in Guatemala by Juan Manuel Alvarado and Alejandro de León Fernández. In an heroic effort to offer a better image of their country, the studio has received notice through its groundbreaking series of high quality publications entitled *Taxi*, a magazine focusing on the region's graphic culture,. Educated in the United States and Guatemala respectively, they have had very diverse professional experiences before joining together in 2004. Aside from producing *Taxi*, the pair can be found hard at work on a number of design and advertising projects in the country. Their work has been exhibited at the CMYK International Magazine Festival in Barcelona, and at the Colophon International Magazine Symposium in Luxemburg.

Bei Sin Titulo handelt es sich um ein Design-Gemeinschaftsstudio, das von Juan Manuel Alvarado und Alejandro de León Fernández in Guatemala gegründet wurde. In dem heroischen Bestreben, das Image ihres Landes zu verbessern, haben die beiden Designer durch eine bahnbrechende Serie von hochwertigen Publikationen mit dem Titel *Taxi* Beachtung gefunden, ein Magazin über die Grafikkultur der Region. Ausgebildet in den USA bzw. Guatemala, sammelten sie zunächst sehr unterschiedliche Berufserfahrungen, bevor sie 2004 ihre Zusammenarbeit begannen. Neben dem Magazin *Taxi* arbeiten die beiden intensiv an einer Reihe von Design- und Werbeprojekten im Land. Ihre Werke wurden auf dem CMYK International Magazine Festival in Barcelona und bei dem Colophon International Magazine Symposium in Luxemburg ausgestellt.

Sin Titulo est un partenariat créé au Guatemala par les graphistes Juan Manuel Alvarado et Alejandro de León Fernández. Dans un effort héroïque pour améliorer l'image de leur pays, ils ont attiré l'attention grâce à leur magazine révolutionnaire et de grande qualité, *Taxi*, consacré à la culture graphique du Guatemala. Ils ont étudié respectivement aux États-Unis et au Guatemala, et ont eu des parcours professionnels très différents avant de se rejoindre en 2004. Parallèlement à *Taxi*, le duo travaille assidument sur plusieurs projets publicitaires et de graphisme. Leurs œuvres ont été exposées au festival international du magazine CMYK à Barcelone, et au symposium international du magazine Colophon au Luxembourg.

1. "Taxi" editorial design
Design Amanda Bustamante
Photo Juan Brenner
Production Revista Taxi

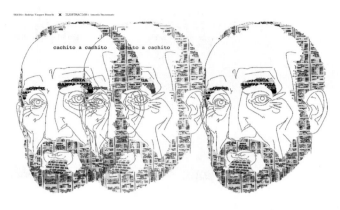

TEXTO: Rodrigo Vasquez Disseño ✕ ILUSTRACIÓN: Amanda Bustamante

cachito a cachito · ato a cachito

1. La lotería es un juego de azar

Como todos los juegos, la lotería posee ese rasgo que Huizinga llama "superabundancia". Es algo superfluo y sólo la irrupción del espíritu, que cancela la determinabilidad absoluta, hace posible su existencia. El juego tiene un sentido y es libre en el sentido que nadie puede obligarnos a jugar. Es una representación, una imitación de algunos aspectos de la vida. Tiene sus propias reglas, las cuales no pueden violarse sin, con ello, destruirlo o cambiar el sentido de dicha representación. Todo juego tiene una tensión: incertidumbre, azar. El azar se opone al determinismo y es un rasgo esencial de la vida.

equiparable a la suerte y la fortuna, y, por lo tanto, a las nociones de fado y destino. Un rasgo esencial del azar es que obedece a una causalidad desconocida, accidental, y parece carecer de propósito. El azar, para algunos, tiene lugar sólo en las cosas terrestres y los acontecimientos humanos. Todo lo demás se supone regido por una causalidad y obedece a un propósito bien definido. Quién sabe.

"Lotería" viene del latín "lote", que significa "parte que le toca a uno en un reparto". Las primeras loterías conocidas se remontan a las antiguas Grecia, Roma y China. En tiempos bíblicos, los animales que se sacri-

RESTAURANTES DEL MUNDO · TEXTO: Redacción Taxi · IMÁGENES: Cortesía de La Bipolar · SOUNDTRACK: Si tuviera no existe / María Daniela

UNA FONDA LUNÁTICA

La vitamina 'T' (tacos, tortas y tequila) es un nutriente fundamental para participar de la euforia que se percibe al ingresar a La Bipolar.

Al incluir esta vitamina en la preparación de platillos populares, que luego se mezclan con una gama de bebidas y un ambiente que imposibilita conciliar el sueño, aparece frente a nuestros ojos La Bipolar.

El clima festivo impera en la localidad, que por cierto está situada en uno de los barrios más in de Coyoacán, en el distrito de Frida. La Bipolar es co-propiedad del actor Diego Luna, Iván Sánchez, Jesús Ochoa y la marca NaCo. Ellos unieron sus ideas para crear un lugar que, aparte de ser una cantina tradicional, ofrece Internet inalámbrico y juegos de mesa para garantizar diversión apta para toda la familia.

En el menú se encuentran los mejores antojitos mexicanos, como las tostaditas del marlín, burritos con queso de soja, quesadillas de jícama y una variedad de comida vegetariana que ofrece algo más que simples ensaladas. Su propuesta abarca platillos muy elaborados como el Fideo seco a los tres chiles o el Tofú endiablado. Todo esto por un precio a partir de $40.

Las delicias son preparadas por los chefs Lula Martín del Campo, conocido por elaborar sus menús para el hotel Habita y Mauricio Montes de Oca del proyecto www.sukambi.com.mx.

Las bebidas más populares incluyen desde cervezas ($27), hasta la bebida de la casa, que son los Martínez ($50), hechos con vodka y aguas frescas. Si se quiere seguir al pie de la letra la frase, que está pintada en una de las paredes "hay que morir borracho para no sentirse tan gacho", son recomendables el Boing de guayaba y el agua de pepino.

Como a veces menos es más, la decoración del lugar es sencilla; posee mesas rústicas de madera y lámparas de aluminio en el techo. Las paredes simulan estar formadas por cajones plásticos, que contrastan perfectamente al caer la noche cuando se transforma en un

antro, por donde desfilan las mejores bandas y DJ's que protagonizan la escena musical actual.

Las facetas de este restaurante se hacen evidentes cuando de día funciona como un restaurante familiar, que se transforma por las noches para convertirse en una de las paradas obligadas del buen trasnochador que no desaprovecha.

GUATE EN · TEXTO: Redacción Taxi · ILUSTRACIÓN: larea inc. · SOUNDTRACK: El Gnifo / Bohemia Suburbana

BLOGÓSFERA CHAPINA

En un lugar no muy lejano, donde la información y el entretenimiento nunca duermen, una telaraña enlaza un sinfín de sitios, dentro de los cuales varios son publicados bajo la firma *made in guate*.

Dentro de la blogósfera hay cientos de guatemaltecos que no pueden dejar pasar la oportunidad que ofrece la autopista cibernética. Por medio de sus blogs ellos le gritan al mundo sus propuestas literarias, visuales, políticas y personales.

www.anecdotario.net es un blog dedicado a comentar las experiencias cotidianas desde una perspectiva fresca con un humor elegantemente sarcástico. Es así como el quedarse dormido en una camioneta acompañando a algunos merolicos, los horrores idiomáticos de todo buen chapín y algunos relatos en los que se reflejan los prejuicios sociales, son el principal atractivo de este espacio. Más de 200 historias escritas por José Joaquín López reciben comentarios de parte de bloggers de todo el mundo que coinciden en esta parada virtual.

La búsqueda de formas alternativas que promueven la libre expresión del pensamiento tiene como resultado a la revista Alberdio (alberdio.blogspot.com). Esta pública de manera independiente artículos, entrevistas y noticias firmadas por sus redactores y colaboradores. Su objetivo es ser un espacio para la discusión y análisis de la situación nacional, para luego elaborar propuestas de carácter social.

La musa abandona su pedestal para ser una parte activa en la telaraña del Internet. Y es que la revolución democratizadora de la web no podía dejar fuera a las féminas, quienes contagian al computador con su sensibilidad poética. Con blogs como Simplemente así (lolita201.blogspot.com) y Ordinaria locura (claudianavas.blogspot.com) la rutina se ve interrumpida para transportar al visitante hacia un espacio en el que las letras transmiten algo más allá de la gramática.

En estas bitácoras electrónicas las propuestas audiovisuales también encuentran su lugar en sitios como www.hemisferio-urbano.com, el cual reúne todas las ramas del arte urbano mundial para que sean conocidas por todas las personas que leen este espacio.

Las opciones de la blogósfera son infinitas puesto que cada link es un desvío hacia avenidas virtuales

que se pelean por desplegarse en las pantallas de nuestro monitor. Es en esta competencia que los blogs chapines se han destacado al obtener grandes números de visitas o de comentarios, gracias a la calidad con su contenido.

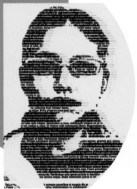

*1946, Venezuela

ÁLVARO SOTILLO

1

1. "Nacionalización
de la Industria Petrolera"
series of postage stamps, 1978

2. "Ictiología Marina" book,
1980, Consejo Nacional de
Investigaciones Científicas y
Tecnológicas (Conicit)

Born in Caracas, Álvaro Sotillo is a well-known and highly regarded designer in Venezuela, having studied with some of the best artists that came from abroad, such as Gego from Germany and Nedo M.F. from Italy. He also enjoyed a close collaboration with the legendary Gerd Leufert, with whom he worked with for over a decade before setting up his own practice, Vision Alternativa. After winning numerous awards in Germany for his book designs, including the Gutenberg Award in Leipzig, he became a founding member of the school of visual communication Prodiseño in Caracas. In 1999, Sotillo designed the presentation for the Ciudad Universitaria de Caracas, which was successfully inscribed to the UNESCO list of World Heritage Centres. He continues to develop editorial and branding projects with an emphasis on typography.

Álvaro Sotillo wurde in Caracas geboren und ist in Venezuela ein namhafter und angesehener Designer, der mit einigen der besten ausländischen Künstlern studiert hatte, darunter Gego aus Deutschland und Nedo M.F. aus Italien. Er arbeitete zudem mehr als zehn Jahre lang eng mit dem legendären Gerd Leufert zusammen, bevor er schließlich sein eigenes Designstudio Vision Alternativa eröffnete. Nachdem Sotillo in Deutschland zahlreiche Auszeichnungen für sein Buchdesign erhalten hatte, zum Beispiel den Gutenberg-Preis in Leipzig, wurde er einer der Gründungsmitglieder der Schule für visuelle Kommunikation Prodiseño in Caracas. 1999 entwarf Sotillo die Präsentation für die Ciudad Universitaria de Caracas, die erfolgreich in die UNESCO-Liste des Weltkulturerbes aufgenommen wurde. Er entwickelt zurzeit Editorial- und Corporate Identity-Projekte mit dem Schwerpunkt Typografie.

Né à Caracas, Álvaro Sotillo est un graphiste très connu et très respecté au Venezuela. Il a étudié avec quelques-uns des meilleurs artistes étrangers, notamment l'Allemand Gego et l'Italien Nedo M.F. Il a également côtoyé le légendaire Gerd Leufert, avec lequel il a travaillé en étroite collaboration pendant plus de dix ans avant de créer sa propre agence, Vision Alternativa. Après avoir remporté de nombreuses récompenses en Allemagne pour ses concepts de livres, notamment le prix Gutenberg à Leipzig, il est devenu l'un des membres fondateurs de l'école de communication visuelle Prodiseño de Caracas. En 1999, Álvaro Sotillo a créé la présentation de la Ciudad Universitaria de Caracas, qui a été inscrite à la liste du Patrimoine mondial de l'UNESCO. Il continue de développer des projets dans les domaines de l'édition et de la stratégie de marque, avec un accent sur la typographie.

2. **"5° Festival Intercâmbio de Linguagens"** cultural festival poster, 2007, Centro de Referência do Teatro Infantil (Karen Acioly)

3. **"Como Nascem os Anjos"** film poster, 1998, Cinema Brasil Digital **Photo** Murilo Salles

4. **"Festival do Rio"** film festival logo, 2000, Festival do Rio

3

Banespa Secretaria do Audiovisual/Minc RIOFILME Empório de Cinema
apresentam

Larry Pine

Priscila Assum

Silvio Guindane

Ryan Massey

André Mattos

Maria Silvia

Como nascem os anjos.

um filme de
Murilo Salles

uma produção
Cláudio Kahns
Romulo Marinho Jr.
Murilo Salles

Escrito por
Murilo Salles
e Jorge Duran
Agnaldo Silva
Nelson Nadotti

diretor de fotografia
César Charlone

direção de arte
Marlise Storchi

figurinos
Maria Helena Salles

montagem
Isabelle Rathery
Vicente kubrusly

música
Víctor Biglione

produção executiva
Romulo Marinho Jr.

direção
Murilo Salles

Duas crianças envolvidas na violência da cidade

2

PETROBRAS | Oi | PREFEITURA DO RIO/CULTURAS apresentam

FIL

5° FESTIVAL
INTERCÂMBIO DE
LINGUAGENS

26 julho > 05 agosto 2007

O MELHOR DA ARTE CÊNICA INTERNACIONAL PARA CRIANÇAS DE TODAS AS IDADES

4

Festival **do Rio**

LUIZ STEIN

1

hamlet
coleção shakespeare
versão atualizada de fernando nuno

macbeth
coleção shakespeare
versão atualizada de fernando nuno

a megera domada
coleção shakespeare
versão atualizada de fernando nuno

romeu & julieta
coleção shakespeare
versão atualizada de fernando nuno

sonho de uma noite de verão
coleção shakespeare
versão atualizada de fernando nuno

Trained as architect and industrial designer, Luiz Stein's career in graphic design spans over 25 years, having worked on a wide range of subjects and fields such as fashion, editorial, theatre. He is most notably recognised for his work in the music industry, having created designs for many of Brazil's music icons, including Fernanda Abreu, Caetano Veloso, and Gilberto Gil, among others. Stein has also directed numerous music promos and has been nominated more than 10 times for the MTV Music Awards Brazil. He also received an award at the Graphic Design Biennial in 2004. Stein is also very politically engaged, having directed the Ayrton Senna Prize and a number of events for AIDS awareness.

Als ausgebildeter Architekt und Industriedesigner umfasst Luiz Steins Karriere eine Zeitspanne von über 25 Jahren, während der er in vielen Fachgebieten und Branchen tätig war, zum Beispiel in den Bereichen Mode, Editorial Design und Theater. Am ehesten kennt man Stein in der wegen seiner Arbeit für die Musikindustrie, wo er für viele brasilianische Stars entworfen hat, unter anderem für Fernanda Abreu, Caetano Veloso und Gilberto Gil. Stein hat zudem zahlreiche Werbeaufnahmen im Musikbereich geleitet und wurde über zehnmal für den MTV Music Awards Brazil nominiert. Darüber hinaus wurde er auf der Graphic Design Biennal 2004 ausgezeichnet. Stein ist außerdem politisch tätig und leitete den Ayrton Senna Prize sowie eine Reihe von Veranstaltungen zur Aufklärung über AIDS.

Luiz Stein est architecte et concepteur de produits de formation. Sa carrière dans le graphisme s'étend sur plus d'un quart de siècle. Il a travaillé sur un vaste éventail de sujets et de domaines, notamment la mode, l'édition et le théâtre. Mais c'est surtout dans le secteur de la musique qu'il est le plus reconnu. Il a créé des graphismes pour de nombreuses icônes de la musique brésilienne, dont Fernanda Abreu, Caetano Veloso et Gilberto Gil, entre autres. Luiz Stein a également réalisé de nombreuses promotions musicales et a été sélectionné plus de dix fois pour les MTV Music Awards du Brésil, et il a reçu une récompense à la Biennale du graphisme en 2004. Il est par ailleurs très engagé dans la politique, et a présidé le Prix Ayrton Senna ainsi que plusieurs événements de sensibilisation sur le SIDA.

1. "Shakespeare Collection" book
cover series, 2004, Editora Objetiva
Design assistant/photo Breno Pinechi

2. "Lulu Santos Programa"
promotional poster,
2002, Lulu Santos, Sony BMG Brazil
Photo Daniel Klajmic

3. "Fernanda Abreu na Paz"
promotional poster, 2005,
Fernanda Abreu, EMI Music Brazil
Photo Jacques Dequeker

4. "Diário de um Louco"
theatre play poster, 1998,
Casa da Gávea
Photo Adriana Pittigliani

5. "Síndromes – Loucos Como Nós"
theatre play poster, 2005, Stage
Photo Adriana Pittigliane

*1978, Peru, www.studioa.com.pe

STUDIO A

1. **"IDP Seminar"** visual identity, 2004, International Design Partnership (IDP)

With over 25 years experience in developing award-winning projects in visual identity, editorial, web, and branding, Studio A is a leading multidisciplinary design consultancy based in Lima. Often inspired by Peruvian iconography, the studio has created a unique blend of regional design with a world class visual language, which has led them to work with nearly all the major brands in the country. Studio A has been a close associate of IDP (a worldwide design network with offices in 17 countries), with whom they have focused on a brief to promote Peruvian culture, history, and also to revive its legacy of creative excellence into the 21st Century. Studio A has been published internationally and its creative directors are deeply involved in the creative community in Peru.

Mit über 25 Jahren Erfahrung in der Entwicklung von preisgekrönten Projekten in den Bereichen Visual Identity, Editorial Design, Webdesign und Corporate Branding ist Studio A eine führende interdisziplinäre Designberatung mit Sitz in Lima. Das Studio, häufig inspiriert durch die peruanische Ikonografie, schafft eine einzigartige Mischung aus regionalem Design und einer visuellen Sprache von Weltklasse, die zu Aufträgen von nahezu allen bedeutenden Marken des Landes führte. Studio A ist ein enges Partnerunternehmen von IDP (ein weltweites Design-Netzwerk mit Studios in 17 Ländern), mit dem es ein Projekt zur Förderung der peruanischen Kultur und Geschichte sowie seines kreativen Vermächtnisses im 21. Jahrhundert durchführte. Studio A wurde international veröffentlicht und ist fest in der kreativen Szene Perus verwurzelt.

Avec plus de vingt-cinq ans d'expérience dans le développement de projets primés dans les domaines de l'identité visuelle, de l'édition et de la stratégie de marque, Studio A est un cabinet pluridisciplinaire de premier plan basé à Lima. Le studio tire souvent son inspiration de l'iconographie péruvienne, et a réussi une alliance originale entre le graphisme local et le langage visuel international, ce qui l'a amené à travailler avec presque toutes les grandes marques péruviennes. Studio A a été un proche partenaire d'IDP (un réseau mondial de graphisme avec des bureaux dans 17 pays), et a travaillé avec le réseau sur un projet de promotion de la culture et de l'histoire du Pérou, et de dynamisation de son potentiel créatif pour le XXIe siècle. Studio A a fait l'objet de publications internationales et ses directeurs de la création sont très actifs au sein de la communauté créative du Pérou.

Tramas Pinturas Recientes

Mariella Agois

ICPNA Miraflores

10 de marzo al 10 de abril

2005

2. Web page & Catalog (Tramas Pinturas Recientes), 2005, Mariella Agois

3. Book Design - Trio (Tres Chefs, Tres Estilos, Tres Sabores), 2006, Ripley

*1965, Brazil

BARBARA SZANIECKI

1. "Revista GLOBAL/Brasil"
magazine cover and editorial design,
2004, Rede Universidade Nômade

1

Barbara Szaniecki was born in Rio de Janeiro and studied graphic design in the Scuola Politecnica di Design in Milan, Italy, having subsequently graduated from the École Nationale Supérieure des Arts Décoratifs in Paris. She has operated her own design studio since 1996, focusing on the publishing, cultural and institutional sectors. Szaniecki exhibited at the Centre Culturel du Méxique in Paris, and in 2000 she won the competition to design the identity for the Brazilian Graphic Design Biennial. Szaniecki is also a researcher and writer, having published numerous articles on on the design of political campaign posters, which she collated into her book, *Estética da Multidão* (Aesthetic of the Multitude). Szianecki also edits two magazines on cultural and media affairs.

Barbara Szaniecki wurde in Rio de Janeiro geboren und studierte zunächst Grafikdesign an der Scuola Politecnica di Design in Mailand, und anschließend an der École Nationale Supérieure des Arts Décoratifs in Paris. Sie leitet seit 1996 ihr eigenes Designstudio mit dem Schwerpunkt auf Verlagen sowie kulturellen und institutionellen Bereichen. Ihre Arbeiten wurden im Centre Culturel du Méxique in Paris ausgestellt, und 2000 gewann sie den Wettbewerb für die Corporate Identity der brasilianischen Grafikdesign-Biennale. Szaniecki ist darüber hinaus als Forscherin und Schriftstellerin tätig und hat zahlreiche Artikel über das Design von Plakaten zu politischen Kampagnen veröffentlicht, die sie in ihrem Buch *Estética da Multidão* (Die Ästhetik der Masse) zusammenfasste. Szianecki gibt zudem zwei Magazine zu den Themen Kultur und Medien heraus.

Barbara Szaniecki est née à Rio de Janeiro et a étudié le graphisme à la Scuola Politecnica di Design de Milan, en Italie, avant d'obtenir son diplôme de l'École Nationale Supérieure des Arts Décoratifs de Paris. Elle dirige son propre studio de graphisme depuis 1996, spécialisé dans les secteurs de l'édition, de la culture et des institutions. Elle a exposé au Centre Culturel du Mexique à Paris, et en 2000 elle a gagné le concours pour créer l'identité de la Biennale brésilienne du graphisme. Barbara Szaniecki est également chercheuse et auteure. Elle a publié de nombreux articles sur les affiches de campagne politique, et les a rassemblés dans son livre *Estética da Multidão* (Esthétique de la Multitude). Elle dirige également deux magazines sur la culture et les médias.

2

4

3

2. "V Bienal de Design Gráfico"
biennial poster and visual identity,
2000, Associação de Designers
Gráficos (ADG), SESC São Paulo
Photo Silvana Marques

3. "Mostra Sul da Poesia Latino-
Americana" cultural event poster
and program, 2002, Centro Cultural
do Banco do Brasil

4. "Seminário Internacional
Capitalismo Cognitivo"
conference poster, 2005,
Rede Universidade Nômade

*2000, Brazil, www.tecnopop.com.br

tecnopop

Tecnopop is a creative collective founded in 2000 and led by Luis Marcelo Mendes, Raul Mourão, Rodrigo Machado, André Stolarski, Marcelo Pereira and Sônia Barreto. The group has been considered to have one of the most innovative approaches to graphics in the recent past and their portfolio has been widely acknowledged for its high quality and distinguished mixture of radical experimentation and systematic and methodological organisation. After gaining respect in many industries, the one-stop shop creative boutique has worked in Brazil, Argentina and the United States, on projects ranging from branding, corporate identity, editorial, exhibitions, web design, movies and music. Tecnopop is based in Rio de Janeiro.

Tecnopop ist ein kreatives Gemeinschaftsstudio in Brasilien, das 2000 gegründet wurde und von den Designern Luis Marcelo Mendes, Raul Mourão, Rodrigo Machado, André Stolarski, Marcelo Pereira und Sônia Barreto geleitet wird. Die Grafikarbeiten der Gruppe werden als eine der innovativsten Ansätze in der jüngsten Vergangenheit angesehen, und ihr Portfolio ist für seine hohe Qualität und hervorragende Mischung aus radikalen Experimenten und systematischer und methodischer Organisation weithin bekannt. Nachdem sich das Kreativstudio in vielen Branchen einen Namen gemacht hatte, führte die Gruppe in Brasilien, Argentinien und in den USA Projekte über Corporate Branding, Corporate Identity, Editorial Design, Ausstellungen, Webdesign, Filme und Musik durch. Das Studio Tecnopop hat seinen Sitz in Rio de Janeiro.

Tecnopop est un collectif créatif créé en 2000 et dirigé par Luis Marcelo Mendes, Raul Mourão, Rodrigo Machado, André Stolarski, Marcelo Pereira et Sônia Barreto. La démarche graphique du groupe est considérée comme l'une des plus innovantes de ces dernières années, et le portfolio de Tecnopop est reconnu pour sa qualité et son mélange caractéristique d'expérimentation radicale et d'organisation systématique et méthodique. Après s'être bâti une réputation dans de nombreux secteurs, ce groupe créatif pluridisciplinaire a travaillé au Brésil, en Argentine et aux États-Unis sur des projets concernant les domaines de la stratégie de marque, l'identité d'entreprise, l'édition, les expositions, la création de sites web, le cinéma et la musique. Tecnopop est basé à Rio de Janeiro.

1. "Hoje" CD packaging, 2005,
Paralamas do Sucesso, EMI Music
Art direction Raul Mourão
Design Giselle Macedo

2. "Animation UK" festival poster,
2004, British Council
Design André Stolarski
Assistant Pablo Uga

3. "Automatica" visual identity,
2007, Automatica
Art direction André Stolarski
Design André Stolarski,
Theo Carvalho

4. "Orquestra Imperial" visual identity,
2006, Divisão e Arte
Art direction André Stolarski
Visual identity Theo Carvalho

5. "A pessoa é para o que nasce"
CD packaging, 2003, TV Zero
Design Marcelo Pereira

6. "Asdrúbal Trouxe o Trombone"
book, 2004, Editora Aeroplano
Design Sonia Barreto

3

4

5

6

*1983, Ecuador, www.markkaregistrada.com

OSWALDO TERREROS

1. "Sostenible Latino"
awareness poster, 2004

Oswaldo Terreros shouldn't just be remembered for founding the magazine *Markka Registrada*, in which he created a striking fusion of editorial, illustration and very good design. His posters of social causes also set a precedent for their modernity and revealing visual language. Apart from his work as the magazine's art director since 2002, Terreros is also the organiser of the collective exhibition *Regalito de la Democracia*, and creator of Morbomán, a character in a series of graphic guises, who reflects the typical Latin American social chaos. Morbomán's imagery and diverse use of photography and vector graphics has rapidly become very popular in the country, with its strong colours and running social-political commentary.

Oswaldo Terreros sollte nicht nur wegen seiner Gründung der Zeitschrift *Markka Registrada* in Erinnerung bleiben, in der ihm eine eindrucksvolle Verbindung aus Editorial Design, Illustration und sehr guter Gestaltung gelang. Auch seine Plakate über soziale Themen haben mit ihrer Modernität und deutlichen visuellen Sprache Schule gemacht. Neben seiner Arbeit als Art Director dieser Zeitschrift seit 2002 ist Terreros außerdem der Organisator der Gemeinschaftsausstellung *Regalito de la Democracia* sowie der Schöpfer von Morbomán, eine Figur in einer Serie von grafischen Gestalten, die das typische soziale Chaos Lateinamerikas widerspiegeln. Morbománs Bildwelten und der vielseitige Einsatz von Fotografien und Vektorgrafiken wurden zusammen mit den kräftigen Farben und den aktuellen sozialpolitischen Kommentaren im Land sehr schnell populär.

Il ne faut pas réduire la carrière d'Oswaldo Terreros à la fondation du magazine *Markka Registrada*, dans lequel il a créé une fusion saisissante de contenu éditorial, d'illustration et de graphisme brillant. Ses affiches pour des causes sociales ont également créé un précédent par leur modernité et leur langage visuel révélateur. Parallèlement à la direction artistique du magazine depuis 2002, Oswaldo Terreros organise également l'exposition collective *Regalito de la Democracia*. Il a aussi créé Moboman, le héros d'une série d'aventures graphiques, reflet du chaos social typiquement latino-américain. Grâce à son imagerie, à l'utilisation polyvalente de la photographie et des vecteurs, à ses couleurs vives et à son regard sur la société et la politique, Morbomán est vite devenu très populaire dans le pays.

2–3. "Morbomán"
character design and poster, 2004

4. "Anuario de la Publicidad Ecuatoriana" annual book, 2004, Markka Registrada magazine

4

2

3

*1991, Chile, www.tesisdg.cl

tesis DG

1

Led by designer Juan José Neira Délano, Tesis DG is a creative studio with over fifteen years of experience in Santiago. After studying fine arts at The State University of New York, following up with an MFA at Yale University, Neira Délano remained in the United States to work for a number of design studios, including 212 Associates in New York. In 1991 he returned to his native Chile to start his own studio whilst undertaking a lectureship at the Universidad Finis Terrae. He currently balances his academic time with commercial projects that include corporate identity, posters, CD packages and editorial. Neira Délano has received three nominations for the Altazor National Arts Awards and is currently Director of the School of Design at Universidad Andrés Bello.

Tesis DG ist ein Kreativstudio in Santiago mit mehr als 15 Jahren Erfahrung und wird von dem Designer Juan José Neira Délano geleitet. Nach seinem Studium der bildenden Kunst an The State University of New York, gefolgt von dem Abschluss Master of Fine Arts (MFA) an der Yale University, blieb Neira Délano in den USA und arbeitete für verschiedene Designstudios, u.a. für 212 Associates in New York. 1991 kehrte er in sein Heimatland Chile zurück und eröffnete sein eigenes Studio, während er gleichzeitig als Dozent an der Universidad Finis Terrae tätig wurde. Gegenwärtig teilt er seine Arbeitszeit zwischen Dozentur und kommerziellen Projekten auf, in denen er sich Corporate Identity, Plakate, CD-Verpackungen und Editorial Design beschäftigt. Neira Délano ist dreimal für den Altazor National Arts Awards nominiert worden und ist zurzeit Leiter der Designschule an der Universidad Andrés Bello.

Dirigé par le graphiste Juan José Neira Délano, Tesis DG est un studio créatif basé à Santiago, qui a déjà plus de quinze ans d'expérience. Après avoir étudié les beaux-arts à The State University of New York, puis avoir obtenu un diplôme des beaux-arts à Yale, Juan José Neira Délano est resté aux États-Unis et a travaillé pour plusieurs studios de graphisme, notamment 212 Associates à New York. Il est retourné au Chili en 1991 pour créer son propre studio tout en enseignant à l'Universidad Finis Terrae. Il partage actuellement son temps entre ses occupations universitaires et des projets commerciaux dans les domaines de l'identité d'entreprise, des affiches, des pochettes de CD et de l'édition. Juan José Neira Délano a été sélectionné trois fois pour les prix artistiques Altazor, et est actuellement directeur de l'École de graphisme de l'Universidad Andrés Bello.

1. **"Centro Cultural Palacio La Moneda"** magazine and program, 2006, Cineteca Nacional
Editor Juan José Ulriksen

2. **"Diarios"** book, 2004, Empresa Nacional de Telecomunicaciones, Chile (Entel)
Publisher Susana Mansilla
Text Paola Doberti
Photo Jorge Brantmayer

BORORO
VICTORIA PERSONAL Y COMPARTIDA

*1997, Argentina, www.tholon.com

THOLÖN KUNST

1. "Faena Hotel + Universe"
visual identity and logo,
Faena hotel + Universe

2. "Mediamax" poster, Mediamax

In search of diversity and with a passion for simplicity, Tholön Kunst has been a leading mouthpiece for the global quality and excellence of graphic design in Latin America. Operating from offices in Buenos Aires and Barcelona (Spain) since 1997, designers Ana Hevia and Pablo Krymkiewicz have specialised in corporate identity and design for editorial and institutional publications. Their works have been featured in a number of regional design publications, and over the last decade they have accumulated clients in many countries, including in Brazil, Chile, United States, Spain, France and the United Kingdom. Their design works for Corona, Eurosport, the MALBA (Latin American Art Museum of Buenos Aires), TNT and Escada, exemplify how their minimalist and objective style can translate into very effective and practical designs.

In seiner Suche nach Vielfalt und der leidenschaftlichen Schlichtheit ist Tholön Kunst für die globale Qualität und hervorragende Leistung des lateinamerikanischen Grafikdesigns ein Sprachrohr geworden. Die Designer Ana Hevia und Pablo Krymkiewicz arbeiten seit 1997 in Buenos Aires und Barcelona (Spanien) und haben sich auf Corporate Identity und Design für Verlage und Institutionen spezialisiert. Ihre Werke wurden in einer Reihe von regionalen Design-Publikationen veröffentlicht. In den letzten zehn Jahren hat Tholön Kunst für Kunden in vielen Ländern gearbeitet, zum Beispiel in Brasilien, Chile, USA, Spanien, Frankreich und in Großbritannien. Die Designarbeiten der Gruppe für Corona, Eurosport, MALBA (lateinamerikanisches Kunstmuseum in Buenos Aires), TNT und Escada dienen als Beispiel dafür, wie ihr minimalistischer und sachlicher Stil in sehr effektive und praktische Designs übertragen werden kann.

Tholön Kunst recherche de la diversité et a une passion pour la simplicité. C'est un porte-parole de premier plan pour la qualité et l'excellence globales du graphisme en Amérique latine. Depuis leurs bureaux de Buenos Aires en Argentine et de Barcelone en Espagne, les graphistes Ana Hevia et Pablo Krymkiewicz sont spécialisés dans l'identité d'entreprise et le graphisme pour l'édition et les publications institutionnelles depuis 1997. Leur travail a fait partie de nombreuses publications sud-américaines sur le graphisme, et ces dix dernières années ils ont travaillé avec des clients du monde entier, notamment du Brésil, du Chili, des États-Unis, de l'Espagne, de la France et du Royaume-Uni. Les graphismes qu'ils ont réalisés pour Corona, Eurosport, le MALBA (Musée des arts latino-américains de Buenos Aires), TNT et Escada montrent comment leur style minimaliste et objectif peut se traduire par des graphismes très efficaces.

Argentina… el país con todos los climas, las tonadas y dialectos, con los 4 vientos y las mujeres más lindas del mundo, montañas, ríos, nieve y calor, selva y desierto, con más de 20 millones de personas en el interior del país, cientos de ciudades y miles de pueblitos, Argentina es variada y nosotros sabemos de ella.

Sabemos que los oyentes del sur se levantan temprano; y los del norte duermen la siesta unas 3 horas cada día religiosamente; sabemos que los del litoral consumen bebidas frescas la mayor parte del año, incluido el tereré y que los de cuyo acompañan sus picadas con los mejores vinos que en esa zona se producen, y en qué pueblos es costumbre dar la vuelta del perro cada domingo y que en todo el país se toma mate como principal infusión.

Sabemos que el 85% de los argentinos son oyentes confesos de radio y que la usan como compañera de sus tareas cotidianas más de 4 horas por día… La radio acompaña a todos los trabajadores del agro en sus mañanas, con la información que más necesitan y aprecian… acompañándose con el paso de los años de los mismos conductores y programas.

El interior es, para muchos, un universo por descubrir y conquistar. Cada zona, cada lugar es único y distinto, tiene su particularidad y aprendimos como llegar a cada uno de ellos.

Con muchos años de trayectoria en el mercado de medios del interior contamos con la experiencia necesaria para brindarte el mejor asesoramiento y los medios de mayor calidad y mejor posicionados de cada plaza del interior de nuestro país.

El interior es una fuente inagotable de riquezas y movimiento económico. Crece día a día a pasos agigantados, consume, produce, realiza, reactiva, compra, vende, escucha, mira, lee y se sobrepone a las mayores tempestades.

Conocemos al interior y te acercamos al público ideal en el momento correcto.

Referencias

(Cantidades por región. Fuentes: INDEC / BCRA / encuestas propias e internet)

*1972, Mexico, www.laflama.com

LUIS TORRES

1

Luis Torres is among the new breed of visionaries in the Mexican graphic design field, implementing a visual language of great personality, plenty of colours and dynamism, and with a heavy load of contemporary illustration. He studied graphic communication at the Universidad Autonoma Metropolitana at Azcapotzalco in Mexico City, and for the next decade has worked on motion and animation, leading his creative name, Flama, to captivate clients in Mexico, Canada and United States. His works have also been published in magazines such as *Forecast* from Switzerland, and *Territory* from Singapore. In 2005 his shot film *Technorganic* was screened at the Interfilm Short Film Festival Berlin and has been reviewed in a number of magazines, including *Stash Magazine* and *Short Film Drawer*.

Luis Torres gehört zu der neuen Generation von Visionären im mexikanischen Grafikdesign, die in ihrer visuellen Sprache ein besonderes persönliches Profil sehr bunt und dynamisch und mit einem großen Anteil zeitgenössischer Illustration umsetzt. Er studierte grafische Kommunikation an der Universidad Autonoma Metropolitana im Bezirk Azcapotzalco in Mexico City. In den nachfolgenden zehn Jahren arbeitete er in den Bereichen Motion-Design und Animation und konnte mit seinem kreativen Namen Flama bedeutende Kunden in Mexiko, Kanada und den USA gewinnen. Seine Arbeiten wurden zudem in Magazinen wie *Forecast* in der Schweiz und *Territory* in Singapur veröffentlicht. 2005 wurde sein Kurzfilm *Technorganic* auf dem Kurzfilmfestival Interfilm in Berlin gezeigt und in einer Reihe von Magazinen erwähnt, darunter im *Stash Magazine* und *Short Film Drawer*.

Luis Torres fait partie de la nouvelle génération de visionnaires du graphisme mexicain. Son langage visuel fait preuve d'une grande personnalité, regorge de couleurs et de dynamisme, et est très proche de l'illustration contemporaine. Il a étudié la communication graphique à l'Universita Autónoma Metropolitana d'Azcapotzalco à Mexico, et a ensuite travaillé sur l'animation et les graphismes animés. Sous son nom de créatif, Flama, il a gagné des clients mexicains, canadiens et américains. Ses œuvres ont été publiées dans des magazines tels que *Forecast* en Suisse, et *Territory* à Singapour. En 2005, son court-métrage *Technorganic* a été projeté lors du Festival de courts-métrages Interfilm de Berlin, et a fait l'objet d'articles dans de nombreux magazines, notamment *Stash Magazine* et *Short Film Drawer*.

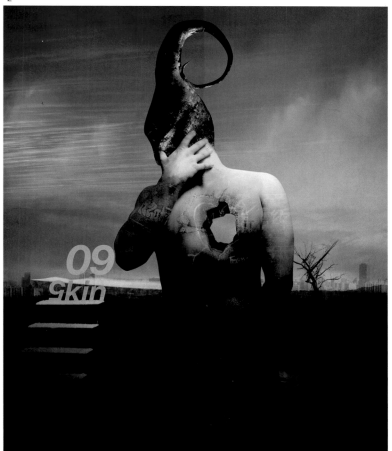

1. "Cuadros de Estilo" poster, 2007,
Oveja Negra Agency
Animator Oscar Lopez
Executive producer Jorge Bobadilla
Film production La Flama

2. "5Kin: 13 imagenes para definir
el Vacio del cuerpo humano"
illustration, 2004, personal work

3. "Mosca" banner, 2005,
personal work

3

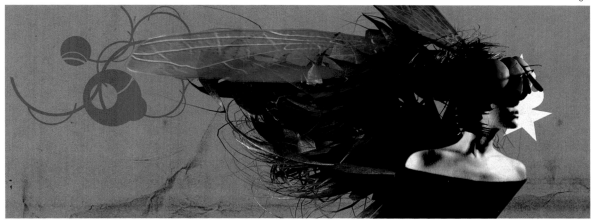

4. "Moo" book cover,
2007, Editorial Cidcli

5. "Juega 10" animated film,
2006, Nike Mexico
Executive producer Jorge Bobadilla

6. "Juega 10" poster,
2006, Nike Mexico

5

CLARISSA TOSSIN

1. "Nina" catalogue
for feature film, 2004
Art direction Clarissa Tossin
Design Clarissa Tossin, Eliane Testone

1

Clarissa Tossin is a Brazilian multidisciplinary artist based in São Paulo, working in the fields of visual arts and graphic design. A Graduate from FAAP, she started her career while still in school, working for the publishing powerhouse Editoria Abril. Upon completion of her studies she went on to work for Trama Records before starting her own "one-woman show" design studio, A'. In a short period of time Tossin has emerged on both the national and international scene — with exhibitions at Sonar Brazil in São Paulo, "Dobra" at La Ferme du Buisson in Paris, and at The Urban Project in New York. Her work has been published in several magazines such as *Novum*, *Étapes*, and *Graphic*. Her renowned roster of clients includes Vogue, MTV, Nike, Custo Barcelona, Duran Duran, Hotel Fasano and O2 Filmes.

Clarissa Tossin ist eine interdisziplinäre brasilianische Künstlerin mit Sitz in São Paulo, die in den Bereichen Visual Art und Grafikdesign arbeitet. Sie schloss ihr Studium bei der FAAP ab, begann ihre Karriere aber bereits während des Studiums, indem sie für das Verlagshaus Editoria Abril tätig war. Nach erfolgreichem Abschluss ihres Studiums arbeitete sie für Trama Records und eröffnete dann ihr eigenes Designstudio A' als „one-woman show". Innerhalb kurzer Zeit wurde Tossin nicht nur in der nationalen, sondern auch der internationalen Szene bekannt — mit Ausstellungen bei Sonar Brazil in São Paulo, *Dobra* bei La Ferme du Buisson in Paris und bei The Urban Project in New York. Ihre Arbeiten wurden in mehreren Zeitschriften veröffentlicht, zum Beispiel in *Novum*, *Étapes* und *Graphic*. Zu ihren berühmtesten Kunden zählen Vogue, MTV, Nike, Custo Barcelona, Duran Duran, Hotel Fasano und O2 Filmes.

Clarissa Tossin est une artiste pluridisciplinaire brésilienne basée à São Paulo. Elle travaille dans les domaines des arts visuels et du graphisme. Diplômée de la FAAP, elle a commencé sa carrière alors qu'elle était encore étudiante, en travaillant pour la grande maison d'édition Editoria Abril. Au terme de ses études, elle a travaillé chez Trama Records avant de créer son propre studio de graphisme, un véritable « one-woman show », A'. En peu de temps, elle a émergé sur la scène nationale et internationale, avec des expositions au Sonar Brazil à São Paulo, *Dobra* à La Ferme du Buisson à Paris, et lors de l'événement The Urban Project à New York. Ses œuvres ont été publiées dans plusieurs magazines, notamment *Novum*, *Étapes*, et *Graphic*. Parmi ses clients les plus connus, on peut citer Vogue, MTV, Nike, Custo Barcelona, Duran Duran, Hotel Fasano et O2 Filmes.

UMA PRODUÇÃO **GULLANE** FILMES
_ A PRODUCTION BY

2. "Rocket Racer"
CD cover and poster, 2004
Design/typeface Clarissa Tossin

3. "Galeria Vermelho" promotional
double-sided poster, 2004
Design/typeface Clarissa Tossin

estúdio tostex

1. "Mini livro Galeria Leme"
book and identity, 2004,
Galeria Leme

Rodolfo Rezende is the head of Tostex. An experienced cultural activist with numerous catalogues and exhibition designs under his belt, Rezende established his studio in 2000, with the vision of becoming a one-stop shop for a variety of cultural ventures, including events, music concerts, theatre, and commercial and independent cinema. The studio has produced works for the Museum of Modern Art in São Paulo, Trama Records, Scientific American Brasil, NetSafe/McAfee, Greenpeace, Oakley, to name but a few. Their integrated approach to communication has enhanced the profile of many companies by implementing better visual communication strategies, combining both advertising and graphic design. Tostex has also produced an extensive catalogue of cover designs for music CDs and songbooks that have been widely appreciated, both within the industry and by the public.

Rodolfo Rezende ist der Leiter von Tostex und ein erfahrener kultureller Aktivist, der zahlreiche Kataloge und Ausstellungen produzierte. Er eröffnete sein Studio 2000 mit der Vision, ein Allround-Studio für eine Vielfalt von kulturellen Projekten wie Kulturveranstaltungen, Konzerte, Theater sowie kommerzielles und unabhängiges Kino zu gründen. Das Studio hat Arbeiten für das Museum of Modern Art in São Paulo, Trama Records, Scientific American Brasil, NetSafe/McAfee, Greenpeace und Oakley entworfen, um nur einige Kunden zu nennen. Durch den ganzheitlichen Ansatz des Studios zur Kommunikation konnten die Profile vieler Unternehmen verbessert werden, da die Verbindung von Werbung und Grafikdesign zu besseren visuellen Kommunikationsstrategien führten. Tostex hat zudem einen umfangreichen Katalog mit Cover-Design für Musik-CDs und Liederbücher produziert, die innerhalb der Branche und der Öffentlichkeit große Anerkennung fanden.

Rodolfo Rezende est à la tête de Tostex. C'est un militant culturel expérimenté, qui a créé une multitude de catalogues et d'expositions. Il a créé son studio en 2000, dans l'intention d'en faire un centre tout-en-un pour différents types de projets culturels, notamment l'événementiel, les concerts, le théâtre et le cinéma commercial et indépendant. Le studio a travaillé pour le Musée d'art moderne de São Paulo, Trama Records, Scientific American Brasil, NetSafe/McAfee, Greenpeace et Oakley, pour n'en citer que quelques-uns. Leur approche intégrée de la communication s'est révélée bénéfique pour de nombreuses entreprises, car elle leur a fourni de meilleures stratégies de communication visuelle combinant publicité et graphisme. Tostex a également produit de nombreuses pochettes de CD et de recueils de chansons qui ont remporté un franc succès, à la fois chez les professionnels et auprès du public.

1 INTRODUCTION

2 EXHIBITIONS

3 ARTISTS

4 MISCELLANEOUS

CAMILA SPOSATI
PAUL HOSKING
RICHARD GALPIN
FERNANDA CHIECO
ROSANA PALAZYAN

17.11.2004

OPENING
ABERTURA

RAQUEL KOGAN

Born in Sao Paulo, Brazil, 1955. Lives and works in Sao Paulo. **SELECTED SOLO EXHIBITIONS 2004** Paulista Concrete, Monica Filgueiras Art Gallery, Sao Paulo, Brazil **1999** Cultural Space Capela do Morumbi, Sao Paulo, Brazil **1998** 20 x 20 x 240, Monica Filgueiras Art Gallery, Sao Paulo, Brazil **SELECTED GROUP EXHIBITIONS 2005** Occupation #2, Rio Palace, Manaus, Brazil • 4th Tokyo International Miniprint Triennal, Japao • Art@Outsiders, Paris, France • XV Video-Brasil, Sao Paulo, Brazil • Information, XII Cerveira Biennal, Portugal • Occupation #1, Paço das Artes, Sao Paulo, Brazil • Portrait, Galeria Leme, Sao Paulo, Brazil **2004** Projection, Paço das Artes, Bilbao, Spain **2003** Escape Point/ Free Área, Imaginary Line, Galeria Marta Traba, Latin America Memorial, Sao Paulo, Brazil • Art Frankfurt, Curator's Choice Imaginary Line Group, Frankfurt, Germany **2002** Imaginary Mexico. A Look on the Brazilian Artists, Casa das Rosas, Sao Paulo, Brazil **2001** I Bienal of Etching Santo André, Sao Paulo, Brazil • III Etching Festival Évora, Portugal • Expanded Drawing, Candido Mendes Cultural Center • The Marchand as the Curator, Casa das Rosas, Sao Paulo, Brazil • Plates for Art III, Lasar Segall Museum, Sao Paulo, Brazil **1998** Galleries of the Palais de Glace, Buenos Aires, Argentina **1996** XX Salão Carioca de Arte. Parque Lage, Rio de Janeiro, Brazil **1995** 1st Tokyo International Miniprint Triennal, Japao **PRIZES AND AWARDS 2005** Reflection & their Inflections, Honour Mention, 6° Prêmio Sergio Motta, Sao Paulo, Brazil **2004** Reflection, Selected to the 5th Sergio Motta Prize, Sao Paulo, Brazil **2002** Reflection, Installation Rumos Transmidia, Itaú Cultural, Sao Paulo, Brazil **2000** Arte Para, Romulo Maiorama Foundation, Acquisition Prize, Belem do Para, Brazil

GALERIA LEME WOULD LIKE TO THANK ALL THE ARTISTS, COLLECTORS, PRESS, JOURNALISTS, GALLERIES AND THE PUBLIC THAT SUPPORT THE ACTIVITIES, SPECIALLY CLAUDIA LAUDANNO, RICARDO TREVISAN, CLARISSA SCHNEIDER, WILLY KAUTZ, JACOPO CRIVELLI VISCONTI, DRAUSIO GRAGNANI, KIM ESTEVE, JOAO GAMA, BRITSH COUNCIL AND MY WIFE DANIELA.

CREDITS ARCHITECTS PAULO MENDES DA ROCHA / METRO ARQUITETOS ASSOCIADOS **ART AND CONCEPT** ESTÚDIO TOSTEX / RODOLFO BEZNOS **ART ASSISTANT** SILVIA SAKURAI **PHOTOS** DEBORA HENGEL, EVERTON BALLARDIN, LEONARDO CRESCENTI, RAFAEL LEITREGER, SERGIO DE DIVITIS, VICENTE DE MELLO, YNAIÊ DAWSON, ZECA PEREIRA DE SOUZA AND THE ARTISTS.

DIRECTOR EDUARDO LEME
OFFICE MANAGER CRISTINA HAAPALAINEN

WWW.GALERIALEME.COM
INFO@GALERIALEME.COM
RUA AGOSTINHO CANTU, 88
05501-010 SÃO PAULO SP BRAZIL
T 55 11 3814 8184
F 55 11 3812 2875

*2003, Colombia, www.typo5.com

typo 5

1

Typo 5, founded in 2003, is the Bogotá-based design practice led by Germán Olaya (b.1979) and Paola Sarmiento (b.1978). This young creative studio has incorporated the language of their generation, a multimedia approach to design combined with a fusion of modern typography, urban graphics, illustration, photography and vector lines. Typo 5 gained rapid recognition from its early beginnings, and its distinctive visual language has been widely published internationally in *Novum*, *Communication Arts* and *i-D Magazine*. A string of awards include the AGFA Young Creatives Contest, the Fabrica Award from Benetton, and the Canon Digital Creators Contest. With a wealth of experience in advertising, the office currently works for a number of big brands, including Axe, Coca-Cola, Renault and Rexona.

Typo 5 wurde 2003 als Designstudio von Germán Olaya (geb.1979) und Paola Sarmiento (geb.1978) gegründet und hat seinen Sitz in Bogotá. Dieses junge Kreativstudio beherrscht die Sprache seiner Generation und entwickelt seine multimediale Annäherung an Design in Verbindung mit moderner Typografie, urbanen Grafiken, Illustration, Fotografie und Vektorlinien. Typo 5 wurde schon von Anfang an sehr beachtet und seine charakteristische visuelle Sprache wurde in großem Umfang international veröffentlicht, darunter in *Novum*, *Communication Arts* und *i-D Magazine*. Die Arbeiten des Studios erhielten viele Auszeichnungen, zum Beispiel beim AGFA Young Creatives Contest, dem Fabrica Award von Benetton und dem Canon Digital Creators Contest. Mit seiner großen Erfahrung im Werbebereich arbeitet das Studio zurzeit für einige große Marken, darunter Axe, Coca-Cola, Renault und Rexona.

Typo 5, créée en 2003, est l'agence de graphisme que Germán Olaya (né en 1979) et Paola Sarmiento (née en 1978) dirigent à Bogota. Ce jeune studio de création a absorbé le langage de leur génération, une approche multimédia du graphisme alliée à une fusion de la typographie moderne, du graphisme urbain, de l'illustration, de la photographie et de l'illustration vectorielle. Typo 5 s'est rapidement bâti une solide réputation, et son langage visuel caractéristique a été diffusé à l'international par *Novum*, *Communication Arts* et *i-D Magazine*. Parmi la ribambelle de récompenses que le studio a remportées, on peut citer le concours AGFA Young Creatives, le prix Fabrica de Benetton et le concours Digital Creators de Canon. Le studio peut se vanter d'avoir des trésors d'expérience dans la publicité, et travaille actuellement avec plusieurs grandes marques, notamment Axe, Coca-Cola, Renault et Rexona.

1. "Botanic" poster, 2005, Canon
Ilustration/design Germán Olaya

2. "Mozart Fest" logo, 2005, Markus Nix
Ilustration/design Germán Olaya
Typography Jay David (Millionaire)

3. "Copyright 0328" poster, 2007, Neo
Ilustration/design Paola Sarmiento

4. "Noise" magazine cover,
2005, Novum
Ilustration/design Germán Olaya

3

Aurochs

2

4

*1958, Brazil, www.tempodesign.com.br

RICARDO VAN STEEN

1. **"Dossiê Esporte"** (Sports Archives),
2006, Globosat, Sportv
Art direction Ricardo Van Steen
Assistant Cássio Leitão,
Laila Rodrigues

2. **"Noel Poeta da Vila"** film poster,
2007, Movi&art Film Company
Creative direction Ricardo Van Steen,
Marcelo Pallota
Typography Cassio Leitão
Photo Alexandre Ermel

Multimedia artist Ricardo Van Steen is the head of Tempo Design, a design consultancy and studio, whose aims are to solve challenges in the areas of editorial, corporate identity, film, advertising, internet and marketing. Having owned an advertising agency and directed numerous commercials, Van Steen has always been an outspoken communication specialist based in São Paulo, and has also carved his own artistic career. Tempo's mission is to create "multimedia communication tools that use all the 5 human senses", and under this motto, they have served clients such as Natura, Globo Television, Trama Music, Branstemp, C&A, and Osklen. Today, their work has shifted away from advertising to focus much more on design for print, film and Internet rather than advertising.

Der Multimedia-Künstler Ricardo Van Steen ist Leiter von Tempo Design. In ihrer Designberatung und dem Studio setzen sie sich das Ziel, sich den Herausforderungen in den Bereichen Editorial Design, Corporate Identity, Film, Werbung, Internet und Marketing zu stellen. Als vorheriger Leiter einer Werbeagentur und Entwickler zahlreicher Werbefilme ist Van Steen ein freimütiger Kommunikationsspezialist mit Sitz in São Paulo, der auch seine eigene künstlerische Karriere verfolgt. Die Mission von Tempo Design besteht in der Schaffung von „Multimedia-Kommunikationswerkzeugen, die alle fünf Sinne des Menschen ansprechen", und nach diesem Motto arbeitete das Team für Kunden wie Natura, Globo Television, Trama Music, Branstemp, C&A und Osklen. Heute hat sich das Arbeitsfeld des Studios von der Werbung auf die Gestaltung für Druck, Film und Internet verlagert.

L'artiste multimédia Ricardo Van Steen dirige Tempo Design, un studio et cabinet de graphisme dont la mission est d'apporter des solutions aux défis rencontrés dans les domaines de l'édition, de l'identité d'entreprise, du cinéma, de la publicité, de l'Internet et du marketing. Ricardo Van Steen a dirigé sa propre agence de publicité et a réalisé de nombreuses publicités. En tant que spécialiste de la communication, il a toujours eu un certain franc-parler. Il est basé à São Paulo, et s'est bâti tout seul sa carrière artistique. La mission de Tempo est de créer « des outils de communication multimédia qui font appel aux cinq sens ». C'est avec cette devise qu'ils ont travaillé pour des clients tels que Natura, Globo Television, Trama Music, Branstemp, C&A et Osklen. Aujourd'hui, le travail de Tempo s'est éloigné de la publicité, et s'est orienté vers l'impression, le film et Internet.

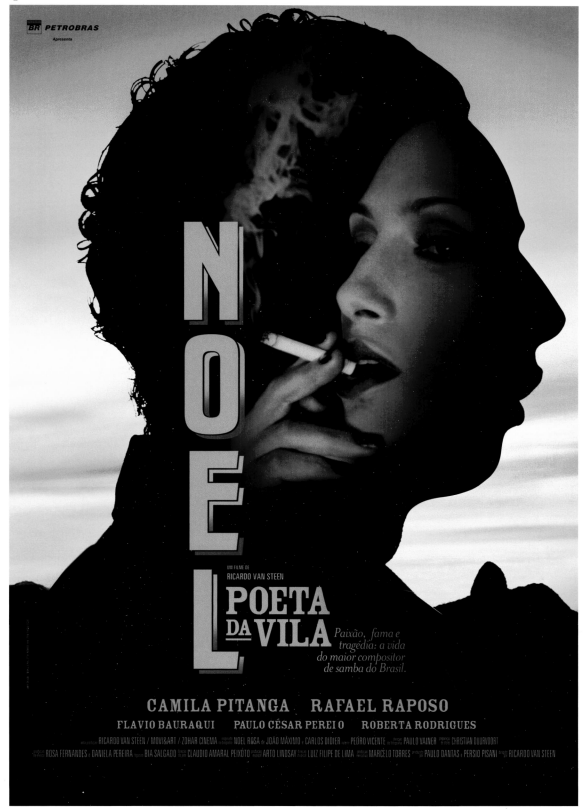

BR | **PETROBRAS**
Apresenta

NOEL

UM FILME DE
RICARDO VAN STEEN

POETA DA VILA

*Paixão, fama e
tragédia: a vida
do maior compositor
de samba do Brasil.*

CAMILA PITANGA RAFAEL RAPOSO

FLAVIO BAURAQUI PAULO CÉSAR PEREI O ROBERTA RODRIGUES

RICARDO VAN STEEN / MOVI&ART / ZOHAR CINEMA NOEL ROSA JOÃO MÁXIMO CARLOS DIDIER PEDRO VICENTE PAULO VALNER CHRISTIAN DUURVOORT

ROSA FERNANDES DANIELA PEREIRA BIA SALGADO CLAUDIO AMARAL PEIXOTO ARTO LINDSAY LUIZ FILIPE DE LIMA MARCELO TORRES PAULO DANTAS PERSIO PISANI RICARDO VAN STEEN

3. "Wish Report" editorial design,
2005, Editora Nova Criação
Art direction Ricardo Van Steen
Design Cássio Leitão

4–6. "Triton" branding for fashion label,
2006, Triton, TF Group
Creative direction Ricardo Van Steen
Art direction Nina Taddei
Design Ricardo Van Steen,
Cássio Leitão

6

4

5

RICARDO VAN STEEN **515**

*1964, Bolivia

SERGIO VEGA CAMACHO

1

1. **"Ayni Rock"** poster, 2006,
El Alto music festival, Bolivia

2. **"Pensar el Hacer"** conference
promotional poster, 2005

Based in the Bolivian capital of La Paz, Sergio Vega Camacho is a graphic designer and cultural activist in both Bolivia and Mexico, having served at the Dirección de Culturas Populares (Popular Culture Direction) in Mexico City and as co-director of the Fundación de Estética Andina (Andes Aesthetic Foundation) in La Paz. A credited art director, Vega Camacho has participated in the International Poster Biennle in Mexico and the Iberian-American Poster Biennial in Bolivia, the latter at which he has also served as a jury member He has exhibited his own works throughout the region, including *Alfabeto Íntimo* in 2004, and his most recent work, *La Paz Impresa* in 2007.

Mit Sitz in der bolivianischen Hauptstadt La Paz arbeitet Sergio Vega Camacho als Grafikdesigner und Kultur-Aktivist in Bolivien und Mexiko, wo er bei der Dirección de Culturas Populares in Mexico City und als Co-Direktor der Fundación de Estética Andina in La Paz tätig war. Als erfolgreicher Art Director hat Vega Camacho an der internationalen Plakatbiennale in Mexiko in Mexico sowie an der iberoamerikanischen Plakatbiennale in Bolivien teilgenommen — bei letzterer diente er auch als Jurymitglied. Seine eigenen Arbeiten wurden in der gesamten Region ausgestellt, zum Beispiel *Alfabeto Íntimo* 2004 und seine neueste Arbeit *La Paz Impresa* 2007.

Basé dans la capitale bolivienne de La Paz, Sergio Vega Camacho est un graphiste et militant culturel actif en Bolivie et au Mexique. Il a travaillé au sein de la Dirección de Culturas Populares (Direction des cultures populaires) de Mexico, et a été codirecteur de la Fundación de Estética Andina (Fondation pour l'esthétique andine) à La Paz. Directeur artistique reconnu, Sergio Vega Camacho a participé à la Biennale internationale de l'affiche de Mexico et à la Biennale ibéro-américaine de l'affiche en Bolivie, pour laquelle il a également été membre du jury. Il a exposé ses propres œuvres dans toute l'Amérique latine, notamment *Alfabeto Íntimo* en 2004, et son travail le plus récent, *La Paz Impresa*, en 2007.

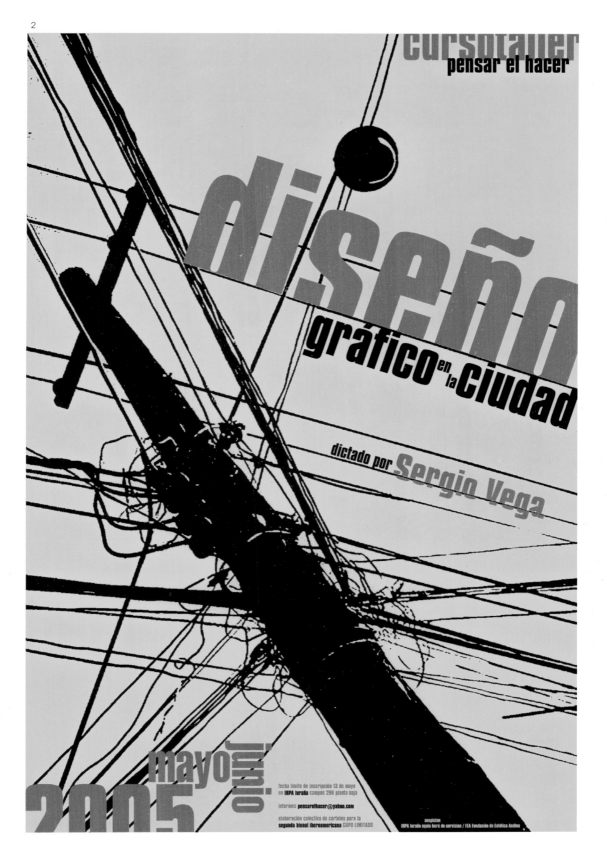

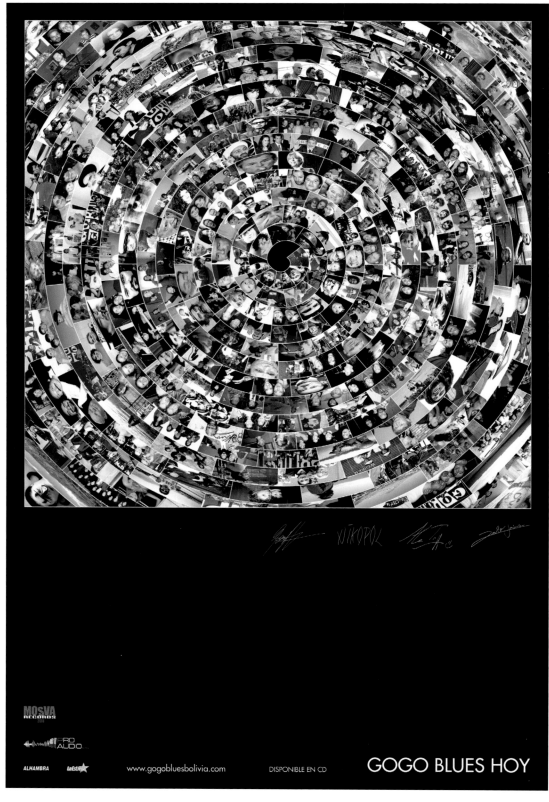

GOGO BLUES HOY

3. "GoGo Blues" poster, 2006

4. "Rabeat, Electrize It"
poster for music promotion, 2005

5. "Espera" poster, 2005,
II Bienal Iberoamericano del Cartel

6. "Reflejos del Agua" poster, 2006,
IV Foro Internacional del Agua

4

5

6

*1969, Guatemala

LUIS VILLACINDA

1

Luis Villacinda has established a career as one of the most recognized and published graphic designers in Guatemala, notably in editorial design, having art directed a number of successful magazines in the country. Entirely self taught, Villacinda began creating at an early age, fuelling his vocational instinct with a lot of reading and exercises in drawing, illustration, composition and photography. He soon realized that design wasn't just vocational, but also a necessity to succeed in life. In his search for reinvention, and a belief that imagination can do anything, Villacinda has gone on to receive a host of accolades, including numerous best newspaper designs at the annual of the Society for News Design awards. His work has featured in *How Magazine*.

Luis Villacinda hat als einer der bekanntesten und am häufigsten veröffentlichten Grafikdesigner in Guatemala Karriere gemacht, vor allem im Bereich Editorial Design, da er für eine Reihe von erfolgreichen Magazinen im Land als Art Director tätig war. Als reiner Autodidakt begann er schon im frühen Alter mit seinen Entwürfen und schulte seinen beruflichen Instinkt mit viel Lesen und Übungen in den Bereichen Zeichnen, Illustration, Gestaltung und Fotografie. Villacinda erkannte schon bald, dass Design für ihn nicht nur ein Beruf darstellte, sondern auch die Notwendigkeit für ein erfolgreiches Leben. In seiner Suche nach Neuerfindung und seinem Glauben, dass die Fantasie alles erreichen kann, hat Villacinda zahlreiche Auszeichnungen erhalten, darunter einige für das beste Zeitungsdesign bei den jährlichen Auszeichnungen der Society for News Design. Seine Arbeiten wurden in dem Magazin *How* veröffentlicht.

Au cours de sa carrière, Luis Villacinda est devenu l'un des graphistes les plus respectés et les plus publiés du Guatemala, notamment dans le secteur du design éditorial. Il s'est chargé de la direction artistique de nombreux grands magazines guatémaltèques. Complètement autodidacte, il a commencé à créer très tôt, et a nourri son instinct de ses lectures et de ses exercices de dessin, d'illustration, de composition et de photographie. Il a vite réalisé que le graphisme n'était pas seulement un métier, mais aussi une nécessité pour réussir dans la vie. Dans sa quête de réinvention, et grâce à sa foi en l'imagination, Luis Villacinda a reçu de nombreuses marques de reconnaissance pour son travail, notamment le prix du meilleur graphisme éditorial de journal lors de l'événement annuel de la Society for New Design. Ses œuvres ont été publiées dans le magazine *How*.

1. "Elacordeon" magazine cover, 1996–2005, El Periodico de Guatemala

2. "Monitor Magazine" editorial and cover design, 2002–2005, Periódico Siglo XXI

CARLOS VILLAGÓMEZ PAREDES

1

MINERIA 77

1. "Mineria 77" poster, 1977

2. "Chuquiagomarka" poster, 2005

After graduating in architecture in 1975, Carlos Villagómez Paredes began a distinguished career in the field that has seen him design numerous buildings in Bolivia, México and Peru. Parallel to his architectural endeavours, Villagómez Paredes has been a pioneering graphic designer in his homeland since 1972, running his own studio and engaging in a number of activities to raise awareness of the cultural identity of Bolivia. In 2003 he founded the Fundación de Estética Andina (Andes Aesthetic Foundation), and has been teaching a number of courses in art, design, urbanism, and architecture at the University Mayor de San Andrés since 1985.

Nachdem er 1975 sein Studium der Architektur abgeschlossen hatte, begann Carlos Villagómez Paredes seine erfolgreiche berufliche Laufbahn mit dem Design zahlreicher Gebäude in Bolivien, Mexiko und Peru. Neben seinen architektonischen Erfolgen ist Villagómez Paredes seit 1972 als Pionier des Grafikdesigns in seinem Heimatland Bolivien tätig, wo er sein eigenes Studio leitet und sich in verschiedenen Aktivitäten mit einem verbesserten Bewußtsein für die kulturelle Identität Boliviens befasst. 2003 gründete er die Fundación de Estética Andina. Zudem ist er seit 1985 als Dozent an der University Mayor de San Andrés tätig und unterrichtet einige Kurse in Kunst, Design, Stadtplanung und Architektur.

Après avoir obtenu son diplôme d'architecture en 1975, Carlos Villagómez Paredes a commencé une brillante carrière dans ce secteur, et a conçu de nombreux bâtiments en Bolivie, au Mexique et au Pérou. Parallèlement à ses projets architecturaux, il est également un pionnier du graphisme dans son pays depuis 1972. Il dirige son propre studio et a mené de nombreuses activités pour sensibiliser le public à l'identité culturelle de la Bolivie. Il a créé la Fundación de Estética Andina (Fondation pour l'esthétique andine) en 2003, et il enseigne l'art, le graphisme, l'urbanisme et l'architecture à l'Universidad Mayor de San Andrés depuis 1985.

CHUQUIAGOMARKA

*1928, Brazil, www.wollnerdesigno.com.br

ALEXANDRE WOLLNER

1

2

Alexandre Wollner is one of the most respected designers in Brazil, having started his training in 1950 at the Institute of Contemporary Arts in São Paulo. In 1953 he left to pursue his studies in Germany at the Ulm School of Design (1954 to 1958) under the direction of such luminaries as Max Bill, Otl Aicher and Tomás Maldonado. Upon his return to Brazil he founded ESDI, the first design school in Brazil, together with Aloisio Magalhães, Karl Heinz Bergmiller and Goebel Weyne. Since 1962 Wollner has worked on the corporate identity development for some of the country's largest institutions. He runs his own consultancy Wollnerdesigno in São Paulo and is a frequent lecturer throughout the region and abroad.

Alexandre Wollner ist einer der angesehensten Designer in Brasilien, der seine Ausbildung 1950 am Institute of Contemporary Arts in São Paulo begann. Im Jahr 1953 verließ er sein Heimatland und setzte seine Studien in Deutschland an der Hochschule für Gestaltung in Ulm (1954 bis 1958) unter der Leitung von Koryphäen wie Max Bill, Otl Aicher und Tomás Maldonado fort. Kurz nach seiner Rückkehr nach Brasilien gründete er zusammen mit Aloisio Magalhães, Karl Heinz Bergmiller und Goebel Weyne die ESDI, die erste Designschule in Brasilien. Seit 1962 hat Wollner Corporate Identity-Projekte für einige der größten Institutionen des Landes entwickelt. Er leitet seine eigene Designberatung Wollnerdesigno in São Paulo und ist häufig als Dozent in der Region Lateinamerikas und im Ausland tätig.

Alexandre Wollner est l'un des graphistes les plus respectés du Brésil. Il a commencé sa formation en 1950 à l'Institut des Arts contemporains de São Paulo. En 1953, il est parti poursuivre ses études en Allemagne à la Hochschule für Gestaltung, à Ulm (de 1954 à 1958), sous la direction de sommités comme Max Bill, Otl Aicher et Tomás Maldonado. À son retour au Brésil il a fondé l'ESDI, la première école de graphisme en Brésil, avec Aloisio Magalhães, Karl Heinz Bergmiller et Goebel Weyne. Depuis 1962, Alexandre Wollner a travaillé sur le développement de l'identité de quelques-unes des plus grandes institutions du pays. Il dirige son propre cabinet Wollnerdesigno à São Paulo, et donne fréquemment des conférences dans toute l'Amérique latine et dans le monde.

3

8

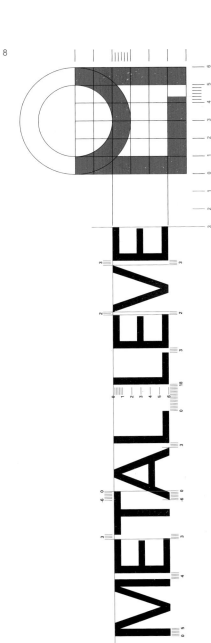

4

5

6

1. "Klabin" logo, 1979,
redesigned in 1999 and 2000

2. "São Paulo Petroleum"
logo, 1986, redesigned in 1996

3. "Cofap" (Mahle) logo, 1971,
Cofap automobile components

4. "Eucatex" logo, 1967,
redesigned in 2003

5. "Fechaduras Brasil" logo, 1987

6. "Instituto Brasileiro de Controle
do Cancer" logo, 2003

7

7–8. "Metal Leve" (Mahle)
modular systems for sign construction
and kerning between types, 1963,
Metal Leve automobile components

WONKSite

1

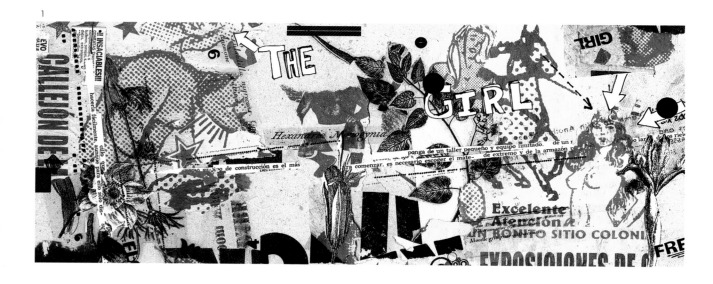

Jorge Restrepo's Wonksite is a creative website that has drawn a lot of interest to his graphic work. A graduate of the *Universidad Nacional de Colombia*, Restrepo now teaches typography at the *Universidad de Bogotá Jorge Tadeo Lozano*. In addition to his educational post, he also works as an art director for the advertising agency JWT in Colombia. With solid experience in editorial design for *Revista Cambio y Inter-Cambio*, his graphics have been widely published internationally, featuring in *IdN* (Hong Kong), *Web Design* (Korea), *Blank Magazine* (Chile, Spain), *Visual Magazine* (Canada), and *Axxis* (Colombia). He has also exhibited in Mar de Plata in Argentina, and Mambo in Colombia. In 2005 Restrepo was nominated as one of the top 100 designers in the country.

Jorge Restrepos Wonksite ist eine kreative Website, die viel Interesse für seine grafischen Arbeit geweckt hat. Restrepo schloss sein Studium an der Universidad Nacional de Colombia ab und lehrt nun Typografie an der Universidad de Bogotá Jorge Tadeo Lozano. Neben seiner Lehrtätigkeit arbeitet er zudem als Art Director für die Werbeagentur JWT in Kolumbien. Er sammelte gründliche Erfahrungen im Editorial Design für das Magazin *Cambio y Inter-Cambio*, und seine Grafiken wurden international in großem Umfang veröffentlicht, darunter in *IdN* (Hong Kong), *Web Design* (Korea), *Blank Magazine* (Chile, Spanien), *Visual Magazine* (Kanada) und *Axxis* (Kolumbien). Darüber hinaus stellte er in Mar de Plata in Argentinien und in Mambo in Kolumbien aus. 2005 wurde Restrepo als einer der 100 besten Designer des Landes nominiert.

Wonksite, le site web créatif de Jorge Restrepo, a attiré une grande attention sur son travail graphique. Diplômé de l'Universidad Nacional de Colombia, Jorge Restrepo enseigne actuellement la typographie à l'Universidad de Bogotá Jorge Tadeo Lozano. Parallèment à son poste d'enseignant, il est également directeur artistique pour l'agence de publicité JWT en Colombie. Il possède une solide expérience dans le design éditorial pour le magazine *Cambio y Inter-Cambio*, et ses œuvres graphiques ont beaucoup été diffusées dans le monde entier, notamment dans *IdN* (Hong Kong), *Web Design* (Corée), *Blank Magazine* (Chili, Espagne), *Visual Magazine* (Canada), et *Axxis* (Colombie). Il a également exposé à Mar de Plata en Argentine, et à Mambo en Colombie. En 2005, Jorge Restrepo a été désigné l'un des 100 meilleurs graphistes du pays.

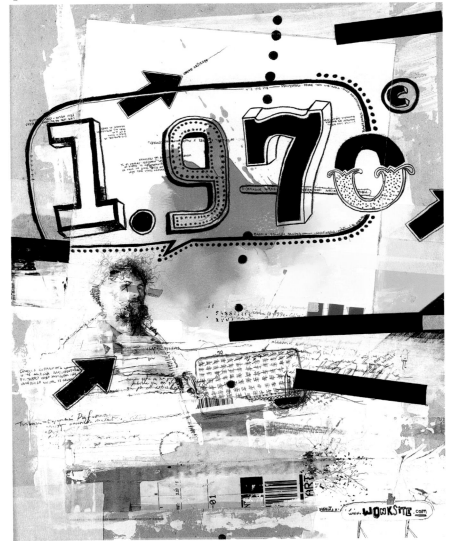

2

1. "The Girl" poster,
2004, Form&Form (USA)

2. "1970" poster,
2007, exhibition 34 Illustrators,
Galería El Nogal, Colombia

3. "ARRRRGH" t-shirt,
2007, La Gorguera

3

*1965, Mexico

MÓNICA ZACARÍAS

1

Mónica Zacarías' primary work is on editorial, always striving to design elegantly layouted books, making the best use of photography, composition and especially typography. Over the last few years, she has produced a number of publications for the Universidad Nacional Autónoma de México, Instituto Nacional de Antropología e Historia, and the Instituto Nacional de Bellas Artes, always proposing a blend of classic and contemporary design. Among her most acclaimed publications are *Art Déco: Un País Nacionalista, un México Cosmopolita, A Propósito de el Quijote*, and *África: Colección de los Museos de Bellas Artes de San Francisco*. Her talents have been recognised with three awards from the American Association of Museums in Washington DC.

Mónica Zacarías' hauptsächliche Arbeit liegt im Bereich Editorial Design. Bei ihren elegant gestalteten Büchern arbeitet sie mit dem optimalen Einsatz von Fotografien, Kompositionen und vor allem der Typografie. Während der letzten Jahre hat sie eine Reihe von Publikationen für die Universidad Nacional Autónoma de México, das Instituto Nacional de Antropología e Historia und das Instituto Nacional de Bellas Artes geschaffen und vermengte dabei stets ein klassisches mit zeitgenössischem Design. Ihre Publikationen *Art Déco: Un País Nacionalista, un México Cosmopolita, A Propósito de el Quijote* und *África: Colección de los Museos de Bellas Artes de San Francisco* haben dabei die größte Anerkennung gefunden. Ihre talentierte Arbeit brachte ihr drei Preise der American Association of Museums in Washington DC ein.

Mónica Zacarías travaille essentiellement dans le domaine du design éditorial. Elle cherche toujours à créer des maquettes de livres élégantes en tirant le meilleur parti des photographies, de la composition et tout particulièrement de la typographie. Au cours des dernières années, elle a produit plusieurs publications pour l'Universidad Nacional Autónoma de México, l'Instituto Nacional de Antropología e Historia, et l'Instituto Nacional de Bellas Artes, et leur a toujours proposé des concepts à la fois classiques et contemporains. Parmi ses publications les plus applaudies, on peut citer *Art Déco: Un País Nacionalista, un México Cosmopolita, A Propósito de el Quijote*, et *África – Colección de los Museos de Bellas Artes de San Francisco*. Son talent a été récompensé par trois prix de l'American Association of Museums de Washington DC.

1. "Art Deco. Un país Nacionalista
un México Cosmopolita"
exhibition catalogue, 1997,
Museo Nacional de Arte (INBA)

2. "Antologías Literarias
del Siglo XX" book series,
2000, Universidad Nacional
Autónoma de México

3. "El ropero de Frida"
book, 2007, Museo Frida Kahlo,
Casa Azul, Zweig Editoras
Photo Pablo Aguinaco,
Graciela Iturbide

ZONA DE OBRAS

1

Zona de Obras is the name of the studio run by graphic designers Marcelo Gabriele and Rubén Scarumizzino, both born in 1967. With offices in Buenos Aires and Zaragoza, Spain, they have, since 1995, focused on creating content and design for cultural, editorial and enterprises, as well as for many national idols in the music industry such as Andrés Calamaro, Daniel Melero, Auténticos Decadentes, Bunbury, ANIMAL, Coti, and Rosario Bléfari among many others. Zona de Obras established itself quickly using an irreverent and pop approach to graphic design, setting up their own music label, and a cultural magazine that has been on the market for over ten years now. Marcelo Gabriele is also a professor of the Architecture, Design and Urbanism course at the Universidad de Buenos Aires.

Zona de Obras ist der Name des Studios, das von den Grafikdesignern Marcelo Gabriele und Rubén Scarumizzino geleitet wird, beide 1967 geboren. In ihren Standorten in Buenos Aires und dem spanischen Saragossa konzentrieren sich die beiden Designer seit 1995 auf Content-Design für Kunden aus den Bereichen Kultur, Verlagswesen und Unternehmen. Außerdem arbeiteten sie für viele nationale Stars der Musik, unter anderem für Andrés Calamaro, Daniel Melero, Auténticos Decadentes, Bunbury, ANIMAL, Coti und Rosario Bléfari. Durch ihr respektloses und an der Popkultur orientiertes Vorgehen im Grafikdesign etablierte sich Zona de Obras sich schnell und gründete nicht nur ein eigenes Musiklabel, sondern auch eine Kulturzeitschrift, die bereits seit mehr als zehn Jahren auf dem Markt ist. Marcelo Gabriele ist zudem als Professor für Architektur, Design und Stadtplanung an der Universität Buenos Aires tätig.

Zona de Obras est le nom du studio que dirigent les graphistes Marcelo Gabriele et Rubén Scarumizzino, tous les deux nés en 1967. Avec des bureaux à Buenos Aires en Argentine et à Saragosse en Espagne, ils se concentrent depuis 1995 sur la création de contenus et de concepts dans les domaines de la culture, de l'édition et de l'entreprise, ainsi que pour de nombreuses idoles argentines et espagnoles de la musique comme Andrés Calamaro, Daniel Melero, Auténticos Decadentes, Bunbury, ANIMAL, Coti et Rosario Bléfari, pour n'en citer que quelques-uns. Zona de Obras s'est rapidement établi une réputation grâce à son approche irrévérencieuse et pop du graphisme. Le studio a créé sa propre maison de disques, et un magazine culturel qui a maintenant plus de dix ans d'existence sur le marché. Marcelo Gabriele est également professeur pour le programme d'architecture, graphisme et urbanisme de l'Universidad de Buenos Aires.

1. "Zona de Obras"
CD series, self-promotion

2. "Imágenes del Rock Argentino"
book

3. "Bunbury" CD packaging

*2004, Mexico, www.zoveck.com

ZOVECK ESTUDIO

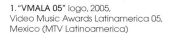

1. "VMALA 05" logo, 2005,
Video Music Awards Latinamerica 05,
Mexico (MTV Latinoamerica)

2. "Hemisphere" Illustration for magazine,
2004, Editorial Premiere

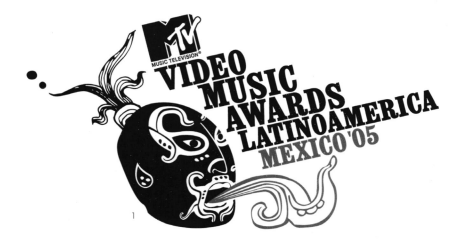

Zoveck Estudio is the creative salon of partners Sonia Romero and Julio "Valiente" Carrasco, who describe their approach to design as an exploration of the deep roots in the popular culture and modern everyday life in Mexico. Their illustrations have been featured in the New York-based magazine *3X3*, and in Mexican publications such as *Complot*, *Chilango* and *ArteMX*; they have also shown their work in a solo exhibition at the Museo de Arte de Zapopan in Jalisco. Romero and Carrasco lecture frequently on popular culture and graphic design, since their irreverent style aggregates most of the symbols, objects, figures and colours that represent the national identity of Mexico, such as *El luchador* (the famous masked wrestler).

Bei Zoveck Estudio handelt es sich um das Kreativstudio der Partner Sonia Romero und Julio „Valiente" Carrasco, die in ihrem Design die tiefen Wurzeln der volkstümlichen mexikanischen Kunst und des modernen Alltags erkunden. Ihre Illustrationen wurden in dem New Yorker Magazin *3X3* veröffentlicht sowie in mexikanischen Publikationen wie *Complot*, *Chilango* und *ArteMX*. Darüber hinaus haben die beiden Designer ihre Arbeiten in einer Einzelausstellung im Museo de Arte de Zapopan in Jalisco gezeigt. Romero und Carrasco halten häufig Vorlesungen über volkstümliche Kultur und Grafikdesign. Ihr respektloser Stil verbindet die meisten Symbole, Objekte, Figuren und Farben, die die nationale Identität Mexikos repräsentieren, wie zum Beispiel *El luchador* (der berühmte maskierte Ringkämpfer).

Zoveck Estudio est le salon créatif des partenaires Sonia Romero et Julio « Valiente » Carrasco, qui décrivent leur approche du graphisme comme une exploration des racines profondes de la culture populaire et de la vie quotidienne moderne au Mexique. Leurs illustrations ont été publiées dans le magazine new-yorkais *3X3* et dans des publications mexicaines telles que *Complot*, *Chilango* et *ArteMX* ; ils ont également présenté leurs œuvres lors d'une exposition en solo au Museo de Arte de Zapopan à Jalisco. Sonia Romero et Julio Carrasco donnent fréquemment des conférences sur la culture populaire et le graphisme, car leur style irrévérencieux utilise la plupart des symboles, des objets, des figures et des couleurs qui représentent l'identité nationale du Mexique, par exemple « el luchador » (le célèbre lutteur masqué).

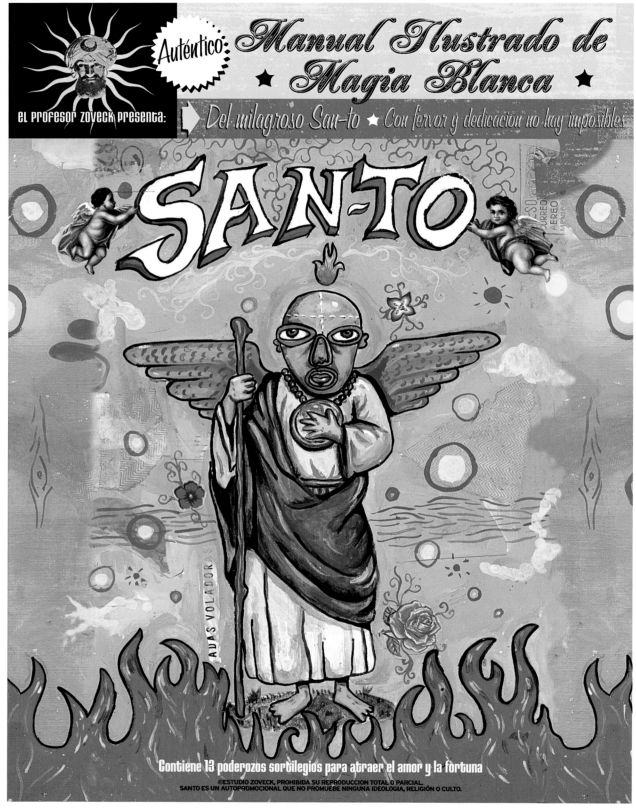

4

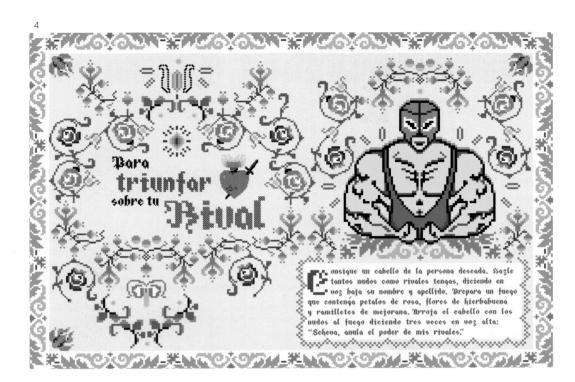

Consigue un cabello de la persona deseada. Hazle tantos nudos como rivales tengas, diciendo en voz baja su nombre y apellido. Prepara un fuego que contenga petalos de rosa, flores de hierbabuena y ramilletes de mejorana. Arroja el cabello con los nudos al fuego diciendo tres veces en voz alta: "Scheva, anula el poder de mis rivales."

5

3. "Illustrated Manual for White Magic"
booklet, 2004

4. "To Triumph Over Your Rival"
booklet illustration
(Manual for White Magic), 2004

5. "Zopilote Ramirez" toy design, 2005

DESIGNERS A-Z

6D Estúdio
www.6d.com.br
Rua Corcovado 250
22460-050 Rio de Janeiro RJ, Brazil
Phone: +55 21 2249 8163

A&J Asociados
Av. Montenegro 716
Galeria El Triunfo,
San Miguel
La Paz, Bolivia
Phone: +59 1 2277 5264

ABV Taller de Diseño
www.abvtaller.com
Calle Chaure, Quinta Cokoco,
Caracas 1041, Venezuela
Phone: +58 212 751 7828

Adé:Design
www.ade.com.ec
Miguel Cordero 6-50 y
Nicanor Aguilar, Of. 203
Cuenca, Azuay, Ecuador
Phone: +593 7 281 6182

Ahumada, Leonardo
Bloc-Diseño
www.blocdiseño.cl
Sánchez Fontecilla 1350
Las Condes,
Santiago, Chile
Phone: +56 2 716 1442

Ají Pintao
www.ajipintao.com
Calle 59 B Sur
Nuevo Reparto Paitilla #30
Panama City, Panama
Phone: +507 213 1612

Albornoz, Janet
http://shk-studio.blogspot.com
Calle 54, Obarrio
Panama City, Panama
Phone: +507 263 9300

Alderete, Jorge
www.jorgealderete.com
Alvaro Obregon 24-8
Col. Roma
Mexico City 06700, Mexico
Phone: +52 55 1998 4688

Alíes, Hugo
Estudio Alíes
www.estudioalies.com
Minas 937
11200 Montevideo, Uruguay
Phone: +598 2 419 4827

Almeida, Luis
Primero de Mayo 206, dept. 5
San Pedro de los Pinos,
03800 Distrito Federal, Mexico
Phone: +52 55 2614 4442

Alvarez, Rogelio López
Alex Dinamo Diseño
www.alexdinamo.com
López Cotilla 1238 Primer Piso
44160 Guadalajara
Jalisco, Mexico
Phone: +52 33 3124 1913

Ánima
www.anima.ec
Carrión E9-17 y Plaza, estudio 2D
Quito, Pichincha, Ecuador
Phone: +592 2 2239101

Arambarri, Eduardo Barrera
Neurografismos
www.neurografismos.com
Dr. Vértiz 976-302, Narvarte
Mexico City 03020, Mexico
Phone: +52 55 5536 6498

Aranda, Renato
Random House Mondadori S.A. de C.V.
http://arandagrafica.blogspot.com
Homero 544, Col. Chapultepec Morales
Mexico City 11570, Mexico
Phone: +52 55 3067 8400

Arbelo, Frank
Bolognia Plan 30 Calle 1 #26
La Paz, Bolivia
Phone: +591 2 272 3285

Armas, Annella
Tierra Chigüire
http://supertierrachiguire.com
Calle Cuira, Quinta Manoa
Colinas de Bello Monte
Caracas 1050, Venezuela
Phone: +58 212 751 8673

Augusto, Yomar
Voó
www.yomaraugusto.com
Mauritsweg 47 E
Rotterdam 3012JV
The Netherlands
Phone: +31 0 6 1550 9146

Azcuy, Ernesto
Catalografica Asterisco
Arte y Comunicación
Calle 12, esq. Av Hernando Siles,
dept. 202. Obrajes, La Paz, Bolivia
Phone: +591 2 70142246

Beltrán, Félix
Félix Beltrán + Asociados
Apartado Postal M-10733
Mexico City 06000, Mexico
Phone: +52 55 5526 3726

Berczeller, Dany
Bercz
www.bercz.com
Galvarino 347, dept. 502
Concepción, Chile
Phone: +56 41 226 8563

Bermúdez Aguirre, Diego Giovanni
Pontificia Universidad Javeriana
Facultad de Arquitectura y Diseño
www.javeriana.edu.co
Carrera 7, 40-62
Bogotá, Colombia
Phone: +571 320 8320 ext. 2388

Bermúdez, Xavier
Trama Visual A.C.
www.bienalcartel.org.mx
Av. Alvaro Obregón 73
Mexico City 06700, Mexico
Phone: +52 55 5525 9411

Bernardo + Celis
www.bernardocelis.com
Zapiola 2193 6-B
C1428CXE Buenos Aires, Argentina
Phone: +54 11 4115 2739

Bianco, Giovanni
GB65
www.giovannibianco.com
247 W 16 St 2nd Fl
New York, 10011 NY, USA
Phone: +1 212 367 9464

Blanco, Ricardo
www.ricardoblanco.netfirms.com
Bolívar 1162
1066 Buenos Aires, Argentina
Phone: +54 11 4361 5805

Boldrini & Ficcardi
www.bfweb.com.ar
Espejo 144
Piso 3, Of. 8
5500 Mendoza, Argentina
Phone: +54 261 423 1918

Brainpatch!
www.brainpatch.com
Rivadavia 82
Piso 2, Of. 1
5000 Cordoba, Argentina
Phone: +54 351 421 4034

Briones, Mairena
Eclética
http://eclecticapty.blogspot.com
Betania, calle 66 0, casa 625
Panama City 083400721, Panama
Phone: +507 261 2971

Burton, Victor
Victor Burton Design Gráfico
Avenida Calógeras 6/501
20030-070 Rio de Janeiro RJ, Brazil
Phone: +55 21 3532 8861

Cabañas, Benito
Abracadabra
www.abracadabra.com.mx
15 poniente 708 A
72000 Puebla, Mexico
Phone: +52 222 404 2056

Candia, Víctor
www.victorcandia.com
Ramirez de Velazco 227 7D,
1414 Buenos Aires, Argentina
Phone: +54 11 4856 4939

Cardia, Gringo
Mesosfera Produções Artísticas
www.gringocardia.com.br
Travessa Santa Leocádia 20
22061-050 Rio de Janeiro RJ, Brazil
Phone: +55 21 2547 0031

Cardoso, Julian
M79
www.visualgore.tv
Carrera 13, 94 A-26
57 Bogotá, Colombia
Phone: +571 651 6363

Castro, Dicken
dicken@cable.net.co
Carrera 8 #91.18, apto. 302
Bogotá Colombia
Phone: + 57 1 236 3763

Cauduro Martino
Cauduro Martino Arquitetos Associados
www.cauduromartino.com.br
Rua Alvarenga 2366
05509-006 São Paulo SP, Brazil
Phone: +55 11 3031 1911

Cha3
www.cha3grafico.com
Parral 4142
Chapultepec, Tijuana
22420 Baja California, Mexico
Phone: +52 664 621 9457

Chang, Eduardo
www.eduardochang.sv.tc
Urbanización Cumbres de Cuscatlán
final calle mezti, Pje #109
Antiguo Cuscatlán
San Salvador
La Libertad, El Salvador
Phone: +503 7729 4423

Corrales, Diego
Calle San Miguel de Anagaes E15-121
Quito, Pichincha, Ecuador
Phone: +593 2 326 3038

Correa de Boutaud, Raul
Revista Blank
Calle 66 San Francisco
Edif. Plaza Belen, Of. 202,
Panama City, Panama
Phone: +507 6667 9924

da Costa Aguiar, João Baptista
Costa Aguiar Desenho Gráfico Ltda
www.joaobaptista.art.br
Rua Itacolomi 523 apt. 2B, Higienópolis
01239-020 São Paulo SP, Brazil
Phone: +55 11 3214 5823

Couto, Ana
Ana Couto Branding Design
www.anacouto.com.br
Praça Santos Dummont 80
22470-060 Rio de Janeiro RJ, Brazil
Phone: +55 21 3205 9970

Covarrubias, Felipe
Galeriazul
www.galeriazul.com.mx
Bruselas 336
Col. Americana, Guadalajara
44200 Jalisco, Mexico
Phone: +52 33 3826 9190

Coyotl Mixcoatl, José Luis
Co_ld Design
www.coyotelabofdesign.com
Tepeyaotla 102, dept. 1
San Bernardino Tlaxcalancingo
San Andrés Cholula
72820 Puebla, Mexico
Phone: +52 222 889 2089

Cuartopiso
www.cuartopiso.com
Calle 13, 43E-27, dept. Antioquia
Region Valle de Aburrá
Medellín, Colombia
Phone: +574 352 0563

Di Patrizio, Damián
www.22-10-78.com
Viamonte 216
X5004AUF Córdoba, Argentina
Phone: +54 351 451 3569

Díaz Milano, Aixa
Av. Río de Janeiro
Edif. Trébol apt. 4-C, Chuao
Caracas 1061, Venezuela
Phone: +58 212 991 4129

Dieterich, Claude
Dieterich Design
www.claudedieterich.com
1114 Sutter Street, apt. 10
San Francisco, 94109 CA, USA
Phone: +1 214 345 1773

Diseño Shakespear
www.shakespearweb.com
Dardo Rocha 2754
B1640FTN Buenos Aires, Argentina
Phone: +54 11 4836 1333

Doma
www.doma.tv
Cramer 3425, dept. 4
1429 Buenos Aires, Argentina
Phone: +54 11 4703 5257

eg.design
www.egdesign.com.br
Av. Ataulfo de Paiva 135/917
22440-030 Rio de Janeiro RJ, Brazil
Phone: +55 21 2274 9247

El Pobre Diablo
www.elpobrediablo.com
Isabel La Católica E12-06 y Galavis
esquina, Quito, Pichincha, Ecuador
Phone: +592 2 223 5194

Elastic People
www.elasticpeople.com
4141 NE 2nd ave, suite 108
Miami, 33137 FL, USA
Phone: +1 305 573 3434

Éramos Tantos
www.eramostantos.com.mx
Suiza 16, Portales Ote
Mexico City 03300, Mexico
Phone: +52 55 5674 1516

Estrella, Paco
www.pacoestrella.com
Robles Gil 143, Col. Americana
Guadalajara, 44160 Jalisco, Mexico
Phone: +52 0133 3587 2580

Estudio Cabina
www.espaciocabina.com.ar
Gavilán 2676 – 78
C1416ADD Buenos Aires, Argentina
Phone: +54 11 4583 4517

Eyer, Leonardo
Caótica
www.caotica.com.br
Rua Visconde de Carandaí 28
22460-020 Rio de Janeiro RJ, Brazil
Phone: +55 21 3204 9355

Farah, Rafic
São Paulo Criação
www.saopaulocriacao.com.br
Rua Gonçal Afonso 71
05436-100 São Paulo SP, Brazil
Phone: +55 11 3816 3334

Faria, Heloisa
19 Design e Editora Ltda
www.19design.com.br
Av. Epitacio Pessoa 3724/101
22471-001 Rio de Janeiro RJ, Brazil
Phone: +55 21 2527 1230

Farkas, Kiko
Máquina Estúdio
www.kikofarkas.com.br
Rua Cônego Eugenio Leite 920
05414-001 São Paulo SP, Brazil
Phone: +55 11 3088 4228

Fileni Fileni
www.filenifileni.com
Av. L.N. Alem 592, Catalinas
C1001AAN, Buenos Aires, Argentina
Phone: +54 11 4313 2262

Fontana, Rubén
Fontanadiseño
www.fontana-d.com
Viamonte 454
C1053ABJ, Buenos Aires, Argentina
Phone: +54 11 4311 1568

Fuentes, Rodolfo
Rodolfo Fuentes Design
www.rodolfofuentes.com
Bernardina Fragoso de Rivera 1517
apt. 202,
11600 Montevideo, Uruguay
Phone: +598 2 903 0552

GAD' Branding & Design
www.gad.com.br
Rua do Rócio 288
04552-000 São Paulo SP, Brazil
Phone: +55 11 3040 2222

Gálvez, Paco
Universidad de Oriente
http://pacogalvez.blogspot.com
21 Oriente 1816
72501 Puebla, Mexico
Phone: +52 222 211 1698

García Balza, Estudio
Estudio de Diseño García Balza
www.garciabalza.com.ar
Tres Sargentos 436, dept. A y H
1054, Buenos Aires, Argentina
Phone: +54 11 4312 5758

García Barcha, Gonzalo
www.gonzalogarciabarcha.com
24 ave. Junot
Paris 75018, France
Phone: +33 01 4257 8448

Garzón, Javier
CRA 13A, 19-56 Sur
Bogotá 0619, Cundinamarca
Colombia
Phone: +57 1 278 6984

Giotto/Latinbrand
www.latin-brand.com
Juan González N35-135
e Ignacio San María, Of. 606,
Quito, Pichincha, Ecuador
Phone: +593 2 246 1075

Giraldo, Luis
Instituto de Diseño Darias
Calle Coromoto, Quinta Marta
Bello Monte
Caracas 1050, Venezuela
Phone: +58 212 941 4352

González Ruiz, Guillermo
www.gonzalezruizdesign.com.ar
Estrada 2670, Martínez
B1640ACD, Buenos Aires, Argentina
Phone: +54 11 4792 0434

González Sáiz, Cristián
www.estudiogonzalez.cl
Espoz 4171, Vitacura
Santiago, Chile
Phone: +56 2 263 6032

GuaZa Estudio Creativo
www.guazastudio.com
Cumbres de Cuscatlan
Av. Lempa y Calle Xochiquetzal L-4
Antiguo Cuscatlan, 503
La Libertad, El Salvador
Phone: +503 2243 3298

Hachetresele
www.hachetresele.com
Belgrano 1050, Of. 26
Neuquén
8300 Patagonia, Argentina
Phone: +54 299 443 3064

Henríquez Lara, Javier
Henriquezlara Estudio
www.henriquezlara.com
Nelson 398 – Int, dept. 10,
Fraccionamiento Terranova,
Guadalajara
44689 Jalisco, Mexico
Phone: +52 33 1280 8377

Hernández, José Alberto
Teoretica
www.josealberto_espaciosvacios.com
Paso Ancho, Monte Azul, casa 3R
San José, Costa Rica
Phone: +506 2226 4207

Hula Hula
www.hulahula.com.mx
Miramontes 2320
04460 Mexico City DF, Mexico
Phone: +52 55 5684 7362

Ideas Frescas
www.ideas-frescas.com
Edif. Eben Ezer, Boulevard Sur
Santa Elena, Antiguo Cuscatlan
La Libertad, El Salvador
Phone: +503 7888 4256

Ideo Comunicadores
www.ideo.com.pe
Av. Reducto 864, Of. 1502
Miraflores
Lima 09, Peru
Phone: +51 1 446 6015

Ideograma Consultores
www.ideograma.com
Privada Puerto Escondido 18
Fraccionamiento Bugambilias
Cuernavaca
62140 Morelos, Mexico
Phone: +52 777 313 8466 ext. 101

Imagen HB
www.imagenhb.com
Av. Federico Lacroze 3280
C1426CQS Buenos Aires, Argentina
Phone: +54 11 4553 0101

In Jaus Design
www.injaus.com
Av. Melián 2752,
C1430EYH Buenos Aires, Argentina
Phone: +54 11 4546 8000 int. 3790

Interface Designers
www.interfacedesigners.com.br
Rua Urbano Santos 17
22290-260 Rio de Janeiro RJ, Brazil
Phone: +55 21 2244 5746

Klotzel, Ruth
Estudio Infinito
www.estudioinfinito.com.br
Rua Dr. Cicero de Alencar 58
05580-080 São Paulo SP, Brazil
Phone: +55 11 3726 9078

Kontra
www.kontra.ws
K 34, 26B-141
Santiago de Cali
Valle del Cauca, Colombia
Phone: +57 2 335 5726

Kunst, Pablo
www.pablokunst.com.ar
Rioja 2074
2000 Rosario, Argentina
Phone: +54 341 449 4955

La Silueta
www.lasilueta.com
Cra 20, 39-57,
Bogotá, Cundinamarca, Colombia
Phone: +571 327 3181

Lacabeza Estudio
www.lacabezacr.com
Apdo Postal 865-2070, Sabanilla,
Urbanización el Rodeo, casa 68
San José, Costa Rica
Phone: +506 820 8385

Lacaz, Guto
www.gutolacaz.com.br
Rua Pamplona 857
01405-001 São Paulo SP, Brazil
Phone: +55 113288 5321

Laika
Laika Comunicadores
www.laikaonline.com
Calle Piura 740 – B
Miraflores
Lima 18, Peru
Phone: +51 1 447 2688

Lange, John
Instituto de Diseño Darias
Calle Coromoto entre
Av. Casanova y Venezuela
Urb. Bello Monte.
Caracas. Venezuela.
Phone: +58 212 952 4867

Larghero, Marcos
Larghero DG
Quijote 2665
11600 Montevideo, Uruguay
Phone: +598 2 4808478

Larrea, Vicente
www.larrea.cl
Av. Los Leones 2896
Santiago, Chile
Phone: +56 2 327 2900

Leite, Ricardo
Crama Design Estratégico
www.crama.com.br
Rua Marquês de São Vicente 22/302
22451-040 Rio de Janeiro RJ, Brazil
Phone: +55 21 25128555

Lins, Rico
Rico Lins+Studio
www.ricolins.com
Rua Campevas 617
05016-010 São Paulo SP, Brazil
Phone: +55 11 3675 3507

Loor, Maria
Maria Loor | Visual Art & Design
www.marialoor.com
12196 SW 124th Path
Miami, 33186 FL, USA
Phone: +1 786 293 2647

Luna, Sara
www.bdmark.com
Robles Gil 143, Col. Americana
Guadalajara, 44160 Jalisco, Mexico
Phone: +52 33 3587 2580

Maca
Gustavo Wojciechowski
Buenso Aires 421, apt. 4
11000, Montevideo, Uruguay
Phone: +598 2 915 2941

Machicao, Susana
Machicao Design
www.machicaodesign.com
Av. Costanera 1000, Edificio Gala 3B
Casilla de Correo
La Paz 08193, Bolivia
Phone: +591 2 277 0996

Magallanes, Alejandro
La Maquina del Tiempo
www.lmtgrafica.com
Av. Universidad 464-A, Col. Narvarte,
Delegación Benito Juárez
Mexico City 03600, Mexico
Phone: +52 55 1107 7746

Martínez, Domingo Noé
Estudio La Fe Ciega
www.lafeciega.com
Maximino Avila Camacho 21-405,
Col. Ciudad de los Deportes
Mexico City 03710, Mexico
Phone: +52 55 5611 0608

Martinez, Marcelo
Laboratorio Secreto
www.laboratoriosecreto.com
Rua Capistrano de Abreu 44/101
22271-000 Rio de Janeiro RJ, Brazil
Phone: +55 21 2539 3146

Martino, Octavio
Martino Graphic Design
www.martinoweb.com.ar
Buenos Aires 560 – 4 E
5000 Córdoba, Argentina
Phone: +54 351 421 1891

MASA
www.masa.com.ve
1ra. Av. con 2da Transv.
Edificio Tibisay, Torre B, Piso 2
Caracas, 1062, Venezuela

Mathon, Pablo
xCOLITTx art+design
www.xcolittx.com.ar
Loyola 1073, Piso 13, depto. A
1414 Buenos Aires, Argentina
Phone: +54 11 4775 9495

Mena, Belén
www.belenmena.com
Manuel María Sánchez E12-158
Quito, Pichincha, Ecuador
Phone: +593 2 600 0455

Menéndez, Pepe
Casa de las Américas
3ra. y G, el Vedado
Habana 1400, Cuba
Phone: +53 7 838 2717

Menezes, Christiano
Retina78
www.retina78.com.br
Praia de Botafogo 148/501
22250-040 Rio de Janeiro RJ, Brazil
Phone: +55 21 2551 5016

Monitor, Estudio
www.estudiomonitor.com
Paris 1394, Col. Arcos Vallarta
Guadalajara, 44140 Jalisco, Mexico
Phone: +52 0133 3630 3837

Mono
www.wearemono.com
Av. Rio Babahoyo 34
Entrerios
Guayaquil, Guayas, Ecuador
Phone: +593 9 449 4174

Montalvo, Germán
German Montalvo Estudio
Calle del trabajo 31`
Col. La Fama
Mexico City 14269, Mexico
Phone: +52 222 409 8833

Montes de Oca, Héctor
Tiypo
www.tiypo.com
Cerro de las Torres 23 Int. 102,
Col. Campestre Churubusco
Mexico City 04200, Mexico
Phone: +52 55 3200 2825

Moore, John
www.johnmoore.com.ve
Calle Auyantepuy
Edf. Florissant, apt. 41, Piso 4
Colinas de Bello Monte
Caracas, Venezuela
Phone: +58 212 285 1814

Morelos, José Manuel
Facultad de Artes Plásticas
de la Universidad Veracruzana
http://dobleu.50webs.com/morelos
Belisario Dominguez 25
Xalapa
91000 Veracruz, Mexico
Phone: +228 817 3120

Moya Peralta, Rómulo
Trama
www.trama.ec
Juan de Dios Martinez N34-367 y Portugal
Quito, Pichincha, Ecuador
Phone: +593 2 224 6315

Muñoz Díaz, Fabián
San Ignacio 22 esq. a Empedrado
Plaza de la Catedral, Habana Vieja
Habana 10100, Cuba
Phone: +53 7 832 1557

Nahón
www.nahon.com.ar
El Salvador 5935
C1414BQK, Buenos Aires, Argentina
Phone: +54 11 47743663

Naranjo, Julián
www.naranjo.cl
Presidente Riesco 3170, Las Condes
7550037, Santiago, Chile
Phone: +56 2 833 0930

Negro
www.negronouveau.com
Avenida San Isidro 4311 5A Nuñez
C1429ADQ Buenos Aires, Argentina
Phone: +54 11 47025851

Olivares, Eric
Cocina Gráfica
www.ericolivares.com
Diputació, 20, 3ro, 3ra
Barcelona 8015, Spain
Phone: +34 93 424 7823

Oliver, Patricio
PO!
www.patriciooliver.com.ar
Vicente Lopez 1747 6E
1425 Buenos Aires, Argentina
Phone: +54 11 48140943

OZ Design
www.ozdesign.com.br
Av. Eng. Luís Carlos Berrini 1461
04571-903 São Paulo SP, Brazil
Phone: +55 11 5112 9200

Padilla, Elman
www.elmanpadilla.com
Sheik Zayed
1st. Jernain Tower
Block B Flat 1403
Abu Dhabi, United Arab Emirates
Phone: +971 50 721 6106

Palleiro, Carlos
www.carlospalleiro.com.mx
Insurgentes Sur 3493, Edif. 7, dept. 401
Villa Olímpica
Mexico City 14020, Mexico
Phone: +52 55 5665 2868

Paranoia Corp
www.paranoiacorp.com
Calle 54, Obarrio
Panama City, Panama
Phone: +507 263 9300

Pérez "Ñiko", Antonio
Escuela Gestalt de Diseño
Av. 1 de mayo 113, Col. Obrero Camesina
Xalapa, 91020, Veracruz, Mexico
Phone: +52 228 840 5500

Periche, Lourdes
L. Periche Agencia Creativa
www.lperiche.com
Gustavo Mejía Ricart 37, Naco, Santo
Domingo, 10124, Dominican Republic
Phone: +809 368 0061

Pimenta, Fernando
www.pimentadesign.com
Rua Intendente Costa Pinto 349
22611-290 Rio de Janeiro RJ, Brazil
Phone: +55 21 2493 1249

Pintos, Ariel
www.arielpintos.com
Calle Cuira, Quinta Manoa,
Colinas de Bello Monte, Miranda,
Caracas 1050, Venezuela
Phone: +58 212 751 8673

Pol, Santiago
Universidad Nacional Experimental
del Yaracuy
Avenida Cedeño 9-26
Quinta San Rafael
3201 San Felipe, Yaracuy, Venezuela
Phone: +58 254 232 5061

Ponce, Nelson
Casa de las Américas
www.lajiribilla.cu/camaleon/nelson
3ra. y G, el Vedado
Habana 1400, Cuba
Phone: +53 7 838 2717

Pozo Marcic Ensemble
www.ensemble.cl
Andrés de Fuenzalida 17 #62
7510077 Santiago, Chile
Phone: +56 2 232 8688

Prieto, Celeste
Celeste Prieto Diseño
www.celesteprieto.com
Ulrico Scmidl 199 Esquina Quesada
Asunción, Paraguay
Phone: +595 21 608 796

Pump Design
www.pumpd.com.ar
Virrey del Pino 2632 13G
1426 Buenos Aires, Argentina
Phone: +54 11 4783 1366

Punga
www.punga.tv
Conesa 1037
CP1426AQU Buenos Aires, Argentina
Phone: +54 11 4554 9306

Ramos, Elaine
Cosac Naify
www.cosacnaify.com.br
Rua General Jardim 770
01223-010 São Paulo SP, Brazil
Phone: +55 11 3218 1440

Randolph, Muti
www.muti.cx
Praia de Botafogo 68/601
22250-040 Rio de Janeiro RJ, Brazil
Phone: +55 21 2551 2692

RDYA
RDYA Design Group
www.rdya.com.ar
Av. Libertador 6570–3A
C1428ARV Buenos Aires, Argentina
Phone: +54 11 4115 1500

Restrepo, Marcela
www.lefthandside.com
Unit 5, 28 Bray Street, Erskineville
Sydney NSW 2043, Australia
Phone: +61 2 9519 9863

Revolver Industries Inc.
www.elrevolver.com
Calle 4ta Sur San Francisco
Chalet 15, Suite 6014
Box 0830-00200, Zona 9
Panama City, Panama
Phone: +507 226 1272

Rioseco Gaggero
www.randg.cl
Nueva Costanera 4076
Santiago, Chile
Phone: +56 2 0953 5187

Rock Instrument Bureau
www.rockinstrumentsite.com.ar
Demaría 4617
C1425AEE Buenos Aires, Argentina
Phone: +54 11 4777 1991

Rodríguez, Gabriela
Estudio Gabriela Rodríguez
www.gabrielarodriguez.com.mx
Puerto Real 47 Int 8, Col. Condesa
Mexico City 06140, Mexico
Phone: +52 55 5286 0750

Roedán, Elías
Casa de Chavon
Gustavo Mejia Ricart 50, Naco
Santo Domingo 10124
Dominican Republic
Phone: +809 922 9850

Rojo, Vicente
Dulce Olivia 141, Coyoacán
Mexico City 04000, Mexico
Phone: +52 55 5554 9328

Ros, Alejandro
www.alejandroros.com.ar
Cordoba 435 3D
1054 Buenos Aires, Argentina
Phone: +54 11 4312 2424

Rovalo, Pablo
Research Studios Barcelona
www.researchstudios.com
Carrer de la Riera 14 Primero
Barcelona 08172, Spain
Phone: +34 936 750 753

Ruiz Gómez, Lonnie
ARCO Producciones S.A.
http://pinol-ilustrado.blogspot.com
C.C. San Francisco
módulo C-3, planta alta
Managua, Nicaragua
Phone: +505 277 5070

Sáez Matos, Sofía
PO Box 9023072
San Juan 00902-3072, Puerto Rico
Phone: +787 748 4551

Salas, Ricardo
Frontespizio
www.frontespizio.com.mx
Fray Garcia Guerra 115
Lomas de Chapultepec, Virreyes
11000 Mexico City, Mexico
Phone: +52 5520 5189

Salgado, Esteban
Velesi Brand Consultancy
www.esdesignow.com
Av. Amazonas N42-40 y
Tomás de Berlanga
Quito, Pichincha, Ecuador
Phone: +593 2 601 0060

Sánchez, Antonio
Antonio Sánchez
http://homepage.mac.com/titonio
Camino Real al Ajusco 491
Tepepan, Xochimilco
Mexico City 16020, Mexico
Phone: +52 55 5653 0716

Sánchez, Ólger
Originarte S.A.
www.originarte.net
P.O. Box 1209-1000
San José, Costa Rica
Phone: +506 8848 0834

Schafer, Daniel
Uva Prodocshons
www.uvaproyectos.com
29 Av. A 3-38 zona 15
Pasadena II, apto. 5, San Lazaro
Guatemala 01015, Guatemala
Phone: +502 5955 3232

Sclavo, Fidel
Avenida Libertador 336 – 4C
1001 Buenos Aires, Argentina
Phone: +54 11 4312 5363

Sin Título/Revista Taxi
www.revistataxi.com
21 Av. B 0-92 zona 15 VH2
Guatemala 01015, Guatemala
Phone: +502 5511 4122

Sotillo, Álvaro
Calle Amazona
Quinta Sarisariñama 86
Prados del Este
1080 Caracas, Venezuela
Phone: +58 212 978 0105

Souza, Jair de
Vinte Zero Um
www.vintezeroum.com
Rua Humaitá 85/201
22261-000 Rio de Janeiro RJ, Brazil
Phone: +55 21 2527 0742

Stein, Luiz
Luiz Stein Design (LSD)
Rua Fernando Magalhães 234
22460-210 Rio de Janeiro RJ, Brazil
Phone: +55 21 2512 9164

Studio A
www.studioa.com.pe
Av. Salaverry 3328
San Isidro, Lima 17, Peru
Phone: +51 1 264 2888

Szaniecki, Barbara
Do Lar Design Ltda
Rua Redentor 209/301
22421-030 Rio de Janeiro RJ, Brazil
Phone: +55 21 25217256

Taborda, Felipe
Rua Duque Estrada 57/101
22451-090 Rio de Janeiro RJ, Brazil
Phone: +55 21 3874 5653

Tecnopop
www.tecnopop.com.br
Praia do Flamengo 100/1101
22210-030 Rio de Janeiro RJ, Brazil
Phone: +55 21 2558 2033

Terreros, Oswaldo
Markka Registrada
www.markkaregistrada.com
Av. Carlos Julio Arosemena, Km 2.5,
Edificio Maqsum, Of. 5
Guayaquil, Guayas, Ecuador
Phone: +593 4 600 2685

Tesis DG
www.tesisdg.cl
Eljuri atrás del Edificio Maqsum,
Local PB2,
765 0130 Santiago, Chile
Phone: +56 2 474 0764

Tholön Kunst
www.tholon.com
Crámer 640, 1° A
C1425ANN Buenos Aires, Argentina
Phone: +54 11 4555 3329

Torres, Luis Eduardo
La Flama
www.laflama.com
Huichapan 10
Col. Hipodromo Condesa
Mexico City 06170, Mexico
Phone: +52 55 5256 0101 ext. 137

Tossin, Clarissa
www.a-linha.org
725 North Western Avenue, suite 209
Los Angeles
90029 CA, USA
Phone: +1 323 791 4866

Tostex, Estúdio
www.tostex.com
Rua Conceição de Monte Alegre 1454
04559-011 São Paulo SP, Brazil
Phone: +55 11 5505 6127

Typo 5
www.typo5.com
Cra 17 #89-17
Edificio ARTA, Suite 611
Bogotá, Cundinamarca
Colombia
Phone: +57 1 636 9666

Van Steen, Ricardo
Tempo Design
www.tempodesign.com.br
Rua Itaquera 423, Pacaembu
01246-030 São Paulo SP, Brazil
Phone: +55 11 3661 7320

Vega Camacho, Sergio
Irpa Luraña
Campos 296 PB
esq. 6 de Agosto
La Paz, Bolivia
Phone: +591 2 243 4649

Villacinda, Luis
Dosalcuadrado
26 Calle 32-31 Z5
Col. Vivibien
Guatemala 01005, Guatemala
Phone: +502 5715 0717

Villagómez Paredes, Carlos
Siñani Design
http://carlosvillagomez.blogspot.com
Prolongación Cordero 404
La Paz 2093, Bolivia
Phone: +591 2 243 3552

Wollner, Alexandre
Wollner Designo
www.wollnerdesigno.com.br
Rua Cel. Palimércio de Resende 287
05505-010 São Paulo SP, Brazil
Phone: +55 11 3815 2020

Wonksite
www.wonksite.com
Calle 51, 13-70, dept. 401
00619 Bogotá, Colombia
Phone: +571 255 1724

Zacarías, Mónica
Fuente de la Infancia 35, dept. 9,
Fuentes del Pedregal
Mexico City 14140, Mexico
Phone: +52 55 26153773

Zona de Obras
www.zonadeobras.com.ar
Cabrera 5488, Of. 1 y 2
C1414HB, Buenos Aires, Argentina
Phone: +54 11 47780395

Zoveck Estudio
www.zoveck.com
Córdoba 219-301
Col. Roma Norte
Mexico City 06700, Mexico
Phone: +52 55 52649011

ASSOCIATIONS

ARGENTINA
Asociación de Diseñadores en
Comunicación Visual de Buenos Aires
www.adcv.org.ar

Asociación de Diseñadores en
Comunicación Visual de Jujuy
www.adcvjujuy.com.ar

Centro Metropolitano de Diseño
www.cmd.gov.ar

Rede Argentina de Design
www.redargenta.com.ar

Unión de Diseñadores Gráficos
de Buenos Aires
www.udgba.com.ar

BRAZIL
Associação dos Designers Gráficos
www.adg.org.br

Design Brasil
www.designbrasil.org.br

CHILE
Asociación Chilena de Empresas
de Diseño (Qvid)
www.qvid.cl

Colegio de Diseñadores de Chile
www.colegiodisenadores.cl

COLOMBIA
Asociación de Diseñadores Gráficos
www.adgcolombia.org

Red Académica de Diseño de Colombia
www.radcolombia.com

COSTA RICA
Directorio de Diseñadores Costarricenses
www.directoriodedisenadores.go.cr

CUBA
Comite Prográfica Cubana
www.prografica.cult.cu

DOMINICAN REPUBLIC
Asociación de Diseñadores Gráficos
de Santiago
www.digraf.org

GUATEMALA
Asociación de Diseñadores Industriales
de Guatemala (ADIG)
http://adigweb.com

HONDURAS
Círculo Creativo de Honduras
http://elcirculodehonduras.blogspot.com

MEXICO
Trama Visual
www.bienalcartel.org.mx

Encuadre A.C.
www.encuadre.org

PANAMA
Panamá Gráfico
www.panamagrafico.com

PARAGUAY
Círculo de Creativos del Paraguay
www.elcirculo.net

Asunción Suma
www.asuncionsuma.com

VENEZUELA
Asociación de Diseñadores Gráficos
www.adgv.org

Galería Venezolana de Diseño
http://gavedi-iddar.blogspot.com

EDUCATION

ARGENTINA
Universidad de Buenos Aires
www.uba.ar

Facultad de Arquitectura,
Diseño y Urbanismo
www.fadu.uba.ar

Universidad de Palermo
www.palermo.edu.ar

Universidad de Mendoza
www.um.edu.ar

Universidad Blas Pascal
www.ubp.edu.ar

Universidad Nacional de Tucumán
www.unt.edu.ar

Universidad de Belgrano
www.ub.edu.ar

Universidad Nacional de La Plata
www.unlp.edu.ar

Escuela de Diseño en el Hábitat
www.edh.edu.ar

Instituto Superior Comunicación Visual
www.cvisual.edu.ar

BOLIVIA
Universidad Católica Boliviana
www.ucb.edu.bo

Universidad Privada de Santa Cruz
de la Sierra
www.upsa.edu.bo

Universidad Privada Boliviana
www.upb.edu

BRAZIL
Centro Universitário Senac
www.sp.senac.br

Escola Superior de Propaganda &
Marketing – ESPM
www.espm.br

Faculdade SENAI de Tecnologia Gráfica
www.sp.senai.br

Istituto Europeo di Design (São Paulo)
www.iedbrasil.com.br

Centro Pernambucano de Design
www.centropedesign.com.br

Escola Superior de Desenho Industrial
ESDI
www.esdi.uerj.br

Panamericana
Escola de Arte e Design
www.escola-panamericana.com.br

Instituto de Ensino Superior de Bauru
www.iesbpreve.com.br

Pontifícia Universidade Católica
do Paraná
www.pucpr.br

Pontifícia Universidade Católica
do Rio de Janeiro
www.puc-rio.br

UniverCidade
www.univercidade.edu

Universidade de Brasília
www.unb.br

Universidade de Caxias do Sul
www.ucs.br

Universidade Federal do Paraná
Design Department
www.design.ufpr.br

Universidade Mackenzie
www.mackenzie.br

Universidade Federal de Santa Catarina
www.ufsc.br

CHILE
Universidad de Chile
www.uchile.cl

Universidad de Valparaiso
www.uv.cl

Universidad del Bío-Bío
www.ubiobio.cl

Universidad Tecnológica de Chile
www.inacap.cl

Universidad de las Américas
www.uamericas.cl

Universidad del Pacífico
www.upacifico.cl

Universidad Santo Tomas
www.ust.cl

Universidad Mayor
www.umayor.cl

Universidad Diego Portales
www.udp.cl

Universidad de la Republica
www.ulare.cl

COLOMBIA
Fundación Universitaria del Área Andina.
www.areandina.edu.co

Universidad Pontificia Bolivariana
www.upm.edu.co

Universidad Autónoma de Occidente
www.uao.edu.co

Universidad de Caldas
www.ucaldas.edu.co

Universidad Jorge Tadeo Lozano
www.utadeo.edu.co

Pontificia Universidad Javeriana
www.javeriana.edu.co

Universidad Nacional de Colombia
www.unal.edu.co

Universidad de los Andes
www.uniandes.edu.co

COSTA RICA
Universidad Veritas
www.uveritas.ac.cr

Universidad de Costa Rica
www.ucr.ac.cr

Instituto Tecnológico de Costa Rica
www.itcr.ac.cr

CUBA
Instituto Superior de Diseño Industrial (ISDi)
Phone: +53 7 781 729

DOMINICAN REPUBLIC
Escuela de Diseño Altos de Chavon
www.altosdechavon.com

UNAPEC
www.unapec.edu.do

Universidad Iberoamericana (UNIBE)
www.unibe.edu.do

ECUADOR
Universidad Casa Grande
www.casagrande.edu.ec

Universidad Santa Maria
www.usm.edu.ec

Universidad Metropolitana
www.umetro.edu

EL SALVADOR
Universidad Dr. José Matía Delgado
www.ujmd.edu.sv

Escuela de Comunicación
Mónica Herrera (ECMH)
www.monicaherrera.edu.sv

Universidad Don Bosco
www.udb.edu.sv

GUATEMALA
Universidad de San Carlos de Guatemala
www.usac.edu.gt

Universidad Rafael Landivar
www.url.edu.gt

Universidad del Istmo
www.unis.edu.gt

HONDURAS
Centro de Diseño, Arquitectura y
Construcciòn (Cedac)
www.cedac.edu.hn

Universidad Tecnológica
Centroamericana
www.unitec.edu

MEXICO
Universidad Autónoma Metropolitana
www.uam.mx

Universidad Iberoamericana
www.uia.mx

Instituto Nacional de Bellas Artes
Escuela de Diseño
www.bellasartes.gob.mx

Escuela Nacional de Artes Plásticas
www.enap.unam.mx

Escuela Gestalt de Diseño Xalapa
www.gestalt.edu.mx

Universidad Anahuac (México Norte)
www.anahuac.mx

Universidad Autónoma de San Luis Potosi
www.uaslp.mx

Universidad Autónoma de Aguascalientes
www.uaa.mx

Universidad de Guanajuato
www.disenougto.com

Universidad Autónoma de México
www.uacm.edu.mx

Colegio de Diseñadores (CODIGRAM)
www.codigram.org

NICARAGUA
Universidad Politécnica de Nicaragua
www.upoli.edu.ni

Fundación Casa de los Tres Mundos
www.c3mundos.org

PANAMA
Universidad de Panamá
www.up.ac.pa

Universidad Católica Santa María
la Antigua
www.usma.ac.pa

Universidad del Arte Ganexa
www.ganexa.com

PARAGUAY
Universidad Católica Nuestra Señora
de la Asunción
www.uc.edu.py

Universidad Americana
www.uamericana.edu.py

Universidad Nacional de Asunción
www.una.py

Universidad Columbia
www.columbia.edu.py

PERU
Instituto Toulouse-Lautrec
www.toulouse.edu.pe

Pontificia Universidad Católica del Perú
www.pucp.edu.pe

Universidad San Ignacio de Loyola
www.sil.edu.pe

PUERTO RICO
Escuela de Artes Plásticas
de Puerto Rico
www.eap.edu

Atlantic College
www.atlanticcollege.edu

URUGUAY
Universidad ORT Escuela de Diseño
www.ort.edu.uy

Instituto BIOS
www.biosportal.com

Universidad de la Empresa
www.ude.edu.uy

VENEZUELA
Instituto Diseño Darias
www.iddar.com

Universidad Nueva Esparta (UNE)
www.une.edu.ve

Instituto de Diseño de Caracas
www.disegno.com

Instituto de Diseño Perera
www.instiperera.com

Instituto Prodiseño
www.prodi.com.ve

Universidad José María Vargas
www.ujmv.edu

Universidad del Zulia (LUZ)
www.luz.edu.ve

Universidad de Los Andes (ULA)
www.ula.ve

Instituto Universitario Tecnológico
Antonio José de Sucre
www.iutajs.edu.ve

Instituto de Diseño Valencia
www.designvalencia.com

PUBLICATIONS

ARGENTINA
Suma +
www.summamas.com

90+10
www.90mas10.com.ar

Ediciones Infinito
www.edicionesinfinito.com

La Marca Editora
www.lamarcaeditora.com

BOLIVIA
Impresión Gráfica
www.impresiongrafica.com

BRAZIL
2AB Editora
www.2ab.com.br

Arcos
www.esdi.uerj.br/arcos

Revista Arc Design
www.arcdesign.com.br

Revista Designe
www.univercidade.edu/iav/rev_designe

Revista Design Gráfico
www.design-grafico.com.br

Tupigrafia
www.tupigrafia.com.br

CHILE
Ediciones Puro Chile
www.puro-chile.cl

COLOMBIA
Proyectodiseño
www.proyectod.com

COSTA RICA
ArtMedia
www.artmediarevista.com

DOMINICAN REPUBLIC
Arquitexto
www.arquitexto.com

ECUADOR
Markka Registrada
www.markkaregistrada.com

HONDURAS
Ediciones Ramsés
www.edicionesramses.hn

MEXICO
A! Diseño
www.a.com.mx

PANAMA
Revista Blank
www.blankpanama.com

El Revolver
www.elrevolver.com

PARAGUAY
Wild
www.wild.com.py

541

AUTHOR

***1956, Brazil, www.felipetaborda.com.br**

1. "A Imagem do Som" series of art books, 1998–2007, Petrobras
Art direction/design Felipe Taborda

2. "100 Posters" catalogue and poster for an exhibition, 2005, Fort Collins Museum of Contemporary Art (Colorado, USA)
Art direction/design Felipe Taborda
Photo Zeca Fonseca

Felipe Taborda is a reference for graphic design in Latin America. As a designer, instructor, lecturer and activist, he has taken the region's visual approach to conferences and exhibitions in over 40 countries during the last decade. He graduated from the Catholic University in Rio de Janeiro before travelling abroad to study at the London International Film School, and at the Institute of Technology and School of Visual Arts in New York. He has run his design studio since 1990, working primarily in the music, editorial and cultural sectors. He created the series *A Imagem do Som* (The Image of Sound), which he has exhibited nationally and internationally. Taborda's works have been published in books such as *The Anatomy of Design, Graphic Design for the 21st Century,* and *World Graphic Design.*

Designer Felipe Taborda gehört zu den bekanntesten Grafikdesignern in Lateinamerika. Als Designer, Lehrer, Dozent und Aktivist hat er während der letzten zehn Jahre die visuelle Annäherung an Konferenzen und Ausstellungen in über 40 Ländern geprägt. Er schloss sein Studium an der katholischen Universität in Rio de Janeiro ab und reiste dann ins Ausland, um an der London International Film School sowie am Institute of Technology und der School of Visual Arts in New York zu studieren. Taborda leitet sein Designstudio seit 1990 und arbeitet hauptsächlich für die Musikindustrie, den Verlagsbereich und den kulturellen Sektor. Er entwarf die Serie *A Imagem do Som* (Das Bild des Klangs), die national und international ausgestellt wurde. Taborda's Arbeiten wurden in Büchern wie *The Anatomy of Design, Graphic Design for the 21st Century* und *World Graphic Design* veröffentlicht.

Felipe Taborda est une référence dans le graphisme latino-américain. En tant que graphiste, professeur, conférencier et militant, il a représenté la démarche visuelle du continent lors de conférences et expositions dans plus de quarante pays au cours de la dernière décennie. Il a obtenu son diplôme de l'Universidade Católica do Rio de Janeiro avant de voyager pour étudier à la London International Film School, ainsi qu'à l'Institute of Technology et à la School of Visual Arts de New York. Il dirige son studio de graphisme depuis 1990, et travaille principalement dans les secteurs de la musique, de l'édition et de la culture. Il a créé la série *A Imagem do Som* (L'Image du son), qui a fait l'objet d'expositions au Brésil et à l'étranger. Ses œuvres ont été publiées dans de nombreux ouvrages, notamment *The Anatomy of Design, Graphic Design for the 21st Century,* et *World Graphic Design.*

GRACIAS

To Julius Wiedemann, who led this project with a perfect balance between enthusiasm and rigor, and who believed in the importance of this book right from my first contacts with the publishing company.

To Daniel Siciliano Brêtas, for the enormous care he took in all the details of this project and his always-welcomed graphic design and editorial suggestions.

To all the collaborators listed in the appendix. To some dear personal friends and others known only over the Internet. Without them all this book would never have been written.

To Ligia Santiago, my assistant, for her professionalism and calmness when working on this complex book.

To Tom Taborda, my brother, for his constant interest, suggestions and contributions which helped make this book much more complete.

Felipe Taborda

Special Thanks

Ronald Shakespear, Juan Carlos Darias, Federico Sánchez Villaseca, Héctor Villaverde, Gustavo Wojciechowski (Maca), Diego Giovanni Bermúdez Aguirre

Thanks

Gerttie Aird, Luis Almeida, Pedro Álvarez Caselli, Oscar Aprea, Walo Araújo, Ernesto Azcuy, Xavier Bermúdez, Ricardo Blanco, Bayardo Blandino, Ernesto Calvo, Natália Campero, Lia & Dicken Castro, Zoraida Consuegra, Roberto Contreras Gonzales, Luis Erlanger, Gonzalo Fargas, Bruno Feitler, Miguel Flores Castellanos, Rubén Fontana, Jorge Frascara, Rodolfo Fuentes, Hernán Garfias, Viviane Haddad Viana, Mariano Hernandez, German E. Hernández Saavedra, Pablo Iturralde, Ruth Klotzel, José Korn Bruzzone, José Land, Solange Magalhães, Fernanda Martins, Paúl Martínez, Belén Mena, Helena de Mion, Sandra Monterroso, Johana Mora, Cande Moreno, Osvaldo Olivera, Luis Paredes, Fernando Patti, Alejandro Paul, Robert L. Peters, Lourdes Periche, Javier Pezzino, Ariel Pintos, Celeste Prieto, Luis Fernando Quirós, Zaidy Rijos, Lonnie Ruiz Gómez, Isabel Sáiz, Lorenzo Shakespear, Alberto Soto, André Stolarski, Teresa Tió, Carlos Valladares, Freddy Van Camp, Henry O. Vargas Benavides, Augusto Valdivia, Luis Villacinda, Domingo Villalba, Mónica Zacarias

© 2008 TASCHEN GmbH
Hohenzollernring 53
D-50672 Köln
www.taschen.com

To stay informed about upcoming TASCHEN titles, please request
our magazine at www.taschen.com/magazine or write to TASCHEN,
Hohenzollernring 53, D-50672 Cologne, Germany, contact@taschen.com,
Fax: +49-221-254919. We will be happy to send you a free copy of our
magazine which is filled with information about all of our books.

Design
Sense/Net, Andy Disl and Birgit Reber, Cologne
Daniel Siciliano Brêtas
Layout
Daniel Siciliano Brêtas
Assistant Design
Ligia Santiago
Typography
Mobley Sans by Alejandro Paul <www.sudtipos.com>
Cover Illustration
"The Real America", 2008, Yomar Augusto
Back-cover Illustration
"IDP trama", 2004, Studio A
Production
Tina Ciborowius

Editor
Felipe Taborda
Julius Wiedemann
Editorial Coordination
Daniel Siciliano Brêtas
Editorial Assistant
Ligia Santiago

German Translation
Daniela Thoma for Equipo de Edición, Barcelona
French Translation
Aurélie Daniel for Equipo de Edición, Barcelona

Printed in Italy
ISBN 978-3-8228-4035-1

TASCHEN is not responsible when web addresses cannot be reached,
if they are offline or can be viewed just with plug-ins or subscription.